Drunk with the Glitter

Women of easy virtue and thoroughly filthy fellows, ageing roués and problem girls, harlots in cars and perfect poppets: Gillian Swanson provides a dazzling gallery of the sexualized figures who inhabited the urban landscape of an emergent modern Britain. She combines a breathtaking story, full of drama and pathos, with sharp-eyed analytical interpretation. With compelling audacity she places the sexualized pathologies of twentieth-century Britain at the very heart of our understanding of how modern life works. Swanson delivers an incomparable, wry backward glance at the disorderly nation, her own sympathies evident on every page.

Bill Schwarz, Queen Mary, University of London

Drunk with the Glitter examines the ways in which urban modernity reshapes 'cultural experience'. In particular, it explores the ways that categories of sexual identity and behaviour were reformulated in relation to the restructuring of urban space and the introduction of new cultures of consumption in a period of modernization. How did the 'altered conditions' of post-war Britain help to inaugurate new patterns of sociability, cultural attachment and intimate encounter?

Each chapter focuses on an area of public controversy which directed attention to those forms of sexual instability identified as threatening to national cohesion, including:

- 'sexual excitations' in World War Two Britain
- the identification of the 'problem girl'
- 'distractibility' and 'synthetic culture' in post-war Britain
- prostitution in new cosmopolitan cultures in the 1950s
- *Lawrence of Arabia* and debates over male homosexuality in the 1950s
- the scandal surrounding the Profumo Affair.

Gillian Swanson is Reader in Cultural History at the University of the West of England, Bristol. Her research focuses on the cultural history of private life, sexual identity and behaviour, and cultures of consumption and entertainment, particularly in nineteenth- and twentieth-century Britain. Her previous publications include *Nationalising Femininity: Culture, Sexuality and British Cinema in the Second World War* (1996, co-editor Christine Gledhill) and *Deciphering Culture: Ordinary Curiosities and Subjective Narratives* (2000, co-authors Jane Crisp and Kay Ferres).

Drunk with the Glitter

Space, consumption and sexual instability in modern urban culture

Gillian Swanson

LONDON AND NEW YORK

First published 2007
by Routledge
2 Park Square, Milton Park, Abingdon, Oxon, OX14 4RN

Simultaneously published in the USA and Canada
by Routledge
270 Madison Ave, New York, NY 10016

Routledge is an imprint of the Taylor & Francis Group, an informa business

Typeset in Sabon by
GreenGate Publishing Services, Tonbridge, Kent
Printed and bound in Great Britain by
Antony Rowe Ltd, Chippenham, Wiltshire

British Library Cataloguing in Publication Data
A catalogue record for this book is available from the British Library

Library of Congress Cataloging in Publication Data
Swanson, Gillian.
Drunk with the glitter : space, movement, and sexual instability in modern
urban culture / Gillian Swanson.
p. cm.
1. Great Britain—Social conditions—1945– 2. Sexual ethics—Great
Britain—History—20th century. 3. Sex—Social aspects—Great Britain. 4.
Sex role—Great Britain—History—20th century. 5. Social change—Great
Britain—History—20th century. 6. Great Britain—Moral conditions. 7.
Sociology, Urban—Great Britain. I. Title.
HN385.5.S93 2007
306.770941'09045—dc22
2007017385

ISBN 10: 0–415–06130–X (hbk)
ISBN 10: 0–415–06131–8 (pbk)

ISBN 13: 978–0–415–06130–8 (hbk)
ISBN 13: 978–0–415–06131–5 (pbk)

Gwyneth Marie Swanson, 1931–2006

Taara and Joseph

Contents

Figures

Acknowledgements

This book has been simmering for a long time. It is 'bookended' by two chapters – one on World War Two and the other on the Profumo Affair – that started life as independent projects, over a decade ago. The more I worked away at what made the Profumo Affair, the further back I had to go to unravel those threads which converged in that particular sexual controversy, until it became clear that a connection between sexual behaviour and consumption in the management of morale in wartime was also being worked through in the 1950s sexual debates which led up to the framing of the scandal. As I amassed the materials on which the chapters in this volume are based, it became clear that those particular figures of sexual instability which were invoked in a general field of commentary and inquiry into the nature of modern life and cultural experience were described most vividly by an emergent but surprisingly dispersed and diversified field of psychopathology, whose origins lay in a peculiarly British address to the question of character from the 1920s. Many other projects were started and completed in the period since, and many other lives were lived, but that line of inquiry has always been tantalizingly there, waiting for me to return to it, and in 2004 I finally got everything else off the desk and bit the bullet.

In the interim, though, my thinking has benefited from many conversations, much comment and advice, invaluable references and lent books, as well as those everyday insights that arise as a result of productive collaborations and exchanges with colleagues. I would like to thank those in Australia who were influential at the point at which the project was generated and developed, especially Tony Bennett, Brett Farmer, Kay Ferres, Elizabeth Ferrier, Mark Finnane, Rosemary Hawker, John MacArthur, Jock McLeod, Colin Mercer, Jeff Minson, Tom O'Regan, Dugald Williamson and Pat Wise. I am fortunate in my present context to have colleagues with an eclectic range of interests in cultures of modernity – and an attentiveness to the anecdotal, the detail and the contingent – which creates a conducive environment for research, oriented less by the conventional framing of cultural studies than its broader interdisciplinary forms. But I would like to give special thanks to those who read later chapters or gave other forms of constructive input: Jane Arthurs, Iain Grant, Michelle Henning, Ben

Highmore, Richard Hornsey, Kath Holden, Moira Martin and Martin Lister. I owe a particular debt to colleagues outside these institutions who supported the development of the project, commented on earlier pieces, or gave their time to read parts of the manuscript at various stages, all of whom offered incredibly helpful advice: Charlotte Brunsdon, Christine Gledhill, Annette Kuhn, Frank Mort, Mica Nava, Susannah Radstone and Bill Schwarz. Friends close by – and not so nearby, but near in spirit – who contributed to this book in material and other ways only they and I properly know, and who I simply couldn't do without, are Katy Beddington, Ruth Borthwick and Jason Todd, Gill Branston, Kate Stewart and Mark Sendell, and Janet Thumim. And Michèle and Bill, Krishna and Tim, and Elaine and Neville generously provided an essential mix of childcare, friendship and other supportive distractions.

Chapter One was originally published as '"So much money and so little to spend it on": moral consumption and sexuality' in Christine Gledhill and Gillian Swanson (eds) (1996) *Nationalising Femininity: Culture, Sexuality and British Cinema in the Second World War*, Manchester and New York: Manchester University Press. An extended version of Chapter Three will appear as '"Shattered into a multiplicity of warring functions": synthesis, disintegration and "distractibility"', *Intellectual History Review*, 17(3) (November), 2007. An earlier version of Chapter Five appeared as '"Flying or drowning": sexual instability, subjective narrative and "Lawrence of Arabia"' in Jane Crisp, Kay Ferres and Gillian Swanson (2000) *Deciphering Culture: Ordinary Curiosities and Subjective Narratives*, London and New York: Routledge. Chapter Six is an amended version of 'Good time girls, men of truth and a thoroughly filthy fellow: sexual pathology and national character in the Profumo Affair', *New Formations*, 24 (Winter), 1994b.

Griffith University and the University of the West of England both supported the project with research expenses and periods of leave. Research leave to complete the book was also supported by the Arts and Humanities Research Council. I was extremely lucky to have the help of assiduous researchers to help compile the archive of primary materials: Jo Haynes, Michelle Jagoe, Jenny Mahon and Ben Worpole. Alanna Donaldson did a fantastic job formatting and proofreading the final manuscript. Rebecca Barden, Natalie Foster and Charlie Wood were wonderfully patient and encouraging editors.

I always intended to dedicate this book to my mother, whose stories of ironing after school next to open French windows while the doodlebugs went over, and running down the garden and throwing herself through the shelter door onto the bed when she heard them start to drop, stimulated my interest in the more everyday aspects of wartime Britain. She also appreciated a good scandal and, unlike me, could remember the names. She was a natural historian, acting as my unpaid research assistant at the British Library Newspaper Collection while I was in Australia, and going

through boxes with me at the Mass Observation Archive, even though she was entirely sceptical about the value of the kind of writing that made things more difficult than they ought to be. But in the end, I have also to dedicate it to the two people who between them have been around for the whole period I have been writing this book, and who have made the rest of life so much more fun over those years as a result, Taara and Joseph. Thanks, I'll be a bit freer now.

Introduction: urban modernity and sexual instability
Space, movement and dispersal

Perhaps what we know best about urban modernity is the way it has reshaped cultural experience. If the concept of modernity concerns processes associated with urbanization and industrialization – the development of the metropolis, the formation and maintenance of civic culture, the introduction of mechanized labour and industrial working cultures, the expansion of commerce and commodified culture – these register most forcefully as changes in the spatialities, rhythms, practices and perceptual modes of everyday life. And alongside the development of modern urban culture, we can chart the emergence of the notion of the individual, as the point around which the 'environments' of modernity cohere. The compelling but fraught relation between urban modernity and the way it registers at the level of the individual is the subject of this book.

Knowledge about this interaction has been provided, historically, by those disciplines of social management – formed in the convergence between the social and psychological sciences – which emerged in the course of the nineteenth century. It was in this context that responses to problems associated with urban living and its patterns of intimate association were developed. The economic, political and social processes distinctive to modern urban life are subject to continual adjustments and realignments, giving rise to an experience of modernity as a series of 'altered conditions' requiring a similar set of adaptations to be made by those modern individuals whose experience is reshaped by its unstable landscapes. This book is based on the assumption that modern cultural experience is bound by the history of these awkward meetings, alliances and confrontations. And it proposes that we can only understand its histories if we bring into view those frameworks of knowledge which inform our understanding of the environments of urban modernity, and which help us imagine those subjectivities formed in relation to them.

In particular, the essays address the way sexuality and consumption feature in the development of modern urban cultures. As the metropolis offered new forms of individual mobility and social encounter, and urban life was formed in terms of distinctive spatialities and temporal rhythms, individual experience was reconfigured at the most intimate levels. The sexual was

identified as a key aspect of the dangers inherent in the new geographies and social relations of the emerging metropolis. Sexual instability became a central motif of modern urban culture, just as a range of problematic figures and sexual pathologies were seen, in their association with new forms of consumption, as symptomatic of urban 'ills' (Swanson 2000; see also Cook 2003: 82). The development and popularization of the 'sexual sciences' at the end of the nineteenth century – which drew on statistics, medicine, psychology and criminology – helped to make a link between sexual disciplines, consumption and national character, through the identification of urban pathologies.

Part of the reason that the sexual was given such significance in the formation of new urban subjectivities lay in a general intensification of the management of individual action resulting from a transition which took place in economic theory. This involved a shift from the classical economics of eighteenth-century liberal political theory, which centralized production, to neo-classical theories centring consumption – understood in terms of a dispersed range of individuals representing the origination of desires and the finite end points of economic processes (Birken 1988). 'Productivity' as a criterion of individual activity and a sign of the achievement of human societies became understood not so much as a capacity for production itself, but rather in terms of appropriate and modified forms of consumption. As the value of products ceased to be defined by the transformations wrought on primary materials by labour, the commodity's value derived from the relationship between scarcity and desirability. Now 'simply attached to objects by the subjective desire of consumers ... value lost its social nature and took on a radical individual character' and the satisfaction of idiosyncratic desire became the end of productive activity (Birken 1988: 32). The focus on consumption could thus be seen to skew the relation between the economic and the social towards a privatized, hence more acutely feminized, individuality whose points of reference lay beyond the social and its mechanisms for self-regulation.

The title of this book, *Drunk with the Glitter*, refers to both the 'lure' of urban cultures of consumption, and the 'altered states' that they were understood to stimulate. Patrice Petro uses this phrase – from Bruno Schoenlank's poem 'Kino' – to signal that mass consumption was viewed as a form of enchantment associated with the glittering commodity, and the irrational basis of mass taste became embodied in susceptible female figures immersed in sentiment, lost to pleasure (Petro 1987). The experience of 'immersion' in the 'attractions' of modern life was further described in terms of a dislocated relation to space and time (see Benjamin 1973; Buck-Morss 1989; Nead 2000). Dispersed across the expanded landscapes of urban commerce, suspended in the moment, the modern individual was drawn in the light of those meanings associated with the commodity and its 'distraction': modern experience became crystallized in a radically destabilizing loss of self encapsulated in the notion of 'drift' (Swanson 1994a; Charney 1998).

As metropolitan culture undermined traditional forms of locatedness, urban experience was understood in terms of a radical 'unmooring' of individual experience. This new relation to spaces and objects was characterized in terms of 'commotion', a disorderly array of stimuli and activity brought about by continual movement, with new habits and patterns of living that encouraged 'inconstancy and ... excitement over variety' (Singer 1995; Schivelbusch 1979: 1). Appraisals of urban life based on its 'disturbances' of natural rhythms, movements and relations also brought into view a new aggregate: the crowd. As Beatriz Colomina has argued of urban modernity, 'crowds, shoppers in a department store, train travellers ... inhabit a space that is neither inside nor outside, public nor private (in the traditional understanding of those terms)' (Colomina 1994: 6). If the private is now 'more public than the public' (Colomina 1994: 8), the crowd represents the turning inside out of not just spatial designations, but those ways of arranging the self which depend upon their distinctiveness, offering a motif for the intermixing of differences in an unsecured environment. In this sense, the crowd stands as the emblem of a modern sensibility created by the emerging conditions of urban life, which consists in distinctive forms of encounter and the varied and fragmented engagements that modern cultural forms offer. Colomina's argument that modern life is characterized by a 'dilemma' not a separation, between public and private, suggests a new mode of perception that is tied to 'transience' and a lack of 'home' (Colomina 1994: 4). The dislocated, unmoored and fleeting view of the space of the city created by new forms of urban mobility correspondingly makes the private – private tastes, habits and desires – available for public scrutiny, turning the private into 'consumable merchandise' (Colomina 1994: 8–11). This process – the 'consumerization of space' (Wilson 1994: 158) – renders individuals visible within a newly defined public arena.

These processes not only challenge the very possibility of spatial distinctions between public and private, but render the definitional impermeability of the private domain of intimacy as the 'home' of authentic individuality antiquated. Don Slater indicates that the depersonalized relationships in modern commercial culture ironically bring individuals into intimate contact precisely on the basis of their lack of personal obligation and their participation in an 'amorphous' gathering on the basis of individual desires and impulses. This leads him to associate the distinctively modern experience of the crowd with the traditional model of the market, as 'a gathering place ... offering *diverse points of focus for diverse and contingent interests*' (Slater 1993: 192–4, my emphasis). The experience of the crowd, as a motif for a modern urban sensibility created by the emerging conditions of urban life, relies on a depersonalization which results from individual interests and desires mobilized in distinctive forms of encounter (Swanson 1995).

As a motif of the anonymity and disturbing differentiation of those urban spaces and populations formed in the context of consumption and

commodification, the crowd is seen as an unprecedented *force* – not just the symptom and creation of modernity but also, in the shift from economic systems centralizing production to those oriented by consumption, its author and driver. Through the motif of the crowd, a reciprocal association between the unruly and voracious 'mob', as an uncontrollable and irrational force, thirsty for pleasure, liable to surge lawlessly forth, and feminine sensuality, understood in terms of a distinctively feminine 'inertia', a failure of the moral capacity for self-regulation, which made women susceptible to 'morbid addictions', became imprinted into appraisals of modern culture (Kaplan 1988; Bourne-Taylor 1988). This gave rise to the perception that modern urban life irritated and excited the emotions and the senses, 'jostling the individual' so that powers of reflection, and above all discrimination – a process in which the individual exerted a judgement borne from the apprehension of conventional boundaries, hierarchies and perspectives – were eroded (Benjamin 1970). The sense that this undermined individual demeanour at the most intimate level is evident in the definitional link between commodification and sexual instability, and its consolidation in the figure of the prostitute, who, towards the end of the nineteenth century, came to embody the problem of consumption in an image of devouring sexuality (Buci-Glucksmann 1994; Armstrong 1999; Walkowitz 1992; Doane 2002; Swanson 1994a).

But it is precisely those landscapes that were seen as 'dehumanizing', perverse and even monstrous which offered the *attractions* of the anonymity and unknown possibilities inherent in urban life (Walkowitz 1992). In particular, those spatial coordinates that reversed the features of domestic landscapes offered women the fascination of expansiveness, promising increased mobilities, unimagined encounters and new forms of urban attachment, and allowing the refashioning of femininity (Nava 1996; Rappaport 2000). As commercial industries and entertainments elicited, and were fuelled by the presence of women in the public spaces of the metropolis, urban space was reciprocally 'feminized'. Formed in the context of 'promiscuous sociabilities', non-familial forms of femininity were seen as undermining to the coherence of sexual categories, suggesting new coordinates of emotion and personality, raising a series of concerns over the potential of urban cultural forms and practices to distort conventional sexual distinctions and identities (Stallsell 1987; Swanson 1994a). Urban life was the source of 'dreadful delight', as Judith Walkowitz has argued, foregrounding the contradictory meanings and tensions surrounding the changed form of women's presence in the nineteenth-century city (Walkowitz 1992). Similarly, it has been seen by Matt Houlbrook as a source of 'perils and pleasures' for homosexual men in Britain from World War One to the 1950s, their radically different patterns of inhabiting urban space, and their disruptive practices of display, consumption and sexual exchange, acting to sexualize the metropolis (Houlbrook 2005). In this light, the derogation of consumption's 'worthlessness' can be linked to an

anxiety surrounding modernized forms of urban culture and the reorganization of sexual distinctions associated with new forms of public presence and self-definition, and their power to disorganize cultural certainties.

The destabilizing potential of urban culture and transformation that the essays in this volume deal with is linked to an interest in the impact of urban cultures – and particularly to cultures of consumption – on individual experience and perspective: the problem of the subjective. The concept of the subjective exists in a tense relationship with notions of objective 'truth' and 'reality', so it is traditionally troubling to the established disciplines of knowledge, such as science and medicine, yet it is central to investigations of the impact of cultural modernity (Flint 2000). How are the disturbances and unmoorings associated with transformations in cultural experience to be made sense of, and how are modern forms of knowledge able to provide an authoritative understanding of the nature of the modern world, if its meaning is registered most fully in the way it recasts subjective experience? Jonathan Crary has argued that a preoccupation with the question of attention – the capacity to screen out stimuli 'from a broader field of attractions, whether visual or auditory' in order to focus in a particular direction – emerged in the late nineteenth century as a distinctive response to the altered environments of modernity, and that this interest was itself a condition for the emergence of psychology. This disciplinary orientation allowed issues relating to urban modernity to be framed in ways that foregrounded individual perception and consciousness as an unstable series of disconnected states (Crary 1999: 1–79). As such, psychology becomes formed in relation to the unpredictability – the contingency – of 'the experiential', rearticulating the problem of urban life in terms of its potential to engender 'instability'.

To preserve this sense of the ongoing instability of modern life and the particular dangers associated with specifically modern subjective orientations, I have focused in the essays collected here on a series of 'moments' at which life appeared to change – and in which the relation between the individual and the 'environments' of modernity was under review. In such circumstances, those knowledges that addressed the relation of environment and self were used to account for the effects of change at both levels, and to point to ways in which it could be managed. The moments of change I have chosen to focus on all occur between the 1940s and the 1960s – a period in which the logic of modernization was embraced in a particularly purposeful way. Cultural historians have identified the period after the end of World War Two in Britain as particularly distinctive in the way it addresses the nature of modernity, revealing 'the extraordinarily contradictory impulses towards the modern as they were expressed within British society' (Conekin *et al.* 1999: 2–3). These modernizing impulses were directed at British life, and gave rise to a distinctive approach to reshaping experience, in which 'the modern emerged as a key signifier and a general referent' (Conekin *et al.* 1999: 10). In addition to the more familiar areas of planning, such as industry and business, manufacturing and distribution, political life, civic

infrastructure and service provision, planners also addressed the way that urban social life was lived, including patterns of travel, commerce and entertainment, and the staging and texture of domesticity, developing new models of domestic and interior design in order to modernize family life and routine. But an attitude to modernity that saw the way it registered at the level of the individual as critical to social stability also informed the way patterns of intimate life were conceived, demanding that patterns of relationality, subjectivity and sexuality should be calibrated to the modernizing of Britain. Questions of character were central to post-war programmes of modernization, and the sexual became seen as a cornerstone of effective citizenship (see Thane 1999).

This provided the grounds for a convergence between those disciplines which claimed to be able to define the forms of emotional stability that would equip citizens for the modern age and secure Britain's future stability. Following World War One, with the development of psychopathology, the instability of the experiential became translated as a matter of national concern, intensifying interest in the relation of individual mental states to forms of perceptual disorder, and their link to pathological forms of behaviour that undermine social cohesion. The convergence of psychology, sexology and eugenics around the management of family life as a question of national concern (and especially as a component of morale in wartime), and an associated specification of 'national character', created a specific field of influence whereby psychopathology became a key mechanism for social management and the sexual a prime indicator of social equilibrium.[1] As Edward Glover warned in his wartime broadcasts on morale, if a breach occurs between family and nation, women's dedication to the nation's interests may falter. He proposed the national as an object of masculine identification and the familial as one of feminine identification, both reiterating the lingering spatial model of difference of the nineteenth century and showing it to be subject to change, less than persuasive in the assumed correspondence of its two component elements. As he questioned the persistence of a model of complementary realms, Glover also made an important assumption that it was women who are less than securely situated within changing national and familial arrangements and whose 'loosening' may incur a disequilibrium which would prove lethal to the community (Glover 1940b; see Chapter One). G. M. Carstairs, in his 1962 Reith lectures addressing the 'changing British character', outlined a field of inquiry into culture and personality in which he made the modernization of sexual culture a central measure for providing social cohesion, drawing on anthropology, sociology and psychoanalysis to develop a 'scientific approach in the study of personality development' which was indebted to psychodynamic psychiatry (Carstairs 1962; see Chapter Six). Glover's and Carstairs' texts bracket a period during which psychopathology became seen as an important means of describing the interaction of personality and environment, and of managing a changing social domain through an inquiry into those intimate encounters and psychic processes through which modern life

could be described. They also bracket the historical range of this volume, which starts with the management of morale in wartime Britain, and finishes with the scandal of the Profumo Affair at the beginning of the 1960s.

As the coordinates of sexual categories became uncertain in a period of changing sexual definitions, controversies worked over their gaps and incoherences, pointing to the boundaries of sexual meaning (see Waters 1999). In those that emerged in Britain following World War Two, a relation between social and sexual identity comes into view as a project – or problem – of self-management. As the experience of war helped to undermine models of the sexual complementarity and presented a problem of redefinition, the deployment of psychopathology as a means of managing social problems at an individual level was the essential condition for this to become legible *as* disruption, while the 'altered conditions' of wartime Britain offered a field for its deployment. In this context, the recasting of modern sociality and subjective experience, and its disorganizing of distinctions between public and private, masculine and feminine, normality and pathology, became reframed in terms of the way those changing environments of modern life manifested in a range of sexual problems and lapses. In order to appraise the way that the sexual is understood to relate to the changing conditions of urban modernity, then, these essays also focus on moments of intensified interest in the sexual as a central aspect of modern urban life in its changing forms. The experience of World War Two Britain brought into focus a series of concerns developed before the war, about the sexual as a component of effective national character. Chapter Two charts the development of a 'social psychology of everyday life' designed to address cultural experience and everyday life in a modernizing Britain. Attention is directed to the 'problem family', whose degenerate features manifest in social pathology, identifying those patterns of domestic spatial arrangements, routines of living and familial relations which constitute an irregular – anti-modern – developmental environment for the next generation of citizens, preventing them forming the patterns of sentiment which allow them to moderate instinctual impulses. Contemporary commentators identify the 'problem girl', whose sexual delinquency and compulsion to steal is linked to her distinctive susceptibility to the 'promiscuous sociability' of modern urban cultures and attachment to 'the gratification of the moment'. It was from this perspective that the impact of those environments on individual character became the object of attention. As psychology, eugenics and sexology were revised and adapted in the context of the modernizing of post-war Britain, they specified a series of new sociabilities and cultural attachments, and so delineated the difficulties of securing individual stability and integrated character within an expanded landscape of urban commerce and consumption. The 'syncopated' cultures of consumption and entertainment in post-war Britain (Chapters Three and Six), and those transformed spatialities of urban life which allowed a spectacularization of intimate encounters (Chapters Four and Five), allowed a focus on the altered environments of a modernizing Britain and their effect on the formation of character.

The disturbances of modern life were framed as questions of character, consciousness and conduct in this period, foregrounding the individual's capacity to apprehend and synthesize reality and to translate impressions into an approach to purposeful action that demonstrated integrated character. In the nineteenth century, psychological inquiry into defects of 'attentiveness' had associated distraction with the transformed urban landscapes of modern cultures. But in 1930s and 1940s Britain, this concept became revived in the context of a concern with the future of adolescent working girls. The damaged landscape of wartime Britain provides a means, in this context, of articulating the disruption to traditions of culture brought by factors other than war in terms of the girls' responsiveness to the 'irregularity' – the intensity, ephemerality and abstraction – of contemporary cultural forms. Defining them in the image of those 'inauthentic' cultural forms that threaten the coherence of modern British character, the distinctive susceptibilities which predispose girls to the lures of urban distractions point to a suggestibility which erodes the capacity to discriminate between reality and fantasy. Lost in sensation, they become defined by a radical disruption of subjective coherence and consciousness. If the problem girl is seen as suspended in the gap between the past and future that characterizes the developmental phase of adolescence – a figure embodying the 'ruins' of modernity – 'distractibility' similarly threatens emotional and psychic ruin, resulting in a degenerative progression towards the disintegrative figure of the schizophrenic, 'shattered into a multiplicity of warring functions'.

In the period following World War Two – and in particular in the 'Wolfenden' decade, the 1950s – the question of how to manage modern sexual behaviour and identity was debated across a range of disciplines, government initiatives, scandals and trials, forming a dispersed field of public commentary. Chapters Four to Six address the two most pervasive figures of spatial disturbance and sexual instability, emblematic of the altered environments of a modernizing, sexualized and commodified landscape of urban Britain: the prostitute and the male homosexual. In the early 1950s, calls to 'stamp out' vice focused on eradicating prostitutes from the streets. While the recommendations of the Wolfenden Committee's inquiry into sexual offences reflected this correlation between vice and visibility – calling for increased penalties for public soliciting – this obscured a series of significant changes to sexual cultures and knowledges of sexual behaviour and character. As social inquiry mapped the features of prostitution in new ways, fashioned in accordance with new forms of spatiality in a modernizing Britain, the prostitute becomes refigured in terms of a spatial schism: her 'state of not belonging' is figured in terms of a radical dispersal as her capacity for 'drift' takes her beyond the borders of integrated character.

In this period, the compelling nature of the category of the male homosexual as a figure of monstrous perversion, damaging to the integrity of British national character, was the result of a decade in which scandals, trials and inquiries centred on whether 'male homosexuality' should be

defined as a matter of law or private morality. This was the other aspect of the Wolfenden Committee's inquiry into sexual offences: it recommended that homosexual acts should only be defined as offences if they breached *public* order and decency, providing a realm of homosexual definition which lay beyond the law. Chapter Five explores the shift in models of homosexuality from the 1920s to the 1950s which makes this argument possible. It takes as its focus two waves of narratives circulating around the figure of T. E. Lawrence. The first, in which he wrote his autobiographical account of the desert war, *Seven Pillars of Wisdom*, foregrounds Lawrence's evasion of the norms of social life, sexual convention and masculine identity which become defined in terms of a sexual 'indeterminacy' related to his Arab identification, and draws on Hellenic models of homoerotic 'comrade love' based on 'mutuality'. The revival of interest in Lawrence as a figure in the 1950s is prompted by a pervasive public interest in identifying the features of homosexuality and culminates in the film *Lawrence of Arabia*, released in 1962, in which the pleasures and torments of Lawrence's corporeal instability were rendered through an aesthetic of spatialized immensity and abandonment. But reappraisals of his sexual character proposed that his experience of 'anal rape' stimulated a form of catastrophic homosexual shame which leads to his breakdown, and see him in terms of a degradation attributed to a foundational homosexual disposition. The impact of this refiguring of homosexuality on the exchange between national identity and masculinity suggests an unhinging of cultural certainties, confounding systems of cultural difference and fragmenting the concept of masculinity as the basis of subjective coherence.

These debates provided the context for the making of the Profumo Affair in the early 1960s, which I argue comprises a key staging of the convergence between concepts of sexual instability and the altered patterns of modernized urban encounters, and a critical moment for consolidating an exchange between the prostitute and the male homosexual as figures who crystallized the problems addressed by the psychopathology of modern life. In Chapter Six, those resolutely commercial sexualities associated with the 'amateur' are shown to be rearticulated in ways which transform contemporary motifs of 'drift' and 'dispersal' to those new mobilities offered by the fashionable restyling of youthful femininities of the 'good-time girls', Christine Keeler and Mandy Rice-Davies. But though the sexual narratives of Christine and Mandy prepared the ground for a public scandal concerning John Profumo, public attention was most definitively oriented towards Stephen Ward, 'osteopath to the famous', who 'introduced' girls to a range of influential figures, and who was tried on charges relating to pimping. The 'indecipherability' of Ward's persona, I argue, disarms sexual categories and classifications and leads him to become defined in an exchange between the pathologies of prostitution and male homosexuality, embodying both the charm and enigma of modernity, and its capacity to produce

lethal instabilities. In this sense, he is figured in terms of *both* a 'world apart' *and* a more dispersed and fluid range of figures and behaviours, as 'perversions' of a sexual nature ceased to be solely a condition of 'others' living outside conventional sexual arrangements and became a *potential* attributed to a range of normalized categories of person.

The different ways in which 'cultural experience' and its critical relation to sexuality and consumption were drawn in this period point to the instabilities of modern urban life and its environments, and the provisional, contingent nature of knowledge and its revisions. These shifts in the terms by which cultural and sexual identity and experiences are understood – and their relation to the environments within which they are enacted – are significant for what they show about the endurability and persuasiveness of cultural repertoires, and the forms of disciplinary knowledges upon which they rely. In the course of the exchanges through which these 'problems of knowledge' were played out, sexual categories became disarticulated. Sexual pathologies were attributed to the effects of new cultural landscapes, helping to define modern categories of identity in terms of a radical dispersal, arising from the impossibility of harnessing the proliferating practices of sexual definition into stable, internally coherent, categories. What was being investigated, in the link between sexual identity, consumption and urban modernity, was no less than the nature of modern cultural life. This was the perplexing question addressed by those disciplinary innovators whose investigations function as attempts to negotiate between the vicissitudes of individual 'experience' – modes of thinking, feeling and behaving – and the contingencies of those environments and conditions in which they are formed and enacted.

There is an 'attitude' to modernity evident in those concerns expressed at moments of cultural realignment. For they propose that the impact of the environments of modern life on cultural experience can be calculated in terms of those instabilities it is seen to stimulate at the level of spatial inhabitations and transactions, individual experience and perception, emotional and affective life. This suggests a particular approach to history. Moments of cultural realignment show something of the tentative nature of the disciplines we know ourselves by – the shifting frameworks of knowledge and the instability of those categories we use to think with. As Arnold I. Davidson argues:

> this type of historical analysis makes it very clear that concepts are neither self-identifying mental stages, nor free-standing objects. The concept of perversion, for example, must not be identified with some mental state that can be found by introspection to, so to speak, bear the label 'perversion'. Nor is the concept of perversion or sexuality to be identified with some self-subsistent object, whose content can be discovered by some kind of intellectual intuition. These concepts are to be identified by the uses that are made of them, by the connections that govern their employment and that allow them to enter into what

Foucault thought of as specific 'games of truth' (jeux de vérité). Since these uses, connections and games of truth are not to be analyzed in metaphysical or transcendental terms, as if they were fixed and unrevisable ... we must attend to 'the history of the emergence of games of truth'.

<div align="right">(Davidson 2001: 181)</div>

The contingent revisions and adaptations to the conceptual frameworks which we draw upon to make sense of the movement of culture and character, the spaces, rhythms and encounters through which modern life is made, and those perceptions, responses and mental processes through which it is made sense of, signal an *undecidability* at the heart of cultural experience as it continually exceeds the limits of knowledge. This suggests we should be attentive to the disparities between those divergent and conflicting accounts which make up the 'controversies' over the nature of modern life and cultural experience, and the conceptual frameworks and mentalities that produce them. It also highlights the instability of those sources such histories rely on: this is not just a matter of the inherently conflictual and divergent narratives that emerge in the context of scandal, for example, but of the investments which cross these different accounts, made more spectacularly evident in narratives of military intelligence and espionage and the forms of 'impersonation' which are part of such endeavours (see Chapters Five and Six). But also, it is significant that the texts these histories rely on are accounts written 'in the subjective' – as individuals attempt to make sense of their own formation and investments, their own situatedness. And, as the retrospective narratives of the Profumo Affair make most evident – particularly in the different accounts that have emerged from Christine Keeler over the years – historical narratives are subject to reinterpretation, as individuals continue to reinvent themselves. As Lawrence's biographer Lawrence James observes of the difficulties of making sense of a figure whose own accounts could not be relied upon for historical veracity (who was himself the subject of a family history and name invented to avoid personal scandal, and who later created for himself a new persona, a change of name and identity): 'history is not just what happened but what people imagined was happening' (James 2005: xix).

For those forms of knowledge we think by also constitute 'environments' of subjectivity. Divergent frameworks of knowledge show that categories of meaning and identity, the ways we make sense of fleeting sensations, flashes and flares of memory, disaggregated impressions and apprehensions – in fact the whole composite of perceptual and cognitive processes we call experience – cannot be fully harnessed by the conceptual orderliness embodied in disciplinary knowledges and its classifications. Cultural experience, then, becomes discoverable only as a series of glimpses – or 'anecdotes' in Stephen Greenblatt's use of the term. An approach to history that is formed from this observation mirrors those forms of cultural experience which are rendered as

'a succession of brief encounters, random experiences, isolated anecdotes of the unanticipated' (Greenblatt 1991: 3). In this book, I have therefore attempted to preserve something of the contingency of modern experience and its changing environments, held in fleeting and fractured moments of change.

1 'So much money and so little to spend it on'

Sexual excitations and familial devotions

Altered conditions

World War Two was crucial to the post-war project of modernizing femininity, especially in the enhanced attention paid to familial and sexual relations. The altered relations of home, work and family life occasioned by war and post-war reconstruction challenged nineteenth-century models of sexual difference which relied on the motif of separate spheres to define distinctive and complementary masculine and feminine natures. Traditional concepts of femininity were also challenged by the increasing recognition of non-familial sexual cultures in wartime and post-war Britain. The consequences of new sexual protocols on the national population were already being debated prior to the war, but were brought into a new focus in the 1940s. The estimate made in the 1937 *Report on Maternal Mortality* that thousands of 'unborn children' had been lost and thousands of 'mothers' had died through abortion was proposed as a 'national calamity' (Griffith 1948: 280). The number of illegitimate births almost doubled between 1940 and 1945 (Minns 1980: 182)[1] and the incidence of venereal disease increased by 70 per cent in the period from September 1939 to the middle of 1941 and then again after US troops arrived in Britain in January 1942, while a national campaign was launched in October the same year.[2] Finally, the incidence of divorce increased during the war years towards a new peak in 1946.[3] These patterns put the concept of a maternal femininity that was chaste, unworldly and tied to domestic life under pressure, as the altered conditions of family life in Britain during World War Two gave a greater visibility to sexual behaviour, especially that of women.

As the public mode of address to women in World War Two was tailored to their movement between spheres formerly considered separate, relations between public and private were recast in proposals for national regeneration and reconstruction. The publication of the Beveridge Report in 1942 instigated a shift in welfare and social management strategies towards supporting married women and mothers, in contrast to previous systems which provided 'relief' for those women who fell outside the norms of family life.[4]

The report thereby consolidated a move to regulate private life as a means of securing British national character, while it simultaneously showed a trend to diagnose and treat problems of 'normal' individuals, marriages and families and the patterns of their everyday life.

The argument that every individual and family should be the target of this programme drew on an expanded rhetoric of 'democracy'. Presented as a mark of British humanitarianism, the concept of democracy proposed a model of educated consensus in opposition to the imperatives of 'dictatorship'. As a Ministry of Information memorandum indicated in 1941:

> The principles of Democracy do not simply affect our political system ... They are reflected in our family life, in our attitude to children, to marriage, to all personal relationships ... They are woven inextricably in the texture of our daily life.
>
> (Williams, cited in McLaine 1979: 153)[5]

Newly visible patterns of private life came to define an 'ordinary', intimate, familial Britain (or more usually England) whose common habits were testimony to unity and stability.

Women's involvement in war work and their role in managing consumption in relation to the exigencies of rationing gave them a more prominent public role which fed into visions of post-war Britain. This interplay between the public and the private became a central part of the realignments involved in reconstruction: private interests were to give way to those of the 'community' as the twinning of 'social legislation' with 'personal discipline' was conceived as a platform for regenerating the democratic process (see McLaine 1979: 154). The regularizing of female sexuality played a part in this process: as the psychiatric management of morale addressed familial, marital and sexual relations as part of a social domain, sexual behaviour and the management of private life became a matter of national definition. Nikolas Rose argues that the psychological sciences are predicated on the specification of individual differences and capacities (Rose 1990: 19). During wartime they offered a taxonomy delineating different sectors of the population and their everyday habits and patterns of living for the purposes of managing morale. In this, the sexual was given a central place in defining national character. The delineation of sexual differences and appropriate forms of sexual behaviour helped to instate a newly modernized British national character, formed from the altered conditions of war.

The question of women's morale, their devotion to the war effort and their contribution to the nation's future in post-war Britain became fundamentally linked to the issue of the effect of the war on their sexual behaviour and its implications for the reconstruction of national character. In particular the management of new sexual cultures – and their connection to leisure, entertainment and consumption – identified women as the prime object of this modernizing process.

Managing morale

Richard Titmuss, in his official history of World War Two, proposes that the concern with morale was its defining feature: 'the subject of morale among the civilian population – and not merely the fighting part of it – was being considered long before anyone believed that war was certain' (1950: 337). The change occurred in response to the new threat of civilian air attack: as early as 1924, an inquiry of the Committee of Imperial Defence warned of the disastrous 'moral' effect of civilian air attack in a future war (Titmuss 1950: 18). Preparations for war throughout the 1930s, based on a greatly exaggerated prediction of the extent of bombing of mainland Britain, assumed a much more extensive psychological impact on the civilian population than occurred: a report submitted by a committee of leading psychiatrists to the Ministry of Health suggested that psychiatric casualties could exceed physical casualties by three to one and Churchill later wrote of ministers anticipating 'the most frightful scenes of ruin and slaughter' (Titmuss 1950: 3–21; see also Shepherd 2000: 174–5). In the expectation that civilians' lack of military training and discipline rendered them particularly vulnerable – a 'hideous question-mark to plague one planning committee after another throughout the nineteen-thirties' (Titmuss 1950: 18) – the spectre of mental collapse and resulting civilian disorder gave an urgency to preparations for a wave of 'neurotic casualties' (Slater and Woodside 1951: 7–8; Schmideberg 1942: 147). Effectively, the forecasts of an outbreak of mass hysterical neurosis meant that emergency services were designed predominantly around a psychological rather than a physical imperative: the avoidance of civilian disorder rather than civilian safety.[6]

The outcome of such concern with regulating the population's mental health was a greater interest in gauging the psyche of the civilian:[7] as Nikolas Rose has argued, 'winning the war was to require a concerted attempt to *understand* and *govern* the subjectivity of the citizen' (Rose 1990: 21, my emphasis). The interest in civilian mental health, notwithstanding the fact that there were many men involved in the home front too, led to a new attention to women and the effects of war on female subjectivity. As government became concerned with the possible failure of civilian morale, women and family life became an object of inquiry, research and propaganda:[8] 'Never before, in the history of warfare, had there been so much study and so many plans which were concerned with the protection and *welfare of the women and children of the nation*' (Titmuss 1950: 17, my emphasis). That neither the degree of bombing, nor the envisaged neurotic collapse on the home front, would transpire was clear by 1940. Even preparations for mass evacuations on the basis of panic flights from the cities had not been rewarded: rather, many mothers had recalled their children and propaganda urged them to reconsider. The government was forced to recognize that the maintenance of familiar routines was one of the priorities of the civilian population.[9] They were also made aware of the

antipathy to 'morale propaganda' designed to prevent panic, and by 1941 this strategy was abandoned by the Ministry of Information in favour of a more 'unambitious' programme of information, explanation and education (McLaine 1979: 240). The scaling down of questions of morale in wartime to the ordinary events of everyday life was promoted by a recognition that people were motivated by the immediate conditions and events they confronted. Civilian morale could not be sustained by the 'glory' of dangers associated with military aims, for civilian risks were taken 'in order that some quite unromantic task should be carried out by the end of a given day' (Bion, in Miller 1940: 184–5). Thus it became clear that, despite a continual adjustment of the routines, habits and environment that formed the texture of certainty, it was the maintenance of the features of normal life in the face of new conditions and experiences that would sustain the civilian population. Such an acknowledgement is embodied in Titmuss' retrospective observation that 'it was not altogether unremarkable that people who were dug out of the ruins of their homes first asked, not for food or safety, but for their false teeth' (Titmuss 1950: 350).

The shift to measures for 'maintaining and fortifying psychological health', rather than dealing with widespread neurotic collapse, allowed psychologists to argue that 'normal' individuals could be encouraged to use 'the simpler aspects of making life livable in war' as a means towards generating their own psychological discipline (Bion, in Miller 1940: 195–6). It was this 'strong inner discipline' which, it was argued, defined the British people, in contrast to the Germans who had to have discipline 'enforced ... by authority from without' (Gillespie 1942: 210). As inner discipline was presumed to be greater amongst those who were responsible not only for themselves but also for their dependants (Gillespie 1942: 11), it became necessary to understand the dynamics of family relations and commitments – the 'everyday emotions' – to maximize the ordinary citizen's ability to withstand situations of stress and danger. Psychiatrists inquired into the reasons for the population's resilience – withstanding or recovering from the terror of bombardment, or managing symptoms of shock while carrying on with the routines of everyday life – to propose that collapse was avoided by those strengths which related to the ordinary features of everyday stability: 'civilians were able to keep around them their family and home, their friends and community, the bastions of their emotional security' (Shepherd 2000: 180). As a result, the objective of enhancing morale was pursued through an ongoing process of studying, monitoring and managing the patterns of everyday life. For example, the nightly abandonment of home by families who 'trekked' to sleep in fields outside major cities was taken as a particularly alarming sign of a constitutionally 'weaker' mental condition amongst a section of the population with a disposition to neurotic breakdown, but later became seen as a safety valve similar to the adoption of tube shelters in London; alarm was defused by information that they returned home each morning to undertake a normal day (McLaine 1979: 121).

Although leading psychiatrists had been appointed for the selection, training and treatment of military forces,[10] psychiatric methods initially received little official recognition in the civilian context, provoking a plaintive call upon the government to take the lead in coordinating a unique opportunity to study pathological states (Glover 1940a: 549). But although the Ministry of Information was not disposed to consult psychiatrists in the development of propaganda (see Harper 1996: 193–4), the psychiatric paradigm had nevertheless infiltrated understandings of 'the subjectivity of the citizen' and how morale could be maintained, and was being deployed by other Ministries involved in the dissemination of information and the organization of resources and personnel as well as providing the basis for the activities of the voluntary organizations.[11] The psychological sciences had become a key means of understanding the nature of personal life, and they now constituted an indispensable field of knowledge for those concerned with developing mechanisms with which to manage everyday life in wartime Britain. Hence psychological studies of family, marriage and parenting conducted through the 1930s informed the monitoring of civilian morale.[12] Claims concerning the centrality of the relationship between mother and child to emotional well-being and the capacity for self-discipline and responsibility, and the deleterious effects of its disruption, gained new emphasis during the war (see Riley 1983: 80–109). With the division of families already in place as an emergency measure, the effects of evacuation, correlated early on with an increase in recorded cases of delinquency,[13] became a particularly important feature of the study of morale and war neurosis, highlighting the disruptive effects of separation from parents on children (Shepherd 2000: 175). In fact it was observed that '[t]he most prevalent and the most marked symptom of psychological disturbance among the civilian population during the war was not panic or hysteria, but bed-wetting' (Titmuss 1950: 349).

Treating the disturbances of 'national character' as it would diagnose and treat the neurotic individual (Riley 1983: 65) and moulding a subjectivity that could sustain the disruptions of war, the psychological sciences also contributed to questions of post-war reconstruction, helping to shape programmes for rebuilding a new, modern and stable British psyche.[14] Questions about how British character could adapt to new post-war conditions and their new moral problems therefore become defined in psychomedical terms: as the Chief Medical Officer at the Ministry of Health stated: 'medicine ... needed to treat the "sick society" as well as the "sick person"' (Hopkins 1964: 142). How then were women drawn into the field of investigation established by the psychologizing of morale, and by the shift to a focus on 'everyday emotions and actions' and the effects of the war on everyday life? How did they become visible, both as individuals and as members of the national community, in the regulation of British character?

The cottager's wife: women and morale

Edward Glover, President of the British Psychoanalytical Society during the war[15] and Director of the Institute for the Study and Treatment of Delinquency, had argued for the application of psychoanalytic models of individual pathology to social problems in the early 1930s.[16] He was consulted by the Ministry of Information concerning the management of morale, and his broadcasts for the BBC in 1940[17] were published the same year in a Penguin Special entitled *The Psychology of Fear and Courage*. They specified the character of British national life in order to promote 'steadiness of purpose' and 'solidarity between the various groups within the state', and provided one of the most sustained popular examinations of the question of women's morale, distilling many assumptions implicit in other psychological accounts (e.g. Gillespie 1942; Miller 1940). Glover argued that, to maintain morale, the population should be trained to exert control over mental stress, anxieties and 'primitive fears characteristic of the thought of children and of savages' which are stirred up from dormancy by war. One of the key themes in this publication is the importance of overcoming the natural instincts: Glover expounds a 'form of war work that can be undertaken by every civilian, irrespective of age, sex or class. He can at least keep his head' (Glover 1940b: 9). Fear, doubt and suspicion in their healthy manifestation may be 'common sense', a manifestation of the 'natural instinct of self-preservation', according to Glover, but the cultivation of various forms of 'self-discipline' is necessary to ensure that they do not remain unchecked and erode morale (Glover 1940b: 19, 23, 66).

Woman was given a particular place in Glover's picture of the unity of purpose, and his account is indicative of the contemporary focus on preserving continuity in the minutiae of domestic patterns.[18] For woman appears as a 'cottager's wife', devoted above all to the simplicity of family life and local routines. Her patriotism is drawn from an archaic yet somewhat suburban pastoralism that stands for the 'inarticulate' devotions of all Britons.

> A cottager's wife may tell you that it simply isn't 'good enough' to have her cups and saucers smashed by Hitler. We know that behind this statement there is not only a passionate resentment of interference but a deep devotion to her family. We know, too, that behind this family devotion there exists a deep attachment to all the simple things that go to make up her picture of England – meadows and cowslips, grazing cattle, the children's cricket pitch on the village green, the church steeple that holds guard over the market square, the local omnibus service, the cinema, the garden fence over which she can gossip or the inn-parlour in which her man can air his opinions or grouse to his heart's content. For to her this is what civilisation means. These *quiet and often secret devotions are the basis of our morale.*
>
> (Glover 1940b: 16, my emphasis)

As Glover argues that women's quiet and secret devotions to family constitute a cornerstone of civilization and form the basis of British morale, he also proposes that the emotional fervour of love of country derives from love of family. 'Love' of country is thereby distinguished from the 'instincts' of defence or self-preservation. It is modelled on the integrated, socialized individual, 'warm-blooded' and 'organised', as opposed to the instinctual basis of the state, described as an 'amorphous mass' (Glover 1940b: 121–2). Glover contrasts this familial version of 'England' with the Nazis' dependence on a 'mechanistic' concept of state (Glover 1940b: 121–2). Elsewhere, Samuel Igra wrote that the 'secret vice' of the Germans was their derogation of the feminine and downgrading of the maternal (Igra 1940). The distinctiveness of the British, it was claimed, was their valuation of a domestic femininity.

Glover's argument that 'sex differences' should be acknowledged in the management of morale derives from his view that the devotion of women to family is the basis of male morale. But this is simultaneously the feature that renders them problematic, for 'once the women are demoralised the end is near' (Glover 1940b: 71).

> The real danger about women's morale is that the war may widen the breach between the family and the State ... [W]omen ... react to their *family* as if it were their country. They see the power of the enemy directed against *their* husbands, *their* children, *their* houses and furniture ... this could result in a determination to defend the family and let the country go hang.
>
> (Glover 1940b: 71–2, original emphasis)

Women are fundamentally to be defined in relation to the family, house and furniture, the survival of these having been identified as critical to the preservation of morale.[19] And this association suggests familial loyalties are aligned with a commitment to *national* interests rather than personal ones. Synchronizing these is of particular importance: failures of morale are identified in terms of a conflict between the national and the domestic,[20] just as their morale is secured through the maintenance of domestic routines, as Glover discusses their 'blazing, almost rebellious, determination to have the husband's meal on the table whenever he comes in' (Glover 1940b: 73). But for this very reason, those women who are not wives are at special risk: single women, deprived of the ties of family love, are of particular concern in their adherence to the national effort, joining those other 'types' whose lack of the stabilizing effects of sexual, emotional and reproductive harmony had led psychiatrists to identify them as especially 'vulnerable' – 'women in their thirties in loveless marriages; menopausal women plunged into confusion or florid psychosis ... and, surprisingly often, men with feelings of guilt relating to masturbation' (Shepherd 2000: 180). In their lack of the familial attachments which

would offer a route to national affiliations, single women are rendered 'defenceless ... their morale tends to deteriorate' and, relapsing into 'phantasies of what they would do to Hitler', they become involved in 'shop counter skirmishes', being rude to the greengrocer instead (Glover 1940b: 75). Their only recourse is to an 'orgy of knitting. Failing such solace they are inclined to eat their hearts out' (Glover 1940b: 77).

Glover's approach, drawing on an alliance common at this time, rests on both a psychoanalytic concept of repressed drives and an anthropological model which identifies certain groups as more susceptible to the disturbances of the instincts (Glover 1940b: 1). This model of what was endangered by the stimulation of fear was echoed by Hugh Crichton-Miller's argument: 'The civilian has no really powerful check to the desire for self-preservation ... which can take a form that is primitive ... There is a real danger that he [the civilian] will seek, not security, but infantile security' (Crichton-Miller, in Miller 1940: 185). Given the assumption that personal discipline represented a directing of these primitive tendencies towards socially acceptable aims and satisfaction, the emotions and instincts represent a key domain in which psychology could be used for a more detailed and intimate form of government of the private life of British citizens. This configuration of psychological interests had emerged from the 1920s onwards, but the governmental imperative of maintaining morale in wartime Britain meant that women's instincts, their adherence to appropriate regimes of sexual discipline, and their role in promoting the healthy functioning of the socialized family, became a key area of public inquiry. When Glover suggests that women are subject to the strains of 'passive endurance', he stresses that war neurosis derives from lack of information and 'useful activity', and situates it as a particular problem in the maintenance of women's morale, which must be addressed through their involvement in the management of family life. What were the means for preserving that alliance of family to country which Glover suggests is so important to women's maintenance of morale on behalf of the community, and what were the signs of its disintegration?

Managing the nerves

Assessments of women's constitutional weakness under stress were to be challenged by war experience, as was the assumption that civilian steadfastness was more at risk than that of fighting personnel, but both still featured strongly in the early years of the war. Studies of the incidence of personnel discharged from the army on medical grounds[21] showed psychiatric disorders to be the most common reason, with anxiety neurosis (the form of reaction experienced by the 'otherwise healthy individual' to an abnormal stimulus) the major class of these disorders recorded. While the numbers per thousand of men and women discharged on medical grounds were almost exactly equal, female service personnel were more than twice

as likely to be discharged on the grounds of anxiety neurosis and hysteria as men (War Office 1948: 1–2).[22] These rates may well reflect a greater disposition to diagnose such conditions in women rather than standing as proof of incidence, as the report speculates. Patterns of discharge, then, can be seen as one indication that women were perceived as particularly susceptible to psychiatric disorders; their complaints were defined as 'instabilities' according to psychological concepts of sexually differentiated patterns of 'war strain'. It is not a susceptibility confined to psychiatric observation of military personnel, either. For when Mass Observation reported on a notable instance of 'hysteria, terror, neurosis' in Coventry, it was women's behaviour – albeit of a type that seems somewhat unexceptional in the circumstances of twelve hours of saturation bombing – that stood as the visible sign of a severe display of broken morale. As the report described the scene: 'Women were seen to cry, to scream, to tremble all over, to faint in the street, to attack a fireman, and so on' (Mass Observation Report on Coventry, 19 November 1940, cited in McLaine 1979: 119).

Hysteria represented not only the surfacing of those primitive instincts that suggested the collapse of social inhibitions, but also was seen as indicating a constitutive psychological difference in women. While anxiety was seen as a response of the 'normally healthy' individual to the abnormal conditions of war, and was situated in a class of psychopathic disorders deriving from masculine impotence, woman's maternal instincts were assumed to predispose her to develop hysteria. Hysterical behaviour, read as an exhibitionistic appeal to a mate, is understood as a natural response to frustrated motherhood, in contrast to a hysterical man for whom such symptoms simply show he 'is regressing to infancy' (Crichton-Miller, in Miller 1940: 205). Hence the psychopathologies associated with women implicitly affirm both their greater dependency – as they rely on male intervention for their satisfaction of maternal desires – and their natural susceptibility to states regarded as regressive in adult men and hence defined as infantile, primitive and unsocialized. In addition, some writers associate hysterical reactions 'with a lower kind of social conscience ... the greater the individual responsibility, the less likelihood of resort to primitive or at least socially inadequate reactions' (Gillespie 1942: 210). While women's maternal instinct could provide the familial context that secured male morale, this could not lead to the 'inner discipline' of individual responses so characteristic of the superior form of British character. It was a fabric of external, domestic relations – as a context for the exercise of their devotion – which secured women's familial natures: once these were disturbed, patterns of female psychopathology made their instabilities more lethal.

Studies of war strain and morale helped the national effort on the home front to be defined in terms of a psychological war, identifying the training of women to maintain the equilibrium of everyday life under adverse conditions as a primary task. Magazines and poster campaigns stressed it was

women who should not lose hope but remain constant, transmitting encouragement to those on the military front or to others waiting at home.[23] The notion of 'nerves' provided a way of discussing appropriate forms of female conduct. Magazine advertisements and articles suggested how women should function: keeping courage, keeping heart, fending off sexual temptations provided by other men, maintaining composure, patience, being understanding, and standing firm. They must avoid succumbing to the selfishness of useless emotions: they must avoid brooding or depression, feeling hurt by men's 'lapses' with other women while away from home. Indulging themselves by confessing to sexual infidelities in letters was tantamount to acting as 'fifth columnists'. Women's magazines gave advice on withstanding the loneliness of evacuation, the grief of bereavement, the strains caused by men's altered behaviour while on leave, and especially rebuilding marriages. Women were thereby exhorted to absorb and manipulate psychological techniques to school the emotions, becoming agents of psychological management, as well as its subjects. Developing techniques of psychological self-management would enable women to manage the manifestation of nerves in those close to them as part of the job of maintaining their family during times of disruption. For example, in one article, 'In Courage Keep Your Heart', women are told that their 'most honourable war work' for their family lies in keeping their home 'a place from which they will go out with strong nerves and sound minds ... from which all their lives they will draw strength' (Waller and Vaughan-Rees 1987: 14).

The importance of this form of advice in psychological management lies in its ability to make the problems of war ordinary; the experience of nervous or emotional reaction becomes something familiar, to be incorporated into the disciplines necessary to morale. Above all, it is women's management of self – their commitment to a selflessness – which is crucial to male morale. In 'Are You Brave?', readers are asked 'Can you forego *self* at a time of dire need for the sake of community, nation, a brotherhood of nations defending their common liberties, the bulk of humanity?' (Waller and Vaughan-Rees 1987: 350). The psychological war women were to conduct on the home front was also one against threats to sexual continence: frequently talk of nerves and 'moods' is about women's susceptibility to temptation or the consequences of sexual misconduct, those lapses in sexual discipline which reveal an imperfectly internalized commitment to marital and familial stability.

Managing consumption

The management of nerves was only one aspect of women's wartime duties, but one linked to national objectives through practices of consumption. In the adoption of techniques in household management, treatments for 'war worry' or 'blitz dreams', or regimes of personal hygiene, appropriate practices of

consumption become a means to – and a sign of – emotional and mental health. Crimes concerning consumption, exacerbated by the black market, were policed in the interests of morale, as they were seen as signs of the extent to which war threatened established codes of morality (Smithies 1982: 4). Wartime disciplines demanded of women that they devoted themselves to family survival through prudent and efficient consumption: it also required that they did so in full recognition of national constraints and of the need to sustain the whole community in times of shortage. In the rhetoric of reciprocity between national and community welfare and that of the individual and the family, a tension arises as the consumer must 'manage' consumption within changing conditions, constantly adapting to new objectives, new supplies, new policies. The consuming woman became the point of coherence in a dialogue between public and private interests, those of nation and family. Accordingly, a psychiatric analysis of the housewife's mentality was targeted by propaganda, as the Ministry of Health's psychiatric medical inspector's statement that 'the housewife, seeking food, has to acquire some of the attributes of the primitive hunter' makes clear (Hopkins 1964: 43). The motivation of the female consumer was seen as an *instinct*, thereby placed on a level with those innate, selfish drives for satisfaction which constitute the sexual instincts. To bring it in line with a social aim, it needed to be disciplined, socialized. To this effect, the Ministry of Food appealed as much to personal investment as it did to communal aims: in its *Tips for Healthy Living*, Sandra the 'wallflower' turns to eating lettuce, 'after which, a radiant figure bursting with vitality, she is seen in the final panel besieged by importunate admirers' (Hopkins 1964: 43). In their address to the consuming woman, then, the Ministry presumed that she was driven by sexual aims as much as by national objectives. From that perspective, rationing and the points system, although (or perhaps, because) they made housekeeping 'complicated', established 'an excellent school of social discipline' which would moderate the female consumer's instincts (Hopkins 1964: 47).

Thus the less 'socialized' drives towards consumption were channelled into more familial directions, towards community cohesion as opposed to the satisfactions of individual pleasures. Ironically, however, it was a concern with managing the forms of female consumption directed towards the satisfaction of individual pleasures – particularly new forms of entertainment and leisure – that resulted in new ways of defining a modern post-war femininity. Here the psychological sciences' attention to female sexuality permitted a connection to be made to consumption, providing a means of refashioning and modernizing femininity. A national address to these new, modern women had to acknowledge options and aspirations crafted from the fracturing of traditional domestic routes characteristic of their mothers. However, managing these new tastes confronted the difficulty of managing the sexual instincts stimulated by the altered conditions of war: hence defining women's sexual disciplines became the central feature of producing well regulated modern femininity.

Psychopathology, war and national character: a problem of the sexual

While the question of women's morale was sexualized in wartime Britain, George Ryley Scott claimed in *Sex Problems and Dangers in War-Time*: 'The sexual excitatory effect of war is known to every student of psychopathological problems ... Woman, granted a new-born partial freedom simultaneously with the means of avoiding the consequences of illicit love, has become drunk on sex' (Scott 1940: 70). For Scott, the chief of war's evils was the creation of amateur prostitutes as the 'disappearance of those barriers which in times of normalcy do so much to keep girls reasonably pure and respectable ... [meant] the girl, in the throes of sexual ecstasy for some passing "hero" ... gave herself to soldier or civilian' (Scott 1940: 40). A key factor identified as favouring the spread of venereal diseases was that 'the nation's womanhood is now mobilised as never before; women have replaced men in a multitude of tasks and have been drafted away from the home' (Laird 1943: 34).

As another psychological expert noted, war destabilized effective familial 'checks' on the sexual instincts of women:

> War has its own sex problems. Girls and women are inclined to be too lenient to men in uniform ... Then there is the problem of many young women in war-time whose husbands have to serve in the Forces. They are not only sex starved, but are open to the temptation of consorting with older men or those in reserved occupations. Again, thousands of girls have joined the Women's Services and are *flung right out of the protection of the home almost into the arms of men* stationed in the localities to which they are drafted.
> (MacAndrew 1941/52: 46–7, my emphasis)

In Scott's view, the psychopathologies of war were derived from abnormal conditions, which caused the 'natural' sexual instinct to become perverted. In women, it was taken as a sign of demoralization in both senses: sexual instability created by the 'smashing of ancient standards' in war brings misery, ruin, social upheaval – for women these 'dangerous potentialities' place them in a 'perilous position' as war is inevitably accompanied by 'a reversion to primeval savagery' (Scott 1940: 71, 76). Scott urged that the methods necessary to deal with these 'social problems' be identified urgently, in the interests of social and individual welfare (Scott 1940: x).

As the departure from the protection of the home put young women in the way of unknown dangers, their 'lapses' were also due to the seductive nature of the new opportunities to be seized. It was not the experience of work *per se*, as much as its ability to provide the financial and other means to participate in a more extensive social realm, that marked the mobile woman's new autonomy. In the debates over how women should manage

themselves under these modern conditions, the focus naturally fell on those single women who could make most use of these freedoms in post-war Britain. In the eyes of many commentators, the availability of contraception also marked young women's distinctively modern departure from traditional heterosexual patterns. Edward Griffith, a popular writer on sex education and marriage guidance, saw contraception offering women a different form of 'equality' and demanding a new kind of moral attentiveness:

> owing to the discovery of modern contraceptive methods ... for the first time in the history of civilisation woman finds herself sexually independent of man ... By virtue of her new power, woman has the capacity to hurt man quite as much as man has hurt woman in the past. She can if she is not careful, disrupt his emotional life, destroy his respect for her, turn him into a cynic and hurt him profoundly. Thus she too has to readjust herself to these new values and learn again the meaning of love and the proper use of power.
>
> (Griffith 1948: 56)

It was not only that new sexual relations must be approached with responsibility for the equilibrium between the sexes, but that the sexual was identified as a cornerstone of the individual's future well-being. A comment typical of wartime sex guidance manuals advised young people that: 'Your happiness, your ambition, your health and your reputation, not for a day, but right into old age, are allied to your behaviour in youth, for sex is virtually the axis of our lives' (MacAndrew 1941/52: 50).

This concern with sexual training drew on a series of pre-war concerns with the family environment as a factor in the incidence of delinquency and mental 'morbidity', and arguments that marital relations needed to be reformed in the interests of stabilizing family life.[24] As the British Social Biology Council's booklet, *Happy Marriage in Modern Life: A Challenge to Youth and Society*, written in 1937, indicates, sex was an important aspect of this process of reshaping marital relations:

> The sexual instincts, upon which marriage has to be built, are the expression of age old instinctive forces ... these sexual forces are potentially dangerous to the individual ... the un-self-conscious instinctive reactions which make up our sexual instincts must be checked and modified if Happy Marriage is to be achieved *in the modern age* ... a new technique of marriage will have to be perfected if the youth of to-day is to accept the challenge which is presented to it by our modern conditions of life.
>
> (Collier 1937: 3–4)

It was this project, addressing the sexual aspect of life, that would allow a 'healthy civilization ... to be built in the modern age ... upon the family

unit' (Collier 1937: 3–4). But while tentative approaches were made in the 1930s to reform marital relations – in their social and also in their emotional and sexual aspects – it was in the post-war period that this project became consolidated. As women and their sexual self-management came into view as a national concern, models of sexual pathology – in particular those that indicated a fracture in the continuity between the sexual and the maternal in contemporary femininity – were used to define the features of appropriate sexual behaviour. The sexual became the axis of a programme to rebuild a new post-war femininity which would prevent delinquency and the cultivation of antisocial tendencies in young people: hence the working-class adolescent girl, potentially susceptible herself but requiring urgent education in her capacity as a future mother and guardian of the national character, was a prime object of research and discussion as well as the target for campaigns of sexual management. Femininity – specifically youthful femininity – became a key site for the redefinition of a modern British national identity.

Adolescent training and the problem of leisure

The working-class adolescent girl is drawn in this context as a composite of the problems of female sexuality and consumption, lacking education in sexual discipline and the emotional self-discipline which would inform prudent consumption. Subject to environmental influences that allow her instincts to become perverted, she requires advice, training and regulation to avoid 'conflicting' with the aim of social health. The need to overcome the excitations provided by war is of particular concern as her family background leaves her without resources to avoid unhealthy sexual inclinations and exposes her to influences likely to pervert the instincts.[25] As it became necessary to specify the techniques for training such girls to take up a responsible, female citizenship in the post-war period, new kinds of femininity became visible.

In his wartime publication, *Young Citizen*,[26] A. E. Morgan identifies the problem of managing the adolescent citizen, whose capacity for socially disciplined behaviour is still to be formed:

> In general terms the adult is a social being while the child is essentially an egoist. The child is a rapidly growing young animal, full of energy and unharnessed desires ... while adults are in control and balanced, employing judgement and responsibility.
>
> (Morgan 1943: 10–11)

In a turbulent stage between childhood and mating, adolescents must face the most potent force of 'the rising tide of sex desire' (Morgan 1943: 162), the emotional volatility of which threatens the development of a socialized personality:

It is a time of urgent enthusiasms, elation and depression, affection, waywardness, faithfulness, faithlessness ... Personality is molten and according to its treatment in this plastic state it will be moulded into something beautiful or ugly, good or ill, perhaps irrevocably. If it undergoes no moulding pressure, if it has no directive discipline, it may spill out into an amorphous lump.

(Morgan 1943: 10)

The similarity to Glover's concept of unorganized emotions as an amorphous mass is striking. According to Morgan, sexual indiscipline is a feature of the absence of 'moulding pressures' in altered conditions, not of a permanent state of altered morals. A pervasive problem is that wartime patterns of work and the shortage of commodities brings the adolescent 'so much money and so little to spend it on' (Morgan 1943: 161–3). Their propensity towards excessive consumption leads adolescents to disreputable pursuits like visiting funfairs, and for girls, drinking with soldiers. Morgan advocates disciplined pleasures, looking to the educative entertainments of youth organizations to take up a position in citizenship training for 'better Britons' (Morgan 1943: 186). Of these pursuits, he proposes housecraft as a suitable occupation for girls – knitting again becomes identified as an index of temperament, this time used towards its regulation as it combines 'economy with a laudable satisfaction of vanity' – and he claims mothercraft as the 'crown of domestic skill' (Morgan 1943: 93–4). These activities constitute an important process of disciplining the 'sex instinct' in a way which directs leisure pursuits towards eventual domesticity, instead of pursuing thrills and intoxicating excitements (Morgan 1943: 158).

Earlier commentators had looked to boys' and girls' clubs to alleviate the problems of evacuation (Gillespie 1942: 149). Youth organizations were identified as an important means of cultivating appropriate leisure pursuits which, for girls, combat a distinctive 'indifference' to the war (Jephcott 1942: 39). Shepherd points out that Glover includes this as one of a range of symptoms of the adverse effects of war experience, along with 'lethargy, retreat from social activities and pessimistic attitudes' (Shepherd 2000: 179). Lady Baden-Powell, identifying the role of the Girl Guide movement as a 'training for democracy' in 1944, quotes her founder husband to define their aim as 'the education and development of character through *their individual enthusiasm from within*' (Cooke 1944: 94, my emphasis). The training of girls towards appropriate enthusiasms allows their attention to be channelled away from new sexual opportunities and the development of new forms of potentially corrupting leisure pursuits, towards a reconstructive future of national regeneration. As well as disciplining their consumption, the process of developing citizenship for adolescent girls is posed as a matter of psychological management and equilibrium, conceived as a dimension of cultivated and responsible domesticity.

'The social problem' in a new light

This response to the impact of war on women's sexual instincts led to the design of forms of extra- and post-school training which, it was hoped, would reconcile the relationship between the social and the sexual according to a new kind of reciprocity. The urgency of a need to 'balance' the two followed from the experience of war, but was also referred to in a more direct address to the psychology of sexual behaviour by Edward Griffith. Part of his assessment of the effect of wartime conditions on the state of Britain's morality hinges on the *materialism* of individualistic, antisocial motivations: 'War, by encouraging a materialist outlook which pays little attention to the deeper values of life and often ignores the personality of those around us, merely accentuates selfishness ... materialism is the curse of this age' (Griffith 1948: 74).

This materialism gave rise to certain 'unsatisfactory conditions in social morality' which included increasing divorce and separation; sexual relations outside marriage; illegitimacy and abortion; and the spread of venereal diseases (Griffith 1948: 73–99). But though the normalizing of young people's sexual energies simultaneously signalled an area of potential instability, Griffith and others in the post-war period departed from previous models which pathologized adolescent sexual awareness, instead developing a new way of incorporating the sexual into the agenda of modern citizenships.

Emotional and sexual lives were to be properly channelled. Though these should not be directed to selfish ends which could 'conflict with society', post-war approaches stressed that social activities should not be privileged to the *neglect* of the 'sex instinct' – especially in women, who needed to exercise their emotions in order to develop a truly feminine personality (Griffith 1948: 180–1). Instead, 'sex experience' is given a place, but one that must be continually attended to, monitored, regulated:

> The vast majority of people cannot see that the problems of our sex lives affect the whole structure of our civilisation; that our attitude to sex colours the whole of our outlook on life ... If our attitude to sex is negative, our attitude to life is warped, and may even become callous, brutal and harmful ... If the war has done nothing else, it has presented *the social problem in a new light* ...
>
> (Griffith 1948: 73, my emphasis)

The development of a 'healthy attitude' to sex is vital to psychological well-being, and carries implications beyond the individual. The negative consequences of 'avoiding' the sex instinct are overcome in the harmonious channelling of the sex instinct into socially worthwhile activities, while exhortations to 'chastity' are seen to thwart 'natural' inclinations too severely. Hence total chastity becomes psychologized as a form of repression with unhealthy consequences:

a *certain amount* of sublimation is the answer ... A mind tortured by the clamorous urge can be eased by occupation with some hobby or study, which is *better than the direct attempt to repress*. This usually fails, as well as being harmful and unnatural.

(MacAndrew 1941/52: 25, my emphasis)

In fact, a recognition of the 'natural' and 'creative' basis of the sexual instinct, to be exercised in moderate and socially responsible ways – a more humane British approach to sex – becomes a defining national feature, a way of marking the difference from the perverted attitudes attributed to the Germans. Samuel Igra attributes the basis of German national character – their 'militarism' – to vices springing from 'sex-perversion', in which he includes 'not only ... the unnatural practices generally associated with the name of Sodom, but also ... all forms of anti-natural immorality in sexual conduct, such as rape with violence and other sadistic treatment of women' (Igra 1940: 10, my emphasis). But while 'mass sexual perversion' is identified as symptomatic of a sadistic national character, its origin lies in the unnatural imposition of repression:

Few understand why Hitler tried to repress sex ... behind his purity campaign lay a deeper and far more sinister scheme ... Diametrically opposed to love and peace are hate and war, and the Nazis believed that by repressing sexuality, which is a component part of love, they would develop hate, aggressiveness and physical strength, especially amongst youths ... in the long run, disobedience to nature's law proves harmful to mind and body ... But Hitler did not care about this as long as his own evil ends were achieved.

(MacAndrew 1941/52: 5–6)

'Natural' instincts were to be governed in ways that afforded the well-being of the individual and thereby contributed to a stable and democratic national community. The definition and management of healthy sexual relationships, a greater attention to the role of the sexual in British national life and the British character and the balance of the exercise of 'sexual energies' with a disciplined moderation made women a particular focus in training aimed at the development of a sound national psyche.

Marital relations and the democratic imperative: post-war femininities

In the post-war period, programmes of marital training and sex education were motivated as much by the need to address a generation of young women whose positioning had been altered by war and new post-war cultures, as it was by the interest in maintaining the birth rate. The reform of marital relations was influenced by two distinct trends: one emphasized the

need for education for motherhood and the other foregrounded women's sexual pleasure as a part of marital life. The first was initiated by D. W. Winnicott. Winnicott's 1944 broadcasts on the minds of wartime mothers had emphasized that the superficial pleasures women indulged in while their children were evacuated – earning more money and having less domestic work, 'having a good time', going out, 'flirting' – were unable to compensate for the disruption of their maternal function (Riley 1983: 89–90). Although John Bowlby's later concept of 'maternal deprivation' proposed full-time mothering as a need of the child, Winnicott emphasized the 'deprived *mother*' (Riley 1983: 89). In his post-war writings, he brings the two components of the maternal relation, mother and child, together, proposing that an increase in the proportion of antisocial children was caused by war and the evacuation scheme: these antisocial individuals, he argues, are the result of an 'interference' with the relationship between mother and child. Antisocial individuals comprise an anti-democratic force: the remedy for such social dangers is 'the mother's tremendous contribution, *through her being devoted*' (Winnicott 1950: 552, original emphasis). The channelling of women's familial devotion into an unbroken maternal relation thereby becomes elevated to a measure for safeguarding a democratic society, 'mature ... well-adjusted to its *healthy* individual members' (Winnicott 1950: 547, original emphasis).

The tone of these ruminations seems antiquated in comparison to the recognition of the diverse opportunities for female refashioning which emerged in the post-war period. However, this project clearly gained purchase, demonstrating a determination to remake motherhood in a form acceptable to those young women whose lives were shaped by new social and sexual experiences. The importance of women's sexual pleasure in marriage was as much a means whereby women's familial devotion was to be secured as it was a recognition of modern femininity. While women's sexual pleasure could contribute to family stability, marital happiness also became identified as an important component of an individual's emotional well-being (Chesser 1958b: 146–9), and the sexual became an integral part of social management in ways that had only been hinted at prior to wartime. In 1962, G. M. Carstairs, in his Reith Lectures, would stress the importance of recognizing newly modernized sexual cultures:

> This is a time when women are taking the lead in re-exploring their own nature, and, in so doing, modifying our concept of man's nature also ... *this has led to a series of personal readjustments in which probably every family in this island is to some extent involved.*
>
> (Carstairs 1962: 72, my emphasis)

The conditions of war had allowed the sexual to become a central aspect of national definition, and women's sexual identity in modern definitions of citizenship had become a necessary part of acknowledging and developing

the 'changing patterns' of British character. In the twenty years following war, the alliance of psychological sciences with programmes of social management ensured that it would become a project conducted on a scale and at a level of intimacy commensurate with the management of wartime morale itself.

2 'The gratification of the moment ... the limit of their mental horizon'

Eugenics, psychology and the 'problem girl'

The social psychology of everyday life

In the late 1930s, a group of psychologists, sociologists and anthropologists conducted a set of discussions, based at Cambridge University, concerning the application of their disciplines to the 'problems of complex societies'. This 'social psychology of everyday life' was designed to facilitate the study of individual psyches in association with those 'patterns of culture' being identified within social anthropology. Pressing practical social problems were to be addressed on an intimate level, as the link between individual and social behaviour was approached in terms of the organization of the instincts, temperament and sentiments. The psychological management of affective life was thereby identified as a critical means of safeguarding social futures (Pear 1939: 3–6; Thouless 1939: 121–3; Bartlett *et al*. 1939: vii).

This attempt to develop an account of culture and character carried the imprint of a more extensive inquiry into questions of national character, degeneracy and social anomaly. Psychology and eugenics converged in the attempt to address British culture at the intimate level of 'character', probing those habits of thinking, feeling and relating to others which were understood to underlie socially problematic behaviour. Psychopathology – a sub-discipline developed from the 1920s and following on from the foundational work of the prominent inter-war psychologist and eugenicist William McDougall – became a central component of those technical knowledges that would help identify mechanisms for the development of that integrated character which allows individuals to become socially adapted in their behaviour.[1]

Drawing on psychopathology for these purposes, C. P. Blacker, General Secretary of the Eugenics Society from 1931–52 and a practising medical psychiatrist, developed a model of 'social psychiatry' as a platform for a 'preventive eugenics': one which implied a disciplined orientation to the self as the basis of those family relations which would nurture effective future citizens. Blacker was much concerned with the argument put forward by the Wood Committee in 1929, that there existed a 'Social Problem Group'

with a high incidence of 'high-grade' mental defectives (Blacker 1952a: 9–10).[2] Their report argued that 'social problems' (or forms of delinquent behaviour) could be traced to a group of families within which there existed an unduly large proportion of 'insane persons, epileptics, paupers, criminals (especially recidivists), unemployables, habitual slum dwellers, prostitutes, inebriates and other social inefficients' compared to other families (Wood Report, cited in Blacker 1937: 2). This proposition was the focus of debate about how social pathology could be prevented and its effects ameliorated for over two decades.

Blacker's interest lay in the move made in the Wood Report from mental defect in individuals to those other 'social problems' embodied in the families of defectives (Blacker 1937). As a crucible of pathology, 'problem families' were understood to provide *both* a strain of inheritance *and* a social environment, in the transmission of innate disposition (defects of temperament, or character, which came to replace defects of intelligence) and in the creation of adverse environmental conditions.[3] Predominant amongst those environmental influences were the effects of 'evil' or squalid homes, unfavourable domestic routines, and inadequate parenting.

'Problem families' and squalid homes: making primitive

Writing in 1952, Blacker argued that: 'The "problem group" had been objectively discussed from the outside as a noxious social aggregate; the "problem family" was sympathetically examined from within as a collection of unhappy and maladjusted human beings' (1952a: 12). This suggested problem families were now defined outside of the framework of mental deficiency, and in terms of psychological problems of emotion, affect and individual adaptation transmitted through the environment of the home. But the shift to a more 'sympathetic' approach to problem families was far from evident in initial inquiries, even if maladjustment and family relations became the focus for psychiatry. The language which prominent studies in the 1940s applied to problem families – their 'degradation' a 'menace to the community of which the gravity is out of all proportion to their numbers' – suggests a rupture between the normal and the pathological, ascribing their condition to faults of character (Women's Group on Public Welfare 1943: xiii; Stephens 1945: 1; Rowntree 1945: vii).

Primary amongst the features identifying the problem family were the squalor and disorder of their homes. R. C. Wofinden's description was the most widely circulated, cited extensively from 1944 to 1952, and used in training social workers for home visits:[4]

> Nauseating odours assail one's nostrils on entry, and the source is usually located in some urine-sodden, faecal stained mattress in an upstairs room. There are no floor coverings, no decorations on the walls except perhaps the scribblings of the children and bizarre patterns formed by

absent plaster ... Furniture is of the most primitive, cooking utensils absent, facilities for sleeping hopeless – iron bedsteads furnished with soiled mattresses and no coverings ... Upstairs there is flock everywhere, which the mother assures me has come out of a mattress she has unpacked for cleansing. But the flock seems to stay there for weeks and the cleansed and repacked mattress never appears ... There are sometimes faecal accumulations on the floors upstairs, and tin baths containing several days accumulation of faeces and urine are not unknown. The children, especially the older ones, often seem to be perfectly happy and contented, despite such a shocking environment ... the general standard of hygiene is lower than that of the animal world.

(Wofinden 1944: 128)

Squalid homes, lack of personal hygiene and domestic negligence are the central features of observers' accounts. The inability of these families to maintain standards of hygiene is linked to a failure of order and functionality, as they show no inclination to assemble the props, utensils and facilities of a purposively designed environment suited to the rhythms and rituals of privatized family life. Objects designed for sleeping and bathing become receptacles of waste. The logic of 'decoration' is disorganized and the surface eroded, as walls exhibit only gashes and gaps in plaster and the incoherent markings of children's play, and floors are smeared with faecal matter. 'Furnishing' is dismantled as mattresses are emptied and their interiors dispersed across the house, 'flock everywhere'. Insidious and permeating, impossible to consign to a distinct place, these 'innards' – nauseating, stinking, soiled, stained – become part of the fabric of 'ordure' which characterizes the problem home and its inhabitants: regressive, disintegrative, dispersed, formless.

These patterns, and their testimony to an inability to arrange and deploy objects according to function and with respect for form, are not just evidence of slips and lapses in hygiene, but an orientation to living which is produced in opposition to modernist principles of domestic design, thriving on the erosion of form and structure and their association with order and purpose. As such, it is an orientation that impacts on the home as an environment for character formation.[5] Certainly there were variations in the extent to which conditions of poverty or housing, or features of character, were understood to determine the domestic defects of such groups (Starkey 2000a: 51–2). But the problem posed by such groups – in fact their defining characterological feature – was their apparent inability to profit by measures for the alleviation of poverty and welfare services offered by the agencies of social reconstruction and modernization, and to benefit from post-war improvements (Stephens 1945: 2). Problem families, then, were understood in terms of a failure – or formlessness – of character, evident in a pathological contentment with conditions that were now seen as incommensurate with the provision of those moulding pressures relating to the

correlation of adolescent character with a modernized family life: 'these families for one reason or another have not kept pace with social progress and are a brake on the wheels' (Wofinden 1944: 127).[6]

If modern forms of domestic order synchronized the physical and emotional landscapes involved in modernizing British character, the *making primitive* of domestic environments was not only the sign of a socially atavistic character, but created the conditions within which social atavism would become a legacy for the character development of the next generation. The concern regarding the environmental condition of the problem family is not one regarding physical ill health (there is no sign of malnutrition) or the psychological disturbance of the children (who are recorded as being happy and contented). Rather, the register of maladjustment is a lack of concern with domestic failure and an apparent happiness that is itself understood as pathologically anti-modern. At the centre of this concern is whether the problem family will reproduce itself, and the formation of the 'problem child'.

Domestic space and temperamental instability: serenity, genophilia and the self-affects

Anxiety over the effects of the social problem group on the wider community fuelled a view that it was 'an intolerable and degrading burden to decent people forced by poverty to neighbour with it' (Women's Group on Public Welfare 1943: xiii). Pat Starkey associates some commentators' apparently greater concern with the 'plight of affected neighbours', rather than with support for the disadvantaged, with a pessimism deriving from the view that the reproduction of the problem family depended on congenital transmission (Starkey 2000a: 49).[7] Starkey's argument depends on an opposition between a biological model – which she sees as determining the attribution of responsibility to the individual – and the identification of environmental factors such as bad housing and poor healthcare – which would allow the causes to be seen as social (Starkey 2000a: 55). However, the concept of social pathology was being complicated in this period by its association with the impact of the affective dimension of environment – particularly in family relationships and the parental modelling of forms of emotional response and behaviour – and its influence on early development in a psychologically informed model of character. While 'mental defect' – seen as a matter of genetic legacy – was an identified aspect of the make-up of the problem family type, patterns of intractability in recidivists were also attributed to a failure of individual discipline, while ingrained everyday habits and patterns of family life were given prominence in accounts of the reproduction of social delinquency. The Women's Group on Public Welfare, in their 1943 report on conditions of living in 'our towns', cited the fact that this group (which they also referred to as the 'submerged tenth', following Charles Booth's survey of London's poor at the turn of the century)

did not join trade unions, friendly societies, classes or clubs, or attend places of worship – rather than congenital incapacity – to explain their failure to respond to 'most social effort'. The Women's Group argued that the means to improve social conditions was education, proposing that alongside the improvement of material conditions 'more effort should be made to rouse and strengthen the human will, both subconscious and conscious, and enlist in it co-operative effort for decent living' (Women's Group on Public Welfare 1943: xiv). Certain principles, such as the respect for property, they claimed, needed to be 'inculcated', as they contradicted human instinct. Only early training would integrate such principles into the child's subconscious (1943: 47). Acceptance of the interaction of hereditary and environmental factors on the psyche of the child – and the identification of the problem of the lack of appropriate training offered by parents who did not themselves accept the 'social code' – indicated the emergence of a psychological approach to solving problems of social delinquency, in a preventive approach to the question of problem families.

As the eugenic concern with problem families became informed by psychological definitions, concepts and approaches, the use of psychopathology to identify the features of 'social inefficiency' increasingly brought into view those instabilities of character which predisposed individuals to the effects of adverse conditions. The study of features of character, and the identification of those defined as abnormal, gave Blacker a means of refocusing the object of eugenic attention. The behavioural features of problem families – 'fecklessness, irresponsibility, improvidence and indiscipline in the home' (Blacker 1946: 118, 1952a: 16) – were thus translated into a psychological model of temperamental instability.

William McDougall's work on temperament and sentiment development in the constitution of character had previously linked psychological and eugenic analysis. Working in their meeting ground, from the early 1920s he developed a model of psychology which linked questions of character to conduct and was critical to the development of models of psychological management of affective life as a crucial means of protecting 'the future of civilization' (McDougall 1927, 1924: vi–vii). McDougall's work was highly influential in inter-war psychology and was cited by Blacker throughout the period of his writing, from his use of McDougall's definition of the different functions of the instincts and the biological basis of instinctual 'tendencies' as part of an innate endowment in 1933 (Blacker 1933: 82, 120), to the association of the sentiments with moral qualities in 1952 (Blacker 1952b: 287–322).

The quality of character, for McDougall, depends upon the sentiments. The 'selfish sentiments' (relating to individual instinctual impulses, such as hunger or fear) must be modified by the 'social sentiments' (those which derive from social adaptation, such as patriotism or altruism). Individual will is exercised over the instincts to regulate conduct according to external demands or constraints. The most fundamental of these social sentiments

was that of self-regard, the ability to evaluate one's behaviour by the standards of the community, its proper functioning allowing the instinct of self-assertion (the pursuit of self-interested, or instinctually based, aims) to be tempered by one of self-submission (placing the needs of others, or the group, above purely selfish aims). This implies a socializing of the instinctual tendencies, tempering and channelling them in particular directions as a result of the recognition of social conventions, indicating a process of social adaptation in the individual which is the basis of integrated moral character.

> In this way, *the self comes to rule supreme over conduct*, the individual is raised above moral conflict; he attains character in the fullest sense and a completely generalised will, and exhibits to the world that finest flower of moral growth, *serenity*.
>
> (McDougall 1908: 404, my emphasis)

If individual sentiment formation – the acquisition of emotional tendencies or structures of feeling that involved directing or channelling the instincts to gain satisfactions which were in line with social aims – was developed through familial training, its aim, above all, was the cultivation of those 'homely sentiments' – parental, filial and marital – which provide the coordinates of integrated harmonious character. This, it was argued, provided the basis of a form of 'demeanour' in the home – led by the marital couple, as they modelled appropriate behaviour – which would create an effective environment for children to develop into effective future citizens: regulating conduct according to external demands or constraints and striving towards identified goals rather than instinctual gratification. For Blacker, then, drawing on McDougall, serenity is that temperamental stability and integrated character which allows effective social adaptation (or 'co-operativeness'). It is therefore a sign of the presence of that 'moral cement which gives shape to what is commonly called character' and is aligned to the 'moral qualities which make for social cohesion' (Blacker 1952b: 289).

Further, Blacker defines a quality he calls 'genophilia' as one of the most eugenically desirable features, providing the basis for the perpetuation of strengths of character through familial lines. This is more than an interest in posterity, for it also involves the 'feeling for children', and a balancing of self-submissiveness (the 'altruism' which allows the child's needs to be put before one's own) and self-assertion (the pride or enjoyment of children as part of the individual's 'larger self', which Blacker refers to as 'egotism'). This creates a well balanced equilibrium which exercises a unifying and harmonizing influence. For Blacker, a 'pre-occupation with children and their welfare' is the emblem of a modern national consciousness. The criterion of eugenic value embodied in this 'condition of sentiment' – a form of altruism – implies a form of character and conduct which underlies the individual capacity for effective parenting. And the social sentiments, directed by an orientation towards the effective care and development of children, are

expressed in marital relations and the arrangement of the home as much as in the parental relation (Blacker 1952b: 289–91).

Serenity implied an adherence to principles of order that became imbued with moral foundations. The importance of harmony and equilibrium, restraint and discipline, to the making of the modern home, sees the development of a regime of aesthetic order, which suggested that physical space should be arranged in terms which relied on an understanding of the appropriate balance between visual and sensory stimuli and their link to those perceptual and emotional responses which would cultivate a familial environment favourable to child development. Just as integrated character was understood in terms of an equilibrium – disciplined according to a hierarchy in which the selfish sentiments were moderated by social sentiments, but also avoiding an over-rigid system in order to allow the satisfaction of the instincts – so too domestic space had to be rationally organized: orderly yet harmonious, uncluttered, soothing, *serene*. Models of interior design, developed in the 1940s and 1950s, made it clear that homes which created an effective environment for families would eschew the regressive, over-ornamental 'clutter', heavy materials and dark colours of older styles – evidence of the 'undeveloped mind' – as well as the 'insincere', ephemeral, 'flippant' pleasures of superficial visual effect and synthetic garishness, to create instead a balancing of 'authenticity' (or the traditional) and the modern which manifested a 'moral unity' suited to the building of effective family life and individual character (Hornsey 2003: 175–204; Hornsey 2009 forthcoming).[8]

The moral reprobation of those families who did not adopt the ascendant regime of order and hygiene in domestic design and management in their homes to ensure the effective development of moral character in children was clear. If the homes of problem families exhibited a lack of order and propriety, and an eschewing of functionality, undermining the purposiveness which links form with function, so too their characters exhibited a failure of that purposiveness – the capacity to strive towards goals – which was understood to be the cornerstone of human character.

Qualities of serenity and equilibrium, the capacity for sustained striving towards goals, and the genophilia which characterized the socially adapted parental couple whose demeanour was tailored to the sentiment development of their children, became the templates of modern character. In contrast, problem families were characterized by 'laziness', 'lack of persistence', 'indifference to the standards of the community', a lack of foresight and purpose, and an 'obliviousness of all but momentary issues' (Blacker 1952b: 21). In this respect, the physical disintegration in their homes was a symptom of a much deeper problem: psychic disintegration.

As problem families displayed a domestic anti-modernism and disorder that acted against the development of purposiveness as a central feature of disciplined character in children, the 'problem girl' – the unstable adolescent girl who had no interest in work and was unamenable to parental control, or involved in sexual adventure or petty crime – came into visibility

in a particularly compelling way. Lacking a family life based in the delicate balance and tempered merging of styles embodied in domestic modernism and based on the continuity of those principles of sentiment development embodied in 'serenity', problem girls became identified in terms of a distinctive inability to internalize values and realize them as aims, and so, in their incapacity to direct their behaviour towards identified goals, a lack of purposiveness.

Sexual delinquency and 'drift': loss, reparation and repetition

The term 'problem girl' was applied to the girl who appeared before the courts on charges of stealing, or was beyond control, in 'moral danger', or in need of care or protection (Joint Committee of the British Medical Association and the Magistrates' Association 1946: 2). In the context of post-war Britain, the association between young people and delinquency was well established, as were the changing conditions that may have created a rupture of traditional familiar cultures and patterns of everyday life. As the Women's Group on Public Welfare put it, in response to the experience of evacuation:

> The war must take its share of responsibility. Irregular schooling, evacuation, sleeping in shelters and bad housing may have accentuated any tendency to moral or emotional instability and may often have provided temptation. But there has also been in recent years, apart from the effects of war, a general slackening of adult moral standards, *the general trend of legislation and propaganda* has weakened the sense of parental responsibility; the influence of religious and spiritual values has diminished; and family life has for many people lost much of its attraction and satisfaction. Against such a background it is small wonder that a proportion of girls go astray.
>
> (Women's Group on Public Welfare 1943: 4–5, my emphasis)

The altered conditions of wartime Britain had disrupted those familial environments which were understood to nurture stable children, and create in them the 'acquired virtues' – such as honesty and respect for other people's property – which depend upon acquiring the capacity for 'self-denial and social conduct' (Women's Group on Public Welfare 1943: 47). But this trend was also understood to have been exacerbated by a less definable set of influences – those forms of government intervention which, by assuming control over family support and welfare, failed to cultivate in individuals the capacity for self-denial which underlies the virtue of parental responsibility, and the spiritual values associated with 'family life'. The antifamilial cultures of problem families, it was implied, were a product of centralized government preventing individuals from acquiring their own capacity for

self-determination, social responsibility and purposiveness. They not only stood as a symptom of wider social failure, but provided the conditions within which the problem child emerged, crystallizing the pathological features of a post-war society. Formed in the context of a regressive trend towards those incapacitating forms of social welfare which fail to promote self-discipline as the basis of social conduct, these children develop in the context of an expanded landscape of 'temptation' as the regenerating consumption and entertainment industries offer those undisciplined forms of 'adventure' associated with 'the street':

> Dishonesty is, unhappily, widespread in our society ... To leave some things alone is the small child's first lesson in self-denial and social conduct ... The child born into a family of low social standard has little chance of this education. Since his elders never accept the social code, it is never 'right' to him but merely a vast conspiracy which it is clever to outwit. Life does not make virtue particularly easy for him. His playground is frequently the street ... So he is subject to the constant temptation to steal from shops and stalls; he is in surroundings where all pleasures cost money; money means too much to him from an early age; delinquent companions are easy to come by; theft offers adventure where no other adventure is; finally, theft and its rewards give him a sense of individual consequence and achievement, the craving for which is inherent in all human creatures, but which may be denied him in home and school. Honesty is an acquired virtue only skin deep with many of the human race; it is little wonder if he fails to pick up even the veneer.
> (Women's Group on Public Welfare 1943: 47)

Patterns of delinquency, then, are a product of a deficit in both social and familial cultures: in the space between the inherent drive for individual self-realization and its enactment, those whose early training fails to equip them with the purposiveness that leads instincts to be channelled into those forms of socially oriented behaviour which are rewarded by a sense of 'consequence' and 'achievement' are led to direct their energies towards the immediate spaces of pleasurable gratification: taking to the street.

A precedent for attributing female delinquency to an instability of character which rested on defective sentiment formation was offered by Grace Pailthorpe's study of delinquent girls between 1923 and 1928.[9] Funded by the Medical Research Council on the recommendation of their Committee on Mental Disorders, Pailthorpe's findings were published in 1932 in an influential report, *Studies in the Psychology of Delinquency*.[10] Her overriding conclusion was that delinquent or socially maladaptive girls were characterized by a defect in sentiment development. In fact, Pailthorpe drew on McDougall's model of sentiment to argue that defects in sentiment, rather than intelligence, were the primary predisposing cause of criminality (Pailthorpe 1932a: 16–17). If the social sentiments enabled the individual to

become socially adapted, tempering the selfish sentiments in recognition of the existence and interests of others, and so internalizing the laws of social constraint, the presence of the altruistic sentiment in individuals demonstrated this in its most elaborated form. Pailthorpe identified a lack of the altruistic sentiment in her group of delinquent girls. Even in the context of their parental role – which was seen as calling on the altruistic sentiment in its purest form – their (altruistic) assertions that they could not let their children starve were invalidated by their inability to act towards this end, as their (egoistic) pride prevented them from applying for guardian relief. And their lack of shame or embarrassment when they contradicted their 'false attitudes' betrayed 'how little the altruistic utterances mean to them'.[11] The girls' failure to develop such sentiments meant they were driven by the instincts.

Pailthorpe's investigations, and her conclusions, provided the ground for the development of the notion of the problem girl, and were formative in developing alternative models for intervention to those of the courts. Her report influenced the founding of the Institute for Scientific Study and Treatment of Delinquency, in the year following its publication. The definition of the problem, and its treatment, appeared remarkably consistent across more than a decade: in their 1946 report, *The Problem Girl*, the Joint Committee of the British Medical Association and the Magistrates' Association reiterated the need for psychiatric treatment of individual girls, and careful selection and special training for staff involved in those 'schools, hostels, or colonies' to which those who were amenable to re-education could be sent.

But the question of the problem girl raised a particular issue that could not be contained within the concept of delinquency. For while it was frequently observed that not all children manifested the deficits of familial cultures in delinquent behaviour,[12] those narratives of temptation and theft proposed by the *Our Towns* report nevertheless have a structural unity in predicating the movement between problem families and street cultures on the drive to satisfy unmet needs. As such, this environmental continuity gives the antisocial behaviour of the problem 'child' a rational base, in the matching of emotional deficit with delinquent behaviour.

But the route from family home to street fails to provide a similarly unified structure for the problem girl's narrative, which is oriented less by the simple adventure of theft, than a more disturbing exchange between theft and 'sexual misconduct'. Accounts of the problem girl's home background stressed that it 'lack[ed] comfort and affection'. Characterized in terms of 'neglect', these accounts conflate physical neglect, or 'living in a very dirty or ill-kept home', and emotional neglect (which is not usually associated with the problem family). For example, Hilda Lewis' psychiatric assessment proposed that 'neglected children who came from dirty homes' were particularly prone to withdrawal, isolation and a fear and suspicion of adults (Lewis 1954: 40). Therefore, while commentary on the problem girl acknowledges that she may come from any background, the dynamic created by these two

forms of neglect both recasts the problem family as essentially one of emotional deprivation, and infuses the figure of the problem girl with those features of social atavism attributed to the problem family. It was this background of neglect which created a pathological form of acquisitiveness, leading the problem girl to petty theft and sexual delinquency. But unlike the delinquent boy's theft – which bolsters his 'sense of individual consequence and achievement' – this is a response which must be understood in terms not of illicit gain, but of loss. For the problem girl, petty theft was an early sign of the development of a precocious sexuality. Through this she repeats her emotional deficit by staging another form of abandonment, as her casual sexual adventures and the financial reward that accompanies them repeatedly (and it almost seems, in the telling, predictably) end in her desertion (Joint Committee of the British Medical Association and the Magistrates' Association 1946: 8).

Such narratives – and their outcome – feature strongly in the lives of those girls in preventive and rescue homes which Pailthorpe analysed in her report. A volume for general readership, including extended discussion of individual case histories, was published in the same year, giving an insight into the motifs by which they described their motivations and behaviour, and into contemporary interpretations of their psychopathological formation (Pailthorpe 1932b). In Pailthorpe's psychoanalytic approach, theft is less a matter of acquisition than it is a compensatory mechanism for inadequate love and parenting, and so in analytical terms stands as a symptomatic surfacing of an earlier loss. Theft, then, is motivated by substitution – a form of reparation. However, as a means of regaining the loved object, it does not only fail, but continually replays this original absence, and so acts not to enhance the self – as in the commonly ascribed motive of 'vanity' – but to inflict damage to the self, in a compulsive repetition:

> A cursory glance at these histories will show a number of examples of anomalies in behaviour, the explanation of which cannot be reached by labelling them all as motivated by 'evil'. For example, one of the girls likes pretty clothes, and does not mind how she gets them. On the fact of it this looks simple enough – her motive is mere vanity, a desire for personal adornment. But – and it is a very big 'but' for the psycho-analyst – she does not stop at stealing clothes for herself; she steals things extravagantly, she steals things of no possible use to herself. And finally she brings herself into a position where she is bound to be discovered, *thereby deliberately losing all she apparently set out to gain.*
>
> (Pailthorpe 1932b: 32, my emphasis)

The problem girl becomes anchored by a narrative which endlessly replays loss, then, in contrast to that jaunty male narrative of streetwise opportunism which characterizes the exchange between the male delinquent and its more buoyant counterpart, the spiv (see, for example, Scott 1954). Her behaviour

becomes understood in terms of 'anomaly', a deviation from normal patterns of psychological motivation and causality, the meaning of which can only be traced through its origination in early life. In this model, the delinquent girl's stealing becomes infused with those conflicts associated with early relations to the parents:

> The child's first love object is the parent of the opposite sex, with a consequent hostility against the parent of its own sex. In the case of a girl she loves the father and wishes him to give her babies. The mother stands in the way and must be got rid of. Guilt and fear arise in relation to these wishes, which become repressed. But the conflict goes on underground and thrusts its way through into consciousness in a multitude of ways disguised in illness, abnormal character traits, inhibitions and symptomatic acts, etc.
>
> (Pailthorpe 1932b: 61)

Pailthorpe's case histories include many accounts of irrational stealing which she associates with sexual conflict and guilt. In a discussion of an older prisoner whose life history she takes as an example of the formation of a disposition of hysterical states of mind associated with female delinquency, she shows that the root of her stealing lies in a thwarted desire for children. Four years ago Mrs Brown stole a dress, and now she has stolen one again: 'I didn't want it either; I had a buzzing in the head; I cannot think why I did it.' At this point she began to cry broken-heartedly. 'My husband and I want children. He is passionately fond of them. With my first husband, when I did not want them, I fell every time.' Pailthorpe's account of this case presents a view that Mrs Brown's stealing was linked with her desire for children with her present husband, giving it a meaning which only exists in the psychic mechanisms associated with oedipal conflict. Her inability to have children with her present husband, who is a good man, is contrasted with her repeated pregnancies with her previous husband, who mistreated her. If she can only have children in the context of punishment, this points to a sense of guilt which results from her association between having a child and the wish to have one with her father.

But Pailthorpe provides a further commentary on Mrs Brown's act of stealing which can only be understood in the context of her other symptoms (diarrhoea) and her hysterical preoccupation with filth: here the infantile association between babies and excrement becomes the basis of the psychic meaning of irrational stealing:

> Then followed an account of her husband's sister-in-law who lives in a lower portion of their house. The sister-in-law drinks. She has a good husband, a number of children, and is 'filthily dirty' (the prisoner is spotlessly clean). This worries her a lot. The children obey the calls of nature anywhere and everywhere. Mrs Brown is responsible for cleaning

the place. Every time she does so, it brings on diarrhoea. For this reason she has frequently to go there, and this of course increases her nausea and vomiting. She is indignant about her sister-in-law's neglect of the children.

Just before she stole the dress she had been disgusted and angry with this woman. ... Next day she had to wait a few minutes for a bus; she went inside a shop which was having a sale, to look around, not intending to buy anything. The next thing she knew was that someone was saying, 'What is that in your basket?' There was a black dress in her basket. She had taken no trouble to cover it, and she does not remember taking it. Furthermore it was perfectly useless to her as it was far too small for one of her size.

(Pailthorpe 1932b: 59)

Pailthorpe's interpretation is that, in the context of her own failure to have children, the neglectful sister-in-law substitutes for Mrs Brown's mother, from whom she wishes to steal the children:

Money, small objects, excreta are well-known symbols in the unconscious for children. The fantasy that babies are made of excreta is an infantile belief ... Psycho-analysis has frequently shown that although nausea and disgust are the symptoms shown on the conscious level, the underlying wish is the desire both to obtain babies and to make restitution.

(1932b: 62)

The landscape of filth which marks the problem family's home, then, provides a background of neglect against which the sexually delinquent girl becomes positioned within a relation of loss. But it also compels her to seek to replay this original harm by acting out her revenge against neglect, in the desire for a baby with her father, in those random encounters embraced by the terms of 'sexual misconduct' and an irrational compulsion to steal. These forms of symptomatic behaviour are understood as the problem girl's re-enactment of the problem family's relation to excrement in terms of a pathological sexuality. The problem girl is not just a product of the defects of the problem family, but is understood to refigure them in a distinctive way. As a result of her lack of the sentiments of serenity and genophilia, her instability of character – and its outcome in her conduct – becomes formed in the dynamics of loss, desire and revenge, recasting the coordinates of social pathology in specifically sexual terms.

It is in this respect that the problem girl presented a difficulty for the courts, who found the entrenched nature of her conduct an obstacle to their reformist role. For not only were her 'undesirable character and standards of conduct' well established, but they related to a 'degree of social insufficiency' which was 'the result of interaction between temperament and

environment'. The problem girl was also identified by the more descriptive classification 'the unstable adolescent girl': if the cause of her instability was an inadequate home, this was the environment in which was formed a pattern of antidomestic character which predisposed her not only to sexual adventure and lawlessness but also to a defining preoccupation with self-gratification (Joint Committee of the British Medical Association and the Magistrates' Association 1946: 3–4).

> Frequently the normal home life is found to have been broken by the death or absence of one or both parents, or that there is such gross overcrowding or such disharmony among the members of the family that ordinary healthy adolescence is well-nigh impossible. The absence of parental love and understanding and control and the lack of stability and security in the home are a serious loss to a girl in her teens and she may try to find compensations outside the home. She picks up casually a superficial knowledge of the 'facts of life', makes undesirable acquaintances and frequently comes into contact with the law. ... She is not interested in her work, she has no security in her firm, and she may drift from one job to another without striking root. ... Having no sense of responsibility towards anyone, she is self-centred and seeks only her own gratification.
>
> (Joint Committee of the British Medical Association
> and the Magistrates' Association 1946: 4–5)

The features of the problem home, then, are etched into the problem girl's character, as her environmental history, interacting with a temperamental weakness, defines her as 'emotionally unstable' – encapsulated in her predisposition to 'drift'. This dual formation is important. Unlike the 'large numbers of girls in atrocious situations [who] rise above them and keep straight', the problem girl's 'defect of character structure' makes her susceptible to translating these early conditions into a pattern of delinquency (Joint Committee of the British Medical Association and the Magistrates' Association 1946: 5). And hers was a very particular delinquency, one whose main feature was a pathological attachment to momentary pleasures, and so must be understood to signify a deeper level of emotional – and moral – disturbance: 'Superficially she is a "good-time girl", living for her own personal enjoyment, morally and emotionally unstable, perhaps guilty of sexual misbehaviour, and unamenable to discipline and control' (Joint Committee of the British Medical Association and the Magistrates' Association 1946: 3).

The problem girl presented a form of instability associated with an immoderate drive for individual gratification: but if on the surface she appeared as a 'good-time girl', beneath, her character took on a more seriously and permanently fractured form.

Apathy and sociopathy

The Joint Committee of the British Medical Association and the Magistrates' Association indicated a striking level of medico-legal consensus in emphasizing the central role of psychiatric treatment. However, they also, like Pailthorpe, faced the problem of the limits of treatment in the face of intractable recidivism:

> there will inevitably remain some girls for whom all help and treatment seems useless. In them the defect of character or of social capacity is so fundamental as to hold out little hope of transforming them into satisfactory members of society. They have *neither the capacity nor the will to co-operate* in anything that is done for them and the moment they are liberated from control they will go back to their former bad ways.
>
> (Joint Committee of the British Medical Association and the Magistrates' Association 1946: 15, my emphasis)

For these girls, immersed in the instincts and driven by impulses towards selfish aims, there was no possibility of introducing 'variety, colour and interest' into their 'drab' lives. This is a life lived in monochrome: a fatalistic repetition of momentary gratification as compensation for parental neglect and failure. In fact, Edward Glover, director of the Institute for the Scientific Treatment of Delinquency from its inception in 1937, in the report *The Psychopathology of Prostitution* in the same year as that on the problem girl, proposed a continuity between the problem girl and the 'larval prostitute' (Glover 1957: 11). The early truancy, wandering and pilfering which brings children and adolescents to be legally designated as 'out of control' or 'in need of care and protection' is accompanied by 'sexual tendencies indicating the possibility that they will later become prostitutes' (Glover 1957: 13). The significance of 'lack of adequate family love in early and later childhood' is primary for Glover, defining them in terms of psychological insecurity and an unconscious urge to obtain revenge for neglect that drives them towards sexual precocity. In fact, he argues that the larval prostitute can be discerned as early as from three to five years of age: 'parents recognise this fact when they say on occasion that a small daughter is a "little tart"' (Glover 1957: 12–13).

The unconscious processes Glover identifies in these behaviours are, primarily, problems concerning the displacement of sexual desire from the parent (as a mechanism of adaptation). For the prostitute this implies a displacement of the sexual impulse from the one parent to 'the many' as a defence mechanism arising from disappointment – a way of denying that there was 'a one and only parental object of parental love' and a replaying of that thwarted and repressed parental desire – an unconscious search 'for the one and only (forbidden) love' (Glover 1957: 8). Glover thereby associated prostitution with a regression to the early anal phase of sexual

development (in which the prizing of money is substituted for the excretory products of the body, seen by the small child as precious possessions) and so he pointed to a primitive dimension to the larval prostitute in the same way as Pailthorpe did in the delinquent girl, as she repeated an archaic form of sexual fixation, her progress towards normal sexual adaptation interrupted by inadequate love relations during childhood.

But for these unconscious conflicts to manifest in sexual promiscuity or prostitution, as opposed to some other form of unconsciously motivated behaviour, there must be precipitating factors, forms of emotional stress which activated the existing conflict, or brought about a regression, and which shaped the form it took. For Glover, the most important of these factors was environmental: a lack of adequate family love in early and later childhood and manifest irregularity in the sexual life of the parents (Glover 1957: 13). It is the effect of both of these which constituted, for Glover, the defining profile of the 'larval prostitute', and which allowed her to be seen in terms of the problem child. In fact, emphasizing the influence of problems of family environment on child and adolescent development, Glover claimed: 'the prostitute is pre-eminently *a problem child in adolescent or adult disguise*' (Glover 1957: 19, my emphasis).

The convergence of attempts to define the emotional disposition underlying social delinquency, then, results in the eventual identification of the 'problem girl' as a character type founded in an exchange with the psychopathology of prostitution. For Pailthorpe, an 'excessive suggestibility and docility leave [one type of delinquent girl] susceptible to any kind of influence', creating a line of passage between psychopathy and sociopathy; unless such girls receive treatment for their psychopathic condition, their fate is 'almost certainly a drifting into promiscuity, with the tragic sequel only too familiar' (Pailthorpe 1932b: 100).

Problem girls were understood in terms of an instability which combined a defective adherence to social ideals with a susceptibility to passive involvements offering momentary gratification. Underlying these patterns, one particularly overriding psychological disposition characterizes such girls, as they are defined in terms of a distinctive apathy, an antisocial 'indifference' through which they cede their responsibility to the wider community: 'even the war does not vitally touch many of these young people' (Jephcott 1942: 39). As a feature of character associated with insufficient social adaptation and a susceptibility to adverse influences, apathy pointed to an excess of self-feeling in girls and young women whose native constitution, family upbringing and social environment led to patterns of affective instability which became a distinctive element in the definition of moral defect:

> they are unstable in their emotions and behaviour, with a sort of gap in their emotions and understanding, which is difficult to define. They fail to appreciate the social effects of what they do and omit to do. They act

on the spur of the moment, recognizing no rule of life but immediate wishes. This social unawareness is reflected in sexual laxity ... [and they exhibit] *an apathy which is both physical and moral*, a dazed inertia reminiscent of that following shock.

(Sheridan 1956, cited in Blacker 1956: 70, my emphasis)

Apathy, therefore, becomes defined as a psychoneurotic symptom and a distinctive psychopathological condition relating to girls' development. While boys' conscious preparation for the world of work leads them to become more purposive and thus to gain a sense of the future, the lack of encouragement for this in girls means they are 'less avowedly purposive' in relation to the future and characteristically demonstrated infantile impulses which must be overcome for social adaptation to occur.

In effect, the underlying problem of the problem girl is that of her apathy: an incapacity of will and purposiveness which becomes a condition of her attachment to fleeting pleasures and is counterposed to the parental disposition, in which altruism becomes a sign of enduring social adjustment. As the problem girl's failure to become adapted to familial aims is defined in terms of developmental arrest, her attachment to 'the gratification of the moment' becomes overwritten with the atavism of regressive, antimodern familial cultures. Her failure to progress to socialized, adult femininity, in order to found a modernized family life, is traced to a radical disruption of subjective coherence and consciousness formed from her inability to proceed beyond the repetition of those hysterical substitutions through which neglect is translated into loss, and a landscape of character oriented around sexual instability and infantile regression.[13]

The ruins of civilization: space, regression, fixity

As Anthony Vidler demonstrates, for critics of urbanism and psychologists alike, the surfacing of regressive, instinctual fears are a uniquely modern response to the 'impossibility of stabilizing modern space or sheltering the subject in a world of rootless psyches' (Vidler 2000: 50). Spatial psychopathologies – such as, in the nineteenth century, agoraphobia and claustrophobia, the fear of vast empty space and that of being in a closed space – are associated with a regression to an earlier developmental phase in the face of the unfamiliar spatial environments of urban modernity (Vidler 2000: 44–5). But in their link to the fear of the crowd, these diseases also become invested with the unpredictability of a formless mass. As the contingencies of social encounter press themselves upon individual consciousness, they rob the individual of purposive force, rendering them passive, constituting them in terms of 'drift'.

But the problem family proposed a disjunctive principle within those very environments understood to shelter the individual from the dislocating effects of modern urban space and experience: environments created in the

exchange between the spatial regimes of domestic modernity and those modes of sentiment formation that anchored individual character. Mark Wigley's account of the aspirational force of modernity, that of 'utility perfected', is framed in terms of 'architectural hygiene'. Subjected to the 'visual logic of transparency to structure and function' it produces a stable landscape of meaning: '[The] *home* is made clean. There are no more dirty, dark corners. *Everything* is *shown as it is*' (Le Corbusier 1925, cited in Wigley 1995: 3, emphasis in original). This purifying of architectural style, manifested in the whitewashed wall as the ultimate sign of the achievement of a cleansed, streamlined modernity, reconciles object with intention and purpose: 'Concentration of intention on its proper object ... An object is held to be made ... for a specific purpose, and to be made with perfection' (Le Corbusier 1925, cited in Wigley 1995: 3).

While modernism as an architectural style may have been embraced with less vigour in Britain, David Matless notes that 'functionalism' became a way of translating architectural modernism in terms which could align 'a modern Englishness in reconstruction' brought about by planning with the maintenance of tradition: nationally characteristic ways of living were to be embodied in new town plans (Matless 1998: 212–3). As Becky Conekin notes of the flagship for post-war design modernism, the Festival of Britain:

> Many of the London planners ... aimed to create a large-scale change in the British public's taste. Their objective was to dispel the fussy, old-fashioned, even 'repellent extravagances of the nineteen-thirties', replacing them with simple, clean lines for interior and exterior design and household objects.
>
> (Conekin 2003: 49)

A more energetic form of modernism also permeated other design modes, particularly those relating to domestic design, such as textiles, furniture and ceramics. The point at which these diverse forms of adherence to the functional dimensions of modernism met, was a pragmatic attention to the way that environmental conditions in towns interacted with family life in particular social groups. Woven into the plans for a future – cleansed and functional – geography for Britain's urban and family life, however, was a concern about intractability, as the landscape created by post-war reconstruction 'offered inclusive citizenship only by marking out an irredeemable human residue' (Matless 1998: 184). Matless discusses the 'feckless, urban mother' whose inability to adhere to patterns of reconstructed family life suggested she was a 'lost cause' in early wartime discussions of evacuation, and Starkey discusses the stigmatization of the poor mother, as some commentators on problem families identify the figure of the mother who was insufficiently attentive to hygiene and childcare as the object of blame for inadequate home conditions (Matless 1998: 183–4; Starkey 2000b). In this context, the problem family constituted not only the stinking residue of

human waste, but an ugly, scribbled gash across the clean lines and white walls of a modernized future citizenry.

But the case of the problem girl required a different kind of manoeuvre from those concerning the modernizing of environments for future citizens. It would require modernism to be used to address psychopathologies characterized by distinctive spatiality. In this respect, the principles of modernist design that were being used to modernize the environments within which new citizenries would be enacted themselves became integrated into models of psychological and social management – and especially into models of character – and thereby created a context for pathological character to be defined in terms of its affective lapses. The disorders which characterized social delinquents were not produced by the entry of the individual into the urban landscape, neither did they simply originate in the *mis*demeanours of problem families, as problems of sentiment formation. Rather, they became woven into the orientations and landscapes of regressive, antimodern domestic environments. Wigley highlights the ideal of cleanliness embodied in modern architecture and design, which 'joins the doctor's white coat, the white tiles of the bathroom, the white walls of the hospital, and so on' (Wigley 1995: 5). But the problem family represents a disturbance to that which cleanses not just space, but *consciousness itself*. It manifests itself as not only that disintegration of space, surface and order which characterizes the squalid home, therefore, but in those disintegrative forms of character embodied in the problem girl.

It is part of the formulation of the problem that adolescence is essentially a state of instability which has to be overcome in order to proceed purposefully towards socially responsible, productive adulthood. As adolescent girls whose familial environments do not provide the moulding pressures of directive discipline, problem girls become fixed in a pre-adult, non-maternal sexuality. Their apparent contentment with the single state, and failure to develop 'parental sentiments' even in the context of maternity, is understood as itself pathological, signalling a developmental arrest, as they become disastrously suspended in the gap between the past and future that characterizes adolescence.

Pailthorpe's case histories – in her words, a set of 'tediously repetitive' anecdotes – tell of dispossession, cruelty and neglect, alongside the mundane details of everyday poverty and fractured families, absence of opportunity and lack of hope – a failure to believe in the promise of a future of changed circumstances. Reading their stories from the present, it is hard not to see the resultant stoicism of the girls as a positive, even heroic, quality. Yet in the context of psychological models which take their passive resignation to such conditions as indicative of an introversion, as a form of recoil from a damaging world which allows them to become 'lost' in self-absorption and 'mere passivity', it is possible to read this response itself as a form of *fatalism* which itself testifies to that defect of will, or lack of purposiveness, which is required for the individual to achieve equilibrium,

integrated character, or serenity. It therefore becomes further evidence that these girls are formed in opposition to the achievement and consequence of the future of civilization: rather, they stand as signs of its ruin.

Those forms of sociopathic character which are seen as distinctive to problem girls therefore become aligned with a hopelessly fragmented subjectivity, altogether removed from the stage of social life, turned in upon themselves, inert. Seen from the perspective of a psychopathology formed in the exchange between psychology and eugenics, as a feature of the cultural experience of a Britain attempting to emerge from the experience of war, the figure of the problem girl becomes formed as a figure of damage and ruin, embodying the neglect and loss of the atavistic cultures of problem families, associated with the dangers of those forces which undermine the 'splendid achievements' of human progress and modern civilization, and returned to a primitive state of developmental arrest that connects her to the sociopathic features of the social problem group. Her specifically sexualized delinquency, however, represents a more primitive regression yet, as she comes to represent a form of identity which is not only antimodern, but in its opposition to the formation of parental sentiments and demeanour, one whose antisocial character is etched into those intimate reaches of individual disposition. The problem girl is figured according to the motifs of a fundamentally determining affective disorder, a character in retreat from the landscape of social interaction to an internalized space of compulsive repetition, marked by neglect and abandonment, loss and insufficiency, revenge and self-punishment.

In this context, the problem girl's promiscuous sociability is understood as a mask for her 'emotional fixity':[14]

> There is a special type of girl ... [who] is over-sexual in her behaviour and easily picked up, but is essentially over-ingenuous, over-trusting and over-credulous where admiration from men and what she thinks is romance are concerned. She easily imagines herself in love, but in fact has *a less than average capacity for the non-sexual expression of affection and for any permanent love.*
>
> (Joint Committee of the British Medical Association and the Magistrates' Association 1946: 8, my emphasis)

Pailthorpe recommends a range of measures, tailored to different groups. Programmes of sentiment training, when offered as part of elementary education, would cultivate sentiment development and prevent defects occurring, and as a remedial measure would improve sentiment formation in those who have it in 'rudimentary' form; individual therapeutic treatment would improve sentiment formation in those whose sentiment defect was the result of emotional conflict or psychopathy. But in her emotional fixity, the problem girl reveals a predisposition to the more serious forms of mental disorder: psychosis. In contrast to that flexible oscillation between

self-assertion and submission which results from the effective functioning of the sentiment of self-regard in the normally developed character, her emotional fixity suggests that 'both [self-assertive and submissive] affects remain in perpetual rigid balance', replicating that fundamental symptom of schizophrenia, 'a loss of emotional or affective contact with [others]' (McDougall 1944: 370). The problem girl's antisocial apathy, as well as her emotional fixity, thus allow her to be aligned with what McDougall refers to as the schizoid personality (McDougall 1944: 377–89). Deriving from a disorder of the sentiment of self-regard which allows her to be caught up in the gratification of the moment, this predisposition to schizophrenic illness (or dementia praecox) is reinforced by her early relation of loss and its compulsive repetition, her regression to a narcissistic phase confirming the affective state within which schizophrenia may develop:

> Schizophrenia ... involves that loss of personal rapport ... which is the most characteristic symptom of the disorder ... It might, then, be suggested that the schizophrenic patient is deficient or altogether lacking in what is commonly called self-feeling, but what we may more properly call the self-regarding affects, the emotion of positive self-feeling or elation, with its tendency to self-assertion, and the emotion of negative self-feeling or depression, with its tendency to submission and docility. But there are many facts which indicate that this is by no means true and that, rather, in the schizoid and schizophrenic these affects are excessive rather than lacking or deficient. I refer to facts of the order that have led Freud to describe Schizophrenia as one of the Narcissistic disorders, and to allege that, in patients of this kind, the libido is fixated on the Ego rather than on any outer object ...
>
> (McDougall 1944: 382–3)

Of the three varieties of schizophrenic noted by McDougall, the 'hebephrenic' is characterized by apathy and dullness, 'giving little outward expression to its emotions' (McDougall 1944: 371). This type is composed of 'inferiors, persons who at their best are poor, weak creatures, and who fail to make good adjustment of such feeble energies as they possess'. Antisocial, weak-minded and lacking in drive, their 'complete indolence and weakness of will' – or 'lameness' – is exacerbated by mental conflict: they become introverted, regress into fantasy, fail to show satisfactory emotional responses, and lose the ability to show affection or arouse it (McDougall 1944: 376–7; Lewis 1954: 47).

Pailthorpe had identified dementia praecox (schizophrenia) as a feature of several of her case studies of delinquent girls, emphasizing the critical importance of early identification and therapeutic treatment; without such treatment, this disease would run its course and beyond a certain point become irreversible. For those girls who evaded or were denied such treatment, the degenerative pattern may reach its final realization in a condition

in which the early symptoms of emotional fixity progress to the complete mental atrophy that constituted the extreme point of schizophrenic decline:

> the patient loses interest in all other topics than himself; the outer world becomes unreal ... But, with the continuance month after month and year after year of this fantastic self-absorbed brooding, which never finds free outward expression in effective action, but revolves always in the circle of incomplete inward activity, the mental powers in general atrophy, the life of rich fantasy gives place to an increasing dementia, until the patient 'glimmers dimly in a corner of the asylum, dull-witted as a cow'.
>
> (McDougall 1944: 389)

3 'Shattered into a multiplicity of warring functions'

Synthetic culture, disintegration and 'distractibility'

Everybody has gone mad on jitterbugging.

(Jephcott 1942: 124)

In 1942, Pearl Jephcott published *Girls Growing Up*, a sociological study of the lives of 'young working girls' in Britain – elementary-educated girls leaving school at fifteen who were mainly employed in factories, small shops, or private houses as 'domestic girls', doing the 'little, unimportant jobs' of the cheapest kind, which demanded little skill and offered no opportunity to learn a craft (Jephcott 1942: 73–9). Jephcott's particular concern was with the features of a wartime environment that gave the girls a fragmented present and an uncertain future:

> Their fathers have gone away with the Forces, their schools have been broken up and scattered, they have seen the destruction of places which have been known to them all their lives, and some of them have been near to violent death themselves ... What future awaits this ... set of girls?
>
> (Jephcott 1942: 35–6)

In Jephcott's account of altered conditions and transformed domestic and social landscapes, the question concerning the future of these girls is framed in terms of the effects of a disrupted environment on vulnerable psyches, and its impact on social cohesion: she situates her appraisal of the vulnerability of these girls within a context of damage and dispersal wrought by the experience of war. But the concerns she expresses relate to a particular transformation in habits and tastes, for that 'susceptibility' which makes the girls' futures problematic relates to a discernible attachment to the 'shallow pleasures' of modern cultures and popular forms. Jephcott's study singles out as a matter of significant concern the girls' over-attachment to the commercial and sexualized entertainments of contemporary adolescent popular culture. In her foreword, Katherine Elliot, Chair of the National Association of Girls' Clubs, comments: 'It is annoying to think of the cheap and shoddy

literature [girls read] when, in the age which has produced the Penguin and other delightful cheap editions, nearly all the great literature of the world can be bought for sixpence' (Elliot, in Jephcott 1942: 3). Not only did these girls read 'erotic bloods' and magazines in preference to books, but their enthusiasm for the cinema was only superseded by an alarming 'craze' for the dance hall, placing them 'at the mercy of the commercial world which in the main puts before them second-rate goods, cinemas rather than theatres, trash magazines rather than books, and synthetic foods and materials rather than the genuine articles' (Jephcott 1942: 38).

The damaged landscape of wartime Britain provides a means, therefore, of articulating the disruption to traditions of culture brought by factors other than war. Emblematic of these dangers, cinemas and dance halls offer the pleasures of intensity, ephemerality and abstraction: the cinema provides a dream world of action, colour, emotion and 'thrills', and the 'hot rhythm and syncopated music' of the dance hall is invoked as the ultimate symbol of the vulgar sentiment and synthetic excitement which characterizes the commercial world's 'sterile recreation' (Jephcott 1942: 118–9, 120–5).

Mica Nava argues that

> the 'syncopated beat' of the new clubs, music and dance steps conveys a sense of the perceived physicality – as well as irregularity or off-beatness – of the impact of American sounds and movement which complemented the cognitive and emotional response to the movies

and constituted an element of the increased personal and sexual freedoms for young women in Britain from the 1930s (Nava 1999: 77). The girls' responsiveness to this 'irregularity' becomes a key motif of socio-psychological commentary on female adolescent development from the 1920s to the 1950s. Seized by the dissonant rhythms of dance hall music, and absorbed in a synthetic world of cinema fantasy, Jephcott's susceptible girls are figured according to the motifs of distraction: an immersion in the moment of the thrill and an attachment to sensation – the 'disconnected' and fragmented experience of a colliding series of 'sense impressions' (Singer 1995: 91).[1] In this respect, distraction in girls becomes a symptom of the cultural irregularity – or dissonance – of emergent forms.

But Jephcott does not just lament the superficiality of modern commercial entertainments and the shallow pleasures of the modern consumer's sensory gratifications. In fact, although she proposes that the danger of commercial forms lies in their erosion of cultural taste, her concern focuses on those distinctive features which make adolescent working girls particularly susceptible to the attractions of derogated popular forms – her fears predicated on an equation between the false values of 'inauthentic' entertainments and a disruption of the processes of adolescent development which results in a defective moral sensibility:

> There is no greatness about the people or the events in their false world
> and nothing which makes any appeal to the idealism which is one of the
> lovely gifts of adolescence. If the food is low-grade it is only too likely
> that the mental and spiritual quality of the consumer will be the same ...
>
> (Jephcott 1942: 111)

For Jephcott, therefore, the problem is not simply an issue of taste, or its
erosion by commercial cultural forms. Rather, these are symptomatic of a
difficulty in the psychological formation of a newly identified grouping,
whose contribution to Britain's national futures depends upon the forma-
tion of their 'mental' and 'spiritual' qualities – the formation of their
character. And in this respect she addresses another dimension which fea-
tures in contemporary understandings of distraction: the 'regression' or
'arrest' of subjective perceptual ability as a symptom of the deterioration of
experience:

> [The girls] are at a stage when they are forming their tastes and,
> although they may realise that the film world is largely one of fantasy,
> they are basing their conception both of worthwhile entertainment and
> of a life that is worth living on the standards set by the film corpora-
> tions. On the whole these are standards which exalt violence, vulgarity,
> sentimentality, and false psychology.
>
> (Jephcott 1942: 111, 119)

The problem of the 'synthetic' pleasures of cultural forms which separate
stimulus from cognitive activity – and so present a 'false' world based on
fantasy – is here translated into a problem of the capacity for 'synthesis'.
The most worrying trend, for Jephcott, is a disruption of the subject's
capacity to distinguish between fantasy and reality and to synthesize
impressions into coherent, conscious thought. Adolescent girls' absorption
in commercial entertainments not only testifies to a lack of ideals, values
and 'standards', a failure to develop integrated moral character, but also a
perceptual dissonance which points to the undermining of that subjective
integration – an alignment between perception, cognition and affect which
allows mental activity to result in meaningful action – to which the capacity
for synthesis testifies.

Clearly, this intensification of concern with the working-class adolescent
girl circulates around questions of cultural experience and attachment, and
the way the reformation – or derogation – of patterns of adolescent taste
and character impacts on social futures. But if these issues become revivified
in a modernizing 1940s Britain, why does it make sense to address them
through the concept of distraction, given its apparent association with (and
emergence in) an earlier moment of urban transformation – the altered per-
ceptual environments of modern technology, space and spectacle as they
register on the metropolis in the last two decades of the nineteenth century?

It is only possible to answer this question by tracing those lines of conceptual development – the continuities and adaptations – which allowed problems of cultural attachment to be approached in terms of the concept of distraction in early twentieth-century Britain. Clearly, this term had sufficient pliability to provide a purchase as much on questions relating to the altered conditions of war and new patterns of everyday living as those of the emergence of new entertainment forms. If the identification of problems of cultural dissonance and adolescent development provided an axis for the adaptation of the concept of distraction and a stage for its material application – and so gave it its historicity – then the conditions of that purchase, the nature of those conceptual innovations which were made, had their origins in those abstractions upon which the term itself was founded, and their fine connections. To understand these innovations, we will need to follow those conceptual threads – the lines of association – which take us back to the internal formation of the concept of distraction as it was developed in nineteenth-century psychological writings, and follow their contingent development in the disciplinary revisions of British psychology in the interwar period.

Associated with working-class girls' 'irregular' attachment to derogated entertainments, distraction moves from its definition at the end of the nineteenth century as a defect of attention, to become symptomatically associated with developmental disturbances specific to adolescent girls and the dissonance of emergent cultural forms. As previous models of distraction are adapted by a distinctively British psychology of character that develops in the early decades of the twentieth century, the notion of attention becomes transformed in such a way that individual 'distractibility' is defined as a separate psychological state, rather than simply as a failure of – or interruption of – attentiveness. Applied to the problem of the working-class girl, the psychological concept of attention is therefore used to define her responses to those commercial entertainments which are emblematic of the altered conditions of modern urban environments in psychopathological terms. Central features of her susceptibility are a passivity and suggestibility which predisposes her to an attachment to over-sexualized entertainments, whose irregularity has a parallel in those forms of instability associated with these girls' lack of cultural moorings.

In the course of this process of adaptation, distractibility became redefined as not just a perceptual state – as a state of consciousness, or 'mind' – but one which is based in the affects: a *state of being*, traceable to a pathological fabric of character through which these girls became susceptible to the lures of sensory excitements and 'thrills'. This association between moral and affective defect provided the basis for distracted girls to become identified not so much in terms of failures of attention, but of a problem of character with social implications: the failure to achieve subjective integration pointed to the degenerative effects of psychosis.

The measure of moral character: attention, consciousness and volition

In her emphasis on the selection and synthesis of impressions as a keystone of subjective integration, Jephcott's discussion rests on a concept of distraction formed from psychological inquiry into modes of attention, whereby it became identified as a defective state. Jonathan Crary's account of the development of new perceptual regimes emerging in the altered environments of urban modernity in the nineteenth century shows how a psychological notion of 'attentiveness' was deployed to bring into being a newly attentive urban citizen (Crary 1999).[2] In the context of those repetitive and monotonous tasks associated with mechanical production, attentiveness implied the perceptual capacity to select from a plethora of stimuli, equipping the individual to preserve a concentrated focus by screening out extraneous stimuli (see Crary 1999; Doane 2002; James 1890: 404). But as well as allowing functional efficiency, it allowed the sensory adjustments required for urban spectacles and emergent commercial entertainments. Distraction also emerged as an issue in relation to the altered spatial landscapes and perceptual arrangements of the metropolis and urban life (Vidler 2000; Charney 1998; Danius 2002), and the influence of emergent forms of mass spectacle (Crary 1999; Charney and Schwarz 1995).

In other words, attentiveness was not understood as simply an instrumental state: from its inception, the issue of distraction was identified as a fundamental problem of modern experience (Crary 1999: 13). This allowed its potential to destabilize individual perception and subjective formation to be painted on a larger canvas. For, in fact, psychological models of attention also proposed that *consciousness itself* is founded in the capacity for attention and resides in a principle of distinction, the selection of some impressions and the suppression of others through 'the reinforcing and inhibiting agency of attention' (James 1890: 139, 284–5, 288). Consciousness, in effect, was seen as a result of discriminative attention (James 1890: 224).

The work of the nineteenth-century psychologist William James was foundational to the development of this concept of distraction. James represents conscious life as the 'stream of thought, of consciousness, or of subjective life', centred on a flow of sensations, images, concepts, thoughts, and feelings in continuous transition (1890: 239–47). For him, inattention was an essential component of managing the business of living – the *habitual* – at a sensory level, and not simply a specifically urban affair:

> We do not notice the ticking of the clock, the noise of the city streets, or the roaring of the brook near the house; and even the din of a foundry or factory will not mingle with the thoughts of its workers, if they have been there long enough ... The pressure of our clothes and shoes, the beating of

our hearts and arteries, our breathing, certain steadfast bodily pains, habitual odors, tastes in the mouth, etc, are examples from other senses, *the same lapse into unconsciousness of any too unchanging content.*
(James 1890: 455, my emphasis)

As such, attention is imprinted with the problems associated with processes of subjective perception: not only are they continually evolving in the light of new thresholds brought by industrial and urban innovation, but regimes of attentiveness were understood to be constantly open to the possibility of failure, instability and divergence (Crary 1999: 77).

James defines distraction and attention as opposites (1890: 404) and it has been argued that he positioned these as two extremes on a continuum of levels of attentiveness (Crary 1999: 47). But James also distinguished various kinds of attention, with different qualities based on their relation to volition, or will. While 'interest' allowed the individual to select from impressions, it was volition which, through its role in sustaining attention, rendered impressions more or less conscious and thus also positioned the self in a position of more or less mastery over the object or idea to which attention was directed (James 1890: 424).

It is this system of classification that provides the basis for distraction to be reformulated in terms of *a defect of character*, in those adaptations of James' model that circulated in Britain in the period in which Jephcott was writing. For while James understood distraction and attention as normal modes of individual consciousness, and describes eloquently the 'confused, dazed, scatterbrained state' which individuals may experience several times a day, those forms of attention he aligns with the condition of distraction are nevertheless invested with different valuations. The experience of distraction is one in which attention becomes 'dispersed', sensations 'melt into a confused unity', and consciousness is filled by 'a sort of solemn sense of surrender to the empty passing of time' (James 1890: 402–4). 'Involuntary attention of the immediate sensorial sort' – passive, non-cognitive, independent of the functioning of consciousness implied by both 'association' and 'effort' – thus lacks the selective interest that protects the individual from the 'utter chaos' of sensation. Distraction, therefore, implies the erosion of distinctions between sensations and a disintegration of conscious experience.

Both the 'scattered condition of mind' that characterizes distraction and the 'extreme mobility of attention' which precedes the development of a capacity for concentration of consciousness are understood by James in terms of a more primitive form of subjective experience (James 1890: 404). Sensorial, instinctive and part of inherited constitution, it precedes the acquisition of those forms of disciplined attention associated with the development of mature adult character: 'Sensitiveness to immediately exciting sensorial stimuli characterizes the attention of childhood and youth ... that extreme mobility of the attention with which we are all familiar in children ... never is overcome in some people' (James 1890: 416–17).

It is in this respect that James' model becomes read as offering the basis of a connection between distraction and defects of character, as he proposes a primitive, instinctual base for the susceptibility to those sensory impressions which form the basis of involuntary attention, and associates this with an undeveloped capacity for distinction. The persistence of this distracted, automatic, passive attention, functioning as a reflex, which makes consciousness subject to the object rather than autonomously directive, expresses the chaotic responsiveness of the undisciplined, undeveloped mind. As such it becomes seen as a defect in the exercise of will as the principle underlying unified individual consciousness.

It is will, then, as an effective force, a property of the individual, which implies a disciplined direction of consciousness originating in the mind[3] – James talks of effort of attention as 'the fundamental act of will' (1890: 562). This reflects the ability to respond to ideals rather than impulses: for James, the addition of effort to the ideal impulse is the critical factor that allows it to overcome the stronger force of the propensity or instinct. In fact, in his statement that 'volition is nothing but attention' (James 1890: 447) and his explicit association of volitional effort with ideals, James suggests that an individual's capacity for voluntary attention is the measure of moral character (James 1890: 548–9).[4]

Cognition and conation

As distraction is positioned as a failure of that effort of will which allows attention to be sustained, it becomes associated with forms of experience which derive from the capricious effects of contingent environmental stimuli – a chaotic series of unsynthesized impressions, sensory, fleeting, vagrant – rather than a centred, disciplined consciousness with the ability to develop selective interest. Contemporary commentary on adolescent working girls' leisure interests in 1940s Britain, both generated and informed by psychologists working in adolescent management and the study and treatment of delinquency, turns to this model of attention to translate girls' over-attachment to commercial and sexualized entertainments not in terms of pre-existing assessments of derogated taste, but as a more troubling process: the girls' immersion in the pleasures of distraction testifies to disruptions to their psychic development, in the derailing of an ongoing process of adolescent development. For if adolescence was a developmental phase with particular emotional snares and difficulties, it was the adolescent working *girl* who was seen as particularly susceptible to an attachment to those entertainments that testified to disorders of attention.

The girls Jephcott studies are, in her view, especially prone to spending their free time in an 'effortless and irresponsible way' since they spend their days on routine work demanding manual rather than mental effort. In particular, they become attuned to the rhythm and tempo of dance music through a familiarity with the mechanical routine and 'continuous din' of

factory work, whose noise and speed 'drugs' them (Jephcott 1942: 3, 85, 113–17, 120). The dance hall and the cinema's 'easy appeal' is based on an escape from the dreary routine of mass production, and becomes a habit that chokes the desire for more authentic forms of recreation (Jephcott 1942: 113). Underlying these preferences, the disruptions of wartime Britain combine to produce, for Jephcott, one particularly overriding psychological disposition in girls, as she comes to focus not so much on the *effects* of those entertainments, as the *susceptibility* of the girls to the pleasures of their immersion in sensation. The exposure to danger and the disruption of family life brought by war, and the routine work they undertake after leaving school with only elementary education leading to unchallenging working lives, creates an insufficiency of will and an overriding apathy – or indifference to the external world – which allows girls to lapse into passivity and be driven by momentary pleasures. This is, in another form, the same lapse that defines the 'problem girl'. But the problem of apathy – which in the context of the problem girl is associated with delinquency – here becomes, in the context of modern entertainments, a condition of distraction.[5]

Jephcott is not alone in connecting apathy in girls with a form of passivity which renders them susceptible to superficial cultural attachments. In the same year that Jephcott's study was published, the psychologist R. D. Gillespie observed that 'passive anxiety' was a more common reaction to the disturbances of war in girls, in contrast to a pattern of active anxiety exhibited in boys (Gillespie 1942: 73–80, 147).[6] And the report of a 1945 committee of inquiry into *The Needs of Youth in These Times* identified 'female passivity' as a distinctive difference between boys' and girls' development: while boys' conscious preparation for the world of work leads them to become more purposive and thus to gain a sense of the future, the lack of encouragement for this in girls means they are 'less avowedly purposive' in relation to the future. Deploring girls' addictions to dance halls and cinemas, it concludes that their 'passive absorption' in such pleasures leads to a lack of a sense of purpose in the development of their 'shallow lives' (Scottish Youth Advisory Committee 1945: 29). The resulting 'emotional suggestibility' and 'pliability' characteristic of the adolescent girl induces in her a disposition formed by a *synthetic* culture, inducing

> a willing acceptance of the ideas, standards, and ambitions of those whose lives are closely bound up with her own and whose affection she is desirous of holding ... if her imaginative fare consists only of cheap novelettes, her dreams will be full of the emotional reactions which they are designed to produce.
>
> (Scottish Youth Advisory Committee 1945: 16–17)[7]

Passivity, therefore, becomes defined as a psychoneurotic symptom and a distinctive psychopathological condition relating to girls' development.

Their openness to those stimuli associated with involuntary attention – the primitive realm of the sensory and the instinctual – itself becomes a sign of psychopathology: dancing, Jephcott comments, is motivated by the satisfaction gained by rhythmical movement which 'psychologists tell us ... is a recognized means by which relief is afforded to anxiety' (Jephcott 1942: 122–3). Passive anxiety is seen as both characteristic of girls' psychological make-up and their psychic response to the abnormal environmental circumstances produced by war, as wartime conditions and the experience of industrial work 'thwart' girls' instincts. And as girls' lack of purposiveness in relation to a future predisposes them to passive responses, it creates a particular kind of 'suggestibility' which leaves them vulnerable to the seductions of shallow romantic fantasies.

Distracted girls are therefore characterized in terms of a distinctive alignment between emotional or affective failure (their apathy) and its correlative in a cognitive failure, their suggestibility. And it is in this context that apathy and suggestibility become fused in a new pathological description: 'distractibility'. While James proposed that an individual may experience a range of attentive states, including distraction, the British psychologist William McDougall, in his recasting of James' model of attention, came to identify 'distractibility' as a distinct and pathological condition, situating failures of attentiveness as symptoms of the relation between affective and cognitive defect.

McDougall acknowledged his debt to James throughout his life, and his model of character became central to debates about adolescent development and integral to programmes for citizenship training. McDougall followed James in identifying the determining role of 'interest': 'interest is latent attention'. And he retained James' emphasis on the role of volition in persistence of attention. But McDougall saw the question of attention in terms of the translation of 'interest' into purposive action: 'attention is interest in action'. And this led him to foreground the concept of 'conation', or striving. In the link between interest, effort and conation, the capacity for attention is founded in the individual's instinctual make-up (McDougall 1923/33: 277).

For McDougall it was the instincts that gave rise to conative striving, and which were, therefore, the 'prime movers' of all human activity. Without them, there is no possibility of mental activity:

> by the conative or impulsive force of some instinct, every train of thought, however cold and passionless it may seem, is borne along towards its end, and every bodily activity is initiated and sustained ... Take away these instinctive dispositions, with their powerful impulses, *and the organism would become incapable of activity of any kind; it would lie inert and motionless ...*
>
> (McDougall 1923/33: 218, emphasis in the original)

But, McDougall's discussion of the role of instinct and conation is framed in terms of attention and its association with 'will':

> an instinct [is] an inherited or innate psycho-physical disposition which determines its possessor to perceive, and to pay attention to, objects of a certain class, to experience an emotional excitement of a particular quality upon perceiving such an object, and to act in regard to it in a particular manner, or, at least, to experience an impulse to such action.
>
> (McDougall 1908/28: 25)[8]

Following James, then, McDougall sees that interest which determines attention as a function of the instinct. Sense impressions attract attention to the extent that they excite the instincts, generating conation, or a striving towards the satisfaction of an impulse. McDougall's notion of instincts as the basis of individual perception and activity gave attention an affective and conative dimension which, as for James, is based on cognition: the subject recognizes or thinks of an object, which evokes the conative impulse to some kind of behaviour which effects change, and brings about further cognition.

But it is James' focus on voluntary effort – as a feature of 'will' that, through its ability to sustain attention, becomes the basis of self-mastery – which for McDougall influences an individual's capacity to adhere to goals (McDougall 1908/28: 448–9; 1932/50: 172–5):

> We say we are trying, striving, endeavouring, paying keen attention, making an effort, working hard, doing our utmost, exerting ourselves, concentrating all our energies: in technical terms, we are manifesting *conation* ... These experiences of striving, of impulse, of desire ... directed towards any one goal ... form a train or succession that hangs together; that is to say they ... have ... *conative unity*.
>
> (McDougall 1932/50: 117–19, emphasis in the original)

For McDougall, the stability and integration of character was a *prerequisite* for a capacity for attention 'of the cognitive sort' and attention and its relationship to volition, or will, becomes a matter of the *quality of character*. In this way, he promoted the capacity for conative persistence – an individual's capacity to strive towards, and adhere to, identified goals – to a central platform of character.

But distractibility is not *only* an instinctual, inherited condition, in McDougall's model. Certainly, individual make-up depended on an inherited constitution or 'native tendencies' made up of primary instinctive dispositions – including fear, anger, tenderness, curiosity, sex, hunger, gregariousness, disgust, self-display and self-assertion, self-submission, and so on. But while these instinctual tendencies comprise the 'dynamic foundations' of character (McDougall 1927: 12) – its fabric – they could only be said to have become integrated into a particular *structure* by the directive

functioning of an acquired set of sentiments, an organized system of emotional dispositions which represents a structuring of affect:

> In the absence of sentiments our emotional life would be a mere chaos without order, consistency, or continuity of any kind; and all our social relations and conduct, being based on the emotions, and on their impulses, would be correspondingly chaotic, unpredictable, and unstable ...
>
> (McDougall 1908/28: 137–8)[9]

It is the sentiment of self-regard, as an *exercise of will*, which brings the individual to discipline individual impulses, or the self-affects, through conscious adherence to ideals and values, and so becomes the basis of integrated moral character.

Purposiveness, in fact, crystallizes McDougall's concept of the value of volition for integrated character (McDougall 1932/50: 136–7).[10] McDougall's emphasis on purposiveness as a critical feature of integrated character transforms distractibility into a form of pathology that signals defect at the level of the fabric and structure of character itself. As the inability to direct attention purposively, then, became seen as a failure of conative persistence, 'distractibility' became defined in terms of that failure, in its connection to apathy as a defect of will and suggestibility as a cognitive defect. Fusing defects of 'native constitution' with those of sentiment formation, and therefore defining distractibility as a problem combining hereditary and environmental factors, McDougall points to 'distractibility' not as simply a state of perception, or even consciousness. As a product of both a constitutional defect and a developmental arrest or distortion associated with a lack of that conative unity that is the prerequisite for integrated character, distractibility becomes defined as a state of being.

Synthesis, the aesthetic sentiment and sexual instability

In the affective pathologies attributed to distractible girls, disruptions to psychological development propel them to take refuge in the pre-cognitive world of unsynthesized impressions. Given the widespread contemporary assumption that purposiveness was a feature associated with adolescent boys' character development,[11] and the association of 'passive' conditions – understood as inherently psychopathological – with girls, this laid the ground for girls' psychic development to be defined in terms of a defective relation to purposiveness, which was understood by McDougall as the basis of the achievements of modern civilizations as well as integrated individual consciousness and character. Defects of attention and purposiveness can therefore be traced back to a deficit of interest originating in a disorder of the instincts which prevents the individual achieving that conative unity that underlies integrated character. Such instinctual disorders, as we

will see, become identified as the basis of girls' psychopathological responses: the thwarting of their irregular instincts provides the foundation for those affective and cognitive disorders which become manifested in distractibility.

If apathy is a psychic state, a psychoneurotic response to a disturbed environment (family, war, work), in distractible girls it manifests in an absence of conative persistence and purposeful action, allowing their psychic attachments to be read in terms of social, rather than solely individual, pathology. As their experience of work threatens to leave them 'embittered' and 'unhappy', their choice of entertainment – 'that contradiction in terms, uncreative recreation' – carries the potential to corrupt vulnerable psyches (Jephcott 1942: 78–9, 85).

Defined in the exchanges between apathy, an undue influence of the self-affects and (in their suggestibility) an absence of the reality effect which amounts to a failure of cognition, distractibility was attributed to 'girls of low morale' whose sexual promiscuity brought them to the notice of the courts, the unstable adolescent 'problem girl' whose lack of drive, initiative and regard for authority characterized a 'defective character structure' which was manifested in sexual misbehaviour and lack of amenability to discipline and control, and teenage mothers institutionalized for child neglect (Stephens 1945; Joint Committee of the British Medical Association and the Magistrates' Association 1946; Sheridan cited in Blacker 1956). In fact, distractibility became a symptom of that inability to discipline the self-affects which linked a 'craze' for dance music, the cinema and erotic literature to a sexual instability (Joint Committee of the British Medical Association and the Magistrates' Association 1946). If their 'dazed inertia' was the manifest state of a deeper affective disorder, their distractibility not only made them vulnerable to those commercial entertainments which over-stimulated the 'sex instinct' and cultivated antisocial tendencies, it actually *derived* from a disorder of the sexual instincts (Jephcott 1942: 125; Joint Committee of the British Medical Association and the Magistrates' Association 1946: 8–9).

In fact, there was a specific precedent for the suggestion that girls' distractibility constituted an affective disorder which was founded in the instincts. In her report on delinquent girls, Grace Pailthorpe defined one particular group in terms of an inability to achieve a balance between self-assertiveness and self-submission, which testified to the effective channelling of the instincts by the sentiment of self-regard: 'the egoistic sentiment in them is almost elemental in that it involves the activities of self-assertion alone' (Pailthorpe 1932a: 16–17, 20, 39). Their egoism – or the dominance of self-assertiveness – led them to be driven by the instincts, while they had not sufficiently developed those social sentiments (familial, religious, patriotic, altruistic) which allowed self-assertiveness to be moderated by self-submission.

They adopt the clap-trap of their particular class, but it is mere imita-
tion, it never takes the permanent form of dispositions and sentiments
... Their pseudo-sentiments can be put on and off as easily as the pow-
der and paint they affect on their faces.

(Pailthorpe 1932a: 17)

This artificiality of values coexisted with a corresponding sluggishness of
the reasoning faculty and a low level of 'adjustment to reality': that they
over-estimated their capacities and did not recognize their limitations was a
sign of their lack of acceptance of the 'reality principle', or their inability to
manage an 'adjustment to reality' (Pailthorpe 1932a: 18).

Suggestibility, imitation, inauthenticity

In Pailthorpe's account, the problem of inauthentic character in delinquent
girls was marked by a combination of an immersion in the self-affects and
an inability to channel and moderate their instincts in accordance with an
apprehension of reality associated with self-regard. But she too approaches
this problem through the quality of the girls' attention. The findings of the
mental tests Pailthorpe conducts bring her to conclude that quality of atten-
tion and the emotional factors affecting concentration were as critical as the
quality of the girls' intelligence. Selecting several tests of attention, as well
as testing related mental processes such as observation and the ability to
sustain attention, in tests of 'perseverance' and memory (or the persistence
of impressions), she also tested for defects of attention through exercises
gauging delinquent girls' 'suggestibility'.[12] For Pailthorpe, then, defects of
attention were not only associated with defects of will (in the testing of vol-
untary attention and sustained attention, both of which rely on effort of
will) but, in tests of suggestibility, they were aligned with the inability to
distinguish between what is real – or an authentic impression – and what is
false – or an inauthentic impression. And in her comments on the results of
the tests, she proposed that, for girls with defective intelligence, the combi-
nation of suggestibility and docility led them to become susceptible to
adverse influences. 'Suggestibility', as a feature of defective attention, there-
fore becomes an indicator of a susceptibility to inauthentic culture and a
failure to synthesize impressions, or to determine what is 'real' (Pailthorpe
1932a: 14–16; see Swanson 2007b).[13]

The girls' implied lack of authenticity, and the explicit association with
artifice in Pailthorpe's account of their 'pseudo-sentiments', links dis-
tractibility with the brash, commercial values of modern cultures and
superficial glamour. The girls Pailthorpe investigates are consigned to
'imitation' rather than the authenticity which derives from adherence to
ideals, and an exhibitionism which suggests a distortion of the aesthetic
sentiment by the instinct of self-assertion, or self-display. And this, she
proposes, not only suggests a sexually specific pattern of affect which

underlies distractibility, but points to its origin in a precociously developed and 'exaggerated' sexual instinct which disrupts that equilibrium of character which allows the individual to modify and discipline the impulses according to the values and ideals of the community.

In her examination of the pattern of acquisition of the social sentiments – which exist in an inverse relation to 'egoism' – amongst one group of girls, Pailthorpe finds that the altruistic sentiment, that sentiment which allows individual impulses to be suppressed in the interests of others' needs, is abnormally low.[14] On the other hand, the aesthetic sentiment, which in McDougall's model is understood to develop in association with the sexual instinct, is unexpectedly high (McDougall 1927: 18). The undue presence of the aesthetic sentiment, Pailthorpe suggests, may be attributed to an 'undue sexual stimulation' characteristic of 'evil' or 'vicious' homes and an 'early sexual development' which represents a primitive instinctualism (Pailthorpe 1932a: 39).[15] These features suggest a set of conditions adverse to the development of the social sentiments, as the prevalence of the self-affects prevent them forming, allowing Pailthorpe to conclude that premature sexual development distorts the aesthetic sentiment. While in its correct functioning the aesthetic sentiment aligns sensory pleasure with aesthetic values and ideals and thus becomes aligned with the social sentiments, these girls demonstrate a superficial form of aesthetic responsiveness based on self-display. Hence the girls become defined in terms of a primitive, instinctual egoism, their 'craving to follow fashion' being simply imitative and exhibitionistic (Pailthorpe 1932a: 60). For aesthetic response to attain value, it must become *more than* a sensory experience – an act of stimulation – and become an act of consciousness directed by volition (Blacker 1933: 122–3). This absence pervades the entire structure of the girls' affective functioning, defining them in terms of cognitive failure.[16]

Defects of attention, therefore, become attached to the regressive influence of the sexual instinct in disrupting the formation of the social sentiments and the ability to discipline the self-affects. The girls' particular form of aestheticism, understood to be related to the sexual instinct, therefore suggests a more primitive, instinctual dimension to their attachment to intoxicating entertainments. This connection links their 'craze' for dance music, the cinema and erotic literature to a sexual instability which reduces them to the sensory dimension of character – or the passivity of non-conative responses and unsocialized impulses (Joint Committee of the British Medical Association and the Magistrates' Association 1946). In effect, Pailthorpe adapts McDougall's argument that there is a constitutive link between an immersion in the self-affects, a premature development of the aesthetic sentiment and an exaggerated role for the sexual instinct, to propose this as a feature of the psychic formation of distractible girls. In her hopelessly fragmented subjectivity, the distractible girl becomes removed from the stage of sociality, outside human temporality and action. She becomes defined as a symptom of psychic disruption.

Suspension, disintegration and psychosis

The centralizing of self-affects, and the lack of centralized 'interest' and capacity to strive as features of distractibility, therefore allow an underlying sexual instability to represent more: the functioning of the senses in the absence of cognition implies a radical disruption to subjective coherence and consciousness. Psychological models of attention based on James' formulation proposed a distinctively processual quality to subjective life and experience, whose unifying principle was understood to be continuity. In McDougall's model, this becomes translated into three distinct stages: the cognitive, the conative and the affective. Progress through these stages allows the translation of cognition into purposive behaviour (McDougall 1923/33: 267). As a result, affective functioning – and its place in the securing of a unity of character defined around the effective channelling of the impulses – is dependent on cognition and conation. But, failing to progress through these stages, distractible girls cannot be defined in terms of 'flow' or continuity. Defects of attention – those forms of apathy and suggestibility which provide the basis of distractibility – culminate in a passive responsiveness to chaotically changing stimuli and the mobility of an ever-changing array of glittering surfaces characterized by 'drift':[17]

> These young people are unable to find pleasure in the usual channels. They lack aim and object in their lives. They drift from pillar to post. There is no centralization of their energies towards accomplishment in any one direction. They are highly distractible, largely because of this lack of centralized interest.
>
> (Pailthorpe 1932a: 94)

The girls' absorption in the dispersed state of distraction – their dependence on the contingency of external stimuli as opposed to that centralized interest which enables discrimination and selective attention – functions as a counterpoint to the processes of voluntary attention which allow them to exercise cognitive ability and conation. They lack the 'synthesizing' capacity which allows them to progress beyond the sensory and the instinctual, to transform sense impressions into coherent, conscious thought and purposive activity, and so integrate affect with cognition and conation. These disruptions to the subject's capacity for synthesis threaten to undermine subjective integration and disrupt the moderation and disciplined channelling of the self-affects which allow an apprehension of the world beyond the self: 'she is entirely unable at the present time to give her attention to anything' (Pailthorpe 1932a: 60). While the delinquent girl's attachment to synthetic culture gives rise to an emotional excitability – Pailthorpe notes the girl's 'mannerisms ... habits, spasms, tremors, blushing ... and her history of states of excitement' – these come to be read as a form of superficial self-display without continuity or consistency:

'pseudo-sentiments' that are as temporary and cosmetic as the girl's make-up (Pailthorpe 1932a: 12–13, 18).

Pailthorpe implies that these girls' progression through the cognitive, the conative and the affective stages of subjective experience is suspended, or arrested. But McDougall's own account of this process reveals a splitting of the cognitive which in itself demonstrates the hazards of a failure to progress beyond the initial stage of cognition. In fact, McDougall proposes the 'natural order' of the three elements of the cycle to be 'cognition, conation, *changed cognition*, affection' (McDougall 1923/33: 267, my emphasis). In this way, he separates cognition into an initial apprehension, or the ability to recognize or think of an object, and a more advanced cognitive ability to synthesize these impressions – a form of 'processing' which assumes the integration of character capable of directing consciousness, or 'conative unity'. The capacity for conation allows the individual to act upon the object apprehended in the first stage of cognition, to convert it into synthesized form, or true cognition. Without the capacity for this active relationship to impressions, the girls become suspended in the automatic reflex of sensory response, unable to move beyond simple apprehension.

The girls Pailthorpe is most concerned about, and who represent the most intractable subjects, unamenable to therapeutic intervention, are those for whom the sentiment defect implied by distractibility has to be understood as having progressed to cognitive deterioration. Symptoms of passivity become integrated into a narrative of degenerative progression which Pailthorpe's case histories allow her to picture in its advanced form: 'the mind is absorbed elsewhere, and cannot be brought to focus full attention on external considerations' (Pailthorpe 1932a: 96).

Pailthorpe's report was critical to the founding of the Institute for the Scientific Treatment of Delinquency (ISTD) in 1932, the year of its publication, and the later opening of its 'psychopathic clinic' (later the Portman Clinic) in 1937. The clinic offered an eclectic approach to the provision of psychoanalytic psychotherapy to treat 'anti-social conduct, especially among young people', and established a particular classification of psychopathic character, resting on faulty emotional development, which in adolescence created a difficulty in managing the 'sudden augmentation of psycho-sexual impulse' and so gave rise to various forms of unstable or abnormal behaviour (Glover 1944: 5–13). These redefinitions consolidated both the association of psychopathic character with problems of emotional development, and the identification of a class of psychoses that arose in response to abnormal environmental influences, Pailthorpe's report providing a compelling case for both. Her advocacy of individual psychotherapy as a means of interrupting the process of transition from juvenile psychopathy to later psychosis, as well as treating the 'temporary psychoses' of delinquent girls, became embodied in the work of the ISTD, essentially giving psychotherapy a new role (Glover 1944: 13).

But while these initiatives promoted the possibility of treatment, they also affirmed the difficulties of diagnosis – the permeability between normal and psychopathic adolescent behaviour, and the continuity between normal adolescent behaviour and adult mental instability.[18] And by affirming the importance of intervening at an early stage, before psychosis developed to a point following which the process of degeneration was unstoppable, psychopathological approaches to the disorders associated with distractibility created a pathway towards complete disintegrative collapse. The treatable psychopath, therefore, was only discerned from the healthy adolescent girl through psychotherapeutic investigation, and so 'normal' adolescent impulses were only distinguished from those which, if left untreated, would later lead to psychotic disintegration, within an individual psychic narrative. The possibility of diagnostic failure, therefore, created a spectre that haunted the development of 'scientific' approaches to everyday adolescent management.

When Jephcott asks what future is awaiting these girls, or Eustace Chesser,[19] in his popular text on adolescent development, represents adolescents as occupying the gap between past and future – their pre-history formed by the 'hereditary memory' of basic instincts which allow individuals to revert to an 'impulse to put self first' which he likens to 'jungle law' or 'savagery' (Chesser 1949: 153–5) – they are confirming a view of the problematic nature of the adolescent phase of development. This is a phase characterized by an 'instability' of emotions and impulses: 'where there are adolescents, the possibilities of moodiness, irritability, sulks, discord, strife, boredom, unhappiness, envy, hatred, malice and all uncharitableness are never far away' (Yellowlees 1943: 7; see also Chapter One).[20]

But in their attention to the struggles involved in progressing towards adult maturity, these writers also confirm the possibility of succumbing to a more primitive state yet. Adolescent girls who prefer sexualized entertainments to the opportunity for more authentic involvements are bounded by an infantile circle of self-interest that, rather than extending into the socially attuned disposition, takes them beyond the self towards a populous landscape of relationality. Absorbed in the sensory realm, immersed in the distracted moment, the girls become fixed in a realm of chaotic sensation, and the pattern of their distractibility, as it is presented by commentators, connects with those disorders which, within abnormal psychology, see them receding into advanced forms of schizophrenia.

The use of psychopathological models to address delinquent behaviour and mental instability in adolescent working girls creates a particular connection between distractibility and mental instability. The distractible girl's absorption in the self-affects constitutes a regressive form of functioning which prevents emotional interaction and recognition of the world outside the self. In its disordering of the individual's relation to the external world, and the inability to grasp 'reality', therefore, distractibility points to a fundamental cognitive failure, predisposing girls to an affective disorder which

threatens to disintegrate character. Those sociopathic cases that exhibit a failure of cognitive functioning, a prominence of the self-affects, a failure of purposive striving, an antisocial lack of affective relation to others, and the alternating extremes of apathy and excitation, are characterized by symptoms of the disintegrative effects of schizophrenia. Characterized according to an unstable oscillation between a generalized apathy and sudden bouts of 'much emotional excitement', contemporary accounts of schizophrenia suggested it derives from the excessive activity of conflicting impulses which 'overflow' their normal boundaries, producing reactions that are 'injurious to the organism' (Harrington, cited in McDougall 1926/44: 375).

But the lack of that capacity for synthesis that secures subjective integration positions distractible girls within a narrative of not just individual, but social, disintegration. Unlike 'the normal youth', the 'schizoid' never learns to 'range himself in his due place in the social order' (McDougall 1926/44: 387). And while McDougall suggests that the self-absorption implied by schizophrenia can be likened to a state of childish sulking, he imbues this with a more dangerous quality, leading to an antisocial form of development:

> sulking is a dangerous condition, already half-way to disorder ... The sulking, the self-absorbed brooding over slights or insults, may terminate in an outbreak of vengeful violence; as in the introverted Malay, who after sulking (like Achilles in his tent) takes his kris and runs *amok*, cutting down every human being he meets, until he is himself cut down. I am suggesting that the schizophrenic state is essentially a morbidly exaggerated and prolonged state of sulking; and that the sudden outbreaks of violence which such patients are liable to, even those that seem utterly apathetic, are strictly comparable to the *amok* in which the sulking of the shy, sensitive, introverted Malay is apt to terminate.
>
> (McDougall 1926/44: 388)

As an aspect of cultural experience in 'modern' Britain, then, the problem of distractibility represents a more sinister threat than an issue of derogated popular forms and cultural taste, as it becomes imbued with the dangers of those forces which undermine the 'splendid achievements' of human progress and modern civilization (McDougall 1908/28: 271–3).[21]

The limits of knowledge

Pailthorpe and Jephcott may point, each in their own ways – Pailthorpe through her promotion of programmes of sentiment development in elementary schools and schemes for individual psychotherapeutic treatment, Jephcott through modes of adolescent training associated with the 'clubs' movement – to the possibilities of individual rehabilitation and social amelioration. But their sense of a programme, of a future, is checked not only by their recognition of the limits of intervention – the problem that those very

features of character which predispose girls towards sociopathic or antisocial behaviour, or lay down patterns of cultural engagement that impede their developmental progression, make them unamenable to those forms of treatment or training open to them – but also by the fact that the models they deploy have to be adapted to a new emphasis on environmental factors, and the obstacles to change, and dissonant influences, that these bring with them. Following half a century of psychological inquiry into the effects of modernizing influences on cultural experience, perception and consciousness – the psychological formation of 'the crowd', the influence of modern urban environments on perceptual modes, the nature of modern 'experience', 'consciousness', 'memory' and the possibility of 'communication', the impact of the recasting of spatial coordinates on 'perspective', the effect of the 'anomie' of modernity on social life[22] – questions of distraction take on a newly materialized character in post-war Britain. The linear pathways of heredity which had dominated the exchanges between psychology, anthropology and eugenics in British social inquiry were no longer considered eloquent enough to explain the distinctive modes of cultural experience – the effect of those dispersed influences – which shaped the development of character in modern Britain. It was a sense of the interaction of environmental influences with instinctual make-up in the psychopathological notion of distractibility that led to the proposition that emergent cultural forms should be seen as an environment of dissonance, and that those cultural attachments that adolescent working girls demonstrated should be seen as part of a symptomatology of possible disintegration.

But while psychological models were adapted towards the affective reformulations which underpinned new sociabilities, those explanations that circulated around 'character' as an enduring, integrated structure – albeit that they now assumed the interaction of constitutional and environmental factors – still proposed a pathway between its internal formation and those patterns of social behaviour which manifested in 'everyday life' as the basis of 'the future of civilization'. In this context, their dependence on psychopathology could only propose lines of continuity between developmental disturbances of character and those forms of social disintegration which manifest as a 'warring' of disparate elements, 'shattering' social cohesion. Seen from the perspective of abnormal psychology, in the gulf between past and future that characterizes adolescent development, distractible girls become figured in the disintegrative figure of the schizophrenic, whose 'lawless' and 'massive' splittings lead her to become 'shattered into a multiplicity of warring functions' (McDougall 1926/44: 395).

4 'A harlot hires a car'

Prostitution, dispersal and displacement in the Wolfenden Report

Women on the streets: vice and visibility

On the morning of 16 March 1951, the Bishop of London led a delegation to Britain's Home Secretary, Chuter Ede. The delegation aimed to impress upon the Home Secretary their view that 'London was the worst capital in the world for vice', and asked him to 'stamp out vice' in London's West End before the Festival of Britain began in May the same year. A spokesman for Paddington Moral Reform Council told Mr Ede: 'We want to put Britain's best goods in our window this festival year – not its worst. In no other capital city are so many women "on the streets".' The concern voiced by the Bishop of London's delegation was taken seriously. Framed in the language of spectacularized vice and moral enlightenment shared by the tabloid press and the Paddington Moral Reform Council, its complaint was received with vigour by the British Home Secretary, who announced that 'a special committee would be set up immediately to consider its requests' (Wallace 1951: 48).[1]

The Paddington Moral Reform Council framed their concern over prostitution in the language of 'vice' and visibility – its sign the figure of the 'common prostitute' on Britain's streets, and its solution increased legal penalties for soliciting. In bringing matters of the government, policing and prosecution of sexual offences to public attention – posed as problems of prostitution, vice and London's streets – the popular press adopted the language of visibility with particular alacrity: in fact, it was the tabloids' own claim that they would represent public interest by directing 'the moral searchlight of publicity' towards the sexual underworld of the metropolis (Mort 1999: 96; see also Waters 1999: 137–40). As they articulated 'a mounting chorus of Press and public feeling' in support of an inquiry, they drew on the traditional image of prostitution as a problem of 'vice', positioning it – as did the Paddington Moral Reform Council – within the remit of legal sanction, as a public harm, and arguing for increased penalty (Gosling and Warner 1960: 8).

Clearly, the staging of this protest about the policing of vice was opportunistically timed to build on an attention to urban presentation that had emerged during the preparations for the Festival of Britain as a showcase of national achievement and technological modernity. In fact, it established a

reciprocal benefit based on a relationship of mutual exclusion: removing the sight of vice from the streets so that those of the Festival could take up that space. But it also built on an association between urban presence and visibility, sexual behaviour and the state of 'civilization' in Britain which had surfaced in debates about the propriety of a public festival as a means for staging a vision of a modernized British future, during its inception (Conekin 2003: 15, 27–8; Frayn 1963: 329). The vice debate was similarly imbricated in the broader question of what kind of modern nation post-war Britain should be – and, importantly, how this would look. And its demand on public attention persisted beyond the 'moment' of the Festival, to whose success it appeared to align itself, in the same way that the planning of the Festival spilt over into a broader project of planning for national recovery and the reimagining of a modernized national identity. For although the announcement of an intention to call an inquiry may have seemed swift, as it turned out a committee was not established until 1954, its brief to investigate the problem of homosexual offences and prostitution, under the chairmanship of Sir John Wolfenden. The Wolfenden Committee spent the next three years examining evidence: its report was submitted in 1957, debated in parliament in 1958, and its recommendations relating to prostitution resulted in the Street Offences Act of 1959.[2] And during that period it acted as a catalyst to those 'associations with an interest in this problem' to bring their own views on the question of prostitution into public view, through the publication of a series of satellite reports for public readership.[3]

But the apparent easy legitimacy of the request to 'stamp out' vice, in Ede's assurance that he would set up an inquiry to deal with the matter, and the persuasiveness of its assumption that this could only be done by eradicating prostitutes from the streets, obscures a series of significant changes to urban sexual cultures. As social inquiry mapped the features of prostitution in new ways, the prostitute became refigured. In this period, she was less easily contained, moving beyond the regions historically associated with sexual commerce into the 'bright lights' of London's more fashionable districts. And simultaneously, she became less distinguishable from other forms of female presence, fashioned in accordance with a more subtle culture of emergent cosmopolitan consumption, riding the wave of a modernizing Britain. In a context in which it seemed increasingly difficult to identify the prostitute as a distinct type – as forms of female sexual presence were proliferating and diversifying and modernized practices of prostitution were emerging – inquiries into the problem of urban sexual commerce were made more complex by transformations in urban spatiality and new forms of urban presence. Simultaneously, an expansive literature deriving from dialogues between psychology, criminology and sexology during the 1940s delineated the contours of the 'prostitute personality', identifying a range of social and psychological factors to account for the prostitute's formation in terms of the ordinary fractures in family relations which influenced her early development, situating her on a continuum with those conflicts shared by a range of

'normal' individuals. Such reappraisals rendered the contraction of prostitution to the common prostitute untenable, exposing instead the proliferation of its forms and the expansion of its conditions of formation and thereby precipitating its dispersal into those landscapes of urban consumption and the ordinary problems of everyday living in a modernizing Britain.

But in this critical period, the popular press (in their seeking out of spectacularized vice), the Paddington Moral Reform Council (in its concern with the visibility of prostitutes on the streets) and the Wolfenden Committee (in its refusal to expand their remit beyond the common prostitute) shared a common failure of vision concerning the emergence of a modern notion of the prostitute as a diversified, modern and even normalized figure. Despite their apparent oversights, though, the refiguration of the prostitute became part of contemporary debate, discernible as a series of caveats, tensions and counterarguments. And as the problem of prostitution expanded to a question about the nature of modern urban life and its pathologies, the prostitute came to stand as a figure embodying those changes to the urban landscape in which commentators were so concerned to situate her, thereby becoming distinctively *spatialized*.

Spatial instability: flux and confusion

In the period between Ede's announcement of an impending inquiry and the establishment of the Committee under the new Home Secretary, David Maxwell-Fyffe, an escalation in the policing of male homosexuality and the publicity surrounding high profile homosexual scandals had created a much greater anxiety about the prominence of a hidden male homosexual 'freemasonry' than the more easily discernible problem of the visibility of prostitution.[4] Matt Houlbrook suggests that it was at this point that the 'respectable' press started to counter the sensationalist approach of the tabloid press with a demand for 'a reasoned discussion of "homosexuality"' (Houlbrook 2005: 254). The Wolfenden Committee's remit was to inquire into the law and practice relating to both forms of sexual offence, and it famously maintained the view that the law should be concerned with matters of public order and decency and not those of private morality. As it turned out, although concerns over prostitution may have stimulated an inquiry into the 'vice' of London in the earliest stages – with the addition of male homosexuality an apparently later thought[5] – the major part of the Committee's inquiry was directed towards gaining a greater understanding of sexual identity and behaviour in relation to the classification of the male homosexual. Circumscribed though it may have been by an attention to those aspects which were relevant to criminal prosecution, in this aspect of its remit – but this aspect only – the Committee made a transition from the *visibility* of vice to the *motivation* underlying behaviours understood as sexually problematic, and examining in detail the features of new homosexual cultures in urban Britain.[6]

The process of tracking the male homosexual brought into view a modern sociability which was played out in fashionable urban venues like the coffee bar as much as in the hidden spaces of the urinal stalls situated in London's parks and squares and the discrete and fleeting interiors of 'furnished rooms' (Mort 1999: 102; Houlbrook 2005: 114–18). The Committee's final recommendation was that legislation should distinguish between private acts and public offences in relation to male homosexuality, decriminalizing private acts to reflect a remit of public order and decency.[7] But, in making a distinction between homosexual practices in private and importuning in public, it also acknowledged the more delicate distinction between 'homosexual acts' and 'homosexuality', its attention to 'latent homosexuality' indicating something of the passage between propensity and enactment, the formation of a homosexual male self (HMSO 1957: 11–12). Frank Mort argues that as the Committee mapped the appearances, rituals and spaces of homosexuality, describing a repertoire of modernized 'flamboyance' that associated conspicuous consumption with sexual display, the male homosexual came to function as a 'signifier of cultural disturbance' (Mort 1999: 92–3, 99). Brought into view across the public and private spaces of London, new homosexual 'types' proliferated. But as Houlbrook points out, alongside this new visibility, the homosexual was bifurcated 'between the respectable and the disreputable, the "homosexual" [as] beneficiary of law reform, and the queer [as] continued subject of social opprobrium and regulatory intervention' (Houlbrook 2005: 254).

But the extensive mapping and classification of character and conduct across public and private spaces that occurred in the case of the male homosexual were not reproduced in that of the prostitute, and in its statement of its terms of inquiry into prostitution, the Report emphasizes that the prevalence of prostitution, the reasons why women adopt the life of a prostitute and questions of 'private immorality' were all beyond the scope of its deliberations (HMSO 1957: 79, 223, 224). Partly, this was due to the Committee's consideration of the existing legislative framework.[8] In the case of prostitution, legislation was already framed in relation to public order and decency, through the designation of 'street offences', rather than, as in the case of male homosexuality, particular acts, whether they occurred in public or private. In the streetwalker's embodiment of a problem of public visibility, the 'common prostitute' fell within the law to the extent that she breached public order and decency through the act of public solicitation 'on the streets'. The Committee's deliberations followed from this: 'our basic proposition [was] that what a man and a woman chose to do in private was no concern of ours or anybody else's, but that public solicitation on the then prevalent scale was' (Wolfenden 1976: 142). Soliciting was defined as a public act that intruded on a person's right to privacy in the street, a right of occupancy – or 'free and uninterrupted passage along the streets of the capital' (Wolfenden 1976: 130) – which could be infringed by sexual activities or sights. And in its association with 'standing forth', or

'sitting, as it were, on show' even in the absence of a specified offer, and the prevalence of 'tacit recognition' (Rolph 1961/55: 60–3), the act of soliciting comes to be tied to corporeal presence and visibility:[9]

> [the law] should confine itself to those activities which offend against public order or decency or expose the ordinary citizen to what is offensive or injurious; and the simple fact is that prostitutes do parade themselves ... habitually and openly ... and do by their continual presence affront the sense of decency of the ordinary citizen. In doing so they create a nuisance which, in our view, the law is entitled to recognise and deal with.
>
> (HMSO 1957: 87)

Seen within this framework, the prostitute appeared to present less of a challenge to the readjustments required to popular understandings of modern urban culture and its types, and so did not elicit the extensive mapping and classification of character and conduct that occurred in the case of the male homosexual.[10] One of the significant differences between the two parts of the inquiry was the presentation of personal testimony from the 'respectable homosexual' (Houlbrook 2005: 256) as a conscious attempt to diversify the Committee's typology. There was no such figure consulted in the investigation of prostitution – only an abortive attempt to elicit testimony from a group of 'girls from the streets' (Wolfenden 1976: 137)[11] – and John Wolfenden could afterwards claim that there had been a difficulty in obtaining a 'first-hand account of the life and attitude of the prostitute herself' (Wolfenden, cover citation, Anon 1959).

It seems, then, that the definition of the prostitute appeared to the Committee as self-evident. In fact, the inclusion of the term 'common prostitute' in the legislation was itself expected to safeguard other women from wrongful arrest (HMSO 1957: 88–9). The Committee insisted that the courts had formed an adequate working definition of the common prostitute: 'the term includes a woman who offers her body commonly for acts of lewdness for payment. (It is not necessary that there should be an act, or an offer of an act, of ordinary sexual connection)' (HMSO 1957: 82). In a circular definition, then, the offence defines the common prostitute, who is therefore marked by the nature of the offence *as the figure who is capable of committing it*. Her definition, resting on a putative offence, therefore relates to a matter of comportment concerning the female body and the visibility of this activity to the gaze of the disinterested observer – the *passer by* – in the public space of the street. The Committee's attention to the practice of soliciting therefore ensures that the definition of the common prostitute is created in the light not of her own formation or motivation, but the tacit recognition in the fleeting glance of the passer by.[12]

The figure of the prostitute therefore becomes fixed in a traditional, even archaic, form. The 'common prostitute' or 'night-walker' lent meaning to

those areas of London associated with her trade – their character created from her presence and their topographies formed from her streetwalking. And her identity was thereby reciprocally concretized – formed from the pavements, alleys and doorways of those grimy, crumbling and desolate areas left behind by urban redevelopment and the post-war emergence of 'bright lights' London and its cosmopolitan cultures of consumption and entertainment. As such, the figure of the common prostitute allowed the Committee to point towards a clearly demarcated range of social problems, with more obvious solutions. Gesturing back to those urban ills lingering on from London's past, she becomes a figure embodying the primitive impulses and the regressive underbelly of British culture, indicating the persistence of those elements which refused to be harnessed to the concerted project of engineering new patterns of everyday life and urban development in modern Britain.[13]

In the Committee's apparently narrow view, then, the prostitute remained associated with older models of urban and moral decay, corruption and degeneration, and those intractably regressive forms of human behaviour which lay beyond the scope of modernizing initiatives: in the absence of a defined reformist role, the only legislative solution was to remove her from public view.[14] In the Committee's dismissal of the 'etiology' of prostitution – the conditions of the prostitute's formation – as beyond its remit, the classification of the prostitute is correlated with the legislative definition of street offences: the changing nature of modern cultures of prostitution, and the diversification of its modes, remained relatively unexplored. And in this averting of the Committee's gaze, modern and hybrid forms of prostitution, calibrated to the features of modernized femininities and emergent cosmopolitan sexual cultures rather than defined against them, are overlooked, displaced from the urban landscape.

As a problem of 'sexual vice' becomes written into accounts of London's streets, the 'stain' of prostitute activity is imprinted into their spaces. In 1960, Douglas Warner, an 'author, journalist and traveller', teamed up with John Gosling – a former detective-superintendent of the Criminal Investigation Department at New Scotland Yard who had spent two years as head of the Vice Squad – to present the results of their 'Inquiry into the Vice of London'. They began their book with an 'Introduction to Vice':

> In the early years of the nineteen fifties the river of London's sexual vice, which had been flowing more or less underground for almost forty years, suddenly flooded into the open. Prostitutes, always a feature of certain West End streets, increased in number and spread to areas where prostitutes had never been seen before. The importuning of passers-by became more blatant. Men were accosted when walking with their wives. Respectable girls, waiting on the wrong corner for their friends, were chased off the 'beat', and sometimes assaulted, by indignant prostitutes. Acts of sexual intercourse took place frequently in Hyde Park in

broad daylight, to the scandal of foreign visitors, including Mr Billy Graham, the American evangelist. The wives and daughters of honest rate-payers found it impossible to walk home without being accosted by men in search of prostitutes or by prostitutes jealous of their 'territorial rights'. Three Members of Parliament moved from their West End homes, and outraged householders complained in the Press that they had to clear used contraceptives from their front gardens.

(Gosling and Warner 1960: 7)

As sexual vice ceases to remain a hidden undertow of London's circulatory system, an expansion in prostitution causes it to burst into visibility, spreading and proliferating beyond those areas in which it had been segregated from the exchanges of domestic, familial sexual cultures. As prostitutes jostle with others present on the streets, they create a crisis of classification as 'respectable girls', wives and daughters are mistaken for prostitutes, and men with their wives are addressed as clients. But it is not simply that different sexual 'types' are being confused – and that those whose public presence is defined in other terms become sexualized. Rather, moving beyond designated zones, the presence of prostitutes on the streets of everyday London brings the spectacle of commercial sexual exchange into view while also rendering the spatial demarcations informing sexual exchange *incoherent*. Billy Graham, on a visit to London for a series of evangelist meetings, famously commented that London's parks had been 'turned into bedrooms, with people lying all over the place' (Gosling and Warner 1960: 74). As Hyde Park – the venue for this particular tourist's response – was the first suggested venue for the Festival of Britain, his widely reported view must have been particularly saturated with meaning concerning the state of Britain. Such a confusion seemingly makes of London's social spaces – its streets, parks and gardens – a stage for the enactment of that which is more properly conducted in private, a recasting of space through a form of unmoored and resocialized sex, which, by becoming spectacularly public, reorchestrates London's spatiality to publicize intimate encounters. Deracinated, the prostitute's presence is radically dispersed across a 'promiscuous' intermixing of private and public life: spatially ubiquitous, she now exists, potentially, *everywhere*.

But this correlation of an expansion of prostitution with spatial influx and confusion also relies on the reduction of the figure of the prostitute to 'women on the streets'. As prostitution is cited as a pressing sign of London's 'anti-modern' existence, a sign that the banks of vice had burst, its residual silted matter – its stain – acts to blot out new types of presence and behaviour, new forms of urban inhabitation and circulation. In the focus on the interplay between street and body, inhabitation and presence, which is called up by the logic of visibility, such transformations are only legible as a flooding into vision, in the 'drift' from private to public, leaving spatial demarcations intact.

Clearly, the concerns being voiced are about the tensions created by modernized sexual cultures, tensions based on an affective dissonance in response to new forms of sexual visibility: public concern with the 'growing shamelessness' of prostitutes was counterposed to the 'intolerable degree of embarrassment' they created (Wolfenden 1976: 130). Mort's account of the changes to London's sexual cultures in this period indicates the tension between visibility and sexual permissiveness. As

> a new commercial style of sexual explicitness ... was predicated on its removal from public visibility ... The reputation of the West End in the 1960s as a 'swinging' centre of permissiveness marked one logical outcome of this version of privatised sexual culture.
>
> (Mort 1999: 107)

Mort sees the Wolfenden Report in the context of a confusion of spatial and social demarcations wrought by social change: 'The Wolfenden report itself confronted this changing moral landscape. Its philosophical boundaries between public morality and private tolerance were a sophisticated attempt to bridge an old and a new sexual code' (Mort 1999: 113). His assessment of the report is based on its identification of the male homosexual as a new, modern figure, with the Wolfenden Committee's distinction between public conduct and private sexual choices allowing space for the fashioning of a homosexual identity beyond the law. But his comment that the prostitute was a 'traditional' target points to the rigidity of the distinction between public and private in the context of prostitution. The traditional figure of the streetwalker was the very obstacle to its ability to address a new sexual code in the case of prostitution: as anchored in the archaism of her definition as in the tethering of her image to the landscapes of 'heavy' modernity, she becomes as spatially fixed as the paved surfaces of the street.

Gosling and Warner's survey was intended as a challenge to the narrow frame within which the Wolfenden Committee reported, and its restricted view of the prostitute. Expanding the classificatory range, they identify twelve different types of prostitute. Of these, there are five types of streetwalker – the 'lower class' – who are firmly locatable, identifiable and securely 'graded' according to the terms by which the common prostitute are defined. Each of these types are identified with – indeed, specified by – the areas in which they work:

> The elite of the five street-walkers was the Mayfair girl; immediately below her was the Soho and Piccadilly woman; the girls of Hyde Park, Bayswater, Victoria and Maida Vale came next; then the Euston–Kings Cross girls and finally, right at the bottom, the floosies of the East End ... Broadly speaking, it remained true that the further away from Mayfair, the cheaper the class of girl. Local variations within these geographical limits were unimportant.
>
> (Gosling and Warner 1960: 35–6)

Clearly their spatial moorings give the streetwalkers a differentiated identity as well as a location, situating them within a vertical hierarchy of status which intersects with a horizontal plane of extension derived from patterns of urban consolidation developed before World War Two. The West End, as the commercial centre, has eclipsed the financial and trade centre of the City – formerly the focus of prostitute activity – and so provides a central mooring point against which outlying areas are defined. Gosling and Warner's account highlights the relation of street prostitution to the slums which surrounded the 'noble buildings' and commercial and entertainment zones of London in the nineteenth century, as they chart the new urban arrangements which changed its location from the start of the twentieth century:

> By the thirties the transformation was almost complete. The City was dark; the Strand had sunk to a lowly position as a playground, and Piccadilly had established itself as the nodal point of the capital's world of entertainment. The luxury hotels and blocks of flats and office in Mayfair offered a potential clientele of wealthy men to prostitutes who solicited there. Hyde Park and the adjacent Bayswater area were filling with girls ready to cope with the overflow of the West End traffic. The Euston–Kings Cross–St Pancras area had become a lucrative hunting-ground for the cheaper girls who handled the demand which debouched from the long-distance trains from the Midlands, the North, and Scotland. Victoria and Paddington, to a lesser degree, catered for travellers from the west and south. Waterloo, however, was virtually free: partly because of its situation above road level, but mainly because it is used chiefly by suburban commutes, with the result that the network of cheap hotels and boarding-houses which surround Kings Cross, St Pancras, Euston, Victoria and Paddington are not found there.
>
> (Gosling and Warner 1960: 19–20)[15]

The forms of urban transformation within which new patterns of prostitution develop are not simply a way of marking the prostitute's dependence on the rhythms and patterns of the male client. What Gosling and Warner are mapping is a process of spatial extension in which a traditional, centripetal urban structure – with an identifiable centre, clear nodal points and radiating lines of entry and departure – still remains intact and coherent. The figure of the prostitute is thereby *adapted* to a pattern of urban sprawl.

If the pattern as it appeared in the 1950s was almost settled by the 1930s, two of the three final changes in prostitute activity which occurred in the post-war years – one innovation, one revival – were also based on a pattern of territorial dependency and responsiveness. Innovations in urban commuting led to 'street-girls' appearing in Maida Vale 'to trap the home-going Londoner as he drove north to the suburbs after the day's work' and Stepney's revival as 'Prostitute's Row' was attributed to 'an influx of womanless coloured men from the West Indies and West Africa' as part of the

bid to fuel industrial recovery through the expansion of the labour market by drawing on colonial populations. The passages in and out of this city space designate incremental change: additional populations, spaces and passages of transit.

Calibrated to those altered patterns of urban circulation and settlement brought by the development of railway travel, urban commuting and immigrant labour, these spaces reflected the shifting nature of the new populousness of metropolitan centres. These were based not only on new work cultures, and patterns of commuting, but also those relating to cultures of entertainment and consumption, markers of a shift in the profile of client demand. As the spread of cheap methods of transport 'brought London within range for many people for whom it had previously been an unattainable Mecca [and] the multiplicity of sporting and social events provided innumerable excuses for making the journey', Gosling and Warner could claim: '[w]e are all middle class now' (1960: 94).

These writers attempt to account for the shifting presence of the streetwalker and her client by using her as a marker of new industrial, commercial and labour patterns as they became imprinted on urban geography and inhabitation. But as the Wolfenden Committee had discovered in its tracking of male homosexual activity, the spatial extension of prostitution's presence occurs as much in the fleeting inhabitation of rented interiors, the cheap hotels and boarding houses characteristic of long-distance rail travellers, as in the streets which surrounded the weekday flats and offices of wealthy clients. These routes and venues created the contours of intimate patterns of corporeal contact and exchange as they became insinuated into the rhythms of city life. In a process of urban sprawl based on a pattern of temporary inhabitation rather than full-time residency, such patterns of circulation are formed from those patterns of removal, evasion and continual substitution which distinguish the choreography of the encounters of prostitute and client.[16] In the shift to Piccadilly as its 'nodal point', what this map of the geography of prostitution inadvertently reveals is a more fundamental transformation of urban spatiality, within which the premise of prostitution's *locatedness* itself starts to unravel.

As prostitution ceases to be concentrated in the City and the Strand, it spreads 'like a stain' north and south of the West End, from Lambeth and Southwark in the south, to Bloomsbury and Regent's Park in the north, and around the mainline stations favoured by new patterns of industry and commerce. It is situated in terms of the exterior access points for outlying residential areas and long-distance travellers, rather than radiating from Piccadilly's central 'nodal' point (Gosling and Warner 1960: 17). What Gosling and Warner are actually charting, in their account of the changes in prostitution in London from the early nineteenth century, is not an extension of the spaces of prostitution beyond a central core but, in the decentralization of London's spatial arrangement, a centrifugal recasting of the urban landscape. If the centripetal urban structure is

formed by a spatial constellation radiating from a central core, its outer areas defined by their distance from it as 'peripheries', the *disjunctive* shift to a centrifugal urban spatiality disturbs this reciprocality, decentralizing the animating dimensions of urban life to precisely those areas which existed at a remove, and eroding 'centrality' as the defining motif of locatedness. Understood in terms of *dis*location, the prostitute is recast in terms of centrifugal spatiality. Changes in patterns of prostitution, therefore, are taken as symptomatic of the respatializing of urban life, inaugurating a correspondingly new form of urban presence.

'A harlot hires a car':[17] distance and dispersal

In their survey of 'vice', Gosling and Warner map the streetwalker in terms of her visibility and spatial locatedness, adopting a model – shared with the Wolfenden Committee and the Paddington Group – which critically depends on the prostitute's identifiability. In fact, defining the problem of prostitution as one of visibility ties it to a spatial designation: the prostitute's visibility is the basis of a new populousness, a pressing urban presence. This alliance between visibility and spatial presence became the most prevalent feature of the framing of the problem of prostitution, but rather than stabilizing the debate, it inadvertently created the prostitute as a figure which pointed to the destabilizing of spatial coordinates. As the prostitute becomes dispersed across the contours of urban life in a modernizing Britain, her transits bring into vision a metropolis and its urban figures poised at a moment of transformation.

As the Committee removes questions of definition, motivation and formation from its deliberations, it adheres to a notion of 'vice' as an absolute: unchanging and beyond contingency. And it also erases the connection between the streetwalker and those other forms of prostitution which cannot be made legible through such spatial distinctions. This expansion of the problem of prostitution had featured strongly in the debate which ran alongside the Committee's inquiry, which those 'associations interested in this problem' posed in response to the Paddington Moral Reform Council's view. Gosling and Warner's identification of twelve distinct prostitute types was one attempt to develop a typology of that expansion: in their classificatory range, the five categories of streetwalker not only point to the existence of a range of alternatives, but are actively defined against their remaining categories – at the other extreme of this array are those types of woman whose living is gained in less explicitly sexual ways. In fact, grappling with the problem of addressing the hybrid types brought by modernized cultures of prostitution, they point to the continuities between the prostitute and 'allied groups', 'including ... the enthusiastic amateur, the gold-digger, the type of individual who marries for money ... and ... we might as well consider the significance of the dowry and the marriage settlement' (Glover 1943, cited in Gosling and Warner 1960: 29–30). Clearly these figures represent a disturbance to the traditional figure

of the prostitute mobilized by regulatory measures: since their area of agency is coincident with existing cultures of sexual courtship, they are removed from the remit of the legislative procedures put in place to solve the social problem of prostitution by targeting commercialized forms of sexual exchange 'on the streets'. This extended classification, therefore, and the introduction of hybrid types, destabilizes a unified view of 'the problem of prostitution' as a spatial category, and instead introduces a pattern of proliferation, formed from the intimate exchanges of modern sexual cultures and dispersed across the spaces of public and private encounter.

In this change of focus, then, Gosling and Warner demonstrate a break in the coordinates of presence informing prostitution, a shift away from the logic of visibility upon which those measures based on the eruption of private vice into public spaces are predicated. Their intention is to upbraid the Wolfenden Committee for its failure to properly address the changing culture of post-war prostitution, a failure borne from its adherence to that logic of visibility which presumes prostitution can be regulated on the basis of its self-evident public presence. And at the centre of this challenge – their claim that the Wolfenden Committee has misunderstood modern cultures of commercial sex – is its inability to confront a form of prostitution both based on, and embodying, these changing patterns. The mobility and fleeting character of post-war cultures of urban inhabitation, consumption and sexual definition bring about a new form of prostitution based on a modernized female sexual character, creating both a new urban type and by extension a distinctively new kind of urban experience, based on a transformed spatiality.

Gosling and Warner open their account of the changing cultures of London's 'vice' with an 'unremarkable incident' which took place in the office of a West End car hire firm:

> One evening [in the late 1950s] ... [a] young woman hired a car. She was well dressed and well spoken. There was nothing in her appearance to distinguish her from any of the growing number of women who since the Second World War had hired cars for a variety of reasons: for an evening at the theatre, a drive to the country-club, a party or a premiere. She produced her driving licence, paid the deposit, and drove away. The transaction was so commonplace that no-one could have guessed that the hirer was about to inaugurate a new type of prostitution ...
>
> The woman did not drive far. She cruised through the streets of Mayfair until she found a suitable parking spot, switched off the engine, propped an elbow on the window-ledge, and gazed speculatively at the passers-by. She made an attractive figure in the driving seat of the new saloon. No doubt many people ... glanced at her, probably in envy. If they did, she ignored them. She was waiting for someone else.
>
> Presently he appeared ... She was interested in only two details: he was a man and he was alone ... She spoke to him quietly through the

window ... Then the man walked round the car, opened the passenger's door, and climbed in ... The girl drove down the street into Piccadilly, turned right, and headed west and north to Maida Vale ... In fifteen minutes they had reached her flat. They alighted and went inside. About a quarter of an hour later they emerged, re-entered the car, and forty-five minutes after the girl had first spoken to him the man had resumed his interrupted stroll at the point where he had left off. London's first car-prostitute had set up in business.

Her success was swift and spectacular, and she proliferated. By 1959 the pioneer had been joined by at least fifty others ... all the girls conformed to a type. They were well dressed, well spoken and intelligent. *Not one could be reconciled with the prostitute of popular imagination.*
(Gosling and Warner 1960: 11–12, my emphasis)

The significance of this account for these writers is not only that it points to women's new mobility and access to technologies since the war, but also that the deployment of the car raises this type of prostitute above the common figure of the streetwalker, albeit that her interruption of her client's 'free passage' along the streets of the capital exactly corresponds to the definition of soliciting. They argue that, in contrast to the findings of the Wolfenden Report, the car-prostitute embodies the changing nature of prostitution: 'a prostitute independent enough to work without a pimp, and sufficiently well dressed and well spoken to hire a car without arousing suspicion ... both she and her client have multiplied and altered in the changing mould of society' (Gosling and Warner 1960: 14–15).

This depiction of forms of prostitution integrated within modern cultures of consumption, involving transactions conducted by 'attractive' young women with quiet manners who act with assurance and are in possession of driving licences, represents a departure from those figures which motivate the policing of the streets. Though spatially located, conventional forms of prostitution already encapsulated a population 'on the move' and the car indicated its association with a temporality marked by moments of spatial refuge: 'the Piccadilly whores who did not possess a room consummated the deal in taxi-cabs. So too, did some of the Hyde Park girls while others used their customers' cars' (Gosling and Warner 1960: 36).[18] The car, then, highlights the confusing of boundaries between public and private spaces and behaviours which is the condition of such fleeting encounters. In this context, the public nature of the taxi and its hire – and even more, perhaps, the client's car – presents not just a spatial confusion but a spatial frailty, a relation to space which is based in impermanence, and so always threatening to fragment, to atomize. But the car-prostitute's control over space derives from her independent rental of the car as a personalized means of transport, at one remove from the streets. Her purposeful use of it to identify and claim a client – who she removes from and redelivers to the trajectory of his walk – allows her to navigate between the very districts

through which the various prostitute types are identified: from Mayfair, through Piccadilly, past Hyde Park, bypassing Paddington to reach Maida Vale. She is drawn to and confined by none of these: her activity becomes resituated. The car stands as a material signifier of her self-determination as she directs her own movement through the metropolis. She evades the territorial anchoring, the spatialization associated with the logic of visibility, an elusive figure moving beyond the established zones of prostitute activity.

If a sense that prostitution had become increasingly 'blatant' in the 1950s had motivated measures designed to eradicate prostitutes from the streets, these difficulties of identification suggested they had in fact not only migrated beyond those areas inhabited by a range of discernible 'types', but mutated in ways which pointed to the limits of the processes of classification through which they could be discerned, presenting a form of categorial instability. In her spatial evasions, as in the way she melts into the landscape of the street as the crowd passes by her car – without the sudden and alarming jostling which characterizes accounts of women soliciting on the streets – the car-prostitute stands in contrast to the prostitute 'of popular imagination' and everyday visibility, whose disrupting of public tourist sights had occasioned Billy Graham's complaint. In fact, the modern prostitute's lack of identifying signs allows her to disappear into the urban landscape: indistinguishable amongst the newly styled femininities of post-war cities, she epitomizes a modern form of genteel feminine confidence and sophistication. The distinguishing features of the prostitute disappear. Visible as a constituent of the modern urban 'scene' – an evident presence – she becomes 'overlooked', a tear in the mapping of London's prostitute population.[19] Her identity and presence become illegible: in a paradigm based on the alignment between visibility and presence, she can only render prostitution *invisible*. And yet, the paradox is that the car-prostitute's presence invites observation. In fact, the challenge of the car-prostitute is not that she is not visible, but that in her illegibility she is not *transparent*.

Containment, removal, immateriality: the 'state of not belonging'

Gosling and Warner's challenge to the Wolfenden Committee, then, is that by reducing prostitution to those forms which involve street soliciting, as a visible urban presence, it overlooks those new modes of presence and circulation which define modern cultures of prostitution, and which link them to emergent forms of urban spatiality. The conventional model of late-modern (twentieth century) urban space is formed around impulses of concentration and dispersal – in the centralization of the amenities and forms of a compact metropolitan core and the emergence of specialized zones of production, leisure and dwelling at the periphery, with improved access and transportation infrastructures. But in this 'movement between' – a feature of the dependence on networks of suburban developments in

particular – a decentralized structure emerges, of the kind charted by Gosling and Warner's spreading 'stain' (Dimendberg 2004: 86–118).

Edward Dimendberg stresses that these developments do not manifest simply in formal, concrete ways – in the built environment, or in patterns of circulation – but in a 'range of attitudes, behaviours and shared interpretations' (2004: 99). If an attitude of 'dispersal' which emerges in the nineteenth-century development of suburbs has become prevalent by the inter-war period – a sense that metropolitan centres exist in an uneasy relation to the authenticity attached to the familial cultures of domestic, private life – new urban cultures of consumption nevertheless offer a new reason for reclaiming the metropolis. But these cultures are formed from a new concept of accelerated circulation and so create the basis of an altered system of movement and space, a pattern of circulation in which boundaries between interior space and the metropolis remain permeable (Dimendberg 2004: 168).

The spatial and rhythmic 'innovations' involved in patterns of modernization not only create a move away from the vertical model of metropolitan centrality, based on the scale of the human body, to a horizontal spatial arrangement – a process of 'sprawl' – but they eventually destabilize space itself, and inaugurate a dematerialized concept of urban presence (see Dimendberg 2004: 176–7). The use of plane travel, cars and telephones allows these prostitute types to occupy the decentred, centrifugal space of a modern urban culture defined by 'distance, speed, pleasure and technologically mediated solitude' (Dimendberg 2004: 205):

> If centripetal space is characterised by a fascination with urban density and the visible – the skyline, monuments, recognizable public spaces, and inner-city neighbourhoods – its centrifugal variant can be located in a shift towards immateriality, invisibility and speed. Separation replaces concentration, distance supplants proximity, and the highway and the automobile supercede the street and the pedestrian.
>
> (Dimendberg 2004: 177–8)

With the emergence of centrifugal space, Dimendberg argues, we see a decline in the role of the street in favour of a metropolitan spatial order oriented by low density and 'scattered communicational intensity', with technologies of independent personal movement that reconfigure urban passage as a temporal, rather than spatial, process (Dimendberg 2004: 178). Persons and objects are seen 'in quick succession, in permanent motion', from a distance: if this is the perceptual modality of the automobile – a city seen from the window of a moving car – the car driver stands as an emblem of this reorganization, a 'mobile perceptual centre' experiencing the world in terms of time, speed and distance (Dimendberg 2004: 166–71).

No longer spatially located, tied to walking the street, the car-prostitute is constantly in motion, enacting a repeated reverse commute: in forty-five

minutes she has driven to the outer suburb of Maida Vale and returned to Mayfair to identify her next client.[20] She interrupts her client's pedestrian passage, moves him from the centre to the periphery and back again to continue his walk. Her work is conducted at a distance from the space of her urban presence, in time removed from urban rhythms, the time of interruption. In her invisibility – the result of an accelerated, decentred, disconnected form of urban circulation outside coordinates of space and time – she evades a disciplinary logic. In her embodiment of a presence outside the coordinates of space and time, she encapsulates the promise of immateriality.

The characteristics of those shifts that were being tracked in studies of prostitution in the 1950s link the prostitute to a fundamental transformation of urban spatiality: its relation to mobility, speed, dispersal, and a consequent move towards 'immateriality'. Dimendberg suggests that these transformations manifest at the level of changing attitudes and experiences, in a 'growing cultural desire for the experiences of velocity and mobility' (Dimendberg 2004: 181). If this can be seen as a subjective adaptation predicated on altered environments, it is one that exists in conflict with the image of prostitution presented by the Wolfenden Committee. The environment of Wolfenden's 'common prostitute' harks back to a more traditional metropolitan form: one of urban concentration, a city of defined zones and visible landmarks, those forms of temporality and spatial anchoring which are embodied in those frameworks of materialized presence. In this model the *reality* of prostitution becomes the location of bodies in space, women on the streets. And Wolfenden's regulatory logic itself harks back to the 'environments of enclosure', a population which by its concentration, its known patterns of distribution, its predictability, may be mapped, known, ordered (Dimendberg 2004: 83).[21] Within this model, those forms of immateriality created by new urban cultures – the will to dispersal – eludes those forms by which presence may be apprehended.

The car-prostitute represents a state of perpetual movement and removal, a form of individual propulsion which binds velocity and distance together with the kind of capricious desire associated with post-war commercial acceleration. As Andrew Thacker notes, the *flâneur* – as the embodiment of a distinctively modern disposition in nineteenth-century metropolitan culture – may have been 'done in' by urban traffic, but this shift to unpredictable passages at an increased pace – with the concomitant risks of collision – and, with the car, to a space of *privacy* in the heart of urban commotion – offered new perceptual possibilities (Thacker 2003: 85–6). If the railway had become associated with the mass, by the early twentieth century – democratically heaving a swarming population of all sections of society in and out of cities along defined routes of passage – the 'technical modernisation' represented by the tube does not so much offer an extension of railway travel – propelling the individual through space, erasing the space of the foreground in favour of the horizon to dislocate the individual from secure coordinates, inaugurating a distanced, disconnected

gaze – but a removal and a containment (Thacker 2003: 86). Designed to allow a daily commute *in* between the outlying areas and city centre, the tube lines effectively flung working-class populations *outward*, from inner-city slums to live in new suburbs. Removing the traveller from the 'bustle' of jammed modern streets, the underground dragged them along a network of burrowing tunnels in 'padded cells', removing them to a world without light or exterior view (Thacker 2003: 86–90). Thacker stresses the disturbance to vision that the lack of exterior view and proximity of anonymous passengers in early tube trains created: 'Advertising worked in the tube because of the arrangement of visual space: at least now one could gaze at images without incurring the potential social embarrassment of exchanged glances with other passengers' (Thacker 2003: 91). They reorganized city space in ways that eroded the centrality of corporeal experience and presence, rendering the perceptual and phenomenological modalities of the-body-in-the-street redundant. The logic of speed is here, then, directed to the organization of urban – mass – populations, and rather than reshaping individual experience, it crowds it out: the perceiving subject melts away as the centre of cognitive apprehension.

In contrast, the car restores to the city the 'will to be the individual' – to remove oneself from the mass – in a new age of technology (Thacker 2003: 86). It offers a distinctive way of situating the self within the experience of modern urban life: from the containment of the street or the underground to the improvisatory passages and expansive scope of individualized technologies of propulsion, from the regulated mobility of the public railway timetable to instantaneous time of personalized temporalities (Urry 2004: 29).[22] While it allows the retention of the individual as a perceiving centre, it revises this to propose a form of presence *that was no longer tied to corporeality*. Untying the coordinates of spatial and temporal inhibition, the car becomes the basis of unpredictable urban encounter, privileging the contingent as the basis of social exchange.

The car-prostitute inhabits the street through a decentred, immaterial – almost spurious – visuality, eluding spatio-temporal structures and bringing a kind of dissonance to the relation between individual and environment. This remaking of individual presence, formed from contingency rather than the coordinates of classificatory certainty embodied in the alliance of visibility with spatial locatedness, and the unchanging absolute of 'vice', confounds the very premise of legal regulation. For the Wolfenden Committee this disturbance manifests as a failure of vision, defining the problem within the contours of an existing model of regulation, contracting offence to corporeal presence, public space to the territorial contours of the street, and failing to find its bearings in the expansive landscape and the dematerialized presence of modern commercial sociality.

Formed from the proximity between modernized sexual cultures and new cultures of prostitution, the figure of the car-prostitute becomes an expression of the transformations of hierarchies of social difference and the

inauguration of those expanded, spatialized individual modalities which accompany new technologies of mobility and communication. If the disfigurement of the prostitute was constituted in a taxonomy of poverty, the features of which were assembled into a narrative of increasing degradation, it was through a taxonomy of modernized, fashionable and youthful gentility – of looks and demeanour – that the car-prostitute became linked to those other 'border' categories, the '"hidden" prostitutes' who do not solicit openly on the streets: those who solicit in cafés at weekends,

> and the regular amateurs of all kinds – the typist who entertains friends to earn pin-money for clothes, holidays and minor luxuries, the girl who accepts men indiscriminately in a foolish belief that only in this way can she catch a husband, the girl who rewards with sexual intercourse the men who take her to the dinner and theatre.
>
> (Gosling and Warner 1960: 27)

No longer can the prostitute and the 'respectable woman' be differentiated through a relation of mutual exclusiveness. The typology Gosling and Warner develop is only completed by the inclusion of their most elite categories, whose activities are associated with modern cultures of sociability and entertainment, and who demonstrate a critical shift in cultures not only of class, but of the coordinates of modernity itself as they are expressed in urban spatiality. These modern equivalents of the courtesan include film starlets or models who 'follow fashion and the fashionable, earning their living by spending week-ends at foreign luxury resorts or in London during "the Season"' (Gosling and Warner 1960: 34).

> Prostitutes congregate where money gathers; or more precisely, they lie in ambush, like brigands on a mountain pass, along the defiles through which money passes. They seek a particular sort of money. The coldness of the counting-house and the bleakness of the bank vaults are not for them. They are the children of pleasure and follow fashion and the playground of the fashionable.
>
> (Gosling and Warner 1960: 15–16)

Fusing the space of the outlaw with that of fashion and the fashionable, spatial exclusion with temporal impermanence, such bandit figures populate a space between new commercial cultures and those of prostitution in a wild zone beyond the centripetal landmarks of metropolitan concentration. No longer distinguishable from, nor counterposed to, those other modern figures with whom they mingle, such types evade the forms of public solicitation which would define them as a 'streetwalker'. Removed still further from the melee of street traffic, they are positioned at the extreme of a continuum of that distinctive spatial expansiveness and extended mobility whose axis point is that of the car-prostitute. Yet in their dependency on the

commercial transaction, they do not so much move not to another *place* as occupy a state which is marked by the temporality of impermanence and the spatial coordinates of exclusion: 'the state of not belonging'.

In this sense, then, the Wolfenden Committee overlooked those modernized types of prostitute who, in their transparency – their evasion and removal from the coordinates by which the regulatory gaze might apprehend them – no longer afflicted the streets with those tourist 'sights' that drew discredit to the capital. The Wolfenden Report's eventual recommendations on prostitution, embodied in the 1959 Street Offences Act, increased penalties for loitering, soliciting and importuning, with the aim of removing prostitution from public view. The Report specifically notes that public concern circulated on 'the presence, and the visible and obvious presence, of prostitutes in considerable numbers in the public streets of some parts of London and a few provincial towns' (HMSO 1957: 81). In this context, it was effective in its aim to remove the sight of prostitution from the streets. Its introduction was welcomed as a means of '"cleaning the streets" of the more obvious manifestations of [the] trade in vice' (Hall Williams 1960: 173).[23]

This coincidence of the Committee's recommendations with the measures called for in the Paddington Moral Reform Council's memorandum may seem to indicate a measure of public consensus concerning legislative solutions to the problem of prostitution, as it became figured in terms of what the law could see. But the impetus towards legislative measures targeting the public visibility of the prostitute may have been more influenced by the Home Office pressing for early recommendations to this end (Mort 1999: 98) than an indication of their non-controversiality. And, while the introduction of a maximum penalty of three months' imprisonment may have literally removed the prostitute from the street, increased penalties were also intended to act as 'straightforward deterrence'. Wolfenden also claimed that a term of imprisonment was intended to promote the acceptance of a probation order, which, when posed as an alternative to a 'nugatory fine', was rarely adopted. Clearly, then, the 'motivations' of the prostitute did fall, albeit in a haphazard and uninformed way, within the Committee's view. In fact, it proffers an opinion on the importance of personality in the prostitute choosing 'a style of living which is to [her] easier, freer and more profitable than would be provided by any other occupation' (HMSO 1957: 223). The 'woman witness' they quote in support of the view that the personality of the prostitute was the origin of this choice was Rosalind Wilkinson, whose survey of 'the common prostitute', conducted for the British Social Biology Council for their submission to the Committee, was published as *Women of the Streets* in 1955, and reissued in a popular edition in 1961 (Rolph 1961/55). But Wilkinson's account of the personality of the streetwalker emphasizes difficult beginnings, personal isolation and vulnerability rather than the opportunism and purposeful choice that the Committee's constellation of the attractions of an easy, free and profitable 'style of living' would suppose.

In fact, Wilkinson's summary chapter on the entry of women into a life of prostitution stresses a predisposing lack of connectivity that she refers to as a 'state of not belonging': '[a] state of social irrelation in a woman [which] would be sufficient to account for her accepting the suggestion of the situation and becoming a prostitute' (Rolph 1961/55: 113). Wolfenden's argument is that the law can only regulate public harm by attending to the question of presence and visibility. Yet Wilkinson's depiction of the life of the 'common prostitute' – which was designed to enlighten the Committee to the very type identified as the object of its inquiry – brings her to suggest that legal penalty is misconceived because of its lack of attunement to the aetiology of the prostitute. For this type of woman, already outside 'ordinary society' as a result of her maladjustment, on the edges of the alternative social world of prostitution, becoming a prostitute offered a form of connectivity and inclusion: 'she becomes a member of that society of which she had been on the fringe in her state of instability' (Rolph 1961/55: 113–14).

From Wilkinson's perspective, then, Wolfenden strategy replays the condition of her formation: 'irrelation'. In a mirroring of the direct penalty of removal by imprisonment, driving her from the streets where she had found emotional solace returns her to that state of intermediacy and irresolution – the state of not belonging – which she had appeased through her entry into the community of prostitutes. In their refusal of a narrative of psychological formation, the Wolfenden Committee could only figure her as always and forever – and only – a prostitute. Proposing only measures for her removal, in the Street Offences Act, the Committee consigns her to that same position of intermediacy – Wilkinson's 'state of social irrelation' – that, in those narratives of formation, constituted the basis of her recruitment. Considered in the context of those accounts of the aetiology of prostitution which surrounded its deliberations, then, the Wolfenden Committee's recommendation of those measures which resulted in the Street Offences Act extended the cycle of repetition, recreating the conditions for drift and dissociation through which it fixed her in an ongoing relation to prostitution.

In fact, it was precisely the impact of legislative measures on this condition of emotional estrangement that prominent sexologist Norman Haire had introduced, a few years earlier: 'Declare any occupation anti-social and worthy of condemnation, and the people engaged in it feel that they are pariahs and outcasts, and they lose their self-respect and really become a menace to Society' (Haire 1948: 228). The Committee's only solution to the conundrum that penalty may reinforce the problem of prostitution lay in expressing the need for work on 'mental health, moral welfare, family welfare, child and marriage guidance'. In doing so, the Report did not just signal the limits of its legal regulation, but *incorporated an alternative logic for intervention*, one which ran at odds with those measures oriented towards the eradication of visibility, and which introduced an incommensurate narrativity to the object of their inquiry.

As the language of prostitution shifted from that of vice and visibility to that of causality – prostitution as motivation and enactment – addressing it through the legal view became inherently problematic. Despite its best efforts, then, by the act of establishing the boundaries of its terms of inquiry, the Committee pointed towards those very questions – those of motivation and formation – that lay beyond it, thereby undermining its own framework for penalty. By its parenthetical reference to the conditions and motives underlying continued recruitment, and the associated need for preventive and rehabilitative measures which it could not itself devise, it indicated the limitations of the framework of visibility it had adopted, recounting its own complicity in the continued existence of prostitution. As its recommended measures target only the streetwalker, it enforces the fracture between 'society' and its outcasts, replicating the centrifugality of modern spatial cultures, consigning the prostitute to the fringes of urban life in a state of irrelation.

The prostitute and the pimp:
'the exploitation of human weakness'

In its reduction of prostitution to the streetwalker, the Wolfenden Committee turns away from those forms of prostitution emerging in the context of the conditions of spatial dispersal which begin to reshape urban life and emerge in new urban subjectivities. This lack of attentiveness is about a 'blindness' to those sexual cultures that develop in the context of the contingent revisions to urban life which can only be understood in terms of the improvisations to sexual subjectivities: precisely those aspects which psychopathology claims to render visible. Mapping prostitutes' inhabitation of the public spaces of the metropolis is no longer sufficient to account for 'prostitution' as part of the sexual culture of modern Britain. Increasingly, it becomes seen as a problem of psychopathology, requiring knowledges which track those states of *dispersal* which form part of the conditions of urban living.

In their attachment to a logic of visibility – countering the prevalence of women soliciting on the streets – the Committee may appear to be blind to the effects of new sexual cultures. But, in fact, the Report does more than point to its own blind spots: it incorporates discussion of those very aspects from which it seeks to distance itself – including a reference to that figure which Gosling and Warner counterpose to challenge its antiquated attachment to more traditional forms of prostitution: the car-prostitute. The Committee's attachment to 'women on the streets' may prevent it from properly addressing the 'independent' – the prostitute who works on her own behalf, without a pimp, whose dispersed mobilities are embodied in the figure of the car-prostitute – but it includes a mention, buried in its final chapters on 'those who live on the earnings of prostitution', of that same process which had featured as the indicator of

a new and modernized form of prostitution in *Shame of a City*, the hire of a car.

Discussing the degree to which the prostitute could be seen as a victim of coercion and exploitation, the Report makes an incidental observation: 'We have, for example, learned of an arrangement between several prostitutes and a car-hire firm whereby the firm made large sums of money out of the use of their cars by the prostitutes' (Gosling and Warner 1960: 100, 305). But the Committee refutes this conception of the exploited prostitute, along with 'the popular impression of vast organisations in which women are virtually enslaved'. 'The firm,' the Report continues,

> was said to 'run' a group of prostitutes, with the implication that they organised the women's activities ... however much unpleasant exploitation there might appear to the outsider to be, and might indeed actually be, the association between the prostitute and the 'exploiter' *was entirely voluntary and operated to mutual advantage.*
>
> (HMSO 1957: 100, my emphasis)

If prostitution could only be seen to fall within the ambit of criminal law insofar as it caused 'injury' to the public in general, it is this same rationale which the Wolfenden Committee uses to move from 'street offences' *per se*, to deliberate on the offences relating to living on the earnings of prostitution, premises used for the purposes of prostitution, and procuration (HMSO 1957: 227–8). This section of the report, addressing 'those who live on the earnings of prostitution', concerns those commercial exchanges which create the economic basis for transactions between public offence and private relations, highlighted in measures which aim to prevent others from profiting from prostitution. The measures relating to this aspect of prostitution primarily relate to the space of the brothel, and the figures of the 'middle man' – the pimp or ponce, the brothel-keeper and the landlord. In this context, the prostitute is recast, no longer as agent of harm, but as, potentially, an object of 'exploitation'. But if the offence of living wholly or in part on the earnings of prostitution relates as much to the *madame* of the brothel as it does to the pimp, it is nevertheless the pimp, as a designated living partner chosen by the prostitute, which the Wolfenden Committee targets in its discussion. The Committee's emphasis on the pimp, and its strengthening of the regulation of pimping, is a striking aspect of its treatment of prostitution, and became a noted element of its legislative innovation and its contribution to reshaping contemporary cultures of prostitution. Yet, surprisingly, as the Committee sustains a more punitive approach to the pimp, it also maintains the argument regarding mutual advantage and lack of exploitation, claiming that the evidence presented to it shows 'nothing in the nature of "organised vice" in which the prostitute is an unwilling victim, coerced by a vile exploiter' (HMSO 1957: 304):

the arrangement between the woman and the man she lives with is usually brought about at the instance of the woman and *it seems to stem from a need on the part of the prostitute for some element of stability in the background of her life* ... in the main the association between prostitute and 'ponce' is voluntary and operates to mutual advantage.

(HMSO 1957: 99–100, my emphasis)

Addressing figures whose definition is bound up with business and property relations – and placing pimps alongside car hire firms – the Committee nevertheless brings the pimp into view in a way which is related more to the prostitute's intimate economy than to her public manifestations (HMSO 1957: 97–109).

But this does not explain why it should prioritize the pimp, rather than the landlord or the brothel-keeper, in the recommendations concerning 'those who live off the earnings of prostitution'.[24] The Committee's qualifying clauses indicate that the difference resides in the companionate nature of the pimp relation. For while it may be an offence for both 'for purposes of gain to exercise control, direction or influence over a prostitute's movements in a way which shows [he or she] is aiding, abetting or compelling her prostitution', in the case of the pimp the Committee, in the framing of this clause, further singles out 'a man who lives with or is habitually in the company of a prostitute' (HMSO 1957: 98). The ascertainment of this offence consists, amongst other measures concerning finance and proximity to her prostitution, in determining 'whether the man and woman are living together' and 'whether the man is doing any work' (HMSO 1957: 99).

If the harm exercised by the pimp is not one of exploitation of the prostitute, it would seem that the injury to the general public could only be sustained by the invocation of a developmental model towards recruitment – bringing the Committee to dabble in the private life of the prostitute in a way which it rejects as part of its remit. In this respect, the power exerted by the pimp destroys the distinction between public behaviour and private aetiology. But if the pimp is not exploiting the prostitute – and in fact is recruited at her initiation – it is the 'personality' of the prostitute which brings the pimp into being. The attention to the pimp in the Wolfenden Report means its case for the relevance of the economics of prostitution to street offences is displaced on to the prostitute's psychopathological dependency – formed through a masochistic attachment to his sadistic control borne from her damaged formation. This creates an invisible presence. What the pimp brings into juridical view is precisely what the Committee had ruled out of court: the 'motives' of the prostitute, and the psychological dynamics of her formation. The premise of the Committee's attention to the pimp is, ironically, the explanatory power of accounts of the psychopathology of prostitution: the very question that it sought to expel from its remit.

It may seem strange that the car-prostitute appears in the Report in the context of the Committee's refutation of exploitation, and its stress on the voluntary nature of the prostitute's associations, and the mutual advantage and reciprocal benefit of those commercial contracts through which others come into view. Literally 'on the street', yet posing a different mode of urban inhabitation and spatiality, her departure from those models of visibility and locatedness upon which the Committee depend clearly demonstrates the limits of its effective engagement with modernized cultures of prostitution. Yet the Report does not make this evident; rather, it turns inward, proceeding to an account of the pathological dependency of the prostitute on the pimp based in an opposition to those forms of modernized 'independent' which the car-prostitute embodies. The narrative of the pimp becomes a solution for the evasive forms of modern prostitution, which becomes presented not in terms of new urban modes, but pathological instability.

In fact, the surfacing of an account of prostitution in terms of pathological dependency provides the basis of one of the most perplexing statements of the Report, one that encapsulates something of the terrain of intractability which confronts a Committee bent on providing legislation for the intimate reaches of human behaviour:

> It is in our view an over-simplification to think that those who live on the earnings of prostitution are exploiting the prostitute as such. What they are really exploiting is the whole complex of the relationship between prostitute and customer; they are, in effect, exploiting *the human weakness which causes the customer to seek the prostitute and the prostitute to meet the demand.*
>
> (HMSO 1957: 100, my emphasis)

As a problem of visibility – women on London's streets – disappears into the indefinable landscape of 'human weakness', so too one of policing – 'commercialised vice' – becomes located in terms of psychopathology, individual causality and the relationship of human unhappiness to social behaviour. As the Committee loosens its grasp on the model of visibility and spatial locatedness which has motivated its focus on the streetwalker, the figure of the prostitute gives way to an account of exploitation which brings into view a different relationship: that of the pimp and the client, locked in a relationship of 'human weakness'. In this context, the prostitute is recast: no longer as agent of harm, but as a figure upon which this displaced relation is written; she becomes a figure of displacement.

'Flung back into the clutches of parasites': the Street Offences Act 1959

The car-prostitute, according to Gosling and Warner, had only a temporary existence. Inaugurated after the Wolfenden Committee was established, and

removed by the Street Offences Act in the year following the publication of the Report, this figure – a modernized version of the 'independent' who works without a pimp – provided a momentary glimpse of a new form of prostitution, calibrated to the features of modernized femininities rather than distinguished against them. As she gestured towards new forms of urban inhabitation, she embodied the promise of the transitory, the contingent, the cosmopolitan pleasures of youthful spatialities and the extensive landscapes of modernity in a post-war Britain in which new technologies intersected with new forms of self-styling: the possibility of becoming a 'being apart' (Merriman 2004: 154–9).[25]

In its reduction of prostitution to the streetwalker, the Committee turns away from those forms of prostitution which develop in the context of the conditions of spatial dispersal which begin to reshape urban life, and emerge in new urban subjectivities, its lack of attentiveness to the independent comprising a 'blindness' to those sexual cultures that develop in the context of the contingent revisions to urban life. But it is, despite itself, concerned with the effects of new sexual cultures. For though its attachment to a logic of visibility may have prevented the Committee from addressing the 'independent', whose dispersed mobilities are embodied in the figure of the car-prostitute, as it countered such contemporary innovations to cultures of prostitution it contributes to its restructuring on the basis of an emerging centrifugal spatiality.

In attending to the geography of streetwalking, the Wolfenden Report reversed the move away from the brothel to the streets that the Criminal Law Amendment Act of 1885 had inaugurated. As post-war cultures of prostitution took place away from the public space of the street, legal measures were designed to eradicate those public manifestations which persisted, and the Committee's recommendations were criticized for 'thrust[ing] prostitution out of sight' and 'sweeping the dirt under the carpet' (Gosling and Warner 1960: 9; Chesser 1958a: 65; Glover 1943/69: 2).[26] But although the Act was, in the faint praise offered by those concerned about its side effects, 'as successful as a vacuum cleaner', concern was expressed that its increased penalty for soliciting had driven prostitution 'underground' (Gosling and Warner 1960: 202), increasing the need for an intermediary and thus returning the independent to dependency on the pimp. Ironically, the effect of the Committee's failure to acknowledge these forms was that the independent prostitute was 'flung back into the clutches of the parasites from whom she was struggling to get free' (Gosling and Warner 1960: 200).

The effects of the Committee's recommended legislation, then, affected streetwalker and car-prostitute equally, as they were dispersed to the closeted spatiality of 'individual premises' (HMSO 1957: 104). As the Committee predicted, the prostitute was forced to depend on those forms of advertising which removed the need for self-presence, or 'standing forth': posting notices in newsagent notice boards and telephone boxes. Atomized,

contained, no longer determining her own transits and circulation, she is rendered static, waiting by the telephone. The incremental extension of prostitution's spatiality across the space of the metropolis was halted, disaggregated from the process of urban renewal and metropolitan expansion. Instead, prostitution becomes marked by spatial fracture, as the prostitute is returned to the leftover spaces of London's archaic network of cheap rental accommodation, a hidden world of seedy bedsits up narrow stairways. As the prominent sexologist and commentator on matters sexual, Eustace Chesser, remarked, the danger was that the call girl network, which was expected to grow following the introduction of the Street Offences Act, would become, 'in effect, a dispersed brothel' (Chesser 1958a: 102).

Alongside the inquiry, the reporting and the debate of the Wolfenden Committee, the pattern of privatizing the material practices of prostitution was accompanied by an increasingly privatized location of its causes, as explanations focused on psychological origins: mapping prostitutes' inhabitation of the public spaces of the metropolis was no longer considered sufficient to account for 'prostitution' as part of the sexual culture of modern Britain. If the problem of the figure of the car-prostitute was a lack of transparency – her lack of fit with the contours of legibility offered by a logic of visibility, her lack of coincidence with the 'tacit recognition' the streetwalker afforded – then it was clear that new forms of knowledge were required to track the innovations to cultures of prostitution. The displacements underlying prostitution's spatial and domestic contours became mapped onto her psyche, as a condition of 'social irrelation' became refigured in terms of characterological fracture. Outside the remit of legal sanction, prostitution became seen as a problem that only psychopathology could unravel, tracking its dispersed formation across the commercial encounters of London life and the intimate processes of the formation of 'personality'. But just as Wolfenden's structure of penalty acted to reinforce the cycle of recruitment, so too it was understood to fix the prostitute, not only in a dispersed spatiality and a relation of dependency on the pimp, but in her pathological formation. However much the car-prostitute's centrifugal mobility allowed her the freedom to remodel herself in the light of modern cosmopolitan femininities, the changes wrought by the Street Offences Act – her relegation to the controlled spaces of a world apart – were understood to initiate a reversion to type that manifested in a visual imprint of moral degradation. Reflecting those typologies of poverty which characterize the streetwalker, the stigmata of prostitution confirms an underlying archaism. In a reversed aetiology, in the aftermath of the Street Offences Act, the prostitute becomes figured according to the features of her 'world apart':

> no matter what differences we may find in the lives and fortunes of individual prostitutes there is one denominator common to them all after they have been in steady prostitution for a number of years. They

show the symptoms of that disease, unknown to medical textbooks, called degradation. The constant, casual contact with man at his most animal, on a cash basis, in a sordid association devoid of any scrap of affection, decency or respect, etches itself into their souls. Outlawed by polite society, fleeced by parasites, forced to consort with thieves and gamblers, the victim of violence and the inflictors of violence on others who try to usurp their territory, they slowly degenerate. Their faces age before their time, their skin coarsens, their speech turns foul until at last it is true to say that they are almost completely dewomanised in every gentle aspect of that word. This, like the mark of Cain on the brow of the murderer, is the stigmata of prostitution which none can escape.

(Gosling and Warner 1960: 85)

The spatial and psychopathological dislocation through which the prostitute becomes remade – as both modern and archaic, cosmopolitan and primitive – is, finally, turned back onto itself. As the initiatives resulting from the Wolfenden Committee's recommendations return her to the confinement of those intimate encounters which follow from her own pathological formation, she becomes definitively, publicly, marked by the stain of an ineradicable degradation.

5 Homosexuality, seduction and psychosis

'Flying and drowning' with 'Lawrence of Arabia'

> In the desert ... identity, like direction, was dispersed; the subject himself immersed in a greater medium, hidden, invisible. Yet this delicious sensation of being curled up in the pocket of the night could not be separated from terror of the immensity. In this world of streaming winds, to travel was never to walk or ride: it was to fly or drown.
>
> (Carter 1987: 290)

> The daydream transports the dreamer outside the immediate world ... it flees the object nearby and right away, it is far off, in the space of elsewhere.
>
> (Bachelard 1964: 183)

From T. E. Lawrence to 'Lawrence of Arabia': shifting sexual frameworks

In 1919, the popular journalist Lowell Thomas mounted a series of slideshow presentations of the exploits of T. E. Lawrence in Britain's World War One 'Desert Campaign'. These generated immediate public acclaim for Lawrence, and were followed by the celebratory accounts of Robert Graves (1927) and Sir Basil Liddell Hart (1934). Lawrence's autobiographical account of his role in the Arab Revolt, *Seven Pillars of Wisdom: A Triumph*, was made available in a popular abridged edition, *Revolt in the Desert* (1927). From that first moment, 'Lawrence of Arabia', as an assembly of cultural narratives, exceeded its historical origins. But more particularly, since then, the figure of Lawrence has taken on a particularly introspective quality, eliciting an inquiry into his sexual orientation as a dimension which is understood to be not so much in tension with his historical persona – an interruption of his public involvements – as foundational to it, a central motivation for his passionate commitment to the Arab cause and his personal investment in acts of daring and danger in a remote and harsh – unsecured – environment.

Graham Dawson situates the 1920s 'heroic biographies' of Lawrence within a generic account of colonial adventure epics, suggesting they offer an 'idealised, omnipotent masculinity' which produces a legendary 'new kind of ideal unity and coherence' (Dawson 1991: 125–36). He suggests that narratives of Lawrence assert heroes of the British Empire just as its power contracts and that such stories shore up and bolster a myth of British greatness with an image of 'idealised masculinity' which is contrasted with 'other and subordinated, "non-white" masculinities' (Dawson 1991: 119). Accounts such as these assume a causal interpretation, in which representations have a discernible function: the coalescence of images into stable forms which reassure or reassert, offering 'wish-fulfilling fantasies' as a kind of ideological therapy for insecure subjects whose preoccupation is the coherence of identity and absolute power (Dawson 1991: 119). Dawson argues that, even in its 'fascination with and fear of the colonised "other"', imperialist military adventure offers an example of the 'exercise of imperial authority', in an encounter with 'peripheral and colonised others' which allows the 'heroic' evocations of a Lawrence who identifies with the Arabs to function as a means of 'repossessing' the other (Dawson 1991: 125–7). And he argues that even the feminization of descriptions of Lawrence offer a masculinity whose power is simply *sustained* by the dissolving of gender difference, as the 'imagined integration' of 'passive', contemplative and 'feminine' or 'effeminate' characteristics with traditional images of the military man of action 'suggests ... an alternative and superior mode of being a man' (Dawson 1991: 124, 137). Further, Dawson identifies the origin of Lawrence's 'subjective fragmentation' as a crisis of individuality and a disruption of the cohesive principle of modern masculine identity on the one hand, and on the other as a crisis in British values and identity, which allows the loss of Empire to be registered on British masculinity (Dawson 1994: 218). As a public narrative, *Seven Pillars* is taken as a lament for – and a simultaneous promotion of – the imperial adventure hero (Dawson 1994: 225).[1]

If we give less weight to the generic characteristics of military adventure and attend instead to the intersection of these accounts of an evasive, even ambivalent, subjectivity with contemporary knowledges of sexuality – particularly their concern with pathologies of sexual formation – the 'dilemma of identity' they foreground complicates the claim that the figure of Lawrence articulates either a triumphant colonial masculinity, or the loss of an idealized moment in which imperial power could be embodied in a masculine figure. My examination of the public interest in Lawrence investigates a different question: since stories of Lawrence became such compelling public narratives, how did the representation of his instabilities intersect with and reflect other (re-)evaluations of masculinity – and its pathologies – that were taking place during the two periods in which he captured public interest? If a radical reassessment of Lawrence occurred in the 1950s, how was this informed by the sexual debates that surround the preparation and release of the Report of the Committee on Homosexual Offences and Prostitution from

1954 to 1957 – generally referred to as the Wolfenden Report (HMSO 1957)? And how did the forms of sexual knowledge drawn on in those debates also inform the most pervasive public representation of his persona, the film of *Lawrence of Arabia* (David Lean 1962), released at the end of that period?

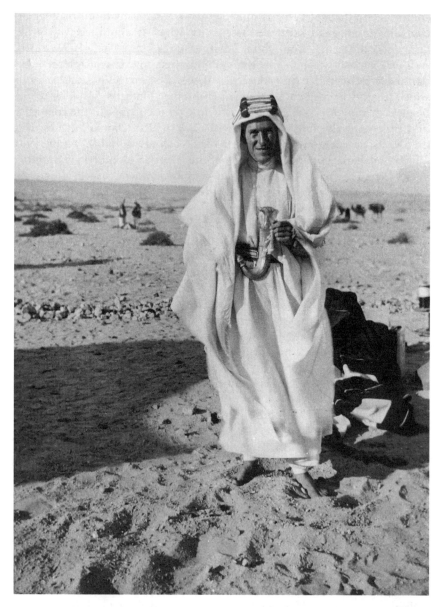

Figure 5.1 T. E. Lawrence in 1917 wearing the white robes and holding the golden-hilted dagger of a sharif. Courtesy of The Art Archive/Imperial War Museum.

It is my aim to consider narratives of Lawrence in relation to those distur-bances to the relations between masculinity, nation and empire as they impinge on the composition and functioning of masculinity as a term. From this perspective, the frameworks used to position Lawrence's instabilities can be seen in terms of a problem of sexual difference – and the identifica-tion of masculinity with heterosexuality – allowing us to read narratives of Lawrence against those models and concepts developed to address mascu-line pathology. The features of the public interest in Lawrence – which bind together cultural difference and sexual instability – can be seen as evidence of a 'categorial instability' within models of sexual difference, which become manifest as a troubling of stable notions of masculinity.

Lawrence's own account of his persona, and the first wave of celebra-tory biographies, are shot through with a series of hesitancies regarding his relation to masculinity. His embodiment of heroic masculinity is further complicated by a series of biographies and newspaper reports which appear through the 1950s, articulating a radical return to the 'heroic' fig-ure of Lawrence, as it had become solidified in the period between, in a way which gave those hesitancies more prominence. For two propositions are shared by the first wave of accounts of Lawrence and those of the 1950s. First, that his movement between cultures either was propelled by, or induced, a radical split in Lawrence's psyche that contributed to a breakdown, and a recurring nervous or depressive condition. The intima-tions of Lawrence's instability include his courting of danger, his preoccupation with his ability to suffer pain, his over-attachment to the male community of the Arab army and his eschewing of officer protocols, his perilously close involvement with the Bedouins, his absorption in the wild expanses of the desert and, above all, his insufficiently grounded national identification as he becomes an ambiguous figure who 'passes between' cultures, adopting Arab costume and the Arabs' military strate-gies, and making himself and his military success dependent on Arab aid.

This indeterminacy is connected to the second proposition, that his was a subjectivity that could not be reconciled to conventional heterosexuality, one which is discussed in terms of a dislike of bodily contact, a hostility to sex and a discomfort with the bodily presence of women. Lawrence himself claims a revulsion to physical matters and a practice of sexual continence while declar-ing a delight in his proximity to other – Arab – male bodies during the desert campaign, and admitting to feeling a 'delicious warmth, probably sexual' during his beating and rape by Turkish guards (Lawrence 1935/26: 445).

Despite widespread personal acclaim, the emergence of early narratives of Lawrence was structured by a pattern of hesitancy and suppression: his writings were given limited circulation, 'edited' or withheld for later publi-cation.[2] The difficulties over his narratives, and the hesitancy about making them available publicly, partly result from their preoccupation with sexual ambivalence. In fact, private or restricted forms of publication – and the omission of more explicit sections prior to a work's appearance

in print – characterizes the publication of sexually controversial work in this period.[3] But it may be that the particular forms of undecidability that Lawrence's figure embodies, in the way it presses against the boundaries of sexual definition, point to fractures in the coordinates of masculine identity as it becomes imprinted with the subjective.

The frameworks through which Lawrence's distinctively unresolved sexual definition was read in this first moment are very different from those deployed during the 1950s. Situated in terms of an elusive form of sexual 'indeterminacy' based on the Hellenic homoerotics of 'manly love' in his own and others' celebratory accounts following World War One, the figure of Lawrence is subjected to a radical reassessment in mid-1950s Britain. The 'reassessment narratives' that emerge at the end of the 1950s make explicit the disturbances posed by Lawrence's unresolved subjectivity and problematic masculine definition, foregrounding his Arab identifications, his sexual ambiguity and talk of his breakdown after returning to England in response to the conflict of his position as a representative of a government which betrayed the Arab cause by promising a freedom it was unable to bestow. Most notably, a biography by Richard Aldington, published in 1955, invoked these factors in support of a damning appraisal of his military achievements, his character and his sexuality.

Lawrence's sexual ambiguity – and a concern over whether his recoil from women, his love of the company of men, and his involvement in flagellation testifies to homosexuality – are a critical part of this second wave of accounts: in fact, it could be claimed that the 'revival' of interest in Lawrence in this second period is itself stimulated by a pervasive public interest during the 1950s in identifying the features of homosexuality. Reassessments of Lawrence bring into focus a series of shifts in sexual knowledges occurring between the 1920s and the 1950s, as several homosexual scandals at the beginning of the 1950s and the preparation of the Wolfenden Report create the conditions for the elaboration of a range of homosexual features and types. Albeit that his 'homosexuality' remains contested and speculative even to the present, writers such as Aldington claimed to reveal that in his letters and writings he had 'unconsciously left a record of his sexual sympathies ... [and] a good deal of evidence as to what sexually repelled him, what he tolerated, and what excited his preference and sympathy' (Aldington 1955: 333). Imputations of a definitional homosexuality, formed in the exchange between tragic inversion and monstrous perversity, contribute to an erosion of Lawrence's 'heroic' persona in ways that refuse the fragile problematics of indeterminacy upon which earlier models were based. Seen in this light, rather than replaying fantasies of colonial power and subjective coherence, the figure of Lawrence instead is premised on a series of exchanges between masculine achievement, sexual ambivalence and subjective incoherence, foregrounding the ambivalence of sexual and colonial relations and the *fragmentation* of relations between national identity and masculinity.[4]

In the subjective: hesitancy, indeterminacy and sexual instability

These are the fractures and indeterminacies – the points of incoherence – which suggest that narratives of Lawrence testify to a categorial instability within the terms of masculinity, introducing the subjective – in its perspectivalism, in its partiality – into the field of knowledge. One of the problems to be discerned in Lawrence's own account is, precisely, its narration of masculinity 'in the subjective'. For, in Lawrence's autobiographical publications, particularly the account of the desert campaign in *Seven Pillars of Wisdom*, personal reflections on his own role – narratives of psychological development, cultural identification and moral introspection – are imbricated in the objective narratives of public history. In the introduction of *perspectival* viewpoint, rather than an authorial narration that offers an overview – reflecting, rather, on the manoeuvres and strategies of the campaign – the conventions of military histories are disturbed. Accounts that follow, which comment on those reflections and highlight the personal element – narrating their absorption in his charismatic heroism – add to this subjective intensification. Lawrence's public persona, based on his military role in the desert campaign, is thereby rendered questionable as the instabilities associated with the subjective become mapped onto his own narrative.

Lawrence's statement of his aim in writing *Seven Pillars* shows a curiously split intention, incorporating both public and private dimensions. In the 'Suppressed Introductory Chapter' to the book, he defines it as a historical document:

> the book is just a designed procession of Arab freedom from Mecca to Damascus. It is intended to rationalise the campaign, that everyone may see how natural the success was, how little dependent on direction or brain, how much less on the outside assistance of the few British. It was an Arab war waged and led by Arabs for an Arab aim in Arabia.
>
> (Lawrence 1939: 140)

But even this framing uses the rhetoric of the personal, in the emotional and moral self-questioning concerning his military role that forms the basis of this statement of difference. Lawrence's emphasis on the perspectival undermines his public persona as military strategist and national representative, as his confession of personal dishonour is transferred on to a critique of the British government's duplicitous role in their promise of self-government as a reward for Arab aid in the desert campaign. Lawrence's 'dilemma' is posed in terms of a disturbing personal shame which pitches him against national affiliation, and he complicates the claim of his subtitle, *A Triumph*, by questioning the justification of his own actions and his leadership *per se*, in a way which renders simple heroism problematic (Mack 1990/76: xxi):

instead of being proud of what we did together, I was continually and bitterly ashamed ... It was evident from the beginning that if we won the war these promises would be dead paper, and had I been an honest adviser of the Arabs I would have advised them to go home and not risk their lives fighting for such stuff ...

(Lawrence 1939: 145)

Lawrence's own complication of his involvement with the Arabs invited systematic interrogation and interpretation from other commentators, as proliferating accounts speculated on and quarrelled over his character and background, his military and diplomatic career, and his psychological investment in the Arab cause. His character itself became the subject of these narratives, despite being legitimized by their constellation around a figure recently elevated to the status of public hero. One of his first biographers, Robert Graves, makes it clear that history is less important to him than the figure of 'Lawrence':

This is not the method of history ... I have attempted a critical study of 'Lawrence' – the popular verdict that he is the most remarkable living Englishman, though I dislike such verdicts, I am inclined to accept – rather than a general view of the Arab freedom movement and the part played by England and France in regard to it.

(Graves 1927: 6)

And in a frequently quoted passage, John Buchan conveys something of the irrational, even lethal, influence the figure of Lawrence exerted over men:

I am not a very tractable person or much of a hero-worshipper, but I could have followed Lawrence over the edge of the world. I loved him for himself, and also because there seemed to be reborn in him all the lost friends of my youth.

(Cited in Mack 1990/76: 460)

Pronouncements on the power of this figure indicate that his fascination could not be limited to his military, diplomatic or political role, and he came to occupy a position outside social constraints. As Churchill indicated, on the announcement of Lawrence's abdication of his diplomatic and political career to enter the ordinary ranks of the RAF:

The world looks with some awe upon a man who appears unconcernedly indifferent to home, money, comfort, rank, or even power and fame. The world feels not without a certain apprehension, that here is some one outside its jurisdiction; some one before whom its allurements may be spread in vain; some one strangely enfranchised,

untamed, untrammelled by convention, moving independently of the ordinary currents of human action.

<div align="right">(Cited in Wilson 1989: 4)</div>

Lawrence's lack of conventional motivations and disregard for social incentives give him a particular kind of romantic allure, but also generate the 'apprehension' that Churchill notes, detracting from the persuasiveness of models of public masculinity. His 'indifference' challenges the mechanisms of social management and creates a flaw in the relation of masculinity, public life and national identity, a point of weakness in the maintenance of those boundaries which mark off individual passions from the 'ordinary currents of human action'.

Lawrence's own refutation of his earlier claim to historical documentation and authoritative overview, in his acknowledgement of his account's preoccupation with the details of the everyday, the ordinary and the trivial, suggest a usurping of the project of history by the subjective:

> In these pages the history is not of the Arab movement, but of me in it. It is a narrative of daily life, mean happenings, little people. Here are no lessons for the world, no disclosures to shock peoples. It is filled with trivial things, partly that no one mistake for history the bones from which some day a man may make history, and partly for the pleasure it gave me to recall the fellowship of the revolt. We were fond together, because of the sweep of the open places, the taste of wide winds, the sunlight, and the hopes in which we worked. The morning freshness of the world-to-be intoxicated us. We were wrought up with *ideas inexpressible and vaporous*, but to be fought for. We lived many lives in those whirling campaigns, never sparing ourselves ...
>
> <div align="right">(Lawrence 1939: 142, my emphasis)</div>

Focusing on circumstantial detail and intimate exchange allows Lawrence to centre the 'fellowship of the revolt' and the effect of the desert landscape in his account, both sustained themes whose connectivity allows his pleasure in the proximity to and admiration of the bodies of other men, to infuse his identification with the Arab cause and perspective. His concentration on these levels of experience brings him to express that pleasure in 'living many lives' which simultaneously exposes him to accusations of inauthenticity, of lack of truthfulness. But this is not an account which can be evaluated in terms of a 'true' version of events: for rather *than* history, he is presenting 'the bones from which some day a man may make history'. Rather, he identifies a particular indeterminacy, a lack of integration held by the unresolved details of the experiential and the perspectival in the absence of a synthetic overview.

As he brings into the writing of history those antipathetic components of experience relating to the sensual, the emotional and the free play of the phantasmatic, Lawrence's subjectivity becomes written in terms of the

processes of subjective projection and the elusive movement of contingency. In the context of the altered states of a landscape of 'open places' and 'wide winds', and the intoxication of 'hope' of being 'fond together', his account of the indeterminacy of unresolved states becomes indissolubly inscribed in terms of a radical estrangement: the 'discontinuous wonders' of an encounter with difference.[5]

But if a hesitancy and indeterminacy characterizing Lawrence's definition contributed to the early suppression and withholding of his narratives, it is precisely the emphasis on the subjective, and the perspectival, which later writers – particularly Richard Aldington – found so problematic, in its perceived dichotomy with the objective 'truth' of 'history'. While earlier writers were inclined to analyse *Seven Pillars* as an 'introspection epic' (Meyers 1989/73: 131), and thereby to gain further understanding of Lawrence as a figure, Aldington's 1955 biography mounted a savage critique of what he referred to as 'the Lawrence legend', proposing that *Seven Pillars* was 'rather a work of quasi-fiction than of history', that Lawrence was guilty of 'a systematic falsification and over-valuing of himself and his achievements' through a desire for 'self-advertisement', and that his major achievement was simply his capacity 'to convince others that he was a remarkable man' (Aldington 1955: 12–13):

> there was 'a real self' ... an unhappy, wistful, tortured, hag-ridden self ... Yet he had the courage, the skill – the cunning, if you like – and the force of will and character to impose on the world his over-valued persona as reality, and to receive world-wide acclaim – for what? For the clever patter and pictures of a glib showman untroubled by the majesty of truth.
>
> (Aldington 1955: 350)

It is partly the refutation of the subjective that appears to be at stake for writers such as Aldington, as he challenges the legitimacy of Lawrence's habit of centralizing his own thoughts, feelings and impressions:

> May it be questioned whether a style so mannered, so literary and so inexact was really the most suitable for an honest war narrative? True, every personal war narrative is autobiography; but War is action, whatever it may involve of plans and preparations, and however much the neurotic intellectual who is writing may have been plagued by mental conflict and divided aims. Action does not ask a too sophisticated style, but rather a speech which is vigorous, direct, and unaffected, where the very existence of the sayer is forgotten in the vividness and meaning of the thing said. Is there a page of *Seven Pillars* in which we are allowed to forget Lawrence of Arabia?
>
> (Aldington 1955: 330)

It is clear from Aldington's objections that the introduction of the subjective disturbs the narrating of masculinity in accounts of military history. In his much later commentary, Gilles Deleuze concludes of Lawrence that his is not merely a 'personal difference', but that the difference that is created by a subjective disposition undermines unified constructions of masculinity and the self:

> Lawrence's undertaking is a cold and concerted destruction of the ego, carried to its limit. Every mine he plants also explodes within himself, he is himself the bomb he detonates. It is an infinitely secret *subjective disposition*, which must not be confused with a national or personal character, and which leads him far from his own country, under the ruins of his devastated ego ... a profound desire, a tendency to project – into things, into reality, into the future, and even into the sky – an image of himself and others so intense that *it has a life of its own*: an image that is always stitched together, patched up, continually growing on the way, to the point where it becomes fabulous.
>
> (Deleuze 1998: 117–18)

This is a quality of writing *in the subjective*, rather than *as an individual*, as the writer becomes caught up in the process of subjectivity, absorbed in the 'force through which the images are projected'. Deleuze aligns this projection with 'an "absence of being", an emptiness that bears witness to a dissolved ego' (1998: 119), and so indicates the damage to a unified conception of being that the subjective narrative brings to public masculinity, emptying it of meaning.

The derogated form of the 'subjective narrative' of *Seven Pillars of Wisdom* thereby invites a focus on Lawrence's 'troubled persona', allowing his military role to recede in favour of his sexual ambivalence as a *problem of subjectivity*. But while he is questioning the legitimacy of the subjective in a public narrative of military action, Aldington is also questioning the subjective as a legitimate dimension of a masculine narrative, or a narrative of masculinity. He creates a popular and enduring pathology for Lawrence that connects his 'Guilty Secret' – the effect of his discovery of his illegitimacy and his parents' guilt at their 'adultery' – with an 'arrested mental development' and 'mental fixation in adolescence', and 'in later life, the bitter antagonism to women as a sex, [and] a puritanical horror of normal sexual intercourse'. Aldington finds a pathological homosexual identity unconsciously inscribed into his writings, alongside 'a downright, if not defiant, statement of Lawrence's disdain for heterosexual and sympathy with homosexual relations', which he argues constitutes a sexual disorder lying at the root of his alleged over-valuation of self (1955: 332–5). Proposing that this 'over-valued self' is the correlative of an 'impulse of refusal, of rejection, of wilful courting of plebeian degradation' he represents it as a fiction created by pathological tendencies (1955: 346–7). Here we have the implication of the introduction

of the subjective: its connection to a disturbance of personality that is ulti-
mately one of sexual disorder, in Aldington's invocation of an underlying
homosexual impulse.

There is a connection, then, between writing in the subjective, Lawrence's
narrative of sexual indeterminacy (and interpretations of his 'sexual disor-
der'), and claims of his homosexuality. The foregrounding of the subjective is
translated into an 'unreliability' which compromises not only the truth of his
account, but his authenticity of self, and ultimately his masculinity. Even
Deleuze claims that Lawrence's 'subjective disposition', though it is not coin-
cident with it, *includes* homosexuality. Why is this such a natural connection,
and how is Lawrence's sexuality explained, and linked to the other features of
his writing?

Convergence, dissonance and sexual indeterminacy: manly love and homoerotic restraint

Lawrence's invocation of a 'fellowship' of men which relies upon being 'fond
together' situates his subjective attachments within the context of a model of
masculine subjective definition that, while it may imply an orientation to the
male body and an association with manly love, did not yet cohere around an
emergent homosexual disposition. For David Halperin, the modern notion
of homosexuality is not an 'overarching principle', a 'triumphalist' discursive
category, but a heterogeneous – and unstable – convergence of 'at least four
different but simultaneous categories or traditions of discourse' (2002:
107–8). If the modern notion of '"homosexuality" as a singular, distinctive
formation ... pretends to represent all same-sex sexual expression',
Halperin's genealogy emphasizes the 'historical accumulation of discontinu-
ous notions that shelter within its specious unity':

> I suggest that if our 'understanding of homosexual definition ... is
> organised around a radical and irreducible incoherence', owing to 'the
> unrationalised coexistence of different models' of sex and gender, as
> Sedgwick says, it is because we have retained at least four pre-homo-
> sexual models of male sexual and gender deviance, all of which derive
> from an age-old system that privileges gender over sexuality, alongside
> of (and despite their flagrant conflict with) a new homosexual model
> derived from a more recent, comparatively anomalous system that priv-
> ileges sexuality over gender.
>
> (2002: 109)

The four 'pre-homosexual' discursive traditions that Halperin identifies are:
effeminacy; paederasty (or 'active' sodomy); friendship or male love; and
passivity or inversion, the history of each of these revealing their internal
discontinuity and heterogeneity.[6] Homosexuality, he argues, is a more
recent category, irreducible to these traditions, bearing the traces of their

discontinuous convergence. What the divergent histories of each of these categories reveal (as Halperin's extraordinarily fine-tuned account of them demonstrates) is their radical difference from 'homosexuality', which depends upon a distinctively modern notion of sexuality, in which

> sexual object-choice attaches to a notion of sexual orientation, such that sexual behaviour is seen to express an underlying and permanent psycho-sexual feature of the human subject ... as an overriding principle of sexual and social difference. Homosexuality is therefore part of a radically new system of sexuality, which functions as a means of personal individuation.
>
> (Halperin 2002: 134)

But as such, this modern term has to be understood in terms of an 'incoherence' that is created by a dissonance operating at two levels: in a divergence between those traditions from whose convergence a notion of homosexuality is made possible, and a conflict between those which are based on a relation to gender and those which are oriented by a relation to sexuality.

The inauguration of the notion of homosexuality has frequently been ascribed to a particular moment of legislative innovation in which the 'male homosexual' was targeted and therefore brought into being as a new category of identity, at a time when psychiatric and sexological writings were seen both to contribute to the pathologizing of homosexual practices and dispositions, and – at times inadvertently, at others purposively – to delineate the contours of new forms of self-definition (see, for example, Weeks 1989; Cook 2003; Cocks 2003; Bland and Doan 1998).[7] Halperin's own account specifies

> at least three distinct and previously uncorrelated concepts: (1) a psychiatric notion of perverted or pathological *orientation* ...; (2) a psychoanalytic notion of same-sex *sexual object-choice* or desire [which] does not necessarily imply a permanent sexual orientation ...; and (3) a sociological notion of sexually deviant behaviour.
>
> (2002: 131, emphasis in the original)[8]

It is not Halperin's task to trace this history, but it is an implication of his genealogical and historicist approach that the concept of homosexuality becomes adapted through a series of adaptations and adjustments to the dissonances between different discursive traditions and their divergent conceptual frameworks. This, after all, is what he is pointing to in his notion that homosexuality is produced through an 'unstable convergence' which draws upon previously distinct and irreducible discursive categories.[9] The adjustments made, as psychiatric, psychoanalytic and sociological adaptations reconfigure elements of the four pre-homosexual categories Halperin identifies as contributing to the formation of a singular but composite and

fractured notion of 'homosexuality', can only be confidently mapped in their contingency, in specific moments. But it is my contention – or, rather, my reading of the implication of Halperin's argument – that their culmination in a category of homosexuality distinguished against that of heterosexuality – as opposed to earlier oppositions embodied in those four categories, for example paederasty versus passivity, effeminacy versus virility, perversion versus perversity[10] – is not only finally (productively) 'incoherent' in *discursive* terms, as Halperin (1990) and Kosofsky Sedgwick (1990) both claim. The productivity created by the mobilization and invocation, adaptation and redirection of knowledges towards particular problems of individual self-definition and everyday problems of relationality and conduct is reflective of the dissonance of earlier traditions, and so establishes an incoherence at the level of the everyday mobility of patterns of sexual imagining.[11]

That gender and sexuality may each be, in different ways, implicated in such problems can be taken as read, but that they may both be *separately* and at times *divergently* harnessed, in this process, towards the anchoring of the varied components of an individual orientation, suggests not only the extent of the claim that the creation of 'homosexuality' involves, but something of its difficulty in resolving dissonance. This difficulty – the task of integrating those divergent components of pre-homosexual definitions and discursive categories – provides an important basis for the unresolved and fractured nature of sexual definition in the period of the first phase of narratives of Lawrence.[12] If the later period sees him ascribed a homosexual identity, what are the persisting motifs from pre-modern traditions that he and others invoke in the first phase of narratives, and may this dissonance be, perhaps, the reason for his figure taking on, in the earlier period, a radical 'indeterminacy'?

In his own and early biographical accounts, Lawrence is figured as celibate, solitary and ascetic. He writes in *Seven Pillars* that his personality prevented him from allowing sexual contact: 'To put my hand on a living thing was defilement ... This was an atomic repulsion, like the intact course of a snowflake' (cited in Mack 1990/76: 419). And in *The Mint* he makes a more elaborate statement in which his lack of sexual knowledge corresponds to that of his fellow airmen:

> I fear and shun touch most, of my senses ... Of direct experience I cannot speak, never having been tempted to so peril my mortal soul ... Shyness and a wish to be clean have imposed chastity on so many of the younger airmen, whose life spends itself and is spent in the enforced celibacy of their blankets' harsh embrace.
>
> (Cited in Mack 1990/76: 421–2)

But most of these statements of sexual disinclination are made in the context of reflections on his antipathy to the bodies of women, and he makes clear his greater pleasure in the sight of male bodies: 'I take no pleasure in

women. I have never thought twice or even once of the shape of a woman: but men's bodies, in repose or in movement – especially the former, appeal to me directly and very generally' (cited in Mack 1990/76: 425). And as he describes the '[E]astern boy and boy affection which the segregation of women made inevitable' (Lawrence 1935/26: 237), Lawrence's valuation of manly love is indicated by his comments on 'boy and boy affection': 'Such friendships often led to manly loves of a depth and force beyond our flesh-steeped conceit. When innocent they were hot and unashamed. If sexuality entered, they passed into a give and take, unspiritual relation, like marriage' (Lawrence 1935/26: 237). The position Lawrence occupies in these exchanges is indistinctly marked, caught in the movement between 'our' flesh-steeped conceit and 'they' who move beyond. The friendships and manly loves he reifies move across the innocent and the unspiritual, with sufficient pliability to become either, on the basis of an unruly 'sexuality': disembodied, unwilled and ungrounded, it is invoked as an external force, acting on manly love, rather than constituting a dimension of it. But more particularly, his self-definition also rests on his claim to celibacy even as he celebrates relations between men that departed from a chaste continence, in ways that make clear his attraction to their homoerotic energy. Lawrence's observations of the sexuality of those Arab youths who comprise his fighting force gives rise to some of the most poetic passages in *Seven Pillars*. But his valuation of 'chastity' and 'celibacy' is here complicated by a less easily translated model of 'sexless and even pure' relations, as he recounts how they would 'slake one another's few needs in their own clean bodies': 'quivering together in the yielding sand with intimate hot limbs in supreme embrace, [they] found there hidden in the darkness a sensual co-efficient of the mental passion, which was welding our souls and spirits in one flaming effort' (Lawrence 1935/26: 30).

Lawrence's is no simple renunciation of the sexual, then: rather, it depends upon a contextually specific, but nevertheless *undefined*, notion of sexual restraint which, poised at a moment of change in the definition of male desire, looks back to earlier models of homosocial exchange, rather than forward to the consolidation of 'homosexuality' as a modern category. A model of 'comrade love', deriving from Hellenic models, became elaborated in a range of writing forms in Britain in the 1880s and 1890s. This model suggested that bonds between men could become the foundation of an ideal spiritual relation. The relations between homoerotic desire, the celebration of comradeship and masculine intimacy, and an acutely responsive and self-reflexive sensibility were composed into a 'new spiritual personality' capable of a transcendent form of ennobling manly love. Drawing on the work of the American poet Walt Whitman's 'sexual candour, love of the beauty of nature and the joys of physical intimacy ... [and his] celebration of comradeship and the common man', H. G. Cocks notes the affinity between the Whitmanesque ideal of 'comrade love' and an English tradition of celebrating youth and manly vigour as an important component of

comradeship, highlighting its homoerotic dimension, a factor which 'cemented Whitman's place in a homosexual canon' (Cocks 2003: 168–9). British writers adopted Whitman's model of a spiritual, transcendent and ineffable love. John Addington Symonds, in particular, stressed the 'inevitable points of contact between sexual anomaly and [Whitman's] doctrine of comradeship' and Edward Carpenter linked it to his notion of sexual inversion to elaborate a particular type of homosexual disposition in the 'intermediate sex' (Cocks 2003: 178–9).

But Cocks also demonstrates that this gave rise to a 'new vocabulary of evasion' concerning intense and intimate masculine attachments (2003: 161).[13] And he shows how the homoerotic element in Whitman's work was translated, in some readings, into a form of intense, spiritual but non-sexual relation, a 'curious and mysterious sympathy bordering on the ethereal', giving 'transcendence' a particular value in the development of a 'pure' form of manly love, a 'true Freemasonry' (Cocks 2003: 170–7). In fact, Cocks' conclusion, in exploring the different ways in which Whitman's celebration of comradeship was taken up both to claim a homosexual disposition and to express non-sexual but nevertheless intense masculine attachments, situates both on a spectrum of 'homogenic love' (2003: 192).

Symonds, for example, argued that transcendent love could lead to a 'luminous ideal of a new chivalry based on brotherhood and manly affection' (Cocks 2003: 178–9), and saw homoerotic attachments as a question of modern ethics, highlighting the importance of their role in Greek martial culture (Bristow 1998: 84).[14] And Carpenter's definition of the 'special affectional temperament' of the intermediate allowed him to claim that it constituted a higher evolutionary type (Porter and Hall 1995: 159). This implied that homosocial attachments – and their erotic energies – were more than solely a sexual matter. In fact, there was disagreement about the extent to which Whitman's version of the love of comrades implied physical sexual love, and Whitman himself refuted Symonds' reading of his work as inferring such a connection as 'morbid' (Bristow 1998: 87). Even the model of sexual inversion stressed its association with gender, rather than sexual, definition. 'Manly love' in this period, then, even at its most homoerotic and even in its physical expression, exists in an uneven relation to the sexual.

Lawrence was 'a figure on the fringes of the Uranian circle' while at Oxford, appreciative of Uranian poetry and painting, and had intimate friendships with men, particularly Vyvyan Richards (which incurred the disapproval of his parents, who suspected Richards of being a homosexual). But according to the accounts of his contemporaries, he was regarded as an eccentric loner more attached to medieval asceticism, and those bonds he did form, intense though they may have been, were understood to be intellectual, based on a Platonic ideal of manly love, an interest in an association between beauty and integrity in the Gothic idealism of William Morris, and virtuous and valiant models of human conduct deriving from the chivalric courtly literature of the middle ages (James 2005: 32–40). From this perspective, it is

possible to argue that his and other contemporary accounts do not simply repress Lawrence's 'actual' homosexuality. If the pathway from an attachment to the bodies of men and a spiritual attachment to 'manliness' did not follow inevitably to become expressed in 'homosexual acts', and the consolidation of such a disposition in 'homosexual identity' was not a given outcome in this period, such a move may have therefore simply been less of a pressing question – or, at least, not the only question – in his sexual definition. In the light of Cocks' analysis, it might be suggested that, since manly love constituted an element in relations that only sometimes became sexualized, we should be attentive to the *indeterminacy* of the sexual.

But more specifically, Lawrence's 'celibacy' represented a commitment to a specific form of masculine restraint, which drew on the bodily discipline of the warrior hero, a Hellenic tradition prevalent at Oxford University in the middle of the nineteenth century, which preceded and contributed to the formation of Uranianism. The warrior ideal, also prominent in the chivalric texts which influenced Lawrence in this period, became an element of a distinctive form of Victorian liberal Hellenism promoted in the Oxford tutorials of Benjamin Jowett and his contemporaries, whose pupils included J. A. Symonds. Linda Dowling argues that the origins of Hellenism as a 'discursive language of sociocultural renewal' at Oxford lie in the Tractarianists' defence of the authority of the Church over the forces of secular materialism and industrial modernity, which they saw as manifested in a 'hectically "commercial" statecraft' (Dowling 1994: 35–8).[15] The sense that English society was becoming 'dangerously unmoored from the realm of the transcendental – the domain of honour and ideals', and driven by the pursuit of prosperity associated with the commercial imperatives of industrial modernity and a rigid regime of respectability associated with Protestantism, impelled J. H. Newman to campaign to propose the monastic principle as a distillation of the 'ancient religious power lying latent within Oxford', restoring the medieval function of the tutorial as a 'disinterested' pastoral relation based on intimacy, friendship, and a striving for equality, inculcating spiritual ideals, and an asceticism and austerity which involved a manly form of self-restraint (Dowling 1994: 38–42).

Celibacy was the epitome of a regime of sacrifice which was allied, in Tractarianism, with fasting and chastisement (Dowling 1994: 42).[16] But the monastic principle that associated asceticism with the transcendent equality of spiritual unity was not solely a regime of bodily self-denial and punishment (although this gives a particular inflection to Lawrence's later involvement in flagellation). It also expressed an affiliation which would offer Lawrence a way of binding his psychic to his political orientation.[17] For if the monastic principle in Tractarianism was posed as a resistance to the stultifying elements of modernity, the restraint[18] and comradeship of the Greek martial ideal – 'blood sacrifice for the common good enacted in the experience of collectivity' – were celebrated as 'clear

and noble imperatives' (Dowling 1994: 48–51). But while this 'reciprocity and interdependence' allowed the chivalric to be superseded and reinflected by the classical republican notion of the 'warrior ideal' embedded in a 'citizen militia', as Dowling demonstrates, Victorian liberal Hellenism further elaborates such virtues in the context of a civic orientation. Political theorists such as John Stuart Mill would redirect the martial ideal of an autonomous, versatile, creative individual, as the embodiment of civic diversity which would counter the 'stagnation', 'uniformity' and 'fragmentation' generated by industrial modernity (Dowling 1994: 58–62).[19] These crushing forces could only be resisted by individuals 'of another stamp', with qualities that exceeded 'manliness', their 'compensatory excellence' being more readily translated in terms of 'energy', 'individuality' and 'diversity' (Dowling 1994: 58–62). It is in this move that restraint and the martial ideal become redirected – through the notion of civic diversity – towards the features of individual self-cultivation, finally bringing Victorian Hellenism to elaborate the coordinates whereby political ideals could become fused with the sexual:

> Within Mill's call for a new ideal of individuality and diversity, for a modern-day Hellenism encompassing such elements as 'pagan self-assertion', 'nonconformity', 'freedom', and 'variety of situations', there may already be glimpsed the outlines of a late-Victorian counter-discourse of sensuous diversity and homosexual dissent.
>
> (Dowling 1994: 61)[20]

Clearly, those virtues which Uranianism built on – and their distinctive translation of Oxford's role in the secular training of a civic elite – became a productive basis for those individuals who were being channelled towards roles in determining national and imperial futures to model themselves. The imbrication of public and sexual affiliations made possible by the translation of the warrior ideal into a mode of self-fashioning also made possible the alliance of an ascetic, celibate and homoerotic masculinity which Lawrence elaborated, as a means of inhabiting the figure of the exceptional individual. That individual 'of another stamp', who stood apart from the comradeship of men in arms – outside the jurisdiction of the world, in Churchill's words – could only embody the promise of national futures in his distance from those 'ordinary currents of human actions'.

It is in this way that Lawrence's own sense of himself as 'a man apart' – the 'node of a national movement' (Lawrence 1935/26: 661; James 2005: 40) – inflects and conflicts with the 'fellowship' of the desert campaign. And it is in this way that his own descriptions of his sexuality in terms of restraint offer continence as a positive translation of pre-homosexual Uranian principles rather than as a form of disavowed 'homosexuality'. Cocks notes in Symonds' adaptation of Whitman:

The question was whether comradeship could suggest ways in which 'the abnormal instincts may be moralized and raised to a higher value' and whether manly intimacy could raise such instincts from the 'filth and mire of brutal appetite'. Symonds, unsurprisingly, concluded that they could, via the agency of a transcendent love.

(Cocks 2003: 178)

Lawrence was to find that notion of delivery less accessible, and the question endlessly troubling, as he inhabited the space between an elevated position of transcendence and the mire of instinctual appetite, locked into the problematics of restraint as both a public and a sexual principle.

Lawrence does not write his experiences or identity in terms of 'homosexuality', and it appears that, whether or not a protohomosexual orientation formed in these years may have later become more solidified in actual relations,[21] his character, his interests and his affective make-up were formed in the context of eschewing the sexual. The question of whether Lawrence was 'actively' homosexual or not – at this time, or at a later date – is therefore of less significance than the fact that in his private letters and his public writings he insistently and consistently affirms a distaste for physical contact and an adherence to a regime of sexual continence as a platform for his definition of self. The lack of specification concerning Lawrence's sexual character in *Seven Pillars* and contemporary accounts may be evidence not so much of a confusion over his sexuality or of a reluctance to speak of homosexuality in direct terms, as has been assumed, but rather of the way sexual indeterminacy – as a positive definition rather than a simple confusion – functions as an effect of the unresolved category of 'the homosexual' as an aspect of masculinity in this period.[22]

But some of the tensions in this model of a transcendent homoerotic formation are also evident in Lawrence's 'indeterminacy'. The more immaterial models of manly love that Whitman, Carpenter and Symonds offered persisted beyond their writing, and circulated well into the twentieth century.[23] In this period, male bodies were available for a variety of forms of erotic contemplation and 'crushes', which were distinguished from an impulse towards corporeal exchange. Within this 'spectrum' of masculine homoeroticism, the defining force of sexual deployments of the body was not their genital nature. In fact, nineteenth-century exhortations to discipline the body towards sexual continence, initially directed towards intensifying a limited set of corporeal energies, were given an autoerotic force: the 'virile struggle' necessary for the mastering of 'a spirited horse' would eventually give rise to 'splendid energy' (Hall 1992: 372). Hence Lawrence's attachments could be defined in terms of a form of celibacy that, rather than being seen simply in terms of an absence of sexual activity, took on a positive sexual meaning, as the exercising of certain focused constraints that *contributed to* a virile (auto- and/or homo-) eroticism.

The concept of a 'chaste' male sexuality – articulated around the body but one in which genital contact had not the central defining force that is claimed for it in more recent models – allows a range of models of sexual love between men without stabilizing them in terms of a classification of 'homosexuality' as an alliance between desire, identity and behaviour. In fact, as David Halperin indicates, the 'equality, mutuality, and reciprocity in love between men' is what distinguishes male friendship as a protohomo-sexual motif. Manly love is distinguished against unmasculinizing forms of 'effeminacy' – implying an excessive (hetero or homosexual) desire, rather than sexual object-choice – and the more unlawful 'violation of the proto-cols of manhood' in the subordinate and receptive passivity of the *kinaidori*, or deviant sexual invert. But manly love must also be distin-guished against the 'perversity' of paederasty ('Greek love'), whose penetration of a subordinate other, while masculinized – as a manifestation of an 'excessive but otherwise normal male sexual appetite' – allows it to be defined as a sexual vice rather than a deviation of gender, perversity rather than pathology. Only 'reciprocal love between male friends [situated] in an honourable, even glamorous tradition of heroic comradeship' adopts the distance from erotic passion that overturns the hierarchy involved in other protohomosexual relations (Halperin 2002: 109–20). It is important to emphasize that, contrary to a more recent tradition, in which male friend-ship offers a cover for closeted homosexual relations, or is taken as a symptom of a – possibly repressed – male homosexual disposition, the model of male friendship which is being drawn on in the mobilization of classical traditions is defined not so much coterminously with male sexual love, as against it:

> Sexual love, at least as it is viewed within the cultural horizons of the (pre-modern) male world, is all about penetration and therefore all about position, superiority and inferiority, rank and status, gender and difference. Friendship ... by contrast, is all about sameness: sameness of rank and status, sameness of sentiment, sameness of identity. It is this very emphasis on identity, similarity, and mutuality that distances the friendship tradition, in its original social and discursive context, from the world of sexual love. Sexual love, in the light of the male friendship tradition, actually sounds like a contradiction in terms ...
>
> (Halperin 2002: 121)

Manly love, then, not only masculinizes the subject, but adopts the required distance from sexual love – the hierarchy involved in corporeal penetration – that allows it to become a relation of mutuality. Lawrence draws on a model of homoerotic formation that renders accounts of the relations between men according to a sentimental and sublimated 'homoerotic ten-derness' distinctive of this period (Fussell 1975: 277). But even in his valuation of manly love, and the spiritual attachments of a 'fellowship in

arms' (Symonds' term, cited in Bristow 1998: 86), he mobilizes an intensi-fied contemplation of the male body, which comes to heighten, rather than erase, corporeality, even in the case of continence.

The 'tease' of Lawrence's narrative, then – in his sympathetic yet dis-tanced account of the young Arabs' relations – lies not only in the dissonance between sexual cultures, and their lack of translatability, but in his attempts to elaborate on this indefinable difference, and his own immer-sion in that fracture. This indeterminacy becomes evident in his attempts to relay a psychic disposition within which he positions himself, moving from a description of the environmental features which created an altered state, to culminate in a statement of the struggle for freedom as the basis of a transcendent relation between men:

> Some of the evil of my tale may have been inherent in our circum-stances. For years we lived anyhow with one another in the naked desert, under the indifferent heaven. By day the hot sun fermented us; and we were dizzied by the beating wind. At night we were stained by dew, and shamed into pettiness by the innumerable silences of stars. We were a self-centered army without parade or gesture, devoted to free-dom, the second of man's creeds, a hope so transcendent that our earlier ambitions faded in its glare.
>
> (Lawrence 1935/26: 29)

But the 'evil' of the tale resides precisely in the subjection to this ideal, as they 'surrendered, not body alone, but soul to the overmastering greed of victory. By our own act we were drained of morality, of volition, of responsibility, like dead leaves in the wind ...' (Lawrence 1935/26: 29). Rather than the possibil-ity of crossing cultures, in the romantic image of a nomadic subjectivity, Lawrence articulates the impossible position of being caught *between*:

> Blood was always on our hands: we were licensed to it ... With the sor-row of living so great, the sorrow of punishment had to be pitiless. We lived for the day and died for it ... Beduin ways were hard even for those brought up to them and for strangers terrible: a death in life ... In my case, the effort for these years to live in the dress of the Arabs, and to imitate their mental foundation, quitted me of my English self, and let me look at the West and its conventions with new eyes: they destroyed it all for me. At the same time I could not sincerely take on Arab skin: it was an affectation only ... I had dropped one form and not taken on the other ... and then madness was very near, as I believe it would be near the man who could see things through the veils at once of two customs, two educations, two environments.
>
> (1935/26: 31–2)

Lawrence's position of cultural dissonance is further complicated by his ambivalent imbrication of the sexual, caught between the elevating moment of mutuality – the 'supreme embrace' of the 'mental passion which was welding our souls and spirits' – and the passive degradation of those who 'offered themselves fiercely in any habit which promised physical pain or filth' (Lawrence 1935/26: 30).

As his narration slips between the authorial first person singular, and the 'we' and 'they' of actors in his narrative, his invocation of the 'nature' of men leads him to a statement of sexual mutuality culminating in the culturally fused – even transcendent – figure of 'man':

> Our privations and dangers fanned this virile heat, in a climate as racking as can be conceived. We had no shut places to be alone in, no thick clothes to hide our nature. *Man in all things lived candidly with man.*
> (Lawrence 1935/26: 29–30, my emphasis)

The promise, then, of a complete moment of fusion is held in the derogating experience of the desert, which yet allows the possibility of man living 'candidly' with man. However, 'candid' has not the absolute value of those terms which are invoked by Lawrence's critics, such as 'truth' or 'reality': in his position between cultures he indicates there is no place for the objective. Lawrence's term invokes, rather, a transparency between individual – subjective – perspectives. The implication of openness, honesty and lack of prejudice or bias in the use of the term 'candid' suggests instead a mutuality gained from the shedding of personal investments to accede to a state of pure sincerity – impartiality. But this ideal is also the source of the 'evil' in his tale, the possibility that this openness may illuminate an incomplete transcendence of the personal – in the *partisan* – which is as bound to sexual, as well as cultural or national, investments. For his movement – and the fragile conditions of this imagined mutuality – might themselves result in a collapsing back into the fractures of the subjective.

The ambiguity of Lawrence's sexual definition, then, rests on the slips and elisions which arise from his erratic and incomplete Arabic identification. He positions himself within a fraught divergence between the homoerotics of celibacy and sexual love, between the elevation of the sexual in an ennobling spiritual unity – 'the supreme embrace ... a sensual co-efficient of the mental passion, which was welding our souls and spirits in one flaming effort' – and its degradation in a 'flesh-steeped conceit'. And so his persona comes to be based on dissonance, the possibility of a failure of impartiality and the elevating condition of mutuality: the shame of the subjective.

'Torn between faeces and poetry': Dera and anality

This divergence becomes the structuring principle of narratives of Lawrence. Even as he asserts a 'chaste' form of manly love as a superior,

anti-domestic, connection, which transcends the 'unspiritual' model of marital love, Lawrence connects this 'clean' form of autoerotic or homoerotic pleasure to the possibility of its collapse into degradation, the terrors of 'filth' (Lawrence 1935/26: 30). As the solitary male body took on the project of continence it was rendered susceptible to 'strains' and failures as much as to glories (Hall 1992: 374–5). And as the prospect of a lapse of continence became inscribed onto the male body, it created a pathway to a very particular form of degradation.

The event which is regarded as the key to Lawrence's character is the 'Dera incident' where he was captured by the Turks while in Arab disguise, tortured and subjected to anal rape by soldiers under the instruction of Hajim Bey, the Governor of Dera. Read as a gap, a tear or a wound, in other words as a disfigurement, the anus inscribes the male body in the same way that the motif of the diseased vagina is inscribed on the body of the prostitute. Denoting filth, waste, and figured as a sewer, at the end of the last century, the identification of the prostitute with the diseased vagina represented the threat syphilis posed to the healthy body of the middle-class mother as guarantor of the imperial race (Armstrong 1999: 207–20). Through its association with prostitution, the anus comes to represent an unsecured, feminized, zone which must be repudiated and erased for the male body to guarantee a socially meaningful masculine subjectivity. As Hocquenghem's elaboration of the anus as a cultural sign of homosexual desire shows, the narrative of masculine sexuality positions the anus as both necessary to the socialization of sexual subjectivities, in the sublimation of its eroticism, and antipathetic to it, in its constitution as a regressive organ, 'private' and evacuated of social meaning: 'The anus only exists as something which is socially elevated and individually debased; it is torn between faeces and poetry, between the shameful little secret and the sublimated' (Hocquenghem 1978: 82).

The sexualized anus thus disorders the processes whereby identity and sexuality are secured in difference, creating a loss of coherence for masculinity. It holds out what Bersani calls the 'nightmare of ontological obscenity ... the prospect of a breakdown of the human itself into *sexual intensities* as ... proud subjectivity is buried' (Bersani 1988: 222).

Lawrence's experience of anality is universally seen as the cause of a recurring nervous condition and a continuing sexual ambivalence, and thereby contributes to understanding him as a fragmented personality of sexual instability and subjective incoherence. Lawrence's letters frequently document his nervous attacks, and in the opening chapter of *The Mint* he writes of his assessment at the Recruiting Office, as the medical examiner stated he had 'nerves like a rabbit', which, upon his ashamed explanation of the scars on his buttocks as 'persuasion', the medical examiner attributes to the flogging at Dera (Lawrence 1955: 35; see also Wilson 1989: 667–8). But the imprint of the floggings did not only testify to their physical damage. Lawrence's 'shame' is created not just by the sexual experience of rape, but rather by his

submission within the scenario of sexual encounter and how his pleasure in this created an infringement of continence. His description of this pivotal experience in *Seven Pillars of Wisdom* is sexually detailed and explicit – ecstatic, even, in parts – as he documents the Bey trembling and sweating in sexual anticipation, his 'fawning' admiration of Lawrence's 'white' and 'fresh' body and 'fine' hands and feet, his flailing attempts to drag Lawrence down onto the bed in his arms and his words of supplication, inviting Lawrence's love. He goes on to write of how the Bey bit him, kissed him and slit his skin to 'dabble' the blood over his stomach 'with his finger-tips' after Lawrence resisted him (1935/26: 442–3). After the Bey ordered his men to beat him and they 'play[ed] unspeakably' with him, Lawrence describes himself as 'completely broken' and they leave him lying on his back 'on the dirty floor'. Lawrence's description of his momentary recovery is oddly pleasant: 'I snuggled down, dazed, panting for breath, but vaguely comfortable.' And he recalls 'smiling idly' at the corporal kicking him to get him up, 'for a delicious warmth, probably sexual, was swelling through me' (1935/26: 445). This precedes the final two definitive lashes of the whip, into his groin: 'the core of life seemed to heave slowly up through the rending nerves, expelled from its body by this last indescribable pang' (1935/26: 445).

After he is returned to the Bey, Lawrence writes that he 'rejected him in haste, as a thing too torn and bloody for his bed ... the fault [resting] upon my indoor skin, which gave way more than an Arab's' (1935/26: 445). But this 'inner' fault – and the damage implied – is not only physical. Lawrence may have been 'broken' by the rape and floggings – 'They splashed water in my face, wiped off some of the filth, and lifted me between them, retching and sobbing for mercy, to where he lay' – but after he escapes it is the persistent recollection of this pleasure that damages his subjective coherence: 'in Dera that night the citadel of my integrity had been irrevocably lost' (1935/26: 445–7).

This episode is seen as critical to Lawrence's collapse, in its alliance of physical and sexual damage and an implied masochism, and an underlying motivation for the severity of the massacre of Turks at Tafas which preceded the 'triumph' of the capture of Damascus.[24] Lawrence's letters differ from his published account of the Dera incident – in one to Charlotte Shaw in 1924, he suggests that, in his attempt to avoid the excruciating pain of further beatings, he had in fact submitted to the Bey, investing the event with a further sense of degradation:

> I'm always afraid of being hurt: and to me, while I live, the force of that night will lie in the agony which broke me and made me surrender. It's the individual view. You can't share it ... For fear of being hurt, or rather to earn five minutes respite from a pain which drove me mad, I gave away the only possession we are born into the world with – our bodily integrity. It's an unforgivable matter, an irrecoverable position ...
> (Cited in Mack 1990/76: 419–20)

In fact, however, it may be that Lawrence was never at Dera and that neither the beatings nor the rape occurred. His biographer, Lawrence James, indicates the inconsistencies in the different accounts given of this event – and uncertainties about the 'evidence' of scarring when he was examined by RAF doctors in 1922, along with accounts of Lawrence's geographical placing and involvements elsewhere on the date he ascribes to the experience – suggest that it was a later fabrication (see James 2005: 245–63).[25] He also proposes that Lawrence could have used this narrative to translate his experience of a homosexual act or fantasy, or to derogate the Turks through an association with paederasty, and that it functions, in *Seven Pillars*, to vindicate the brutality of the attack on the Turks at Tafas (although there is a significant gap between the two incidents, and the motivation of the attack at Tafas is rather clearly inscribed as a response to the extreme brutality of the killings of women and children in the village). What is certain, however, is that the event comes to represent the experience of *shame* which links the experience of passivity, anality and pleasure, to a failure of restraint all the more catastrophic in the way it becomes inflected by his loss of self-possession – a failure of self-discipline that damages his claim to inhabit the position of the individual 'of another stamp', by allowing his identification with Arab culture to become infused by hostility towards the Turks.

For Lawrence, the Turks represent the 'uncivil' imbalance of active/passive relations articulated by anality – his erroneous contention that venereal diseases transmitted by sodomy were rife in the Turkish army, whose officer class exploited their rank to abuse their men (James 2005: 74, 252), translates the Arab perception of the Turks as an occupying power in terms of a perverse sexual asymmetry distinguished against the 'mutuality' prized in his own code of transcendent manly love and which motivate his celebration of youthful Bedouin relations.[26] His overlooking of Arab atrocities and his counterposing of the 'wholesome' Bedouin unfamiliar with 'personal inequality' against the 'subservience' of the 'puny', 'confined' and 'mean' Indian cavalrymen towards British officers invokes the 'horror' of the embrace of passivity in the face of colonial rule as an alternative to attempting to 'prevail' over an opposing force (Lawrence, cited in James 2005: 300; see Lawrence 1935/26: 43). This is the relation between Dera and the severity of Arab attack following the Tafas massacre.

From the perspective of his Arab identification, the shame of Turkish rule can only be vindicated by the liberation of Damascus, symbolizing the release of the Arab world from Ottoman bondage, and the 'triumph' of Lawrence's personal quest to facilitate Arab freedom (James 2005: 294). Dera provides the motivation for this, representing the collapse of free Bedouin mutuality into the passivity imposed by colonial rule. His improbable escape, his 'super-human reliance' travelling without medical treatment, his magically swift return to Aqaba and his miraculous recovery to almost immediate functionality (James 2005: 252) all contribute to the fabrication of an exceptionality coterminous with an ideal individual embodying Hellenic virtues, the model

of the 'gifted individual' who embraces the warrior ideal in the interests of the common good – civic diversity as embodied within the individual.

But if Lawrence attests that Dera represented the 'irrevocable' loss of the citadel of his integrity, this is both bound up with the erosion of the ideal of fellowship, and constituted through a determining relation to an infringement created through the imposition (whether enforced or not, whether actual or not) of passivity of a bodily sort. His statement suggests this recognition that something was irrevocably lost to him comes to him in a gradual dawning of the 'burden, whose certainty the passing days confirmed' (Lawrence 1935/26: 447). The meaning of the burden of his experience is ambiguous: is this a psychological burden – his 'maimed will' – or a corporeal one, as signs of disease emerge as the imprint of his passivity?[27] Whatever it was, and whatever actual event or imagined relation it referred to, it implies that his experience of anality became a foundational degradation, the eruption of passivity permanently destroying the integrity he had so indissolubly linked to the transcendent mutuality of male friendship.

Lawrence's Arab identification becomes a sign of his inability to form an alliance between sexual and social modes of masculinity. His passivity is read as humiliation, an 'effeminacy' which disorganizes masculinity. In the context of these challenges to sexual distinctions, Dera represents the imposition of a foreign and primitive anality onto a cultivated British male body, which becomes torn and bloodied, covered in 'filth'. As Lawrence's body and psyche become marked with the experience of anality, the consequence of this was his corporeal, moral and psychic disfigurement: the destruction of the citadel of his integrity.

The effect of the submission he links to Dera – whether through his sexual response to his flogging and rape, his subjection to the Bey, or some other dimension of experience he plays out in this narrative – becomes the core of narratives of Lawrence, as the reliving of his experience is seen to cause recurrent episodes of depression, his further sexual recoil, and his staging of further beating episodes later in life, which enables him to re-enact both gratification and penance, replaying 'the fusion of intimacy and simultaneous desecration' (Wilson 1989: 666; Mack 1990/76: 427–41). The explanation for the severity and endurance of the psychological torture Lawrence suffers on account of Dera has been found in the stylistic similarity of his expression of the fear that his feelings would be 'violated' by his mother, if she knew of them, and had got 'inside the circle of my integrity' or in its revival of the earlier conflicts associated with his mother's childhood beatings (letter to Charlotte Shaw, 1928, cited in Meyers 1989/73: 119; Mack 1990/76: 420). But there is also a stylistic similarity in his expression of his identification with the Arab response to the massacre of women and children at Tafas which becomes the stimulus for a reciprocal massacre of the Turkish police battalion at Dera, to his recounting of Bedouin youths' 'slaking' of each other's needs 'in their own clean bodies'. The term returns in a murderous image of 'agony'; after the massacre of

Tafas, another massacre, of the Turks, occurs 'by Lawrence's order and for the only time in the war': 'In madness born of the horror of Tafas we killed and killed, even blowing in the heads of the fallen and the animals; as though death and running blood could slake our agony' (Meyers 1989/73: 119–20, 134–5; Lawrence 1935/26: 633; see also James 2005: 302).

The wider significance of Lawrence's sense of the destruction of his integrity, in *Seven Pillars*, has been found in his feeling that he betrayed the Arab cause in his promises of freedom for their aid in defeating the Turks, of which he said: 'I was continually and bitterly ashamed' (Lawrence 1935/26: 275–6). But it has also been connected to his horror at his own savagery, in a form of vengeful attack that creates a relation between the Hellenic model of the warrior and those guerrilla tactics coincident with Bedouin warfare. The connection of his Arab identification, his capacity for savagery and his indeterminate sexuality provides the basis of future readings of his troubled response to the visceral horrors of the Arab Revolt and its connection to his preoccupation with the shame of defilement.

However, the shame of Dera becomes invested with further – national and cultural – meanings, as Lawrence replays his sense of personal degradation through his narrative; its key significance lies in stimulating a masochistic pleasure which becomes imprinted on his sexual consciousness:

> Probably it had been the breaking of the spirit by that frenzied nerve-shattering pain which had degraded me to beast level when it made me grovel to it, and which had journeyed with me since, a fascination and terror and morbid desire, lascivious and vicious, perhaps, but like the striving of a moth towards its flame.
>
> (Lawrence 1922, cited in Wilson 1989: 668)

Dera, and the meanings of anality, thus stand as the consolidation of those traits of instability that Lawrence exhibits, marking his body and subjectivity in ways which signal the unravelling of masculinity: a transition from the mutuality of transcendent manliness, to the abject effeminacy of the passive invert, the *kinaidia*. As Halperin points out, it is not the fact of being penetrated that distinguishes the *kinaidia*, as a sexual classification, and through which it becomes seen as a violation of manhood, but the penetrated male's pleasure. His 'constitutional defect', or 'disfiguring peculiarity', suggests an unredeemable 'deviance of gender identity, sensibility and personal style ... a lack of the masculine capacity to withstand the appeal of pleasure ... as well as a tendency to adopt a specifically feminine attitude of surrender in relations with other men' (Halperin 2002: 122–3). This pleasure, then, threatened the equality of relations between men through which true manliness is achieved.

Yet this moment, and what it told about Lawrence, had revealed a greater problem, which speaks more to the preoccupations of Aldington and others with his potential homosexuality and its capacity to erode his narrative integrity – the inherent struggle of restraint in homosocial relations, and the

possibility of surrender. Lawrence expresses his ambivalent attitude to ambition, his discomfort with his pleasure in fame ('a horror of being known to like being known') and his 'self-distrusting shyness', all of which rest on a terror of the failure of masculine mutuality as the basis of 'fellowship' or manly love. He attributes to himself the obstacle of:

> a craving to be liked – so strong and nervous that never could I open myself friendly to another. The terror of failure in an effort so important made me shrink from trying; besides there was the standard; for intimacy seemed shameful unless the other could make the perfect reply, in the same language, after the same method, for the same reasons.
>
> (Lawrence 1935/26: 563)

It is only in the context of mutuality that relations between men become equal, impermeable to the shame of 'surrender'. And it is only in the context of that mutuality that they can be truly candid. And what threatens that mutuality is a dissimulation in one's own interest, a withholding of self and an enactment of self-estrangement that amounts to *impersonation*: 'I began to wonder if all established reputations were founded, like mine, on fraud' (Lawrence 1935/26: 562). Lawrence's inability to be 'candid' represented a form of partisanship that he proposes – in a statement that positions it as the coefficient of anality – has the capacity for destruction at a yet deeper level: 'the eagerness to overhear and oversee myself was *my assault upon my own inviolate citadel*' (Lawrence 1935/26: 563, my emphasis).

'Homosexuality' in 1950s Britain: inversion and perversion in 'the space of elsewhere'

Aldington's controversial pillorying of Lawrence in terms of a shameful, dissimulating – 'cunning' – and self-regarding homosexuality appeared in 1955, contributing to contemporary readings of *Seven Pillars* which suggested Lawrence's instability derived from a catastrophic homosexual shame (see James 2005: 431–47). An escalation of attention to the 'problem' of male homosexuality in the 1950s consolidated the definition of 'the homosexual' as a generalized 'disposition' within which was subsumed a sexual orientation – allowing the contribution of elements to converge in a fraught figure combining deviant gender and sexual definitions. In this context, Lawrence's disposition – his 'sexual indeterminacy' – became inflected by contemporary inquiry into the 'motivations' of the male homosexual. This interest was partly stimulated by a string of homosexual scandals, including the defections to the Soviet Union of Guy Burgess and Donald Maclean in 1951, the trial of Lord Montagu and Peter Wildeblood for homosexual offences in 1954, and ongoing cases of prosecution of public figures arising from newly targeted police operations in Britain's metropolitan centres (Hyde 1970: 212; Weeks 1989: 240–1; Waters 1999: 137–8; see also

Houlbrook 2005: 254). The film *Lawrence of Arabia*, released in 1962, was made in the four years following the publication of the Wolfenden Report, and released two months after the trial of John Vassall for espionage, amidst

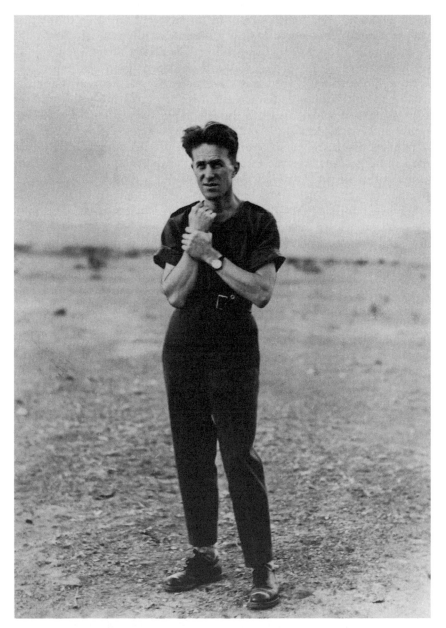

Figure 5.2 T. E. Lawrence in India in 1928 during his time in the RAF, after he changed his name to John Hume Ross. Image © Hulton-Deutsch Collection/CORBIS.

claims that he was recruited by the threat of blackmail for homosexual practices.

Lawrence of Arabia, then, appeared at the end of a period in which the popular classification of the homosexual and the features of homosexuality as a 'condition' were under revision.[28] An increased attention to the psychopathology of homosexuality, in this context, allowed a focus on the formation of the homosexual disposition and brought about a redefinition of the category of the 'invert'. But with the opening up of the pathway between 'homosexual propensities' (involving a psychic disposition as much as a sexual inclination) and homosexual activity involving acts of various sorts, social and sexual, the focus also fell on practices of 'initiation'. As the transition between disposition and act thereby became redefined as a matter of 'seduction' – leading an invert to adopt the practices of the pervert – the modern homosexual became associated with the lethal instabilities of the psychopathic personality. How did the Wolfenden Report aim to refocus public attention by delimiting homosexual offence, and in what way did other texts informing the Committee's – and the public's – consideration of the problem help to redefine the figure of the male homosexual? It is my argument that the modern notion of homosexuality as a defining 'orientation' became consolidated in a particular way in this period, providing an impetus for translating Lawrence's sexual indeterminacy and subjective fracture in this frame and creating a field of representational potential for Lawrence as a figure, with divergent outcomes.

The key initiative of the Wolfenden Report, in its reporting on the 'problem of homosexual offences', was its recommendation that male homosexual acts in private should be decriminalized. The Committee's founding distinction in making this case was that between homosexual 'offences' and 'homosexuality' as a state or condition (HMSO 1957: 11). Arguing that homosexual 'propensities' were not the business of law, the Committee nevertheless argued that it needed to investigate the psychological 'motivations' of male homosexuals, in order to understand how they came to commit offences – in other words how propensity could influence behaviour (HMSO 1957: 12). Without completely accepting the psychoanalytic claim that a homosexual component was part of every individual's make-up, it proposed that homosexual 'urges' were not confined to practising homosexuals, and a transient homosexual phase was 'very common' (HMSO 1957: 11–12). The Committee therefore argued against the view that homosexuality could be seen as a physical or mental disease or illness – and also against its corollary, that this should imply diminished responsibility in the case of homosexual offences, and be dealt with medically rather than penologically (HMSO 1957: 13–15). While its founding distinction acknowledged the formation of 'homosexuality' at the level of the individual, then, the Committee retained a focus that remained within the legal remit: offence. The offending homosexual breached the protocols of public demeanour – even in the context of consent. He therefore represented a

masculine lapse of will as the faculty that should overcome the bodily urges that derive from homosexual 'propensities'.[29]

Homosexual offences, therefore, warranted public regulation rather than individualized treatment. But in the Report's rezoning of the 'problem' of male *homosexuality* to a private domain, there to become a matter of self-management rather than of public regulation, the dissonance between homosexual exchange and public masculinity was translated to a problem of (homosexual) character. The reason why the Committee's logic, in this regard, took so long to gain public acceptance (in contrast to their complementary recommendations for increased policing of homosexual acts in public) was in this attention to the *passage between* homosexual propensities and acts. Discussed at length outside the Report, in the debates surrounding its recommendations, homosexual propensities became defined as antipathetic to a masculine disposition, as a component of those 'disinterested' relations between men whereby the public realm was constituted. While heterosexual associations – and those between women – are given a 'natural' location in the family, there is *no place* for associations between men in private that is not understood to have an origin in the public domain. Reciprocally, the private matter of individual discipline has implications for the governance of masculine relations in public. Moving between, the homosexual body disorganizes the boundaries between private disposition and public demeanour.[30] The concern that the Report's recommendation to decriminalize homosexual acts in private, rather than sharpening the line between public and private, suggesting a collapse of the distinctions between them, was articulated in the Commons debate:

> [In the Report] ... statutory authority is given to all adults to approach other adults and attempt by invitation or otherwise to get them to go to a private place for homosexual behaviour ... *Adult males can get other adult males to go to some private place.* They can set up as lovebirds anywhere.
>
> (Mann 1958: 455, my emphasis)

Homosexual acts in private in this reasoning – and the delicate division between character and conduct that would ensure an attentiveness to those infringements which implied offence – became a public matter, a matter of public regulation, a matter of public conduct. The fear that the Committee's recommendation would sanction a *pathway* between private propensity and public act, with homosexuality as a characterological disorder contaminating the protocols of public masculinity, appeared to be confirmed by homosexuals' 'shamelessness' in relation to the commission of offence: 'the increased tolerance [of homosexuality compared to that before World War One] has given homosexuals a greater feeling of importance. They are ready to admit their offences without any feeling of shame and guilt' (Gosling and Warner 1960: 181). In the space between 'homosexuality' and 'homosexual

offences', then, such debates give rise to a public figure of social shame: 'the homosexual'.

But if the nature of homosexual offence could be redefined, it was a relative term: what differentiated an act from an offence were the circumstances in which it was committed. The absolute it referred to and relied upon was, of course, the commission of a homosexual act. In this respect, the Committee argued that the most common homosexual act was one that could not be defined as an offence in the present law: solitary masturbation with homosexual fantasies. But the Committee also argued a homosexual propensity did not necessarily imply a homosexual act. What interceded, to prevent this, was the determining force of individual 'control' harnessed to social 'responsibility'. This allowed the Committee to reject the medical view put to them that homosexuality was an illness, invoking Barbara Wootton's view that 'the concept of illness expands continually at the expense of the concept of moral failure' (HMSO 1957: 13; Wootton 1956: 434). It was in the domain of individual 'responsibility' and 'control' that culpability could be ascribed. And it was on this basis that it asserted the remit of the law in relation to the commission of homosexual acts that constitute public offence and the limits of the law in matters of individual private morality (HMSO 1957: 24).

These were the limits the Committee set itself. And so it was that, although the Committee argued against employing the distinction between 'invert' and 'pervert' which some of its witnesses deployed, they did so on the basis of its value for differentiating levels of culpability, rather than its *definitional* value. Certainly, these two were terms with significant contemporary force in articulating the distinction between disposition and act that underlay the Wolfenden Committee's distinction between 'homosexuality' and 'homosexual offence'. The prevalent view of the divergence between the tragic invert and evil pervert is evident in the Church of England's influential 1954 advisory paper to the Wolfenden Committee, 'The Problem of Homosexuality': 'an invert is a man who from accident or birth has unnatural desires ... whereas a pervert is a man who either from lust or wickedness will get desires from either natural or unnatural functions' (cited in Allen 1962: 172; see also Waters 1999: 147–8). Articulating such a distinction relies on the attachment of sexual excess to the pervert: in pre-homosexual models, sexual excess – including that which was heterosexually directed – was associated with an effeminacy derived from an unmanly lack of restraint, an inability to master the impulse to pleasure, and a pliability (or 'softness') directed towards the exigencies of *seduction* (Halperin 2002: 111–12). Redirected towards the definition of the pervert, in this context though, it retains the implication of a distorted masculinity without the implication of effeminacy. But this is achieved by investing the category of the pervert with the meanings of *'perversity'* as *moral depravity*, or vice, rather than *'perversion'* as a *sexual orientation*.[31] If the invert suffers from a perverse form of sexual desire, this defines his disposition rather than his behaviour. And since

disposition must be concretized in behaviour for moral culpability to be associated with it, it has no implication of 'perversity'. But the pervert's own characterological distortion is divested from a sexual orientation: the commission of the act is imbued with the deviant qualities of 'lust' or 'wickedness', allowing individual impulse to prevail over social restraint, rather than an unchanging disposition. In these terms, the distinction represented a *reversal* of those pre-homosexual models from the convergence of which the modern notion of homosexuality was developed: distortions of sexual desire – those of the 'active' homosexual, or the active figure in homosexual exchange – now become more monstrous than those instabilities of gender that gesture back to the fundamentally disordering – effeminate and passive – figure of the *kinaidia*.

This dual definition informed the contemporary view of the Burgess and Maclean case. Guy Burgess' homosexuality comes to be seen as the sign of a character of 'innate viciousness' whose perversity leads his charismatic influence – residing in his 'squalid' and 'grubby' 'charm' – to be put to destructive ends: 'the flashing smile of the fire-raiser, full of secret pleasure in mischief and destruction'. Preying on Donald Maclean's suppressed homosexual propensities, weakly controlled by an 'infantile' 'hysterical' character, he entices him away from his family into national betrayal, espionage and treason and personal destruction (see West 1965: 255–60). The distribution of moral blame is clear: Burgess' homosexuality is due to perversity, Maclean's due to his perversion, Burgess represents the evil pervert, Maclean the tragic invert.

But the Church of England's definition of the invert is based on an inherent or 'accidental' (environmental) constitutional perversion of desire. Its lack of attribution of culpability to the invert – legal or moral – lies in the lack of presumption of an act. The invert needs to have committed no act to be defined as such: rather, his is a *condition*, over which he has no control. In the Wolfenden Committee's concern with the distinction between constitution and offence, the act may be the condition of offence but it also gives it a definitional contingency – the nature of the circumstances in which the act occurs. But in the Church of England's invocation of the figure of the 'invert' as a figure of perverse (i.e. unnatural) desire, the concern passes to the distinction between constitution and act *per se*. If, in this model, the onus is on the act itself, the invert is consigned to continence as a result of his impossibly perverse desire.

If offence must be based on the act, and so distinguished against homosexual constitution, the boundary between constitution and act becomes definitionally prominent. This is brought into sharper focus by the dispersal of such models as that put by the Church of England, but also on the conflation of act and offence in the existing law at this time.[32] Furthermore, in the Report's opening sections on 'homosexuality', considerable space is given to forms of homosexuality which are based on continence, in the discussion of sublimation and latency. In the course of this framing, it draws a

form of positive continent homosexual definition that manifests in a variety of non-sexual ways.

Sublimation, the redirecting of a homosexual drive towards an acceptable aim, provided a means for those with an acknowledged homosexual disposition to rein in their propensities. An irreducible danger, however, lies in the ineradicable presence of homosexual propensities, and the imperfection of those forms of restraint that would prevent the condition manifesting in overtly sexual behaviour:

> Many persons, though they are aware of the existence within themselves of the propensity, and though they may be conscious of sexual arousal in the context of homosexual stimuli, successfully control their urges towards overtly homosexual acts with others ... so that their homosexual condition never manifests itself as overtly sexual behaviour. There are others who, though aware of the existence within themselves of the propensity, are helped by a happy family life, a satisfying vocation, or a well-balanced social life to live happily without any urge to indulge in homosexual acts.
>
> (HMSO 1957: 12)

Latent homosexuality, which differs from sublimated homosexuality in being a disposition that the individual is unaware of, is nevertheless related to it through the lack of overtly sexual behaviour. The Committee indicates that the features of an unacknowledged homosexual disposition may emerge in ways that allow sublimation to occur:

> among those who work with notable success in occupations which call to service to others, there are some in whom a latent homosexuality provides the motivation for activities of the greatest value to society. Examples of this are to be found among teachers, clergy, nurses and those who are interested in youth movements and the care of the aged.
>
> (HMSO 1957: 13)

In fact, most of the sociological and medical accounts of male homosexuality from the 1920s to the 1960s make a distinction between 'homosexual propensities' which could be sublimated in socially valuable work, and an involvement in homosexual activity (for example, see Anomaly 1927: xii, 117–28; Allen 1962: 196). Sublimation offers the space for a continent form of homosexual pleasure divested of social shame. In fact, one of the Committee's achievements in acknowledging a homosexuality that is not tied to its expression in a homosexual act – even while we must acknowledge that in this period it was predicated on a suppression of sexualized forms of presence and behaviour – is to point to *a dispersed form of non-sexual homosexual expressiveness*. In this way, however, it also discounts the possibility of a sexually indeterminate masculine self-definition, recasting it in terms of an

unacknowledged homosexual disposition, and providing the context for the figure of Lawrence to be recast in terms of homosexual expressiveness.

'The space of elsewhere': dispersal, displacement and sublimation

The fascination of Lawrence's escape from the conventional coordinates of masculinity – based on *Seven Pillars* but informed by the debates of the 1950s – provides the context for the film of *Lawrence of Arabia* to draw on two modalities of homosexual expressiveness. The first relies upon his own account of continent homoeroticism, pointing to a voluptuous pleasure in his abandonment, while the second regime invokes the figure of the 'invert', originating in a dissonance between masculine physiology and feminine psychology, and depicted in terms of a 'weakness' or passivity which is given a positive inflection through its sublimation. The common element in these two models is that they are not dependent upon the existence of homosexual activity.

Such a sublimated, non-sexual, homosexual expressiveness provides an aesthetic repertoire for Lawrence of Arabia. In this, it departs from the model of those contemporary British films which represent male homosexual exchange, whose attention to the passage from constitution to act points to the tragedy of an inversion which cannot be contained by continence: constitution configured in terms of social shame. A film such as *Victim* (Basil Dierden 1961), whose narrative concerns homosexual blackmail, uses a landscape of private, dark, hidden spaces, austere back rooms, pinched passages and dingy corridors, in a scenario concerning the passing over of sexual evidence in secret packages. The film takes up a liberal position on legislative debates over homosexuality, locating the 'problem' of homosexual blackmail not in homosexual activity but in ignorance and prejudice. But it elaborates this threat against a range of drawn and grey, haunted and paralysed, homosexual characters. Even as it represents the victim of blackmail – the tortured image of the loyal husband struggling to overcome his homosexual inclinations – in the restrainedly elegant and emotional performance of Dirk Bogarde, *Victim*'s constitution of homosexuality is undoubtedly one of the closet; the confinement of private shame, a secret, an interruption of the constitution of public masculinity within British national identity. Even the moment of a representation of passionate longing that Andy Medhurst uses to retrieve in *Victim* the articulation of homosexual desire – Bogarde's passionate delivery of a speech where he talks of 'wanting' the boy Barrett (Medhurst 1984: 31–2) – derives its effect from a break in his voice, an aural *interruption*, a strangulated disordering of speech. In contemporary films addressing the 'social problem' of homosexuality, the forms of rhetoric for male homosexual desire foreclose its expressiveness.

In contrast, the figure of Lawrence is clearly situated by more expansive repertoires of homosexual identity and behaviour. His exhibitionistic delight in disguise and cross dressing, his feminized appearance, his gestural and linguistic hesitancy, all invoke the motifs of a dispersed, non-sexual, form of homosexual expression in the late 1950s. But further, in *Lawrence of Arabia*, we find a relocation of the generic framing of divergence away from the internalized aesthetics of suppression pervasive in British films of this period, towards a repertoire of expressive fullness, as the signatures of gender are rearranged into a spectacular, cinemascope and technicolour aesthetics of an epic of travel. This plenitude of visibility and the swelling waves of the orchestral score figure Lawrence's unresolved subjectivity not through negation and interruption – a gap, a flaw – but through *immensity*. Lawrence's movement across the desert escapes the meanings of lineage, location and masculine embodiment, the everyday.

Elusive and permeable in the billowing folds of his Arab robes, his figure is constantly resituated as the changing terrain of the desert and the shifting sands transform the contours of a landscape across which corporeal relations are enacted. Caren Kaplan points to the alliance between the 'desert as a site of critical and individual emancipation in Euro-American modernity [and] the nomad [as] a subject position that offers an idealized model of movement based on perpetual displacement' (Kaplan 1996: 66).[33] Boundariless, infinite and continually in a process of transformation, the situating of a refigured body of contradictory sexual inscriptions in the desert is one of the most striking differences of *Lawrence* from contemporary masculine images. Rather, as Marjorie Garber notes, it connects with a sexualizing of the desert – in narratives predicated on masochistic submission – in films of the 1920s, distilled in the iconic white-robed figure of Rudolph Valentino, which provide a contextualizing reference point for the later filmic representation of T. E. Lawrence (Garber 1992: 309). This suggests a shared exaltation in evasion and indeterminacy: Lawrence's image as the embodiment of inversion.

This figuration of Lawrence's body disrupts not only the coordinates of contained corporeality, but also the organization of geographic and cinematic space, as the sublime landscape of the desert is associated with a subjectivity cut loose from its conventional coordinates. A barren and uncultured landscape has long been associated with the sublime as a solitary experience in which sensibilities are extended, and visionary capacities and physical powers are enhanced, in the escape from the visual contours of the everyday (see Horne 1991: 87). But the alliance of a panoramic gaze – endlessly displaced by new and ever proliferating views – with the landscape of the desert blocks the positioning and sociality of commanding vision, which depends on an elevated and distant fixed viewpoint that links vision and knowledge in an assertion of absolute space (Harvey 1989: 224, 260). As it moves across the spaces of the desert, then, the panoramic gaze and its cinemascope image in *Lawrence* replaces the authority of commanding height with an assertion of

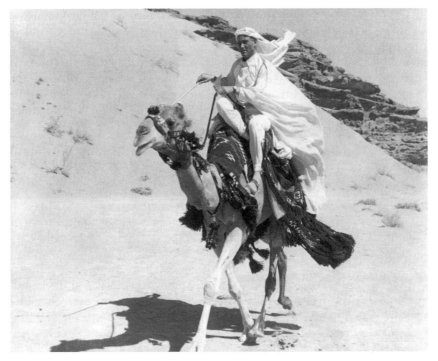

Figure 5.3 Peter O'Toole as Lawrence in *Lawrence of Arabia*. Image © Underwood
 & Underwood/CORBIS

horizontality; the aesthetics of abandonment and the dream of the unbroken
vista that dissolves boundaries and secure classifications (Burns 1991).

As the expanse of the desert opens out vista, it simultaneously prevents
the visibility of one's own position by reference to landmarks, through the
'vertical deprivation' of endless desert and a receding horizon (Carter 1987:
285). The *cost* of excessive visualization, then, is placelessness, the dispersal
of self. As Paul Carter has noted, the immensity of space suggests to the
traveller 'the tenuousness of his balance and stability in the world' (Carter
1987: 289). At the other end of the freedom of the open expanse of the
desert is a terrain where space fails to cohere into place around the stable
perspective of the subject. At the other end of the repertoire of non-sexual
homosexual expressiveness is the perpetual displacement of placelessness:
wandering in the space of elsewhere, the homosexual body embodies the
perspectival chaos that threatens the dissolution of subjectivity.

Against this background, Dera disturbs the pleasure in abandonment and
immersion, and provides the mechanism for homosexual propensities to
develop into something more lethal, investing Lawrence's 'instability' with
murderous consequences. The film's change of tone after the Dera incident,
as the damage to Lawrence is shown to lead to the murderous climax of the
Tafas massacre, and its omission of the period of Lawrence's life documented

in *The Mint*, which allows this event to be succeeded by the final sequence including his fatal motorbike ride, allows Dera to give a particular reinflection to his temperament and connects him to contemporary pathologies of homosexuality. Focusing on the circumstances in which homosexual propensities give way to homosexual acts – and the lethal effect of this collapse – the reinterpreting of the figure of Lawrence in terms of what now comes to be proposed as the pivotal event of *Seven Pillars* articulates a contemporary preoccupation with homosexual *seduction*.

Inversion, perversion, seduction

As the Wolfenden Committee discussed the disjunction between homosexuality and homosexual acts, it is clear that while sublimation was defined in terms of restraint, or self-control, in its dependency on a continent form of 'homosexuality' it simultaneously invoked the possibility of its failure, in lapses of continence:

> Our evidence suggests however that complete continence in the homosexual is relatively uncommon – as, indeed, it is in the heterosexual – and that *even where the individual is by disposition continent, self-control may break down temporarily under the influence of factors like alcohol, emotional distress or mental or physical disorder or disease.*
>
> (HMSO 1957: 12, my emphasis)

The sublimation effect that defined latent homosexuality was particularly fragile, its sublimation being achieved by processes inaccessible to the conscious mind. But if latent homosexuality could be directed to socially acceptable ends through its repression, the Committee also suggested that its unconscious mechanisms may be manifested in other – more troubling – forms of non-sexual behaviour:

> Sometimes, for example, a doctor can infer a homosexual component which accounts for the condition of the patient who has consulted him because of some symptom, discomfort or difficulty, though the patient himself is completely unaware of the existence within himself of any homosexual inclinations. There are other cases in which the existence of a latent homosexuality may be inferred from an individual's outlook or judgement; for instance, a persistent and indignant preoccupation with the subject of homosexuality has been taken to suggest in some cases the existence of repressed homosexuality.
>
> (HMSO 1957: 13)

Such comments suggest that the public danger of homosexual lapses is more closely related to the presence of men with sublimated homosexual propensities – acknowledged or latent – and their susceptibility to committing

those acts which may comprise an offence, than it is to the practising homosexual whose propensities are satisfied in private. This creates a particular attitude to the homosexual's susceptibility to lapses, and the precipitating conditions of the passage from homosexual disposition to act. The more subtle repertoire of restraint and indeterminacy mobilized in the period in which the earlier narratives of Lawrence appear is surpassed: as the exchange between inversion and perversion becomes consolidated in an attention to practices of initiation, a model of sublimation becomes transformed by the repertoire of seduction.

While some sociological accounts advocated 'sympathy' for the predicament of individual homosexual men, they also proposed that the prevalence of male homosexuals in the community constituted a 'social infection' (Hauser 1962: 24; Gosling and Warner 1960: 185). Most of the calls for a replacement of juridical with medical treatment were motivated by the understanding that 'one-sex institutions' like prison 'spread' homosexuality, on the basis that 'the urge will always seek its outlet, and if the natural object is absent it will find a substitute' (Gosling and Warner 1960: 181). The presence of homosexuals in prison thus endangered those with unrealized propensities: 'The homosexual is becoming bolder and a great many are going outside their own circle for their affairs, thus helping to widen the incidence of homosexuality among men who might otherwise have remained heterosexual' (Gosling and Warner 1960: 181). It was precisely the foregrounding of seduction which characterizes the public trials and sociological investigations of homosexuality, with a corresponding preoccupation with individual 'susceptibilities', those features of character which allow an individual to be drawn to homosexual activity, or lapse from continence, within psychological disciplines. This recasts the expansive repertoire of homosexual expressiveness into one of seduction, turning on the boundary between the 'normal' world in which a homosexual disposition was offered the space for a sublimated expression, and that space of 'elsewhere' in which a secret, internalized homosexual communicative code allowed a 'perverse freemasonry' to flourish:

> There is a kind of 'freemasonry' among homosexuals. John Gosling has seen them seek each other out in large crowds, sometimes by a special type of ring worn on the wedding finger, and sometimes by casual remarks. They use an argot and a phraseology meaningless to the heterosexual but fraught with significance for the fellow homosexual ... Another method of making contact with fellow homosexuals is to chalk up signs in the farthest corner of public conveniences. The signs are unintelligible to all but the *uninitiated*.
> (Gosling and Warner 1960: 184, my emphasis)

Those dialogues and practices of a hidden homosexual freemasonry formed the basis of the Wolfenden Committee's induction into the world of

London's homosexuals, in the interests of familiarizing its members with their 'motivations'. Testimony from detectives involved in homosexual entrapment provided, as Frank Mort has demonstrated, a 'sexual map of the metropolis', even though the translation of that expressive code used between members of the initiated emerged in the service of the eradication of homosexual sights (Mort 1999: 102). This was complemented by Peter Wildeblood's testimony, which, framing the homosexual experience in terms of 'inversion', rendered a 'psychic map of the mind', making at the same time an argument for disclo-sure (Waters 1999: 143–51; Mort 1999: 111). His argument proposed the movement beyond an internalized network of communicative transparency to an openly expressive repertoire of homosexual identity unsecured by those forms of restraint which presumed continence as their aim:

> [Wildeblood's account was framed in terms of] the discourse of sexual disclosure … [declaring] his sexuality openly, as a form of identity which was constitutive of his personality … Bound up with that commitment to openness was a distinction between two different social spaces which were available to the homosexual: confined and guilty, private space and a public arena, in which a more open life might be lived. As Wildeblood put it, a life lived in secret crippled the personality; freedom brought 'decency and dignity' to a homosexual's sense of who he was.
>
> (Mort 1999: 109)

The 'movement beyond' the shaming confinement of the homosexual freema-sonry was predicated on the public recognition of practising homosexuals. And yet, the social shame of 'sexual perverts' lay in 'blatancy', a 'glorying' in their shame (see Houlbrook 2005: 244). The way that this might be resolved was through an expressive aesthetics of restraint, demonstrated in the discre-tion of the 'respectable' homosexual, which, rather than marking itself out from heterosexual marriage – an 'unspiritual' 'to and fro' in Lawrence's description – validated itself through its *replication* of the 'spiritual reciproc-ity' of domestic, marital relationality (see Houlbrook 2005: 249).

Wildeblood, in fact, predicated his bid for acceptance, in *Against the Law*, published in 1957 and in a Penguin edition two years later, on precisely this delicate marking out of the unshameful – as opposed to shameless – homosexual identity, arguing for tolerance for those men who appear 'like everyone else' 'outwardly respectable', discreet and 'careful', 'quiet and well behaved' (Wildeblood 1957: 13, 39).[34] Wildeblood reworked the notion of inversion away from biological models to argue that homosexuality was not a 'monstrous perversion deliberately chosen', as the current state of the law would have it, nor was it a form of effeminacy (he cited Lawrence of Arabia in support of his claim that it had been practised by war-like peoples and fig-ures), but a 'condition of mind' which coloured a 'whole outlook' (Wildeblood 1957: 11, 39). He argued that this condition differentiated men in 'only one respect', that of being attracted towards men, and as such it was

a personal issue of which he was no more ashamed 'than I would be of being colour-blind or of writing with my left hand' (Wildeblood 1957: 8).

As an unchangeable condition, a 'tragic disability', Wildeblood argues for a form of homosexuality based not on continence – as it must be to remain lawful – but on lack of harm, which derives from mutuality: '[the homosexual] cannot see why he should be condemned to perpetual continence, when there are so many other men like himself with whom it would be possible to enter into a relationship which would do no harm to anyone' (Wildeblood 1957: 12). The lack of shame associated with such a lack of continence derives from the homosexual's deployment of restraint in the service of an alternative and self-defining moral code, and its foundation in mutuality. In this, it contrasts with a (shameful) model of heterosexual excess – 'promiscuous' and 'deceitful' seductions – and the 'agony and shame' through which he characterizes his relationship with the RAF corporal, Eddie McNally, who testified against him in his trial (Wildeblood 1957: 37). Based instead on the disjuncture between Wildeblood's quest for 'an ideal companion; someone strong, courageous and reliable' and McNally's weakness, effeminacy and perverse hatred of the very kind of men he sought out, this disjointed correspondence is precisely the inverse of mutuality, hence its shamefulness (Wildeblood 1957: 42–3).

In the recognition that he will remain a social misfit, denied the 'companionship that comes with marriage, or the joy of watching his children grow up', the homosexual seeks a partner 'so that together they may build a shelter against the hostile world'. These are the 'austere consolations of self-knowledge and integrity', the 'strict morality' of the men who attempt to resolve their own struggle according to the principles of 'moral law' (Wildeblood 1957: 8–13). Regimes of restraint become reframed, in this context, entailing not sexual continence, but another austerity, a form of social continence, as the male homosexual finds solace in a life lived apart, mutuality formed in the space of 'elsewhere'.

But a homosexuality without the continence assumed by sublimated modes was nevertheless tied in indissoluble ways to the dangers of seduction by the *disjunctiveness* of 'the homosexual world' (Wildeblood 1957: 39). While the Wolfenden Committee and psychological expert testifiers dismissed the idea that a homosexual disposition could be created by 'seduction in youth' (HMSO 1957: 15–16, 33; Chesser 1958a: 55), in relation to the age of consent for homosexual acts in private the Committee endorsed the view that it should be higher than that relating to offences against young girls, on the basis that 'a boy is incapable, at the age of sixteen, of forming a mature judgement about actions of a kind which might have the effect of *setting him apart from the rest of society*' (HMSO 1957: 27, my emphasis).

The acceptance of those forms of homosexual expressiveness directed beyond the boundaries of homosexual recognition, and designed to create for the homosexual a public presence alongside 'the rest of society', is, however,

hampered by the collapse of distinctions between invert and pervert in the repertoire of seduction. It is not just the 'shamelessness' of 'blatant' homosexual sexual expressiveness, but the possibility that this may in itself create a pathway to initiation, the passage between propensity and act, with potentially irremediable results. As the *Sunday Pictorial* series on 'Evil Men', published in 1952, stated: '[S]o many *normal* people have been corrupted and in turn corrupt others ... once a callow youth has become enmeshed in the practices of the pervert ... it is hard to win him back to normal life' (*Sunday Pictorial* 25 May 1952: 6). The forms of fascination invoked by the category of the homosexual – the ability to move into another space beyond the limits, to offer infinite and unknown gratifications – simultaneously place those who succumb to their charms outside the coordinates of 'ordinary human action'.

In contemporary representations of homosexual expressiveness the fractures to public masculinity were embodied in figures of fascination *and* danger. The motifs generated by such disturbances to the repertoire of sublimation are clear in a depiction of John Vassall by Rebecca West, writing in 1965 but reflecting on the impact of the events surrounding his trial in 1962. Here we find a feminized figure, 'doe-eyed, soft-voiced, hesitant and ephebic', 'a much sought-after "queen", playful and girlish' (West 1965: 361–2). Vassall is represented as wandering in an interim space between worlds:

> The public imagination was haunted by visions of the slender figure in sweater and tight jeans who lurks in the shadow by the wall, just outside the circle of the lamplight, whisks down the steps of the tube-station lavatory, and with a backward glance under the long lashes offers pleasure and danger.
>
> (West 1965: 382)

As the homosexual represented a realm of unlicensed corporeal pleasures, the spaces outside 'normal life' constituted the space of elsewhere as the site of lethal pleasures.

Wildeblood's testimony stands as a significant attempt to redefine the notion of inversion, away from the dichotomized figures of invert and pervert embodied in the definition put forward by the Church of England. In this revised model, the notion of inversion is stripped of its opposition to the moral failure involved in lapses of continence, and redirected towards a repertoire of sexual openness. But it was another aspect of his argument which helped to supplant a notion of homosexuality as torn between tragically restrained inversion or monstrous perversity, with susceptibility of unmastered 'propensities' providing the passage between. For, he argues, homosexuality derives from a developmental arrest which disturbs the adolescent boy's passage from an original bisexual formation to an exclusive attraction towards the opposite sex: 'The man remains as the child was, failing to discriminate between the sexes; or he develops in the abnormal direction of being attracted only towards his own sex' (Wildeblood 1957: 10).

In this context, Wildeblood rests his case on the most radical innovation to notions of inversion, made within 1950s psychopathology. In their development of a model which accepted neither that homosexuality was an 'inborn' condition, nor that it arose from a 'perverse wish to behave differently from others', but retaining inversion as the central term informing a homosexual disposition, psychopathologists argued that a homosexual disposition was created by early influences and hence was neither a matter of heredity, nor a sign of individual corruption. Rather, its 'tragedies' resulted from an 'immaturity' or a lack of development formed from dysfunctional family patterns which were as unwilled as 'dwarfism' (Berg and Allen 1958: 35).

The prominent psychopathologist Clifford Allen[35] – himself opposed to the imprisonment of homosexuals and instead supporting treatment and affirming the possibility of a 'cure' based on insulating those with homosexual propensities – claimed that, if left untreated, homosexuality would be more likely to lead to psychoses than the other sexual perversions (Allen 1962: 181–8). Allen also claimed that homosexuals were fixated in an incestuous stage of infantile development which meant that 'the average invert has strong ambivalency in his emotional relations which make his affections a source of danger to the loved one', making homosexual murder common, and compelling homosexuals towards suicide (Allen 1962: 186). In this, Allen is drawing on a widespread association between homosexuality and psychopathic personality introduced by the leading criminologist Norwood East.[36] East defined the psychopathic personality as 'a non-sane non-insane individualistic and discordant person', citing T. E. Lawrence as an example of the supernormal psychopathic personality who 'may be unable to overcome his constitutional disabilities ... his range of usefulness is restricted if his responses to stimuli are ruled by perverse urges and inhibitions' (East 1949: 129–30). In the same volume, he emphasizes that sadism and masochism are linked and, though not exclusively linking either with homosexuality, suggests that sadism is a 'common accompaniment of homosexual crimes' (East 1949: 114–15).[37] What comes to replace the dichotomized model of invert and pervert, then – continuing the trajectory initiated by the motif of seduction – is a developmental model within which inversion is defined as a developmental disorder relating to psychopathic trends which render the homosexual susceptible not to 'corruption', but to a form of subjective disintegration: psychosis.

It is this dangerous outcome which the distinction between disposition and act signals in the late 1950s. And the pathway between homosexual disposition and homosexual activity is provided in the exchange between 'seduction' and initiation. The instabilities of character implied in this model of homosexuality are understood to inaugurate a dispersal of subjectivity which renders them as nothing more than an immoderate absorption into 'intensities', with lethal consequences.

Flying or drowning: the dangers of unbecoming

It is this context of knowledge that allows accounts of Lawrence to move from an elusive indeterminacy, or ambivalence, to become an embodiment of a divergent model of vulnerability and perversion. The passage from one to the other, from homosexual propensities to homosexual activities, and its consequences for masculinity, is what preoccupies the film of *Lawrence of Arabia*. While Lawrence's 'fascination' offers the pleasure of wandering, abandonment and the sublime, cross-cultural identification and sensual pleasure in the first part of the film, *Lawrence of Arabia* also works from the instability attributed to homosexual consciousness and the homosexual body. Here, rape and other forms of sexual initiation are elided in the implication that physical penetration had the capacity to unleash in Lawrence a foundational, and lethally suppressed, homosexuality, motivating an outpouring of murderous sadism, and the framing of his 'curious' motorcycle accident as suicide.

The second part of the film narrates Lawrence's descent into brutality, murder and corporeal debasement as his involvement with the Arab Revolt sees him acting outside Anglo-French military strategy and ceding the rational embrace of military discipline to an emotional identification with the Arab cause which brings him to enact the massacre at Tafas as an act of revenge. But the event which provides a route from the earlier 'Lawrence' to the later one is that of Dera, a pathway premised on the relationship between seduction and initiation, and its destructive consequences for masculine self-definition: for it is this event which brings him to grovel in the blood of the Turks at Tafas.

Caught between drowning and flying, faeces and poetry, the desert figure wanders between the fear of the void and the fantasy of the sublime. Although the film's aesthetic offers the pleasures of abandonment, even the repertoire of horizontality and panoramic space invokes the 'other' side of the anal scenario. The fascination implied by breaking free of sexual and cultural categories is linked to the 'repulsion' that such a disordering of systems of difference also brings. In discourses of homosexuality, that repulsion is associated with the meanings of anality, the descent into psychosis, and the unravelling of masculinity.

As his Arab identification disorders masculinity itself as the proposition of cultures, the awkwardness of Lawrence's mastery of the processes of survival and accomplishment in the desert exposes his existence between the domains of classification. As the Bey touches his body and comments on the fairness of his skin, we see that his is an incomplete mimicry. He justifies his attempt to recoil from the Arab Revolt by pointing to the same piece of skin caressed by the Bey: 'A man can do whatever he wants ... but he can't *want* what he wants; this is the stuff that decides what he wants ...' A mark of his different constitution, this irreducible bodiliness renders masculine identification incomplete; its failures are to be read from his body's surfaces. In the spaces of masculine exchange, Lawrence remains 'between'.

The negative meanings of the anus in this cultural repertoire are evident in the depiction of the events of Dera in *Lawrence of Arabia*, as Hajim Bey examines Lawrence's body, ordering him to be beaten. As Lawrence is pushed down to lie face down onto a bench, the Bey looks from the door-way, gazing directly between Lawrence's splayed legs. When Lawrence is finally released, he falls, exhausted, into the mud. Implications of buggery are as inseparable from the beating here as they are in the controversies over his accounts of what happened at Dera. However, they have none of the delicate alliance of pleasure and pain that exist in his own renderings and lack the ambiguity in Abraham's comment on war neurotics that 'the dam-aged part of the body receives from them a significance as an erotogenic zone which did not previously belong to it' (Abraham 1921: 27). Thus they validate only one side of the double meaning of the anal scenario, moving beyond the pleasures of seduction to its consequences for masculine self-definition. Thrown out like waste, Lawrence's beaten body represents homosexual desire itself: the breaching of corporeal boundaries and the possibility of passive pleasure and its dangers to masculine subjectivity.[38] To T. E. Lawrence in *Seven Pillars of Wisdom*, the Arab is like water – elemen-tal, fluid, liminal, without boundary or edge. 'And like water,' he says, they 'would probably prevail' (Lawrence 1935/26: 43). So they do, but for the figure of Lawrence of Arabia following the Wolfenden decade, for whom there is now 'only the desert', the anal body is marked under the sign of absence, emptiness, meaninglessness.

Postscript: unravelling colonial masculinity

Lawrence of Arabia wrote in its own way a sexuality posed as problematic in this period, one which was used to play out a series of concerns over British national identity and cultural authority. But why, in 1958, would David Lean and Sam Spiegel (its director and producer), bent on a film about Gandhi, switch to finding an intelligible project in the narratives of Lawrence? As the possibilities and dangers of 'passing between' are mapped on to the unstable figure of Lawrence in the desert, we can read its representations of differences back on to those which clustered around a fragmented national masculinity and its declining hold on a position of cultural centrality.

That there was an overlap in systems of knowledge shared by those sur-rounding the Suez affair and the film is signalled by the appointment of Anthony Nutting – who resigned from Eden's government on the sailing of the British expeditionary force – as the film's Director of Public and Political Relations, and in his authorship of a connected biography of Lawrence (Nutting 1961). But there is a further chain of association between the events of Suez and public debates over male homosexuality. It was Sir David Maxwell-Fyffe who had announced that 'Homosexuals, in general, are exhibitionists and proselytisers and a danger to others, espe-cially the young ...', and was Home Secretary during a period in which

homosexual prosecutions in London escalated and there was a proliferation of trials of public figures for homosexual acts (Weeks 1989: 241).[39] It was also Fyffe who set up the Wolfenden Committee – and subsequently argued against its recommendations to decriminalize male homosexuality in private. In 1956, now restyled Lord Chancellor Kilmuir, it was his sanction that allowed the British expeditionary force to sail.

Peter Rawlinson, in his autobiography, talked of the Suez crisis as that which brought the House of Commons to '[erupt] into a madhouse':

> For a government backbencher it was rather like being a spectator with a ring-side seat at a particularly bloody prize fight, in which one's own man was often on the ropes, sometimes driven to the floor but somehow always climbing back on to his feet to carry on the fight, acquiring thereby a dignity which his attackers singularly lacked ... The passion and the fever swept away all judgement. We were all naked partisans.
>
> (Rawlinson 1989: 69–70)

These interconnections of personnel and their involvement in events surrounding Wolfenden, Suez and the filming of *Lawrence of Arabia* suggest historical events do not proceed on an autonomous basis, according to a defined set of principles, but through the deployment of common cultural repertoires and may be as driven by the instabilities deriving from the unhinging of their certainties as by positive determinations.

The nationalization of the Suez canal – the event that precipitated Britain's 'Suez crisis' – represented a weakening of Britain's colonial hold on the Middle East. In his contribution to the fostering and supporting of the Arab Revolt against the Turks in World War One, Lawrence had helped ensure that the Allied Forces – Britain, France and Russia – gained control of Arab territories. If 'the potentially explosive power of Arab nationalism thus became a key to Britain's plans for imperial expansion in the Middle East' after World War One (Spurr 1993: 129), in the 1950s that same power was turned against Britain, exploding its own sense of imperial power and centrality. Britain's 'Suez failure' therefore directly undid and reversed the very achievement and 'triumph' created by Lawrence's support and betrayal of the Arab cause, rendering his figure as a hero as problematic as that of British imperial masculinity itself.

In the exchange between masculinity and national affiliation, an overlapping range of knowledges – specifically those concerning male homosexuality – informed the figuration of the male body in a film whose immediate landscape was one of British colonialism. As the spaces of empire contracted from the late 1940s, so too national spaces became rezoned as immigration, the changing sexual profile of labour relations and the recasting of class boundaries exercised the formulation of legislation and government policy in 1950s Britain (Hall 1980). International relations became strained as British public services submitted to US pressure to

'purge' homosexuals who were held to corrupt the integrity of social institutions. Espionage scandals showed the extent to which concerns over the alteration of the 'natural' patterns of British social life, the permeability of not just social and national boundaries but the contours of British national identity, could be mobilized in an address to questions of sexual definition and exchange.

Following Britain's disastrous attempt at military intervention after the Suez canal was nationalized in 1956, colonial dynamics took on a problematic recognition of failure. Yet while the 1950s biographies of Lawrence may have foregrounded the 'darker' side of the Desert Campaign and made the selection of this particular subject relevant in the aftermath of Suez, *Lawrence of Arabia* recasts the discourses of colonial erosion, offering a *pleasurable* engagement with scenarios of dispersal, of fragmentation and loss. This is achieved in the figuration of Lawrence's body within a space of extended horizontality through the alliance of desert landscape, a panoramic gaze and its cinematic correlative in the cinemascope image. The pleasures *and* torments of Lawrence's corporeal instability are based on his mobility in an unsecured landscape.

In the context of colonial decline, there are further spatial disruptions, as reterritorializations bring into view those spaces 'in-between' which have no place in the colonial accounting of cultural difference, and the hybrid identifications that are part of colonial presence are displaced back onto the places of 'home'. For as the shift towards Arab nationalism is consolidated through the nationalization of the Suez canal, this gesture does more than cut loose from a colonial power and reverse colonial dynamics – bringing about 'Britain's final military and diplomatic humiliation' (Bohne 1990: 3–4) – it rezones the territories of the Middle East, shifting the centre of meaning to a Pan-Arab position that was inconceivable within a colonial rhetoric of national identification and difference. The gesture of nationalizing the canal not only exposes the specific spatiality of colonial discourse but also reverses the colonial gaze, to bring the figures embodying colonial presence within its sights.

As Arab nationalism presses its own designations of otherness into colonial dynamics, systems of cultural difference are confounded. The conventions of colonial geography are 'not only literal descriptions of the physical settlement patterns of the European community, but also vivid testimonies to the culture's obsession with naming, with demarcation, and with segregation' (Ching-Liang Low 1989: 84). This spatial order offers a unified position of colonial authority and coherence, maintaining a separation, a difference, from a culture where 'private and public spaces are not delineated', which threatens to 'run riot, spilling and intermixing', and so lies 'out-of-bounds' for colonial subjectivity (Ching-Liang Low 1989: 87). But these demarcations also provide the conditions whereby centrality becomes destabilized. For Greenblatt, 'the colonial impulse is a desire to know one's own culture by the encounter of, the knowledge of, that which

is alien' (Greenblatt 1991: 124). In its pursuit of the possession of the other as an *alien* object, the constitution of self within the colonial dynamic moves from radical alterity to *an identification that risks self-estrangement*, as military encounter is read in terms of attachment and differentiation (Greenblatt 1991: 128).

After Suez, then, the canal becomes the mark of another passage between. As the territories of Europe's other shift, such a gesture renders British colonial discourse meaningless: a gap, or tear, in the figuration of British identity whose distinctive intelligibility is formulated around an irreducible difference designated in space and ultimately marked upon the male body. This exchange is the precondition for the existence of a hybrid third term, one that testifies to a loss; of certainty, of cultural authority, of the centrality whereby colonial identity can be secured. It simultaneously undermines the fiction of a self-sufficient masculinity whose coordinates are of difference rather than dependency as it allows the pleasures of absorption, the pleasures of other worlds and hybridizing exchanges. As his 'lawlessness' draws on the psychopathological models of male homosexuality circulating in the 1950s, the figure of Lawrence in the desert accomplishes a double task. It designates a cultural and sexual instability that now shows the impossible fiction of British masculinity, in its relation to cultural achievement and colonial authority.

6 'Good-time girls' and a 'thoroughly filthy fellow'

Sexual pathology and national character in the Profumo Affair

A problem of knowledge: sexual definition and national character

The sex scandal presents a problem of knowledge: secrecy and the recipro-cality of concealment and revelation are vital to the dimension of scandal in sexual narratives. But the representation of scandals in Britain in the 1950s and 1960s becomes part of a larger operation of sexual debate and contro-versy, drawing on a public domain of sexual knowledges and bringing into focus the different ways behaviours and relationships, identities and collec-tivities are made sense of in law, psychology and medicine, and the popular circulation of knowledges in the press. In 1962, the Reith Lectures were commissioned as 'a review of the State of the Nation, in the light of changes which have come about in the community and in private life since the begin-ning of the century' (Carstairs 1962: 7). For G. M. Carstairs, the Reith lecturer for that year, sexual definition was a critical feature of these realignments, and he pointed to the need to develop a newly modernized sexual culture – in particular one that acknowledged women's sexual iden-tity – and proposed this to be a necessary part of acknowledging and contributing to the 'changing British character'. The cost of not doing so would be the development of social neuroses, specifically those concerning sexual definition, which became indicative of 'social malaise' and under-mining to national solidarity and cohesion.[1]

Models of sexual complementarity were brought under pressure between wartime Britain and the early 1960s, as the spatial disruptions to systems of sexual difference brought about the reorganization of work, and domestic life through war and post-war reconstruction gave rise to a refashioning of sexual cultures. While traditional models persisted, they became reshaped and resituated by those forms of social management that, drawing on the alignment of psychology, eugenics and sexology examined in earlier chapters, identified the sexual as a means of securing social equi-librium, integrating it into the modernizing process. These models of sexual management were designed to inaugurate more flexible and interac-tive models of sexual identity, promoting common interests and working

against the 'too rigid' inculcation of difference which would work against family cohesion or national identification and become a cause of neuroses. As those modern forms of social – and sexual – involvement available to (or claimed by) women demanded a new conception of their familial relations, so also those 'weak' and too 'rigid' forms of masculinity came under review. The concern that these transformations could breed unsecured forms of sexual definition was manifested in an attention to sexual pathology.[2] The identification of sexual pathologies became a means to chart those forms of sexual identity that would guarantee the health of the social, in what was no less than a project of defining sexual citizenship. And so the effective individual became identified through its others: those defined as pathological and threatening to social coherence. Sociological, psychological and medico-legal studies of the 1950s increasingly focus on the two main categories that were seen as problematic to the definition of sexual instability as a matter of social and national definition: prostitution and male homosexuality. How do the debates which surround those two pathologies – in the 'Wolfenden period' – inform the scandal of the Profumo Affair, in 1963, and so come to be mapped on to an affair surrounding the sexual indiscretions of a government minister?

The Profumo Affair (and previous sex scandals in Britain from the early 1950s) drew on a changing field of sexual knowledges during a period in which the modernization of feminine sexuality pointed to a very specific instability: that of the articulation of masculinity with national identity. It did this by forming an association between the pathologies of female prostitution and those of male homosexuality, passing from an affair concerning the indiscretions of Jack Profumo, Secretary of State for War in Macmillan's cabinet, to one which centred first on the 'good-time girls' Mandy Rice-Davies and Christine Keeler, and eventually rested on Stephen Ward as a central figure of monstrous perversion which threatened the integrity of British national character.

While the disturbances made by women – in the girls' youthful, fashionable and even self-publicizing sexual mobility – may have initiated a concern with national definition, such a concern was ultimately a question posed about the forms of masculine self-containment and authority which stood as guarantor of the social and the national, in a period during which the sexual was taken as a privileged index of character. What prostitution proposes *for masculinity* is unregulated masculine desire, operating outside the management of sexual life that underpins social cohesion. Male homosexuality came to be seen as an extension of that same lack of sexual discipline, but one which allowed masculinity to be marked *both* by the feminine *and* by an excessive masculine desire, antipathetic to the forms by which public life was regulated. It was this bifurcate problem of the sexual for masculinity that was seen as symptomatic of the difficulties of achieving a secure national character untrammelled by the instabilities of sexual pathology.

The Profumo Affair broke in March 1963, when questions raised in the House of Commons used rumours that John Profumo was involved with a 'call girl' to interrogate his political responsibility and raise concerns over the preservation of democracy (*Daily Express* 22 March 1963). This attention to the conduct of Profumo within the parliamentary forum was accompanied by a wave of reports surrounding Mandy Rice-Davies and Christine Keeler, as their stories of sexual exploits involving a government minister blurred the distinction between private pleasures and public persona through which it is possible to take up the authority of the public figure. This is an authority which is based on a separation from those attributes associated with the feminine: the private, the sexual, the corporeal. In the context of political life, the public persona became inflected by the private negotiation of corporeal pleasures and desires. As they shaped and reshaped accounts of sexual difference, these stories can tell us about the instabilities of sexual identities constructed across the conceptual divide between public and private life.

The statements of the good-time girls became the hinge of accusations of impropriety against John Profumo, centralizing the accounts of the very people whose unreliability – in their potential for allowing state secrets to pass into unregulated realms – motivated public scrutiny of a potential lapse in security and hence enabled the scandal to be brought to public attention. Mandy Rice-Davies' response to the suggestion that Lord Astor denied having a sexual relationship with her – 'He would, wouldn't he?' – pointed to the sexual as compromising to objectivity and integrity in such figures.

However, in the course of the police investigation of the events surrounding the scandal, scrutiny of Profumo and his associates gave way to questions about the morality of Stephen Ward. A friend of the object of Profumo's lapse in discipline, Christine Keeler, Ward was known as a 'provider' of young girls at the parties of the famous and came to be tried on charges of pimping. Ostensibly, Ward's trial had little to do with Profumo; neither he nor the person who introduced Profumo to Stephen Ward, Lord Astor, who rented Ward a weekend cottage on his estate at Cliveden, were called to testify. But in the superseding of questions of political integrity, public propriety and democratic access to the 'truth' surrounding Profumo's involvement in his affair, the attention to Ward in his trial showed a shift to questions of private conduct and moral integrity. The identification of Ward as 'culprit' thus allowed a national scandal to be displaced onto a scrutiny of private 'truths' of character, intentionality and the correct demarcation of sexual relations, questions which were framed in terms of pathological masculinity. How did this allow a scandal which was so spectacularly oriented around Profumo's relation to Christine Keeler, and her friendship with Mandy Rice-Davies, to eventually become one which spoke of the relations of men and masculinity?

The Profumo Affair: social authority and sexual pathology

On 8 July 1961, at Lord Astor's Cliveden estate, nineteen-year-old Christine Keeler, who was living in Stephen Ward's flat in Wimpole Mews, met John Profumo, Secretary of State for War in Macmillan's Conservative government, and they started a short affair. In the same week, it was alleged, she slept with Eugene Ivanov, the Soviet Naval Attache in the London Embassy.

Divergent claims suggested her affair with Profumo lasted between three weeks and five months.[3] On 31 July, MI5 asked the Home Secretary to warn Profumo, who had been visiting Wimpole Mews, of the friendship between Ward and Ivanov, who was probably a spy. Accounts differ about the nature of this relationship and the warning. The official version at the time, published in Lord Denning's report on the security aspects of the affair, was that Ward was dangerously under Ivanov's influence and so could not be trusted (HMSO 1963a: 85). Another, later, semi-official version was that of course Ivanov was a spy – as Naval Attaché it was assumed he would be – a situation tolerated so that the British government would have access to an unofficial and unacknowledged conduit to the Soviet government. According to this account, Profumo was warned because Ward was working for MI5 as conduit to the Soviets through Ivanov during a period of unstable East–West relations, involving the Cuban Missile Crisis and the dispute over the US providing West Germany with nuclear weapons (West 1983; Knightley and Kennedy 1987: 77, 90). The more recent version, now generally reiterated in present accounts, is that Ward was using Christine Keeler to sexually entrap Ivanov for blackmail and a forced defection to provide intelligence about Soviet infiltration of Britain's security services, at a moment when confidence (specifically that of the US) in the UK's contribution to Western intelligence was severely damaged. Profumo was simply getting in the way.[4] Others suggest that as a result MI5 attempted to enlist Profumo's aid and that he refused (Summers and Dorril 1987: 150–2).

Subsequent to his warning, on 8 August 1961, Profumo wrote a letter to Keeler, breaking an arrangement to meet her. The affair only came to light eighteen months later, following an incident where Johnny Edgecombe, one of Keeler's lovers, slashed the face of Lucky Gordon – another lover – and in pursuit of Christine shot at the door to Ward's Wimpole Mews flat where she was staying with Mandy Rice-Davies. Christine was called as a key witness in his trial. Her anticipated evidence at the trial of Johnny Edgecombe, and her almost simultaneous offer of her story and Profumo's letter to two popular newspapers, the *Sunday Pictorial* and the *News of the World*, promised a spectacle of disclosure which gave rise to a flurry of activity, involving Profumo in a meeting with Ward and Astor. In January, Ward saw Ivanov, who left the country eleven days later, offering MI5 good reason not to pursue Profumo's breach as it could no longer present a danger to security. Neither the letter nor the story was published. On 26 January 1963, Christine, approached about Ward's role, told her story to the police.

Christine failed to appear at the Edgecombe trial in March, and instead of adopting the common practice of adjourning in the absence of a key witness, the trial went ahead. Rumours of a judicial anomaly circulated and some suggested Profumo helped her disappear, conspiring to obstruct justice. On 22 March, Profumo read a prepared statement to the House of Commons, attesting that there had been no impropriety in his relationship with Keeler and that he had not seen her since December 1961.

On 5 June, Profumo revoked his denial, acknowledging that he was guilty of improper conduct in his relationship with Keeler and in contempt of the House in his lie. He resigned from office and his name was removed from the Privy Council. Three days later, Ward was arrested and, after a magistrate's hearing, committed to trial at the Old Bailey the next month on charges of procuring and living off immoral earnings. The night after the first part of the judge's summing up – generally supposed to have pointed towards a guilty verdict – Ward took an overdose of Nembutal. He was found guilty while in a coma, and, without recovering consciousness, died three days later.

In September, Lord Denning submitted a report on his inquiry into the security aspects of the case as a Command Paper to the Prime Minister. He declared the honourability of Profumo, the innocence of young girls 'enmeshed in a net of wickedness', and the utter immorality of the 'sexually perverted' Ward whose involvement in 'vicious sexual activities' were in aid of Ivanov and the Russians (HMSO 1963a: 18–19, 26, 35).

It is easy to construct a view of the public vilification of Ward as a scapegoating exercise, distracting attention from a sleazy situation that massively undermined public confidence, and identifying someone to be held responsible. And this was not only an affair about adequate government; increasingly it was recognized as part of a set of conflicts surrounding faltering national security systems that had begun to affect US and UK relations in negative ways. In the aftermath of the Guy Burgess and Donald Maclean defections in 1951, the United States exerted pressure on the British government to follow their example in 'purging' homosexuals from prominent positions within public life, especially in the public and security services. But as Leslie Moran shows, the public inquiry following this scandal did not identify their homosexuality as a factor for national concern. At this time, other factors, such as membership of elite groups and codes of invisibility, allowed homosexuality to be viewed as a benign feature, even one in the national interest (Moran 1991: 156–7). Also, as Moran indicates, the Burgess affair was not the only, or even the prime, factor, leading to the emergence of the idea of homosexuality as a security risk. It took another five years for the assertion that homosexuality was a 'character defect' to be adopted as a way of identifying figures of potential national danger within the security and public services. Moran attributes its first appearance to *The Statement on the Findings of the Conference of Privy Councillors on Security* (HMSO 1956a). Though even here, the main feature identified is

'the Communist faith [which] overrides a man's normal loyalties to his country', while homosexuality is identified as a 'character [defect] ... tending to make a man unreliable or expose him to blackmail, or influence by foreign agents', and is put on a par with drunkenness, addiction to drugs and loose living.[5] At this point, the scandal was retrospectively 'rewritten', with the figure of Burgess used as a means to mobilize the conjunction of homosexuality, character defect, and threat to national security (Moran 1991: 156–7).

It is arguably only after the Vassall Affair that the figure of the homosexual is consolidated as a prime danger by the security services. Nevertheless, the concept of homosexual danger was already established in psychiatry, and the British Medical Association argued in 1955 that public hostility to homosexuality was based on

> their alleged tendency to place their loyalty to one another above their loyalty to the institution or government they serve ... [t]he existence of practising homosexuals in the Church, Parliament, Civil Service, Forces, press, radio, stage and other institutions constitutes a special problem.
>
> (British Medical Association 1955)[6]

In the adoption of US measures, homosexuality was used to address relationships between men and between women and to subject them both to a programme of purging, but it became definitively connected with relations between men in Britain, so that only the male homosexual was brought into the realm of scrutiny and regulation.[7] An escalation of metropolitan policing operations associated with this increased attention initiated a series of male homosexual scandals throughout the fifties.[8]

Prior to the Profumo Affair, the trial of the Admiralty clerk, John Vassall, for spying for the Soviet Union following his entrapment and blackmail for homosexual practices while at the British Embassy in Moscow, had severely weakened confidence, not just in the security services and state institutions, but also in their regulation by government. Graham Mitchell, the Deputy Director-General of MI5, was himself under suspicion of being a KGB agent, as later was the Director-General, Roger Hollis. Mitchell was in fact under surveillance at the very moment he went to see the Prime Minister's private secretary about the potential of a security breach by Profumo.

While Ward was most probably working for MI5, providing sexual 'lures' as well as diplomatic favours through his entourage of girls, the spy scandals of the 1950s, including Guy Burgess, Donald Maclean, John Vassall and Barbara Fell, gave prominence to sexual identity and sexual practices in the context of Britain's international and internal relations. In a context of altering allegiances with Europe and the United States and the recasting of colonial relations, mobilities across boundaries of class, race and gender within Britain were being negotiated by the creation of alternative sexual

networks. In addition to the new social mobilities articulated in post-war government rhetoric, Stuart Hall documents the increasing importance of women and black immigrants to the labour force during the fifties. While Britain's expansion of industries catering to mass domestic consumption in the fifties targeted the 'consuming housewife', it also relied upon its largest market, the working class. It is this range of factors, Hall suggests, that informed the legislative debates of the fifties and sixties and against which they may be seen as situating women within British public life in a context of recast patterns of social relations (Hall 1980).

The importance of modernizing sexual relations in this period, a process that started in earnest at least as far back as the 1930s, but which was understood to be part of a programme of post-war recovery of Britishness, was to address a set of problems concerning sexual development that, it was stated over and over again, had arisen because of 'altered conditions' during the war years.[9] The escalation of clinical, medico-legal and sociological studies addressing the classification, treatment and prevention of socio-sexual 'problems' or 'maladjustments', especially juvenile delinquency, adolescent disturbances and neuroses, and sexual promiscuity in girls, constitutes one strand of this concern.[10] From 1953, homosexuality and prostitution became linked in public attention to sexual 'vice', and led to the framing of the inquiry conducted by the Wolfenden Committee.[11]

Contemporaneous with this identification of 'aberrant' sexual trends, though, we can see an ongoing concern with the ways new immigrants might alter the 'natural' patterns of British social life, appearing in press reports and correspondence as well as in parliamentary debates, and visible in a different way in medical texts on the incidence of venereal diseases amongst immigrants and its spread to other populations. But in particular, we can also discern an assumption that immigration caused an increase in prostitution and a concern that 'undesirable immigrants [were] exploiting simple-minded, depraved white women', as pimps (Smart 1981: 53). Some of the features of the Affair, and its identification of the figure of the pimp as culprit, take on particular meanings in this context. In addition to Profumo and Ivanov, Christine had two West Indian lovers, Lucky Gordon and Johnny Edgecombe, the former being spectacularly ejected from the Old Bailey by police, helmets in disarray. The stories of Ward and Keeler visiting black jazz clubs in Notting Hill and their dabbling with (and reports of her 'addiction to') marijuana offered another side to the images of an 'underworld of sin and vice', while it was of course during the trial of Johnny Edgecombe that Keeler's liaison with Profumo was placed in danger of being revealed. A significant aspect of the affair was not just that Profumo had shared a woman with a Soviet agent, but also with black men, and this needs to be understood in the context of contemporary debates over immigration and concerns over the permeabilities of not just national boundaries, but British national identity. That sexual exchange was seen to threaten the contours of such boundaries and identities is evident in

Ludovic Kennedy's reference to Christine as 'a sort of bin for the world's refuse: Russians, West Indians, politicians, peers, all had been grist to her mill' (Kennedy 1964: 39). His further comment indicates the 'spoiling' of femininity by such associations; 'the taking of drugs by a teenage girl who counted negroes among her lovers was a thing that lingered in the mind: to many people it would seem about as far in depravity as one could go' (Kennedy 1964: 151).

There are, then, two aspects of the Profumo Affair that are especially revealing of the extent to which it draws on contemporary debates over the relation of the social to the sexual. The first is that the sexual, and especially psychosexual pathology, was used to articulate a *series* of differences which were seen as problematic to the development of national character, connecting the sexual to forms of class and racial difference but also using it to address a more dispersed and diversified set of sexual definitions that could not be contained by sexual categories modelled on absolute categories of difference and complementarity, normality and pathology. The second feature is that 'illicit' sexual exchanges were used to present a problem of social authority: of the management of public life, models of effective citizenship, and the way these can become linked to masculinity. Britain's self-definition was being interrogated through questions of sexual identity and exchange.

It is these connections that explain why the Profumo Affair was used to address the forms of public authority whereby the social is regulated and governed, and which indicate why it might in particular have drawn on conceptions of homosexuality as pathology. When the British Medical Association asserted that 'homosexual practices tend to spread by contact, and from time to time they insidiously invade certain groups of the community which would otherwise be predominantly heterosexual' (1955: 27), it showed how far it considered homosexuality to pervert the principles of public good that regulate public institutions, attributing public hostility to homosexuals to the alleged tendency of 'homosexuals in positions of authority to give preferential treatment to homosexuals or to require homosexual subjection as expedient for promotion' (1955: 28). Richard Hauser proposed the need 'to *contain* the evil' of 'spreading' homosexuality within organizations, and to combat the 'homosexual freemasonry', in his 1962 study *The Homosexual Society*. Hauser attributes this problem of homosocial exclusivity to the habit of sexual segregation in education, and an antiquated perpetuation of 'the male society' where the belief that women, 'not excluding a man's own wife, are a distinct race of beings', creating a disposition susceptible to homosexuality and preventing the development of effective sexual relations as a feature of a healthy social realm (Hauser 1962: 24, 158–60). Debates over homosexuality pointed to the need to revise the relations between masculine and feminine by pathologizing an 'excessively' masculine culture deriving from men's privileged relation to the public realm. The association of male homosexuality with the feminine, as we will see later, allows these instabilities to be expressed in terms of disruption of sexual categories.

'The promiscuous hospitality of a disorderly house'

In the concern over Profumo's behaviour we see a complicated exchange being charted between the public and the private in the operation of political life. One key to understanding how the Profumo Affair came to take on such importance in its working over of revisions to the relation between sexual character and the national interest is its link to the public reaction to the Conservative government's handling of the Vassall spy scandal, a case which was credited with reactivating scare campaigns over homosexuality that followed the defections of Burgess and Maclean (Hauser 1962: 61). Vassall was blackmailed for homosexual activities while serving in the British Embassy in Moscow in 1956, thereafter passing documents to the KGB. Soviet informers to the CIA had revealed details of a spy in the Admiralty over a period of some months before Vassall was discovered, a period during which the CIA lost confidence in the British Security Services and its screening procedures. MI5 was considered to have been so severely infiltrated by KGB agents at all levels that Soviet defectors conspicuously chose to reveal their information to the US.

Vassall was discovered in September 1962, only four months after George Blake was sentenced to forty-two years' imprisonment for espionage offences over a ten-year period, practices which the Lord Chief Justice Parker stated had rendered much of Britain's own intelligence ineffective (West 1983: 92). The Vassall trial took place later that year and was followed by a public inquiry conducted by Lord Radcliffe (HMSO 1963b). During the Radcliffe Tribunal's investigation of the security aspects of the Vassall Affair, the two journalists responsible for breaking the story, Reginald Foster and Brendan Mulholland, refused to reveal their sources and were subsequently imprisoned amongst widespread condemnation. Their imprisonment was believed to have been brought about by the government's attempt to restrict the circulation of information, and hence to have been motivated by the embarrassing revelation of security failures in key institutions. During a debate over the government's actions surrounding the imprisonment of the journalists, opposition MPs raised questions in the House that linked the disappearance of a key witness in the Edgecombe trial, and the rumours and insinuations concerning her relation to a Cabinet Minister, to the government's apparent punishment of those journalists who allowed the Vassall Affair to become public. The critical link between these cases was the perversion of public institutions in the government's interest.[12]

In the midst of a non-legitimized discourse of private gossip and speculation, the possibility that Christine Keeler's removal involved a perversion of justice produced the 'silent witness' as a sign of the suppression of information whose circulation would have benefited 'the public interest' (*Daily Express* 22 March 1963). Demands were made for an investigation into the reasons for the trial proceeding in the absence of Christine as key witness, and the conditions of her absence. Rumours about the Minister and the missing

witness (*Daily Express* 22 March 1963) served to question the coherence of the public individual whose identity and autonomy guarantees the viability of contractual relations governing the social – that which must place public principles over private self-interest. From their apparently unconnected beginnings, we can see that questions of principled public conduct were focused around an interest in the conduct of government representatives in the Vassall Affair and that of the 'minister and the call girl', as the disorderly intrusions of the figures of the male homosexual and the promiscuous young woman were seen to elicit lapses in the disciplines of masculinity that guarantee a democratic body politic. The alliance of these two categories of person would come to inform the later focus on the figure of Stephen Ward.

Once Profumo admitted to a sexual relationship with Keeler, the scandal refocused on a potential breach of national security and political responsibility: the possibility of a security leak through Keeler to Ivanov. A concern that the political and legal institutions that act as ultimate guarantors of objectivity and impartiality could have been vulnerable to perversion by human self-interestedness was refocused towards Profumo's possible act of passing on knowledge and his political integrity. A conflict between public interest and privatized sexual cultures, between the public representations of the body politic and private embodied masculinity, was posed in terms of Profumo's ability to carry political office, for his authority could only be intelligible in terms of his public role, a subject exercising judgement unclouded by his corporeality (Gatens 1991).

Thus, while Profumo's lie to the House bore testimony to a failure of his sense of duty, it was used rather as a symptom of his disordered sexuality. Should he as a public figure not have shunned such a liaison even if he did preserve national security? In the development of modern liberal democracies, systems of sexual difference align the feminine with the particular, the corporeal and the familial, rather than the principle of public good. Rational civil order is founded on a division from the disorder of womanly nature: while woman becomes both antipathetic *and* foundational to the emergence of democratic citizenship and masculine rationality, men of the polis must maintain a devaluation of the private, an exclusion of the feminine and the sexual from public life (Pateman 1989). Definitions of appropriate sexuality thereby become central to the techniques of self-management that maintain the distinction between public and private.

Profumo's apparent over-valuation of private pleasures and his under-valuation of the principles of discipline and self-management allowed a contamination of his character as the bodily, the sexual and, especially, the feminine were spoken of in relation to his public persona. By allowing the sexual, the private and the personal to intrude, Profumo blurred the boundaries between public and private arenas, allowing the masculine to become contaminated by its opposite. As Macmillan later said, the problem was not that Profumo had his affair, but that he did not keep the two sides of his life separate.

It is not only woman's nature which is at stake in this chain of association, but her ability to reflect *an excessive sexuality in men,* which is only restrained by relegating the sexual to the private. The presence of feminine voices in the reporting of the scandal thus brought into view what might be seen as the origin, or source, of disorder. The disturbances surrounding Profumo were exacerbated by the circulation of newspaper stories detailing 'Confessions of Christine' (*News of the World* 9 June 1963) and 'Men, Money and Mandy' *(Daily Express* 24 June 1963). The explosive nature of their stories was shown by a headline declaring: 'Mandy TALKED – and it's DYNAMITE!' (*News of the World* 5 May 1963). Something of the difficulty of accepting testimony from such sources, and the outrage that the trial of Stephen Ward could sully the representatives of the Crown by forcing them to draw upon it, was shown in an attack on Ward on the day his death was announced by Peter Earle, the *Daily Express* reporter who covered the Ward story: 'Look at the muck the Crown had to rely on at the Old Bailey ... Lying Whores; frightened little scrubbers; irresponsible little tarts ...' ('The Hidden World of Stephen Ward', *News of the World* 4 August 1963).

The feminine provides a point of disturbance not only to the relations between men in public, but to the forms by which masculinity is construed. After all, in the Profumo Affair, the stories told by the girls were about *male* sexuality and *male* desire – and men's inability to embrace the principles that negate corporeality and self-interestedness. As the public figure representing democratic government becomes contaminated with questions of private conduct and the sexual, the scandal articulated the presence of those elements denoted as 'feminine' *within the construction of masculinity itself.*

It is for these reasons that the sexual can be seen to undermine the authority of public figures and institutions and is linked to a disturbance in sexual meanings and identities. The conception of authority which allows an individual to occupy political office is based on men's grasp of certain disciplines – in this case sexual disciplines. But men's sexual 'needs' are spoken of in contrary ways: in terms of bodily urges, the force of sexual passion and loss of control. As Profumo's actions brought the girls' stories into discourse, he shattered his ability to claim the authority of public office. As Rebecca West refers to the 'feeble' speeches recorded in Hansard in the aftermath of Profumo's resignation, she comments that 'they would not be delivered or listened to in public were it not for the charity inherent in the conception of democratic government, but,' she cautions, 'there is a marked difference between the proper charity offered by a hospital and *the promiscuous hospitality of a disorderly house*' (West 1965: 378, my emphasis).

The erosion of Profumo's authority is thus one that spreads to men's grasp of the principles of democratic government, as the language of the improper licence of prostitution transforms it into a disorderly establishment. What followed, the trial of Ward for pimping for the girls whose stories so damaged Profumo, showed the problems of securing the social according to the intelligibility of the sexual. The parade of their stories in

the press in the run up to Stephen Ward's trial therefore did more than undermine Profumo as a public figure; it also challenged the autonomous functioning of authority in public life. Hence the claim that it was a scandal that toppled a government.[13]

Instead of pursuing the problem for masculinity around the figure of Profumo, the scandal therefore shifted attention to the 'good-time girls' and Stephen Ward as they offered a relay of meanings for that which disorders masculine authority. This provides a key to the relation between male homosexuality and prostitution, in their ability to represent that which falls outside conventional masculinity. The transfer was achieved through the framework offered by a contemporary legislative focus on prostitution and homosexuality, producing feminine and feminized figures situated within a topography of current sexual debate and regulation. The Wolfenden Report, published five years previously but with its recommendations still a matter of debate in the Houses of Commons and Lords at this time, reformulated this disturbance according to the language of perversion.

The Wolfenden Report is seen as the key document in debates around the limits of sexual expression and sexual practices in the post-war period, as it drew on moral and social debates at the beginning of the 1950s and was influential in framing the legislative debates and social inquiry from the end of the decade onwards.[14] The 'Wolfenden Strategy' invoked the 'public good' as a principle governing the regulation of the display of sexual practices and opposed it to 'matters of private moral conduct', the 'private lives of citizens' in a 'shrinkage of legislative control over personal conduct combined with a more rigorous policing of the cordon representing the public domain' (Brown 1980: 3; Hall 1980). The sexual was therefore relegated to a private arena of personal conscience and self-control, to a moral imperative located in the individual, while regulation was organized around the public protection of that individual right to privacy – including the right of occupancy of the streets without being offended by sexual activities or sights.[15] In this reasoning, the sexual was associated with the terrain of the moral and ethical as domestic principles, as opposed to the rational and political principles that inform interventions in the management of sexual conduct and which should be brought to bear in the case of a disorderly incursion of the private into the public. The distinctions between public and private realms of sexual conduct made by the Wolfenden Report sanctioned freedom as a masculine attribute maintained by privatizing the relation to women's bodies. At the same time as maintaining the spheres that organize sexual relations and interactions, then, it maintained the meanings and categories of masculinity and femininity and their apparently unproblematic connection to sexually differentiated bodies. This enabled the report to define the sexual as private, ungovernable and *feminine*.

The Wolfenden Report proposed a realm that it suggested lay beyond governance, absent from public discourse, in recommendations displacing the body for the correct functioning of social life. Simultaneously, it showed

the limits of the law in addressing such a realm and stated the importance of medical and psychological agencies in their management of the sexual as an important component of social stability. It was not the access of men to women's bodies that should be reduced in legislation over prostitution, then, but the manifestation of the sexualized body in the public sphere.[16] Hence the displacement of women's bodies also safeguarded against the corporeal intruding *in the forms by which men regulate their relations in public.*

The prostitute, the consumer and the model: 'good-time girls'

The Wolfenden Report's interest in eradicating women's presence in public was not an innovation, nor did the Committee claim it to be. This impulse has characterized the history of legislation concerning prostitution, whether in a framework of medico-moral management, as in the British Contagious Diseases Acts of the 1860s, or in one which combined a discourse of the rights of individuals to privacy on the streets with that of regulation, in the case of Wolfenden's inspiration of the Street Offences Act 1959. If the segregation of social spaces is used to define a segregation of sexual identities, the sexualization of the presence of women's bodies on the street is a result of the transgression of such definitions. Women's entry into public life, therefore, does not render them masculine, but more *'dangerously feminine'* (Wigley 1992, my emphasis). As they cross the boundaries of appropriate feminine restraint and modesty, they signal the lack of internal self-control that justifies women's containment in the domestic, simultaneously indicating a breach of masculine control of public space in their testimony to an effectively regulated domestic realm.

In the late nineteenth century, the aftermath of the success in pressing for the repeal of the Contagious Diseases Act saw legislation and feminist and liberal campaigns which maintained the prostitute as a class separate from other women, enforcing their displacement from public space in a targeting of 'women of evil life' within social critique. These were the victims of the Ripper murders, located in the poor Whitechapel district and without permanent residence, of middle age and frequently having quit a previous marriage, they were far removed from the image of 'errant daughters' that had previously been the focus of liberal and feminist support for the 'rescue' of prostitutes. Their presence on the streets had brought local criticism of 'nogoodnicks, prostitutes, old bags and drunks'. Their lives were said by Canon Barnett to be 'more appalling' than the actual murders. Clearly delineated from the 'respectable' women and innocent young girls of privatized, domestic femininity, a legislative framework could thus be formed around such an object (Walkowitz 1982: 566–9, 1992).

The question of the sexual status of the two major female protagonists in the Ward trial, Christine Keeler and Mandy Rice-Davies, was one of the central features in the investigation of Stephen Ward; the girls did not

exhibit the signs that allowed a correspondence to be made between social pathology and a realm of sexual pathology. In fact they showed their distance from the trappings of a separate existence. Their presence at the parties of the aristocracy, their affairs with men of power and influence, their lifestyles of cars, planes, holidays, furs and jewellery, separated them out from other women in a more desirable way than the Whitechapel prostitutes. Their lives were built around mobility, not loitering. They visibly consumed as much as they were consumed. Rather than the 'women of evil life', their photographic presence on the front page more accurately simulated the images of stars and celebrities.

This indicates the way women's bodies become a point of dialogue between public presence and private pleasures. As prostitution is one key mode of female entry into the public realm, it is linked to that of consumption, seen throughout the twentieth century as a distinctively feminine activity and involvement. From the late nineteenth century's address to the female shopper in the expanded consumption industries, women's claim to entry into the public realm and their access to modern forms of civic life and citizenship has been associated with their definition as consumers and its association with the public presence of the prostitute, hence their entry has been sexualized (Pumphrey 1987; Swanson 1994a).[17] The prostitute and the female consumer became linked in the emphasis placed on appearance, adornment and display of both the *sexual* body and the *mobile* body that exceeds its domestic place.

It was partly the features of style and fashion, as motifs of consumption, that marked out an interim range of public female types – in particular the amateur – in terms of a *sexual sickness*, characterizing women of the fifties who displayed an imperfect sense of sacrifice and duty to their families. The origins of this strain of sickness were traced back to the New Woman of the twenties, exercising an 'over-emphasised' female desire (Wilson 1980: 72, 83; HMSO 1956b). In the commercial expansion following World War Two, a culture of consumption became seen as a *difficulty* facing women, for their desires could so easily become uncontrolled.[18] Yet simultaneously, the post-war escalation of consumption industries made leisure commodities addressed to the female consumer a key aspect of the remodelling of femininity. The very pleasures offered to women in the move to a modernized feminine definition became a danger to their moral and sexual self-management.

This relationship between consumption and the sexual provides the context of the good-time girls of London in the early sixties. The good-time girl's access to the means to consume – paid work – was obscured, and so she was situated in relation to the sexualized, leisured and idle female body, seen as characteristic of modern life from the end of the nineteenth century.[19] In the context of the 1960s, this body's prejudicial association with the debased commodities of mass culture was associated with a more seductive realm of glamour, in its fashionable adornment by clothes and cosmetics. In the figure

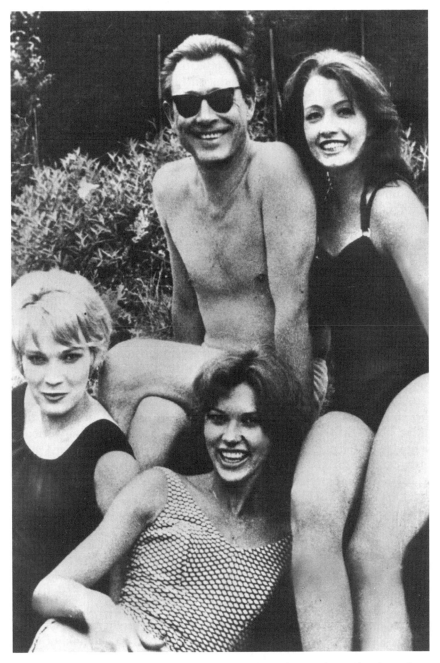

Figure 6.1 Christine Keeler and Stephen Ward at the pool at Cliveden where Christine met Jack Profumo. Photo by Express/Getty Images.

of the model (both a term used to refer to 'Ward's girls' and as a career aspiration voiced by them) the decadent *idle* body of the sexualized figures of nineteenth-century culture was replaced by a mobile body deliberately and artfully *stilled* in the adoption of the pose, the gesture. The model offered a figure which moved across work and leisure, the toiling and the decorative body; as she struck her pose she linked the work on and with her body to the domain of sexualized and commodified consumption.

The figure of the model also contained the sexual ambiguities constructed in the exchange between the consuming woman and prostitute. The permeability of classifications of the model and the prostitute was shown as Lord Denning, in his report, inferred that Christine's 'vocation' as a prostitute was clear from the newspaper photos of the 'missing model' (HMSO 1963a: 20, 52). This shows the fragility of negotiating public and private appropriations of the female body; from its public display there emerged a reading of her private 'susceptibilities' or dispositions of character. At this time, one in which Lord Astor had married the model Bronwen Pugh, modelling was a career of utmost glamour for the modern girl, giving a new form of access to social mobility. Denning's assumption that modelling was a euphemism for prostitution was not simply a social gaffe or a remnant from former times, however, but an indication of the delicacy of definitions of legitimate sexual exchange and female identity, as the private arena of unlawful sexual exchange became yet more difficult to ascertain.

If it could be proved that Christine and Mandy were involved in prostitution while they were living with Ward, then it was incumbent upon him to prove that he had not been living on immoral earnings. Since the disparity between his and their earnings – and Mandy's assurance that he gave them more money than they gave him – did not suggest that he was supported in any way by them, his knowledge of their activities while they lived in his flat remained the key point of proof, sufficient to satisfy that he had provided goods and services for the purposes of prostitution. The prosecution questioning pursued this line and so the two strands of the investigation were directed towards the girls' sexual practices and the extent of Stephen Ward's knowledge and responsibility for them.

While the status of those witnesses who declared themselves as prostitutes was easy enough to ascertain, the press, counsel, witnesses and commentators showed a common difficulty in finding a definition of the status of Christine and Mandy: they became objects of contestation. Neither part of that group 'of the utmost respectability' whom it was claimed Ward had propositioned or seduced, nor part of the identifiable group of working prostitutes for whom he was charged with pimping, a definition of them nevertheless had to be found. Some of the problems of classification are shown in the proliferation of inexact terms used to describe them: models, call girls, popsies or good-time girls. Their embodiment of a clash of sexual traditions and cultures is seen in the modernized character of the American term 'party girls' and the Victorian ring of Lord Hailsham's quaint phrase

'women of easy virtue'. In her account of the case, *The Mandy Report*, published in 1964, Mandy referred to herself as the 'perfect poppet':

> I am good company for men. I listen to their problems, I sympathize with them. I build up their egos and above all I am never possessive ... I do not regret having been paid in full for all the things I have done. And when I say 'paid' I mean in the luxurious way in which I have been kept by rich men.
>
> (Rice-Davies 1964: 35)

Griffith-Jones, the prosecuting counsel, put the case that 'the women were prostitutes, not street walkers admittedly, but women who sold their bodies for money none the less' (Kennedy 1964: 25). It is clear that the trial became a test not only of the boundaries of acceptable forms of exchange for sexual practices, but also of its acceptable conditions. In the course of the trial, the preconditions of guilt became increasingly closer to conventionally accepted sexual models.[20] In fact, the terms of the good-time girls' sexual exchanges forced a scrutiny of sexual definitions. Mandy pointed the finger directly: 'And am I so different from other women? So before you throw too many stones at Mandy, have a good look at yourself' (Rice-Davies 1964: 36). The exact relation of the girls to the category described by the Wolfenden Report and the Street Offences Act was shown to be as uncertain as their position within the spatial demarcations employed.

While both girls admitted they had been left money after sex at times, the extent to which this proved a sale with a contract was unclear. One problem in ascertaining their status was their evident pleasure in their sexual practices or associated forms of sociabilities; another was their age. The prosecution and Denning referred to them as 'sixteen-year-old schoolgirls from their homes in the country' (Kennedy 1964: 202). They thus became defined in terms of the most susceptible category of person, who the same prosecutor in the trial of Penguin Books for the publication of *Lady Chatterley's Lover* two years earlier had been at pains to assert would not be the only category of person to be harmed by reading the novel. The sixteen-year-old schoolgirl stood, by implication, as the paragon of innocence and vulnerability – it was *assumed* such innocence would be violated if such a category of person read the book. Instead, a potential to harm a wider range of categories of person had to be proved for the prosecution to stick. It was the 'man on the Clapham omnibus', in Lord Devlin's phrase, who should be used as a key test of 'normal' tolerances and thus prove that the book offered abnormal, excessive offence in its public circulation. The sixteen-year-old schoolgirl, as vulnerable, corruptible, and hence needing to be shielded from the 'normal' practices tolerated in public life, was thus counterposed against the average citizen, the stable public man. Christine and Mandy could not be included in either definition. They became both objects of corruption and subjects of offence, occupying the uncertain category of

both excessive innocence and excessive desire. They existed outside the norms of public *and* private sexual definition.

In their representation of a modern form of femininity, the girls entered the public realm at their cost. Christine's postcard from Spain, 'Having a Ball', hit the front page (*Daily Express* 24 March 1963). Mandy was interviewed at London Airport and arrested there (Knightley and Kennedy 1987: 168). Christine was met by detectives at the airport on her way back from Spain and photographed stepping down from the plane in sunglasses like an arriving celebrity. Their stories were of travelling down through France, sailing to New York, getting fed up and flying back. They were seen in cars and taxis and were constantly on the move. These bodies in motion, seeking out fun, were actively complicit in their transgressions: 'We moved in the kind of world where the normal code of morals has no place; where there is no dividing line between good and bad, only that between a gay time and boredom' (Rice-Davies 1964: 21).

While new directions in criminology and sociological studies in this period defined young women's sexual practices as a form of delinquency and marked the limits of normal behaviour against sexual 'deviance', they erased their activities from the history of changes in female sexualities. Knightley and Kennedy, for example, in their later account, assert that Christine was 'a nymphomaniac in the true sense of the term, in that she felt emotionally secure only when she was giving her body to someone' (1987: 57). They thus impute to her a transparent psychology which sees her conduct as driven by a unified set of characterological impulses, reading her as pathological rather than situating her in a context where the practices they dub 'promiscuous' had become routinized and even fashionable; a shifting field of female sexual practices taken up for a variety of ends and pleasures. As the good-time girls showed the entry of young women into new domains, their definitions could no longer be contained by lingering nineteenth-century models of spatial segregation and notions of complementarity. While the girls' delinquent scenarios were, by implication, counterposed to the normativity of passive, domestic femininity, these oppositions were reiterated with a failing confidence; the exchanges between illegitimate and emergent sexual styles disorganized the forms of difference conventional models proposed.

In a new moment of sexual and social definition, the unresolved relations of masculinity and femininity became unstable, their boundaries renegotiated. The precarious figure of Christine in these transformations in femininity shows something of the instabilities of sexual models. Her attempts at glamorous self-presentation were described in flawed terms, as 'she had little skill in applying make-up or wearing clothes and always managed to look slightly scruffy' (Knightley and Kennedy 1987: 57).

It was the sort of dress that aims at being chic and looks rather vulgar ... despite the tarty high-heeled shoes, she was tiny, a real little doll of a

girl, and here of course was half the attraction ... the small oval face with the high cheekbones and a hint of Red Indian blood. She was in short like an animal, and one could see at once her appeal to the animal instincts of men.

(Kennedy 1964: 35)

As her sexual relations with West Indians were used to testify to Christine's lack of sexual decorum – and to imply a hidden racial origin, a 'mongrel' formation – her sexual difference was defined in this correspondence: a mysterious, primitive and instinctual 'otherness' which offered the clue to her susceptibility to corruption, a 'child-like' closeness to nature and an over-representation of sexuality. The propensity to exceed conventional models of youthful femininity was presented by recourse to corporeal intrusions, 'primitive' sexualities and animal instincts; an unruly sexual realm which required more effective governance. As the irreducible difference of femininity was played out, the female body could exceed the control of culture only for a limited time. Such pathological involvements, it was implied, would become irrevocably written onto her physique: Rebecca West referred to Christine's appearance at Ward's trial as 'a pitiful sight. She remained beautiful but her beauty was now a thin veil worn by a sick and grubby child' (West 1965: 403).

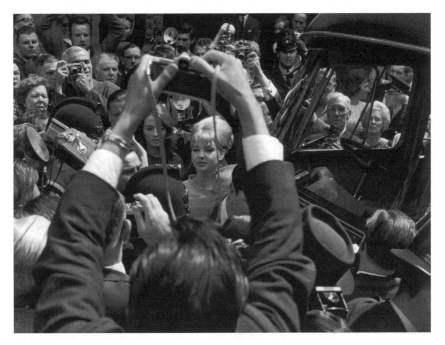

Figure 6.2 Mandy Rice-Davies and Christine Keeler arriving at the Old Bailey during the trial of Stephen Ward in 1963. Photo by Evening Standard/Getty Images.

Masculinity and perversion: a 'thoroughly filthy fellow'

At a crucial point in the scandal, immediately after Profumo's resignation, the decision was made to prosecute Stephen Ward. The character around whom the figures of the scandal and their sexual exchanges were clustered, Ward was an osteopath, artist and 'source of beautiful women for the aristocracy',[21] moving around the social circles of the elite with a train of young girls in his wake. In the concern with prostitution shown by the Wolfenden Report and its associated legislation, the pimp – or the ponce as he was frequently termed – falls within legal view as an intrusive presence in the domain of sexual transaction. While prostitution was not itself unlawful, pimping, like male homosexuality, was – even in private. Ward's prosecution juggled uneven notions of public harm and the definition of the harmful object.

What did 'modern' sexual practices, made so much of in the trial, say about the forms of government that were implicated by Ward's scandalous connection to politicians and their own 'indulgences'? Were the methods of disciplined self-management, assumed as necessary for men's assumption of political responsibility, put at risk by their exercise of less restrained sexual tastes? And where did Ward lie, in the space between sexual life conducted in private and the public figures who populated his social and sexual networks?

Ward was tried on an ostensibly simple set of charges concerning living on immoral earnings and procuring.[22] However, the routine nature of this charge was belied by an immense investigation completely disproportionate to a case of pimping. Five officers were put on overtime for six to eight weeks to interview over 140 witnesses up to fourteen or fifteen times.[23] Christine was interviewed 26 times (Thurlow 1992: 145). The trial of a figure who, even in the prosecution's opening address, appeared as a 'libertine' rather than a criminal (Kennedy 1964: 32) staged a debate over the social and sexual implications of changes in moral frameworks for self-government. The representations of conflict between competing elements in the contemporary field indicated an instability in the forms by which new knowledges could be incorporated into previously established models of social and sexual definition.

Ward not only represented an intrusion in conventional modes of regulating contact between men in their exchange of women's bodies, but he was also shown as a figure who manifestly aided women to use sexuality as a mechanism for social mobility and an entry into the public arena.[24] Just as it was described in the Wolfenden Report, Ward's definition as a pimp depended upon being 'habitually in the company of', or exercising influence over, prostitutes (HMSO 1957: 98) – a too-close relation to the female body.

The figure of Stephen Ward thus reformed the problem that new kinds of female fashioning posed for sexual relations into a question specifically addressing masculine associations and definition. His disturbing feminine knowledge had a ready context in his profession. As an osteopath, his

professional relation to bodies in examination and treatment was derived not from the gaze, surgery and dissection, as in conventional medicine, but by manipulation and touch. In their physical contact, the bodies became joined, breaking down the separation maintained in empirical scientific observation. The distinctions between these different kinds of medical knowledge situated the meanings of osteopathy according to a historical division between *observation*, which does not alter the matter under investigation, and *touch*, which acts upon and has the potential to 'alter physically its object'. They thus position osteopathy with the 'sciences called experimental', linking a certain sense of tampering with the natural, outside clearly established regimes of practice, with a potential for stepping outside the domain of normality: 'it is only through the stopping of a "normal" activity – its suppression or destruction – that the function of an activity can be known' (Cartwright 1992: 137–8).[25] Situated in a domain where normality and pathology meet, touch is aligned with an invasive engagement with the object – and, potentially, the destruction of its conventional activities. Ward appeared both dangerously near the body and threatening to its natural processes. His skills provided him with the power to render bodies obedient: 'hands had always played an important part in his life. With them he had healed the sick, sketched the famous, excited women' (Kennedy 1964: 161). His sketching and his osteopathy, both of which put him 'in touch' with royalty, the aristocracy and political figures, thus became linked with a perverse, disruptive and invasive corporeality.[26] It wasn't so much that Ward actually disrupted the bounds of masculine and feminine definition, but that what he came to represent for the association between masculinity and nation came to be defined by the frameworks of social psychopathology which were used to regulate their relation. Hence he was fashioned into a figure whose features were identified according to available models of disruption: a sexual *indefinability*, as the disruptions of masculinity by the feminine became linked to signs of social pathology. The sexual debates circulating this affair helped to map such instabilities through a transformation of the body of the prostitute into that of the male homosexual. How did this occur in Ward's prosecution for pimping?

In his discussion of sexual legislation in the 1950s, Louis Blom-Cooper refers to the attention to 'men who consort with' prostitutes given by the Royal Commission on the Contagious Diseases Acts 1864–9, where he notes that a crucial difference made between the prostitute and the pimp is that 'with the one sex the difference is committed as a matter of gain; with the other it is the irregular indulgence of a natural impulse' (Blom-Cooper and Drew 1976: 92). As he links the pimp's antisocial cultivation of bodily digressions to Lord Devlin's assertion that 'a challenge to the morality of the "average man" is a threat to the entire social order' (an argument he made against the liberalization of legislation concerning male homosexuality), we can see how the nature of Stephen Ward's threat to the social order comes to

be defined by an irregular masculine subjectivity too closely associated with the indulgences of the body, whether his own, or those of others. Blom-Cooper argues that the significance of Lord Devlin's perspective lay in his view of the social order as 'being in a state of delicate equilibrium needing only a slight nudge to precipitate [it] into an abyss of chaos and a *hopelessly lost identity*' (Blom-Cooper and Drew 1976: 90, my emphasis).

Ward's 'character' was thereby established in contrast to the forms of appropriate conduct and sexual management that provided a 'self-contained' masculinity, these becoming the crux of the prosecution. What links the different accounts of 'who' Ward was is their attention to his relationship to masculine sexual tastes and behaviours, against which he became *indecipherable*. Neither conventionally acceptable nor totally deviant, he disarmed sexual categories and classifications.

In his access, control and proximity to the sexual exchanges surrounding women's bodies, Ward's persona broke down the division of public and private behaviours and eliminated the distance from female bodies that masculinity requires for its coherence to be marked by sexual difference. While the figure of the pimp documented this infringement on a level of public harm, the invocation of homosexuality – in stories surrounding the trial and accounts of Ward written much later – supported the implication of an infringement of democratic relations and the coordinates of masculinity itself. In the heightening of the body in the scrutiny of Ward's subjectivity, the feminine and the sexual were admitted to the public arena to unseat absolute difference as a mechanism for defining sexual categories.

Ward was repeatedly referred to as a 'pygmalion' figure who taught working-class girls how to speak, dress and behave, remaking them into high-class 'popsies' who could socialize in elite class and professional circles on the exchange value of their sexual availability. His knowingness regarding women – a too-close familiarity that disturbed relations of difference, opposition and complementarity – rendered him on the one hand too powerful in his broaching of irreducible gulfs, and on the other emasculated and perverse in its demonstration of his capacity for feminine forms of knowledge and identification. The possession of both became constitutive of his particular inscription of a pathological immorality. By his connection to the sexual and his public attachment to women's bodies, Ward was feminized. He thereby became an ambiguous, mysterious figure: the enigma of sexual difference as an impossible fiction.

In an exchange between prostitution and homosexuality in the context of debates surrounding the Wolfenden Report, the disturbance Ward effected was formulated according to the language of perversion.[27] The language of sexual offence situating Ward as a pimp was allied with that of sexual pathology, proposing a subterranean homosexuality that pitted him 'against society' (House of Commons 1958).[28] In this area of its recommendations, Wolfenden re-marked the boundaries of legal purview to consign homosexuality to a space apart from the national public sphere, to

become a matter of managing character. Stephen's proximity to the circulation of the bodies of women defined as prostitutes gave him a privileged position in signifying the threat of the intrusions of the feminine to masculine identity, and hence he embodied the threat sexual redefinition posed to social equilibrium.

The Report's liberalizing impetus therefore led it to address public regulation and private freedom. Only the section concerning homosexuality exhibited a need to define the role of responsible civic consciousness as *constitutive* of the social. 'Homosexual identity' – and 'homosexual propensities' – were therefore given an existence beyond the corporeal realm of homosexual practices. While the prostitute's body was constructed as antipathetic to the social, requiring eradication from its spaces, the homosexual was pathologized through an implicit susceptibility to a breakdown of masculine consciousness. It was a willed self-control which was to be exerted over the bodily 'urges' deriving from homosexual propensities; the capacity for such discipline, allowing a fully formed *social* masculinity, was to be acquired through the influences of effectively managed family, work and social life (HMSO 1957: 12).

Male sexuality was given a new emphasis in this recasting of the forms by which the relations between men were to be regulated. As part of this attention, the homosexual was not just represented through the *intrusion* of the male body, but its corporeal refashioning, understood as *disturbance*: while one symptom of a breakdown of self-management was an indulgence in public 'display', another was their 'effeminacy'. Both were features which made them identifiable as objects of medical discourse. As the British Medical Association memorandum of evidence to the Wolfenden Committee stated confidently: 'the behaviour and appearance of homosexuals congregating blatantly in public houses, streets and restaurants are an outrage to public decency. Effeminate men wearing make-up and using scent are objectionable to everyone' (1955: 26). The homosexual body was thus reflective not only of a lapsed consciousness but also of a lapsed masculinity: falling outside models of disciplined bodily deployment, it gained physical signs that connected it to a disorderly 'feminine' corporeality. As Wolfenden shifted attention from the 'homosexual' as a person to 'homosexuality' as a flexible field of behaviour to which all men are variably disposed, it adopted the model of grading men's sexuality across a continuum between homosexual and heterosexual desires (HMSO 1957: 12). It was this move which provided the conditions for seeing homosexual 'bodily urges' as a natural arena of disorder for masculinity, disrupting 'self control', especially in the case of diminished responsibility caused by emotional distress, mental or physical disorder, or disease.

Despite Wolfenden's attempt to disavow disease models in the understanding of homosexuality, in psychopathological typologies of homosexuality, signs of effeminacy were taken to be 'symptoms'. The

British Medical Journal greeted the Wolfenden Report by citing Barbara Wootton's argument, cited in the Report, that 'the concept of illness expands continually at the expense of the concept of moral failure' (Wootton 1956), adding:

> The undesirability and immorality of such acts are not in question. What is questionable is whether the present law is the best way of diminishing them, or whether more success would come from better education and the strengthening of individual responsibility ... Psychiatrists have usually lent support to the majority view recorded by the Wolfenden Committee.
>
> (*British Medical Journal* 1950: 631)

Kenneth Soddy, in an article in the *Lancet* endorsing the Wolfenden Report, following a further Commons debate in 1960 in which the recommendations were again dismissed, and arguing against the 'conventional' disease model, defines homosexuality as a 'deficiency disorder', comparable to the damage caused to bone formation by rickets, whereby

> a disturbed pattern of growth and physical (mainly mechanical) pressures causes gross deformity. Thus the boney structure becomes misshapen and all the attendant disabilities follow ... It does not force the analogy to suggest that in the case of the homosexual too, it is the disturbed pattern of emotional growth due to deficiencies in relationship formation, combined with severe social pressure, that do the actual damage.
>
> (Soddy 1960: 199)

These arguments legitimize medical attention to 'relationship deficiency and subsequent character distortion' (*Lancet* 23 July 1960: 199), allowing medical institutions to claim an enhanced role, passing between public and private, in its address to national character and the management of masculine pathology: 'everything which helps to encourage physical and mental health, social responsibility and stable family life is the concern of the medical profession, for on these factors are founded the virility and soundness of national life' (British Medical Association 1955: 7). Clifford Allen further endorsed the importance of psychosexual management in 1962 when he stated that 'the psychological basis of homosexuality is one which has been a long time coming to the front ... homosexuality is mixed inseparably with a whole host of other perversions' (1962: 170), and suggested it should be treated with as much concern as 'some other chronic disease' which affected the population (1962: 174).

Pathologizing Ward: a feminized disposition

Ward came to represent a greater problem than sexual mismanagement, then, as his prosecution posed a question concerning the efficacy of measures for desexualizing relations between men and their impact on masculine character. Framed according to the features of a disordered masculine consciousness, Ward became inscribed by the *disorder of sexual difference* represented by homosexuality. In the absence of an act – for no evidence of Ward's homosexuality was ever put forward[29] – the means by which this was achieved was through a construction of his disposition as *feminized*, a corporealized subjectivity constructed both during the trial and in the period since, which linked him to the female figures and their occupation of the public domain of the sex scandal. The uncertain status of the good-time girls as prostitutes and their challenge to the use of sexuality and sexual difference as a mechanism of intelligibility were thus connected to Ward's feminization according to the pathologies of homosexuality.

The association of prostitution with the homosexual and its connection to implications of a treasonable identity had a precedent six months previously in the trial of John Vassall for espionage, while association of the homosexual with social instability in the 1950s is shown by Elizabeth Wilson in her reference to the case of Guy Burgess (Wilson 1980: 101). As newspaper reports framed Burgess as an 'unreliable pervert, in whom one proof of his sinister nature was his sexuality, another his Communism', his self-definition as both homosexual and communist might be compared with the coupling of Ward's consistent refusal of conventional sexual frameworks and his sympathies for 'communist ideas', a link made in Denning's commentary. This association contributes not only to *aligning* homosexuality with espionage and treason, but allowing it to *become an identity* (as well as an act) of treason. The evidence or 'sympathy' or commitment to communist principles is seen in similar terms to the presence of homosexual 'propensities'.[30] The homosexual as spy, defector or enemy thereby becomes antipathetic to the cultivation of 'sound' national character: Ward is proposed as an enemy.[31]

But while contemporary press commentary on both Vassall and Ward was largely condemnatory, reports showed an attention to their elegant style and luxurious, urbane forms of living; they also offered figures of glamour and seduction. The double figure of the homosexual as tragic invert or evil pervert could not account for the fascination invoked by unknown gratifications. The homosexual thus becomes positioned with the feminine as a figure of the glamour and brittle temptation of unregulated consumption, and an object of seduction. As the figure of masculinity's own exclusions, he is situated in a realm of unlicensed corporeal pleasures in a hidden world of secret sexualities, as the seductive venues of spaces outside 'normal life' become sites of wayward fantasies and lethal pleasures. The motif of a lethal seduction, just as much as questions of blackmail or legislative focus, thus informs the alignment of the homosexual with the prostitute.

The 'hypnotic Dr Ward['s]' (Rice-Davies 1964: 30) charm, voice (Kennedy 1964: 22) and 'fish-eyes' (Rice-Davies 1964: 23) brought those around him – including Ivanov – 'under his spell', 'mesmerising and intriguing' even those who were repulsed by him (Peter Earle, *News of the World* 4 August 1963). The 'complete control' he was supposed to have over women, especially Keeler, not only rendered her malleable to the influence of his knowledge, but suggested that the possession of such knowledge was itself a perversion.[32] His domination by the impulse of the perverse[33] and his possession of feminine skills and knowledge formed Ward into a deviant, almost murderous, figure as he was shown to move into unsurveilled spaces, stalking the backstreets in his pursuit of prostitutes. His movement across masculine and feminine, and his problematic divergence from medical protocols, rendered him a defiant, even monstrous, figure as he was compared – even in a sympathetic account – to Doctor Jekyll and Mr Hyde (Charlton 1963: 13).[34]

Even Ward's sexual skill was interpreted in contradistinction to conventional masculinity. In Mandy's words:

> Stephen proved to be the most accomplished lover I have ever enjoyed. To this day I remember his prowess in bed. His skill in love-making was, I think, due partly to his dislike of normal sexual relationships. Because of this – or perhaps to make up for it – he worked particularly hard to give satisfaction to the women he slept with. (Unlike the majority of men, incidentally, who are selfish lovers.)
>
> (Rice-Davies 1964: 23)

Ward's sexual interests were described in contrast to conceptions of conventional male sexual behaviour. His postponement of the immediacy of pleasure and his refinement of the art of petting became seen as a 'perversion', 'a hint of dangerous pleasures to come ... Pleasure was always to be round the corner. Never to be taken now' (Charlton 1963: 30). The contrast between this and Mandy's conception of men's sexuality as a stick of dynamite – if you light the fuse, wait for the explosion – was reinforced by a description of Ivanov, published under Christine Keeler's name in the *News of the World*, ravishing Christine on a rug:

> Now he had really gone mad ... There was a wild threshing about; a real Russian romp! ... I struggled to my feet. I was gasping and saying, 'No, no. You can't ...!' But I knew there was no holding him and I didn't mean it anyway.
>
> Here was my perfect specimen of a man. And he wanted me. He couldn't have stopped now anyway ... he was just kissing me with all the power of a man in a frenzy of passion. I made one last attempt to get away. But he caught hold of me. Our very impetus carried us through the door and we half fell into my bedroom.

... he was like a God ... Clumsy perhaps, but only because he so wanted me. He said so.

<div align="right">(News of the World 16 June 1963)</div>

In the face of such a classic version of complementarity as the basis of sexual difference, Stephen's concentration on other pleasures fell outside such terms of definition and his sexuality became *unreadable*. During the testimony of Christine and Mandy, Ward's 'sexual disorder' was set in the context of psychological or emotional volatility:

> As she [Mandy Rice-Davies] is cross-examined in the witness box, Dr Stephen Ward sits in the dock, sketching her ... Then his mood changes and he sucks his knuckles, pinches his lips or stares unseeingly ... Suddenly, he smiles, shifting his tall, lithe frame in a beautifully cut dark green suit.
>
> <div align="right">(News of the World 16 June 1963)</div>

The accounts of Ward linked his artistic temperament (HMSO 1963a), superficiality (Rice-Davies 1964: 23), gregarious sociability, his capacity for talk (Kennedy 1964: 132, 185; HMSO 1963a; Peter Earle in *News of the World* 4 August 1963), his name-dropping, his interest in the famous (HMSO 1963a: 7), his use of men to achieve upward mobility and his 'little' sexual appetite (Summers and Dorril 1987: 14), his 'precision' and a 'soft reluctance in the way he used his fine hands'[35] into a composite of feminine attributes and dispositions manifested in an exchange between his 'character' and his body. In the reporting of the trial, references were made to his elegance, his soft white skin, tall lithe frame, etc. Warwick Charlton, whom Ward used to record his 'own' story, comments on Ward's physiology as his 'feminine aspect'; he had 'unusually white skin', a hairless chest, and a 'boyish appearance ... slim and lithe', while his 'grace and precision' were 'like ... a Dior model' (Charlton 1963: 15, 21).

These features were presented as evidence of a suppressed homosexual disposition. Ludovic Kennedy was the most explicit:

> There was no mistaking the now familiar figure, the roué of fifty who looked thirty five, perceptive eyes set in a face rather too full to carry them, boyish hair swept back along the sides of the head to meet at the back of the head like the wings of a partridge. Ageing men who look half their years are often fairies; and one wonders whether within this screaming hetero, a homo was not struggling to be let out.
>
> <div align="right">(Kennedy 1964: 21)</div>

The transformation of Stephen's body held certain dangers, as destructive powers threatened to exceed its physical limits. Kennedy goes on: 'All the

time one had the impression of damned waters, banked fires ... one realised that behind this bland exterior, was a man of daemonic energy ...'[36]

The hands that touch the bodies of men and women became symptoms of his depravity, a visual surfacing of evil the consequences of which he could not finally escape, in a description that suggested homosexuality in its reference to literary origin. It came from Peter Earle, on the occasion of Ward's death, referring to a meeting just prior to his trial:

> Then I found myself looking at his hands – once so lithe and clean, like a surgeon's. They were dirty, now, with ugly little marks on them ... I myself had an absurd impression that he was going rotten, that these hands of his were like the picture of Dorian Gray in Oscar Wilde's great work about a man who found perpetual youth but whose wicked life was reflected by changes on an oil portrait of himself.
>
> (*News of the World* 4 August 1963)

In a similar way to the 'stigmata' associated with prostitution, this assumption that the homosexual body would become marked by the dispositions and habits of sexual character and lifestyle used personal testimony, opinion and readings of Ward as *evidence* of a dangerous latency that, ultimately, social conditions could not counteract. When Mandy wrote of a 'bit of the Devil' that exists in every woman, we know she was referring to forms of promiscuous sexuality which pushed against the boundaries of the definitions of prostitution. When she wrote about the 'bit of the Devil' in every man, that environment and home training could not mould, which in some stayed dormant and in others came out never again to be contained, she was strikingly close to the language the Wolfenden Report used to describe the existence of homosexual 'propensities' (Rice-Davies 1964: 36).

In his double representation, as masculine *and* feminine, (homosexual) consciousness *and* (feminized) body, Ward embodied disorder: the available model for such a crisis was constructed in the Wolfenden Report, a masculine consciousness open to the propensities of homosexuality. But Ward's appearance was further pathologized according to models available in medical discourse and popular representation; his perversions, seen as a latent homosexuality signified by a 'feminized' disposition, testified to his ability to undermine social cohesion. The invasion of the male body by the 'disorderly feminine', a corporeal disruption of masculinity, translated a threat to national security into the language of an enemy within: a disturbance to national character.

It could be said, therefore, that, although it was his access to women that allowed the 'discovery' and feminization of Stephen's body, it was rather the relations between men that were under scrutiny in such exchanges. The original exchange of Christine between Profumo, Ivanov, Edgecombe and Ward was succeeded by another, as the spectacle of the trial presented the sexualized body of Ward in the public arena – both to be exchanged by

representatives of the law in the drama of prosecution and defence, and to become a participant in exchange himself. The judge and defence counsel receded in the public memory of the trial in comparison to the moments when the prosecutor, Griffith-Jones, addressed the court about this 'thoroughly filthy fellow' and interrogated Ward in the witness stand, in a dialogue of masculine sexual identity. Griffith-Jones' social and moral conservatism – it was he who, in the prosecution of Penguin Books two years earlier, had asked the jury to consider whether they considered *Lady Chatterley's Lover* a suitable novel for their wives or servants to read – clashed with Stephen's embodiment of modern sexual libertarianism and social mobility. This masculine exchange presented a scenario of conflicting sexual frameworks.

The enemy within: disturbing masculinity

The stories of the Profumo Affair used the feminine as a means of inscribing a disordered male consciousness onto a male body as evidence of a lack of containment and secure classifications. Masculinity became divided. Inscribed by sexual difference, *it took on the meanings of both terms: both a displaced femininity and an uncontained masculinity.*

As their contact with Ward brought the bodies of men into view, their corporeal presence in social exchange also became visible. It was this 'reduction' to the body that the Cliveden swimming pool weekend, when Ivanov and Profumo meet Keeler, showed. As Ward stated in a newspaper interview: 'You've no idea how amusing it was to have the Russian and the British War Minister in the swimming pool together' (Peter Earle, *News of the World* 4 August 1963). His stories of treating men of power in his capacity as osteopath included one of Winston Churchill, whose bedroom he entered to discover Churchill sitting up in bed, cigar in mouth. As Churchill jumped out of bed, Ward realized he had on only his pyjama top (Summers and Dorril 1987: 39).

Ward thus marked masculinity with the stain of corporeality, rendering sexual difference visible and provisional in representations of an excessive masculinity, prone to wayward desires and beyond regulation. An 'enemy within', the unruliness wrought by femininity within a male body was a motif for disorder in the national body. The concern with defining the scandal in terms of an affliction could be seen in Harold Wilson's assurance in the Commons debate following Profumo's resignation that the scandal should not be seen as a 'canker at the heart' of Britain but a 'diseased excrescence, a corrupted and poisoned appendix of a small and unrepresentative section of society that makes no contribution to what Britain is, still less to what Britain can be' (House of Commons 1963). The concern was based, then, on whether the affliction was invasive or could be excised.

The prostitute and the homosexual were situated outside of the arena of socialized identities, occupying a field of unnatural relations that showed

the inadequate functioning of programmes of social management. As the homosexual was pathologized according to a breakdown of masculine consciousness by disturbances relating to unmanageable instincts, the development of a capacity to control such instincts, allowing a fully formed *social* sexuality, became an aim of the programmes of sexual, marital and familial training, brought together with the development of typologies of pathology in the post-war period. When Clifford Allen justified the widespread study of homosexuality amongst prisoners by reference to the habit frogs had of mating with pieces of wood in the absence of suitable partners, he suggested that the instincts of men were unruly and in certain conditions could become unmanageable: 'So strong is the instinct to copulate,' he stated, 'that an animal, *and presumably a man*, will attempt to perform sexual congress with unsuitable partners if no suitable ones are available' (Allen 1962: 174, my emphasis).

The problems of newly modernized and public femininities disturbed the coordinates of sexual difference and the alignment of sexual bodies with public and private spaces, and thereby disturbed the structure of morality, discipline and authority that was implied by such relegations. The Wolfenden strategy of separating off the private sphere from an arena of sexual regulation and management underscored a problem of sexual classification. As models of domestic femininity which had underpinned men's association in the public sphere were undergoing a transformation in the post-war period, the relations between men required new forms of definition. Relations between men in public were placed under a new form of scrutiny; masculine identity itself emerged as an uneven and volatile category, a problem for the definition of the social and national character.

The Profumo Affair appeared at the end of a period during which a massive programme of sexual management was initiated along with a redefinition of 'normal' sexual behaviour and identity through a detailed typology of sexual pathologies. As his trial disrupted the correspondence between physiology, bodily deployment and identity, the case of Stephen Ward showed the difficulties of implementing such redefinitions in the absence of a model of sexual difference pliable enough to accommodate new forms of social and sexual being. The scandal brought forth stories of corporeal disturbance, representing an excessive masculinity, prone to wayward desires and beyond regulation. The ambivalence of Ward's sexual definition during the trial – the assumption of a foundational homosexuality held beneath a veneer, the sign of a corruption that threatened to bring about the nudge that Lord Devlin had suggested would lead British society into the 'abyss of chaos and a hopelessly lost identity' (Blom-Cooper and Drew 1976: 90; Kennedy 1964: 35) – ensures that Ward's trial stood as testimony to an unresolved, illicit and unaccountable incommensurability between the social and the sexual.

Notes

Introduction: urban modernity and sexual instability

1 Some of the developments relevant to the integration of psychodynamic psychiatry into the medical field, its association with other fields, such as biology and anthropology, its connection to the study of national character, and the importance of the concept of psychopathology as a challenge to somatic models of disorder, are outlined in Pines (1991) and Berrios (1991).

1 'So much money and so little to spend it on'

1 Although Minns notes that the inflated figures which caused such concern were partly produced by the fall in numbers of women marrying following conception, showing different patterns of courtship and non-marital sexual activity (Minns 1980: 183).

2 Government response was provoked by a medical lobby, the Medical Society for the Study of Venereal Diseases, and followed a survey by the British Institute of Public Opinion which found that 80 per cent of the population favoured 'official dissemination of information' reported in September 1942 (Laird 1943: 9–10). Laird suggests that the adoption of measures to combat the wartime increase in venereal disease is part of a democratic imperative: 'The privilege of democratic life carries with it individual responsibility in the affairs of the State and health problems are no exception to this rule. We must not and dare not fail: success or failure DEPENDS ON YOU!' (Laird 1943: 11).

3 See Carol Smart (1996).

4 Martine Spensky sees this shift occurring between those acts that came out of the Beveridge Report and those previous forms of provision which were initiated by the New Poor Law of 1934 (Spensky 1992: 105).

5 Memorandum by Francis Williams, 21 May 1941, INF 1/251 (McLaine 1979).

6 For example, the first evacuation committee in 1931 proposed the need for avoiding 'a disorderly general flight', rather than keeping civilians away from areas likely to be bombed. Titmuss' account of the evacuation schemes describes them as 'simply and solely a military expedient, a counter-move to the enemy's objective of attacking and demoralising the civilian population', preventing chaos, confusion and panic resulting from an unplanned mass exodus (Titmuss 1950: 18–23).

7 Concerns that soldiers suffering from 'shell shock' were 'malingerers' in World War One can be contrasted with concerns in World War Two with civilian 'apathy', 'deep shelter mentality', anxiety neurosis and other mental disorders. Ironically, it was the later reassessments of shell shock, and the greater circulation of its psychiatric definition as war neurosis, that led to the deployment

of models of psychiatry, psychology and psychoanalysis in understanding civilian responses to war experiences, from air raids, evacuation and propaganda, to rationing.

8 Mass Observation, noting the sanguine way in which working people met the national situation in the course of their investigations of public opinion in the run up to war, observed that 'it was only when the international situation threatened to enter their own homes, as gas, that a real mass response was apparent' (Harrisson and Madge 1939/86: 217).

9 Titmuss' account suggests that this was a basis for considering a reversal of the assumption that the soldier's morale would be more steadfast than that of the civilian (Titmuss 1950: 349). The hesitancy of his observation is remarkable, though, and, since it is made four years after the end of war by a historian given full access to official sources, suggests that even in the course of nearly six years of war there was little to base his speculation on in the form of public statements or studies. See Shepherd's suggestion that the scale of recorded cases of traumatic neurosis could partly be attributed to a lack of opportunity or motivation to report symptoms – hence they remained untreated – and his consideration of Edward Glover's argument that psychiatric assessments, first influenced by the alarmist predictions of mass neurosis, may have subsequently been affected by the shift to a more stoic notion of British endurance after 1940 (2000: 178–9).

10 The RAF appointed Charles Symonds, a neurologist and psychiatrist from Guy's Hospital, as Consultant Neurologist. The Royal Navy appointed a group from St George's, while J. R. Rees, of the Tavistock Clinic, was appointed Director of Army Psychiatry in 1939 (Shepherd 2000: 168; Trist and Murray 1990). See note 21.

11 Although, as Rose (1990) argues, psychologists did not make a major contribution to the government's management of morale, psychology did have a significant practical influence and an indirect impact. For example, R. D. Gillespie (1942: 162) shows that both the Ministry of Health and the voluntary organizations associated with the Mental Health Emergency Committee formed the basis of an extensive range of civilian services addressing the 'pathological problems of war', and gave 'advice to parents and lectures to ordinary citizens, ARP workers, and others'. Other non-governmental measures for gauging morale, such as the Wartime Social Survey and Mass Observation, framed their research by reference to psychological models of the individual citizen; most of the popular manuals offering advice for post-war adjustments also adopted psychological explanations of behaviour and relationships (e.g. Bendit and Bendit 1946: 81–2).

12 Studies in these areas were conducted across psychological sciences, revised forms of eugenics and sexology and drew on the application of anthropological methods into studies of home populations.

13 Delinquency peaked in 1941 and was a matter of investigation throughout the war. It is not certain whether this was due to an increase in delinquent behaviour or the coincidence of factors such as a greater interest in monitoring delinquency, the availability of psychiatric and medical mechanisms for recording and addressing the symptoms of adolescent 'maladjustment', and an emerging field in psychology which sought to study the effect of environmental factors on the development of the child.

14 Harry Hopkins, writing in 1964 about the effects of war experience on the remaking of Britain, suggests that the psychiatrist was a familiar, routine figure 'in uniform from the outset' and popularly accepted, as is evident in the coining of the phrase 'trick cyclist' (Hopkins 1964: 198).

15 Glover replaced Ernest Jones, who had moved to the country. He was an influential proponent of 'social psychiatry' which, in his version of it, linked psychoanalysis, psychology and psychiatry to programmes of social and sexual management.

16 W. R. Bion, a member of the Tavistock group – whose 'Leaderless Group' test merged the selection procedures of military officers and those of psychologists and psychiatrists and has been understood to do 'as much to win the war as the invention of the Bailey Bridge' and remains in use in the British Army (Shepherd 2000: 192) – used Glover's argument to suggest that insights concerning individual psychopathology in military personnel could be applied to the community as a whole, to deal with 'the rather different problems of a civilian population' (Bion, in Miller 1940: 184).

17 See Joy Leman (1996) on this programme.

18 Despite the grandiose framing of the problem of neurosis, Glover's mechanisms frequently stress 'homely remedies', such as barley sugar for shock, and his suggestions for preparedness show that psychoanalysis, while helping understand the processes of neurosis, is not essential for its treatment: 'one precaution ... deserves special attention. It is to have handy some form of ear-plug. Curious as it may seem, this is a form of mental treatment' (Glover 1940b: 63–4). As Shepherd notes, Edward Mapother – 'the most powerful and respected man in English psychiatry' at the outbreak of World War Two – was suspicious of the use of psychotherapeutic methods, arguing, on the basis of a perception that they had exacerbated acute cases in World War One, that they should be replaced by 'common sense methods of restoring morale' (Shepherd 2000: 167).

19 Ben Shepherd indicates that secret government reports on the effects of bombing in Hull and Birmingham observed: 'having one's house demolished is most damaging to morale. People seem to mind it more than having their friends or even relatives killed' (Shepherd 2000: 179).

20 Though Glover discusses women's resentment at their husbands' need to work overtime as a major feature of their response to war (Glover 1940b).

21 The prevalence of psychiatry in assessment, treatment and training was greatest in the army (Rose 1990: 41).

22 Women were recruited to the forces at younger ages than those of military men, and as the incidence of the most significant disorders increased with age these figures are age-standardized (War Office 1948: 10). (NB: the report surveys only those below officer rank.)

23 As Janice Winship (1996) shows, a close liaison was established between magazine editors and the war ministries. The following discussion here is dependent on the invaluable anthology of material from women's magazines in wartime by Waller and Vaughan-Rees (1987).

24 As the wartime interest in disruptions to family life brought into view environmental factors and their potential to cultivate pathological characteristics, it allowed psychiatry to take a central role in the development of new programmes of social management, while its connection with distinctive and modern forms of sexology and eugenics provided a concerted programme of research and training in family, marital and sexual relations. Environmental factors become identified as causal of antisocial characteristics as opposed to inheritance during the 1930s, although heredity continued to be seen as providing an important predisposing character (Rose 1986: 177–9).

25 See Chapter Two.

26 This is an updated version of his research for a 1938 survey on behalf of the King George's Jubilee Trust.

2 'The gratification of the moment ... the limit of their mental horizon'

1 Ben Shepherd suggests William McDougall was 'perhaps the most prolific and influential British psychologist before [World War One]' (Shepherd 2000: 421). A. A. Roback cites McDougall's *An Introduction to Social Psychology* as 'the first systematic attempt to study the groundwork of character' adding that it had 'exercised a remarkable influence in psychological circles since its appearance in 1908' (Roback 1927: 188). McDougall was involved in the treatment of 'shell-shocked' soldiers during World War One and established his distinctive approach to psychopathology in *An Outline of Abnormal Psychology* (1926). See Thomson (2006) for an extended and compelling account of McDougall as 'the most celebrated British psychologist of the first half of the century' (55).

2 As Blacker notes, the Wood Committee's survey was not the first study of the familial incidence of social dependency, for this equation was a key component of the statistical work conducted by Karl Pearson from the 1890s, and E. J. Lidbetter's genealogical surveys conducted between 1910–23 were also influential (see also Burdett 1998: 47).

3 Pat Starkey dates the introduction of the term 'problem families' to the period of World War Two, and suggests it was possibly used for the first time as a 'quasi-technical term' by the Women's Group on Public Welfare in its publication *Our Towns: A Close-Up* in 1943 (Starkey 2000a: 46).

4 Wofinden was the deputy Medical Officer of Health for Rotherham when this account was first published. He became Medical Officer of Health for Bristol, and later the first Professor of Public Health at Bristol University.

5 Frameworks of eugenic thought are in this period adapted to include environmental – rather than solely inherited – factors, which may influence the formation of socially pathological character 'types' and behaviours.

6 Starkey notes that the problem family was perceived as a 'serious threat to the work of reconstruction' after the war, in her detailed account of the work of the Family Service Units (2000a: 2). She also cites the view of the Medical Officer of Health for Liverpool, Dr C. O. Stallybrass, that problem families had 'stone age standards in an age of steel' (2000a: 50).

7 Starkey suggests that 'mental handicap and malfunction' were given disproportionate attention in wartime accounts of congenital weaknesses characterizing problem families, and cites Wofinden's claim that 'sterilisation of mental defectives would reduce the numbers of the defectives in the next generation ... If mental defectives were efficiently ascertained and adequately dealt with we should have progressed towards solving the slum problem' (Starkey 2000a: 50–2). However, it is clear that, in the post-war period, mental 'instability' – which was understood to derive from the interaction of hereditary predisposition (including features of temperament) and environmental influences (stimulating psychopathic responses) – came to be seen as at least equally important (and in some accounts was attributed with greater significance) in creating the kind of dysfunctionality upon which the reproduction of social delinquency in the problem child was based (see, for example, Blacker 1952b; Lewis 1954). Blacker also lays more emphasis on the reciprocal role of 'parents' in creating a favourable environment for the child, and the temperamental defects characteristic of the father of the problem family, than Starkey's account of the attribution of the responsibility for the problem family to the mother would suggest (Swanson 2007a).

8 Hornsey is discussing the Britain Can Make It exhibition in 1946 and the work of the Council of Industrial Design in the 1950s.

9 Pailthorpe studied 100 delinquent girls in prisons and 100 inmates of preventive and rescue homes. She observes that commonalities between the two groups predominate, attributing this to 'home conditions and social standards [which] are less exacting and are different from the standards of those who rule them'. However, there were a greater number of unsatisfactory homes and girls of 'subnormal intelligence' in the group sent to preventive homes, as well as of girls with 'developing', as opposed to 'rudimentary', sentiment (see below). This leads her to argue against institutionalized upbringing on the basis of the damaging effect of the absence of parental love and the effect of repression on sentiment development (1932a: 41–2).

10 Mathew Thomson indicates that the Medical Research Council's biomedical orientation acted as a brake on attempts to develop psychiatrically directed research – and research-led psychiatric services – by members of the Board of Control, during the 1920s and 1930s, except in the context of the genetics of mental disorder, and was unsupportive of the Board of Control's proposal to establish a network of psychiatric research clinics (Thomson 1998: 92–3). Edward Glover, the Director of the Institute for the Scientific Study and Treatment of Delinquency, directly attributes its establishment to Pailthorpe's recommendations (Glover 1944). The clinic was renamed the Portman Clinic in 1948 when the National Health Service took over the treatment of offenders, and the Institute renamed the Institute for the Study and Treatment of Delinquency (ISTD).

11 Pailthorpe divides those girls who exhibit defects in sentiment development in terms of 'rudimentary sentiment development' (61%) and 'developing sentiment' (23%) in the group of prison inmates (1932a: 17).

12 'A bad environment does not necessarily produce delinquency' (Joint Committee of the British Medical Association and the Magistrates' Association 1946: 5).

13 Albeit that their 'anti-familial' characteristics 'speak to' the question of marriage and motherhood, the problem girls' apparent unsuitability for future roles as potential mothers is not the whole – and I wouldn't even suggest the central – basis of the working-class adolescent girl's embodiment of a disintegrative force. Throughout this period, her irregularities of character and consciousness are painted on a much broader canvas of cultural dissonance. Nevertheless, this articulation of a disintegrative potential also 'speaks to' the question of marriage and motherhood in both a symbolic and a literal sense. For example, estimates of the probability of children of schizophrenics contracting mental illness led C. P. Blacker to propose that those who had 'passed through a severe illness of this kind' should avoid having children, and warn that the 'members of a schizophrenic family should, at all costs, avoid marriage into another such family' (Blacker 1934: 126–31). Questions concerning patterns of marriage and assortative mating, and their relation to mental defect and antisocial behaviour, became the basis of much research into private life and character from the mid-1930s up to the early 1950s in Britain, much of it driven by eugenic thinking. An attention to the 'problem girl' in this context can be seen as one variant of a range of concerns with the nature of modern cultural experience which, in psychopathological models, are addressed on an individual and social level (see Swanson 2007a).

14 'Mental conflict, a slow imagination, subnormality and mental defect, ill-health, or a sense of unfair imprisonment are all apt to cause the flow of emotions to *become fixed in a more or less degree*' (Pailthorpe 1932a: 102, my emphasis).

3 'Shattered into a multiplicity of warring functions'

1 As a feature of the transformed environments of modern life, the intense sensory stimulation of contemporary urban amusements is understood to so transform the texture of subjective experience that the sensorium itself becomes 'calibrated' to the speed, immediacy and fragmentation of a modern life 'increasingly saturated with sensory input' (Singer 1995: 72–93; Crary 1995: 47).

2 Crary argues that it is through the study of attention that psychology claims a knowledge of the individual subject: 'For attention was not just one of the many topics examined experimentally by late nineteenth-century psychology. It can be argued that a certain notion of attention is in fact the fundamental condition of its knowledge' (Crary 1995: 48).

3 Robert H. Thouless identifies this as a weakness in James' notion of will, in that it does not account for *how* a train of thought may be altered, given a conflict between propensity and ideal in which the propensity is the stronger impulse (Thouless 1925/44: 296).

4 As Thouless points out in his discussion of James' and McDougall's concepts of volition, there is no absolute reason why propensities may not result in moral action, or for the association of volitional effort with an ideal impulse as opposed to a propensity, but it is an assumption shared by both that these follow divergent routes (Thouless 1925/44: 294–7).

5 See Chapter Two.

6 Gillespie bases his claim on a 1940 study of child evacuees by Straker and Thouless (Gillespie 1942: 249).

7 The Committee is also equally confident in attributing developmental disturbances to the effects of industrial work on girls, as they become 'minor adjuncts of the machine' (29).

8 McDougall's *An Introduction to Social Psychology* was first published in 1908, revised numerous times over the next two decades, and published in an expanded edition in 1928. McDougall left the chapters which appeared in the original volume intact, but added supplementary chapters which responded to new material, and incorporated further concepts. This appears in one of the original chapters.

9 This appeared in a chapter from the original 1908 version.

10 'A *purpose* ... is ... the enduring consequence of an act of volition ... Purposeful action is action of this highest type' (McDougall 1932/50: 136–7).

11 This gendering of purposiveness was assumed by a range of psychological schools – Gillespie, for example, was no follower of McDougall, and in fact was overtly critical of his model of psychology.

12 Pailthorpe used the Hamblin Smith scheme for the prisoners and the Terman modification of the Binet-Simon Tests for the preventive and rescue home inmates, concluding that the first were more suitable for testing adults (Pailthorpe 1932a: 14, 33).

13 In Pailthorpe's view, those girls who are preoccupied with their own troubles and conflicts – girls who are unable to put their own self-interests aside and master their characters sufficiently to exert that volition which allows them to achieve a state of serenity – are prevented from achieving sustained attention, and so incapable of directing their attention towards external objects or aims, or becoming purposive (1932a: 5).

14 While she assesses girls in prison according to the greater degree of self-assertion they exhibit, Pailthorpe develops a more nuanced account of defects in sentiment development amongst girls in preventive and rescue homes. She finds that

35% of girls in preventive and rescue homes exhibited rudimentary sentiment development, and 48% intermediate development of the sentiments, a greater proportion in the second category from this group than amongst the girls in prison. Her findings indicate that these range from a 'very slightly developed familial or religious sentiment' amongst the girls with rudimentary sentiment development, through 'a fair degree of familial sentiment and a slight degree of one or two of the others' amongst girls with intermediate sentiment development, to the normal group in which 'the egoistic sentiment is not so pronounced, the family sentiment is much more developed, along with two or more other sentiments' (Pailthorpe 1932a: 39).

15 Pailthorpe argues that a precocious sexual development characterizes 'members of this social order' and follows from cramped living spaces which entail children occupying beds in the same room as their parents (1932a: 39).

16 In fact, in his study of working-class patients, Blacker suggests that the substitution of sensory excitation for aesthetic beauty is a characteristic pattern, and this lack of those aesthetic values which shape ideals and aspirations betrays in them an absence of the pivotal values – interests, beliefs and sense of purpose in life – underlying the directing of human behaviour (Blacker 1933: 80–1). Blacker therefore implies that a defect in the area of aesthetic value is evidence of a defect in the fundamental platform of character, purposiveness.

17 See Charney (1998) for a discussion of the concept of 'drift' and its crystallizing of states of consciousness associated with modern life.

18 'That picture of a child at the mercy of its own unorganized emotions, oscillating from extreme to extreme on the slightest provocation, illustrates the childish lack of social adaptation and, by the way, could be paralleled in the cases of a great majority of adult neurotics' (Yellowlees 1943: 6).

19 Eustace Chesser was a medical practitioner and psychologist working in London, one of the founders of the Society for Sex Education and Guidance, later the Marriage Guidance Council, and a writer of popular advice manuals on questions of sexual development and behaviour for parents and teachers. *Grow Up – And Live* (1949) was written 'to help boys and girls to accommodate themselves to the world in which they are growing up' and includes a foreword by R. A. Butler, architect of the Education Act 1944.

20 Henry Yellowlees was Physician for Mental Diseases and Lecturer in Psychological Medicine, St Thomas's Hospital, London, Consulting Psychiatrist with the British Expeditionary Force in France, and Examiner in Mental Diseases and Psychology in the University of London and the Royal College of Physicians.

21 I would not wish the argument that the girls come to embody a process of erosion which is associated with a question about the quality of national character to be taken too narrowly. The claims McDougall makes about civilization and character here, for example, are situated in a discussion of the racial specificity of the prized instinct of 'curiosity', which can be taken as the opposite of apathy, and which also recurs in Elliot's promotion of attempts to cultivate 'enthusiasms from within' in girls through the clubs movement (Elliot 1942).

22 For some amongst many accounts of these inquiries, see Durham Peters (1999: 93–4); Charney (1998); Crary (1999); Vidler (2000); Hacking (1995); Jay (2005); Luckhurst (2002); Gates (1988); and Kushner (1993).

4 'A harlot hires a car'

1 In fact, so influential did the Paddington group seem in the stimulation of this initiative that Ede was asked in parliament in April to confirm that their proposals – which included heavier penalties and, in particular, gaol sentences for prostitutes – would not determine the scope of the investigation of a committee of inquiry. For, as the parliamentary questioner, Barbara Castle, argued, a number of 'associations interested in this problem' did not accept the proposals put forward in the memorandum prepared by the Paddington representatives (*The Times* 6 April 1951: 7). Surprisingly, perhaps, in the light of the preoccupation with the policing of vice over the following decade in the British press, the Paddington group's visit did not feature in *The Times'* record of the day's news – only those questions in parliament which followed the subsequent announcement of an inquiry into sexual offences.

2 Evidence was submitted by forty-six interested organizations, six government departments, and nearly fifty individuals (Gosling and Warner 1960).

3 For instance, the British Medical Association (1955) and the British Social Biology Council (Rolph 1961/55) published their evidence in reports.

4 These scandals include the Montagu–Wildeblood affair and the prosecution of public figures such as John Gielgud, as well as those which were more properly spy scandals but whose reporting had highlighted the problem of sexual entrapment and blackmail – most notoriously that of Guy Burgess and Donald Maclean.

5 Mort suggests that press attention framed in terms of the 'twin problems' of prostitution and homosexuality dates from 1953, in anticipation of the coronation (1999: 96).

6 Wolfenden's remarks, in his later autobiography, appear to confirm this marginalizing of the psychological formation of the prostitute, in the division of attention to the two parts of the Committee's remit:

> We were not concerned with homosexuality *as a state or condition*, except in so far as that was relevant to the treatment of those who had already been convicted by the courts. We were not concerned with prostitution as *a social phenomenon*, except in so far as there were offences against the criminal law in connection with it and with solicitation for immoral purposes.
>
> (Wolfenden 1976: 135, my emphasis)

The attention given by public opinion mirrors the different balance between public and private aspects across the two aspects of the Committee's inquiry: '[in the case of prostitution] the objection was to the public and flagrant nature of the soliciting: [in the case of male homosexuality], the objection was to what was widely called "unnatural vice"' (Wolfenden 1976: 131). That the Committee's attention was motivated by what came within the view of public opinion – and the imbrication of law with morality, public opinion and private matters – is supported in Wolfenden's later comment on the delay in initiating legislation which decriminalized male homosexuality in private: 'in sensitive matters of private behaviour any government should wait until public opinion is ready for any steps any government might take' (Wolfenden 1976: 144).

7 The 'Wolfenden Strategy' combined a rigorous policing of the public domain with the shrinkage of legislative control over personal conduct (Brown 1980: 3).

8 The Committee's inquiry reflected the different framing of these two types of offence in the existing law, suggesting that the division of attention across the two parts of the Committee's inquiry followed from its consideration of those aspects that fell within legal view, as well as from those which were the subject of public concern.

9 'Standing forth' is the term Wilkinson employs, drawing on William Acton's ety-mological definition of prostitution as 'standing forth, or plying for hire in open market' (Acton 1870). Wilkinson discusses the variations in practices of soliciting:

> It is possible to describe a standard pattern of prostitution behaviour on the street: a woman walks up and down a fairly short stretch of pavement address-ing the men who pass, asking each one to return with her for immoral purposes ... There are, however, variants on each activity and term in this concept; many prostitutes arrested for soliciting deviate considerably from it ... comparatively few men become customers as a result of a prostitute's suggestion.
>
> (Rolph 1961/55: 60–3)

10 Mort indicates that there were concerns within the Committee about the 'unbal-anced' and 'less fulsome' investigation of the dimension of its remit concerning prostitution, and a difference in attitude between the three female members and the twelve male members. But its refusal to accept evidence from moral cam-paigners as opposed to professional experts was decisive:

> In particular the power of purity and feminist groups, which had an extensive history of involvement in urban sexual politics, was severely curtailed by the workings of the Wolfenden Committee ... Effectively, the Wolfenden Committee marked a long-term defeat for such traditions of sexual politics.
>
> (Mort 1999: 97–8)

11 The visit was called off by the group themselves a few hours beforehand because they were uncomfortable about attending the Home Office premises where the Committee sat: 'So that piece of first-hand experience was denied us' (Wolfenden 1976: 138).

12 As Wolfenden himself indicated in response to an objection put to him that the report did not reflect the equal guilt of the client, in its focus on penalizing the prostitute: 'he may be just as guilty as she is of what you and I might call the sin of fornication: he is not as guilty as she is of the offence of cluttering up the streets of London' (Wolfenden 1976: 142). Clearly this distinction rests on the greater visibility of the prostitute, based on her apparent identifiability.

13 See Rendell (2002) and Walkowitz (1980) for histories of urban sexual visibility and its intersection with cultures of prostitution in the early and mid-nineteenth century respectively.

14 The Report states: 'we are not attempting to abolish prostitution or to make prostitution in itself illegal. We do not think that the law ought to try to do so; nor do we think that if it tried it could by itself succeed' (HMSO 1957: 95). The Committee also indicated that the common prostitute was a stable definition and denoted a category for whom measures provided for deterrence had been unsuccessful: 'We believe that most of the prostitutes loitering in the streets are those who are well established in their habits, whom repeated fines have failed to deter' (HMSO 1957: 93).

15 Matt Houlbrook indicates that the area around Waterloo was a notable cruising ground for homosexual men in this period, although it had in earlier decades been known as an area inhabited by prostitutes aiming to 'tempt' young soldiers (Houlbrook 2005: 48).

16 Wilkinson emphasizes the impermanence of the prostitute's clientele:

> It is the aim of many street prostitutes to have sufficient private custom not to need to solicit; a clientele can be built up through contacts made originally in the streets but has to be reinforced by periods of soliciting. The non-availabil-ity of a girl at any particular time results in an immediate falling away of customers.
>
> (Rolph 1961/55: 61)

17 This is the title of the chapter in which Gosling and Warner discuss the development of the car-prostitute.

18 Rosalind Wilkinson also notes: 'Several of the girls I met who live in Stepney and other parts of East London have solicited in Rupert Street, Soho, using taxis' (Rolph 1961/55: 52). Clearly, though, the temporary and public nature of the taxi and its hire give this a different meaning from the car-prostitute's hire of a car.

19 Gosling and Warner group her with the seven of the twelve prostitutes of London: those who do not solicit openly on the streets and so represent the 'hidden' prostitute (Gosling and Warner 1960: 26).

20 'What belongs more to everyday life in centrifugal space than the daily commute, that ritualised movement between the urban centre and its environs that organises the schedules of so many who dwell within it?' (Dimendberg 2004: 202).

21 Dimendberg is here drawing on Deleuze (1992).

22 Instantaneous time is formed from the 'individualistic timetabling of many instants or fragments of time' as opposed to the 'official timetabling of mobility [according to] modernist clock-time based on the public timetable' which was introduced alongside the development of railway travel (Urry 2004: 28–9; see also Schivelbusch 1979).

23 'One of the first things which American and other overseas visitors to Britain interested in social problems have usually remarked upon, when visiting London, has been the open solicitation of men by women prostitutes in the London streets. If the Street Offences Act, 1959, continues to have the success which it seems to enjoy at present, this topic will no longer appear as routine in our conversations with these visitors, and we shall all be relieved' (Hall Williams 1960: 173).

24 The Wolfenden Report's emphasis on 'those who live on the earnings of prostitution' leads them also to draw brothel-keepers into legal view, but, as Gosling and Warner point out, the pimp emerged in the aftermath of the 1959 Street Offences Act which outlawed the brothel, and effectively flung the prostitutes out onto the streets (Gosling and Warner 1960: 191–6).

25 Merriman argues that the M1, whose first sections opened in November 1959, should be understood as a project quintessential to post-war British reconstruction:

> a type of road unseen in Britain ... assembled and ordered through the movements, experiences, work and materials associated with labourers, engineers, architectural commentators, drivers and passengers ... [it was] a modern, youthful and somewhat other or foreign place that was woven into the landscapes of contemporary Britain.
>
> (Merriman 2004: 154–9)

He quotes a contemporary opinion that 'more than anything – more than Espresso bars, jeans, rock'n'roll, the smell of French cigarettes on the underground, white lipstick – [the M1] is of the twentieth century' (Merriman 2004: 158). In his discussion of the new spatialities associated with motorway driving, Merriman also indicates that 'motorway drivers would become "a being apart while ... on the motorways" ... members of a distinct yet transitory social group that "changes from minute to minute"' (Merriman 2004: 157).

26 As Wolfenden later commented: 'we were not so simple-minded as to suppose that prostitution could be abolished by law [but] there were some things which were better swept under the carpet than lying about on top of it' (Wolfenden 1976: 142).

5 Homosexuality, seduction and psychosis

1 Dawson reads *Seven Pillars of Wisdom* as an 'energizing narrative' for the 'real' T. E. Lawrence, which he understands as both a product of his biographer Thomas Lowell's encounter with Lawrence's own self-imaginings, and a narrative which 'impacts back upon the ways that Lawrence sees himself and the way he is [and likes to be] recognised by others' (Dawson 1994: 192–3).

2 *Seven Pillars* first appeared in a privately printed edition in the early 1920s, given limited release in a subscribers' edition in 1926 and was not made available for general readership until 1935. An introductory – 'suppressed' – chapter was removed from the 1926 version, appearing first in a volume of uncollected writings, *Oriental Assembly*, in 1939. It was restored to *Seven Pillars* only in 1962, when it was published by Penguin Books. A delay also occurred with the release of his second autobiographical volume, *The Mint* (Lawrence 1955): written from 1922–8, and published in a subscribers' edition in 1936, Lawrence made a note in his will that this volume should not be published until after 1950. It was finally released in 1955.

3 For example, Edward Carpenter's book *Love's Coming of Age* in 1896 was released without the section on 'The Intermediate Sex' until the 1906 edition (Porter and Hall 1995: 159).

4 The approach outlined is different to that of reading Lawrence's autobiography in order to chart those patterns of fantasy which manifest his psychic conflicts, as we find in Kaja Silverman's account (1992). Her analysis promotes a reading of *Seven Pillars* in terms which 'reveal' a reflexive masochism which both acts 'as a defense against the castrating consequences of feminine masochism' to sanction a retreat from heroic masculinity, and also sustains and promotes virility and authority as components of masculine identity. For Silverman, Lawrence's 'identity' is thus discoverable through a psychoanalytic analysis of the text alongside other supporting evidence of its textual 'tropes', such as his letters.

5 This is Greenblatt's term used to represent the first European encounters with the New World (1991: 2). See also Swanson (2000: 33).

6 Halperin emphasizes the provisionality of these categories: 'My descriptions are not proper historical descriptors – how could they be, since the first four categories cut across historical periods, geographies and cultures?' He also stresses the variability of the practices and relations that the terms refer to:

> For example, 'sodomy', 'that utterly confused category', was applied historically to masturbation, oral sex, anal sex, and same-sex sexual relations, among other things, but my second category refers to something much more specific – not because I am unaware of the plurality of historical meanings of 'sodomy' but because I use the term 'active sodomy' specifically in a transhistorical fashion to denominate a certain model or structure of male homosexual relations for which there is no single proper name.
>
> (2002: 110)

7 Legislative and policing initiatives include the Criminal Law Amendment Act (1885), which adapted legislation relating to buggery and indecent assault to criminalize acts of 'gross indecency' between men, and the use of public order acts and licensing acts to regulate the public display of homosexual identities (Houlbrook 2005: 19–21). Houlbrook stresses that the 'idiosyncratic and contingent' nature of policing practices meant that 'The *de jure* exclusion of queer men from metropolitan London collapsed amidst the operational realities of modern police systems' (2005: 21). See also Cook (2003). These histories usually identify the first use of the term 'homosexuality' as a positive descriptor – positive in the sense of its designatory force and also in the sense of its attempt to counter negative classifications – which appeared in print for the first time in German in 1869 (Halperin 2002: 130).

8 These intersections provide, of course, the landscape for the emergence of psychopathology as a discipline (see Chapters Two–Four).

9 'Homosexuality, both as a concept and a social practice, significantly rearranges and reinterprets earlier patterns of erotic organisation' (Halperin 2002: 132).

10 Each of these also implies a different relation to components of masculine orientation, desire, conduct or status, for example instinct, feeling or passion, physical appearance as distinct from deportment, mannerism or act. They also invoke different evaluative criteria, for example equality, mutuality, disinterestedness, etc. (see Halperin 2002: 109–25).

11 In this sense, discursive adaptations and revisions occur as a result of the 'eventfulness' of historical narrations of self. See Bakhtin (1981: 275–94) for an account of the dialogic nature of discourse, its terms produced through a series of social interactions (Swanson 2000: 134–5).

12 Such an end is not continuously held in sight, and is not necessarily a primary aim in the particular instances of conceptual readjustment and reformulation that constitute such discursive rearrangements.

13 Cocks is discussing a reading group of 'Bolton Whitmanites' whose 'intense interest in sexual inversion' was never written as homosexual identification:

> Many of the men involved were not avowedly homosexual. Among those that did express an interest, loving marriages and intense friendships with women were not unusual ... They were not necessarily homosexual in the modern sense, since they lacked the post-Freudian imperative to act on one's desires, but an intense love existed between some of them which became a means to experience homosexual desire. Their separation from any sexually dissident subculture meant that when they did recognise an intense intimacy among themselves and perhaps in others, it required a new vocabulary of evasion to be spoken of, and new understandings of consciousness in order to be acknowledged.
>
> (Cocks 2003: 161)

14 Bristow indicates that Symonds was also attentive to a distinction between 'ethical homosexual virtues' and 'same-sex eroticism', in his critique of the acceptance of the former and the condemnation of the latter, in contemporary British culture (Bristow 1998: 91).

15 In the ascendancy of 'statecraft', 'essential religious principle was crassly exchanged for profitable and peaceful relations with powerful interest groups' (Dowling 1994: 38). As Dowling indicates, the other customary name for Tractarianism is the Oxford Movement, which represents

> the University of Oxford as a decisive battleground in the Victorian struggle over the socio-political order ... As an episcopal seat and the leading school of the Anglican Church, Oxford would inevitably experience any changes in the relationship between Church and state with the sharpest immediacy.
>
> (Dowling 1994: 36)

She argues that,

> when we view it against its original mid-nineteenth-century background of deep and conflicting socio-political anxieties, Jowett's tutorial becomes visible as an instrument of profound ideological change, as a traditional structure now deployed to new purpose, effectively channelling a saving new gospel of intellectual self-development and diversity into the souls of the civic elite who would guide Britain, as Jowett believed, through the darkening wilderness of the century's end.
>
> (1994: 33)

The great irony would thus always be that the mid-Victorian liberals ... would so far succeed in their polemical work on behalf of Hellenism as quite unexpectedly to persuade the late-Victorian homosexual apologists that in

Hellenism they themselves would find a no less powerful, no less liberal language, a legitimating counterdiscourse of social identity and erotic liberation.

(1994: 36)

16 Such Tractarian practices would inspire admiring tributes from non-Tractarians, and Dowling includes Tennyson's invocation of the figure of Sir Galahad as the celibate ideal. Galahad, of course, is the ideal hero in Malory's *Morte d'Arthur*, which Lawrence read in August 1910 as he left Oxford, and again in 1917–18 when he was involved in the Arab campaign, alongside Homer's *Odyssey* (James 2005: 38–9; Calder 1997: xix).

17 For another significant point of continuity in the development of Uranianism from Tractarian beginnings, at Oxford's Oriel and Balliol Colleges, was its association with Roman Catholicism and, in particular, the Roman Catholic Church in Ireland. In the second half of the century, the impetus encapsulated in Tractarianism was aligned with Roman Catholicism. A precipitating factor in the development of Tractarianism had been that 'the new Parliament that had been elected by the tradesmen and tenant farmers enfranchised through the Reform Bill voted in 1933 to abolish ten bishoprics in Ireland' (Dowling 1994: 37). Newman, along with other Tractarianists, converted to Roman Catholicism, and the reaction against the Roman Catholic church was fuelled by Catholic immigration following the potato famine in Ireland. Biographers make much of Lawrence's affiliation with his father's genteel status, which allowed him to identify with his Irish lineage. And in an interestingly perverse twist, Lawrence James also argues that his association with the Anglo-Catholic Uranian circle may have been influenced by an interest in flouting his parents' Puritan orientation – and the 'stiffer elements' in his Oxford college, Jesus – rather than an interest in the opportunity for sexual identification, in this period (James 2005: 38).

18 Or self-discipline, *sōphrosynē* (see Dowling 1994: 47).

19 This involved a shift from the model of Graeco-Roman classical republicanism towards an enlightened rational progressive ideal coincident with Athenian Greece (Dowling 1994: 59).

20 Dowling goes on to argue that it is Victorian Hellenism's dependence on German Hellenism that allows individual self-cultivation to retain a martial dimension through the doctrine of civic diversity as a means of ensuring the security of the polity from both external and internal forces (1994: 61–2):

When the notion of civic diversity is relocated within German and later Victorian liberal Hellenism, this underlying martial dimension to diversity and versatility, even as they both are being deployed in a larger campaign against the psychic fragmentation and cultural stagnation produced by industrial modernity, continues on a buried level of psychocultural implication to impart a public and civic orientation to a Hellenism that might otherwise seem to be entirely private and aesthetic.

(Dowling 1994: 62)

21 See James' account of the rumours and allegations of his homosexuality during the 1930s and the possibility that his withdrawal from public life, and perhaps his fatal motorbike accident, were related to charges of indecency with servicemen at his home at Cloud's Hill (2005: 261–2).

22 There are, of course, more specific uses of the term sexual indeterminacy in this period, to denote an unnameable and pathological sexual orientation. Linda Dowling, for example, indicates that Charles Kingsley's 'extreme reaction to Tractarian "effeminacy" [see below] arose in part because of his fears over his brother Henry's sexual indeterminacy' (Dowling 1994: 44).

23 As Cocks argues:

> Historians have tended to assume that both Carpenter's Utopianism and Whitman's ethos of comradeship became largely irrelevant during the 'Wilde century' that followed 1900, when sexual science and effeminacy came to dominate the representation of homosexuality. But at least at the beginning of the twentieth century, Carpenter and Whitman were still prominent figures in a homosexual canon.
>
> (2003: 195)

Cocks indicates the invocation of their names alongside that of Wilde in early 'lonely hearts' advertisements, suggesting the popularization of their views. As Porter and Hall indicate, Edward Carpenter's *Love's Coming of Age* (1896) was repeatedly reprinted over the following forty years, the section on the 'intermediate sex' and the 'Uranian type' being included in editions from 1906, and 'his ideas enjoyed a wide influence well beyond the specifically "Uranian" constituency' (Porter and Hall 1995: 159).

24 The Arab massacre of the Turks at Tafas was reparation for the rape of Arab women and the Turkish massacre of the inhabitants of Tafas, including sadistic killings of women and children (James 2005: 300–3).

25 Also, in the account of his escape in *Seven Pillars*, he is met by Faris and Halim, whom he tells 'a merry tale of bribery and trickery, which they promised to keep to themselves, laughing aloud at the simplicity of the Turks' (Lawrence 1935/26: 447). There is no indication that they noticed signs of beating. This inconsistency supports James' view that the event was fabricated.

26 James quotes Lawrence's further comment: 'Incidents like these ... made the thought of military service in the Turkish army a living death for the wholesome Arab peasants, and the consequences pursued the miserable victims all their after life, in revolting forms of sexual disease' (Lawrence, cited in James 2005: 252). James sees this as a personally motivated vilification which was not based on fact.

27 The header for this page, in the 1935 version, following 'Passing Out' and 'Life Again', is 'Hiding a Secret'.

28 See Waters 1999 for a consideration of the way in which psychiatry and psychoanalytic accounts informed the 'remaking' of knowledges of homosexuality.

29 Wolfenden's address to sexual offences thus posed a corporeality which constituted a disorderly realm within the construction of masculinity (see Chapter Six in this volume).

30 This discussion is extended in Chapter Six in this volume.

31 This distinction is explained in Halperin (2002: 113).

32 This was not helped by the indistinct boundary drawn between offence and act in the Report's distinction between public and private acts in terms of those that caused public offence.

33 Advocating caution against critical practices that romanticize or mystify 'marginal' regions or figures which therefore continue to represent them through the lens of colonial discourse, Kaplan notes the way the figure of the nomad has been celebrated as: 'the one who can track a path through a seemingly illogical space without succumbing to nation-state and/or bourgeois organisation and mastery' (Kaplan 1996: 66).

34 See Waters' account of *Against the Law* as contributing to 'distinctly modern forms of selfhood' and a respectable homosexual identity (1999).

35 Clifford Allen was called to give expert testimony by the Wolfenden Committee.

36 Norwood East was knighted for his contribution to forensic psychiatry. He developed his approach to offenders over a long career in the Prison Medical Service, and became HM Commissioner of Prisons, as well as lecturing at Maudsley Hospital. He drew extensively on William McDougall's notion of character in *Society and the Criminal* (East 1949), particularly in his emphasis

on the involvement of self-regarding behaviour (i.e. the 'selfish sentiments') and the importance of conscience in the development of 'character developed under moral guidance', of will and social conventions and habits in controlling the 'natural tendencies' and 'striving' as the condition of life (East 1949: 185–6, 61); see Chapter Three in this volume.

37 East also defines sadism and masochism according to McDougall's notion of a failure of the self-regarding sentiment, 'as the impulses of the two opposed but independent instincts of self-assertion and submission respectively' (1949: 114); see Chapters Two and Three in this volume for an examination of McDougall's model of sentiment.

38 As D. A. Miller shows in his account of Hitchcock's *Rope* (1990).

39 Though Houlbrook refutes Weeks' implication that this was a result of Maxwell-Fyffe's 'anti-homosexuality', arguing that his comments 'were not expressed as a *reason* to increase police surveillance but represented his *response* to rising prosecution figures – they followed rather than preceded public policing shifts' (Houlbrook 2005: 35, emphasis in the original).

6 'Good-time girls' and a 'thoroughly filthy fellow'

1 'Neurotic illness is a more sensitive indicator [than psychotic illness] of the new stresses which occur in a period of rapid social change' (Carstairs 1962: 69, 21–2, 80). Carstairs goes on to talk of male homosexuality and the conflict between Victorian and modern definitions of feminine roles for women.

2 Many of the publications of the British Social Biology Council or the Eugenics Society, as well as those related directly to psychiatry for example, point to the pressures of modern forms of living, which they see as initiating a sexual confusion or form of breakdown that results in 'anti-social' sexual behaviours.

3 Profumo said in his Commons statement in June 1963 that the last time he saw Keeler was in December 1961. Keeler agreed. In his evidence to Lord Denning's inquiry, given some months later, he brought the date forward to August – nearer the time he was warned about Keeler and Ward's connection to Ivanov. Denning explained that he mixed up the parliamentary recesses and so could not remember if it was one month or five (HMSO 1963a: 15). Keeler's version nowadays is that it lasted six to eight weeks (Keeler and Meadley 1985: 15; Keeler and Thompson 2001), while another source puts it as five weeks (Thurlow 1992: 77).

4 This has been reiterated in Knightley and Kennedy (1987) and Thurlow (1992) and is an assumed truth in most current newspaper references.

5 HMSO (1956a: 2–3), cited in Moran (1991).

6 The influence, if any, of the psychiatric profession on the adoption of such measures has not, as far as I know, been documented. Certainly the direction of psychoanalytic studies of war neurotics ('shell shock' victims) in World War One connected them to a latent male homosexuality that Karl Abraham (influential for the developers of psychodynamic psychiatry such as James and Edward Glover, whose work at the British Psychoanalytic Society would contribute to the formation of the Tavistock Square Clinic) identified as insufficiently fitting them to put their own interests second to those of an abstract conception of the general good of the mass (Abraham 1921: 25–6).

7 For an account of the operations against homosexuals in the US Government services, see d'Emilio (1989). This suggests the way in which questions of masculinity were articulated in models of British national identity took a culturally specific form, especially in the ways it displaced the feminine onto the male homosexual.

8 See Weeks (1977: 159) and Hyde (1970: 212–16). The prosecution of five men for homosexual offences in the Montagu–Wildeblood trial in 1954 is probably

the most famous of the cases, referred to in the Commons debate on the Wolfenden Report and documented in Wildeblood (1957).

9 See Chapter One.

10 See Chapters Two and Three.

11 See Chapters Four and Five.

12 The *Daily Express* (22 March 1963) reports Lord Chief Justice Parker as saying that 'the interests of the State must come above those of the individual'.

13 However, while Lord Alec Douglas-Home succeeded Macmillan after his retirement in October 1963, the Labour victory in 1964 was not a convincing defeat and was only developed into a sound majority in 1966.

14 See Chapters Four and Five.

15 The legislative framework defined by the Wolfenden Report proclaimed its principle of 'public good' as distinct from individual self-interestedness, rationality from desire. This entailed a delicate balance between a discourse of the individual's right to autonomy and self-regulation *in private* which could only be ensured by the regulation of the *public*. The Wolfenden Report thus addressed the divide by defining public good as the protection of individual right. In doing so, however, it managed to blur the separation of spheres as the individual right to 'privacy' had to be maintained in public as well as in private.

16 The historical specificity of desexualized relations governing public life can be seen in Halperin (1990). Halperin shows how, in classical Greek society, ritual sexual relations between men and boys were used to align male sexuality with social 'procreativity'. In his *Symposium*, Plato argued that the correct ethic of pederastic relations was to acculturate young boys and provide a sexual ritual that offered male citizens a means of being 'born' as social subjects. Halperin also shows the importance of a symbolic construction of the feminine to the articulation of such an ethic, indicating a different use of the mechanism of sexual difference, yet one which nevertheless indicated a continuity of meaning and function for woman in her opposition to the body politic.

17 Concerning the power of consumption to aid women's entry into the public sphere and sexual exchange as a means of access to the arenas of consumption and public entertainments, see Peiss (1984); Walkowitz (1992); Nava (1996); Armstrong (1999); Rappaport (2000); Rendell (2002); Nead (2000).

18 In 'A Report on Shopping' (Mass Observation 1948: 10) one male respondent commented: 'I think it is true to say that in a good many cases shopping today has brought out some of the shabbier traits of character on both sides of the counter.' See also Chapter One in this volume.

19 For the practices which centred the management of the body as a feature of feminine individuality, see Perrot (1990: 457–94).

20 This is the very reason why, it has been argued, male homosexual practices (especially sodomy) have been so much more severely policed than other sexual offences. Jeffrey Weeks (1989: 240) points out that when the Wolfenden Report considers arguments for maintaining buggery as a special offence it is on the basis that 'it most nearly approximated to heterosexual coitus, and might therefore be a temptation away from it'. See also Wilson (1980: 103).

21 Lord Denning more prosaically refers to Ward as a 'provider of popsies for rich people' (HMSO 1963a: 84).

22 Two charges of procuring abortions were to have waited until the next session (Thurlow 1992: 180).

23 Philip Knightley interviewed on *The Media Show*, BBC1, 1990.

24 Ward was seen to make a hobby of 'making' working-class girls into models, socialites or starlets. A 'close friend' said of him: 'People were always asking him where he got the girls. He didn't get them, he made them' (Irving *et al.* 1963: 33).

For accounts of the girls he was credited with 'making', see Knightley and Kennedy (1987: 25–32); Summers and Dorril (1987: 38–58).

25 Cartwright is discussing Claude Bernard's 1865 *Introduction to the Study of Experimental Medicine*.

26 The preoccupation with Stephen's hands has endured. Keeler's most recent account claims: 'Literally, Stephen had his fingers on the pulse of the Establishment ... As an osteopath he was remarkably skilled with his hands but he could manipulate people's minds almost as easily' (Keeler and Thompson 2001: 31–2). The title of a chapter elaborating this equation between his professional skills and mental influence is entitled 'Hands On'.

27 In this respect Stephen embodies *both* 'perversity' as vice with 'perversion' and a disposition (see p130).

28 Arguing against the Wolfenden Committee's proposals in the debate on 26 November 1958, William Shepherd (Cheadle) proposed the following:

I want to discourage the homosexual by the discouragement of the law because the homosexual in society has a very difficult place indeed. *He becomes against society.* He becomes bitter, his mind becomes twisted and distorted ... It is essential in the interests of the man himself that we should do everything to discourage him ... *If a man can be diverted from homosexual practices he ... will become a better and happier citizen.*

(House of Commons 1958, my emphasis)

29 Although Summers and Dorril attempt to chart his friendships with known homosexuals (1987).

30 The instability – even interchangeability – of the attributes of national danger during this period are shown in *The Statement on the Findings of the Conference of Privy Councillors on Security* (HMSO 1956a: 2): 'In this paper for convenience and brevity the term "Communism" is used to cover Communism and Fascism alike.'

31 Wolfenden's use of the model of the continuum thereby becomes rearranged by this residual dichotomization.

32 Both of these are suggested in newspaper reports; see *Daily Express* (4 August 1963).

33 Summers and Dorril (1987: 37) summarizing the retrospective commentary of Jocelyn Proby, Ward's mentor in osteopathy. While not a contemporary comment, such later accounts depend on the readings that are generated in the period when Ward's 'pathology' came to stand as a contemporary truth, and so they take up many of these frameworks for Ward's character.

34 Walkowitz indicates that the divided figure of Dr Jekyll and Mr Hyde, in Robert Louis Stevenson's 1886 *Shilling Shocker*, informed contemporary commentary on the Jack the Ripper prostitute murders. This mention of Jekyll and Hyde suggests that the Ripper narrative informed commentary on Ward (Walkowitz 1992: 206).

35 American journalist Dorothy Kilgallen, writing at the time of the trial, cited in Summers and Dorril (1987: 37).

36 The comment continued, 'And at the age of fifty to have put such frequent and unusual sexual strains on himself called for more than ordinary endurance' (Kennedy 1964: 160), placing Ward as both subject and object, an active and passive body, placing strains and enduring them.

Bibliography

Abraham, Karl (1921) in S. Ferenczi, K. Abraham, E. Simmel and E. Jones, *Psycho-analysis and the War Neuroses*, London, Vienna and New York: The International Psycho-analytical Press.

Acton, William (1870) in C. H. Rolph (ed.) (1961/55) *Women of the Streets: A Sociological Study of the Common Prostitute*, London: Ace Books.

Aldington, Richard (1955) *Lawrence of Arabia: A Biographical Enquiry*, London: Collins.

Allen, Clifford (1962) *A Textbook of Psychosexual Disorders*, London: Oxford University Press.

Anomaly (1927) *The Invert and His Social Adjustment*, London: Baillière, Tindall and Cox.

Anon (1959) *Streetwalker*, London: The Bodley Head.

Armstrong, Nancy (1999) *Fiction in the Age of Photography: The Legacy of British Realism*, Cambridge, Mass: Harvard University Press.

Bachelard, Gaston (1964) *The Poetics of Space*, Boston: Beacon Press.

Bakhtin, M. M. (1981) in M. Holquist (ed.) *The Dialogic Imagination: Four Essays by M. M. Bakhtin*, Austin: University of Texas Press.

Bartlett, F. C., Ginsberg, M., Lindgren, E. J. and Thouless, R. H. (eds) (1939) *The Study of Society, Methods and Problems*, London: Kegan Paul, Trench, Trubner.

Bendit, Phoebe D. and Bendit, Laurence J. (1946) *Living Together Again*, London and Chesham: Gramol Publications.

Benjamin, Walter (1970) *Illuminations*, London: Jonathan Cape.

Benjamin, Walter (1973) *Charles Baudelaire: A Lyric Poet in the Era of High Capitalism*, London: New Left Books.

Berg, Charles and Allen, Clifford (1958) *The Problem of Homosexuality*, New York: Citadel Press.

Berrios, German E. (1991) 'British Psychopathology Since the Early 20th Century', in German E. Berrios and Hugh Freeman, *150 Years of British Psychiatry, 1841–1991*, London: Gaskell.

Bersani, Leo (1988) 'Is the Rectum a Grave?', *October*, 43: pp. 197–222.

Birken, Lawrence (1988) *Consuming Desire: Sexual Science and the Emergence of a Culture of Abundance, 1871–1914*, Ithaca and London: Cornell University Press.

Blacker, C. P. (1933) *Human Values in Psychological Medicine*, London: Oxford University Press.

—— (ed.) (1934) *The Chances of Morbid Inheritance*, London: HK Lewis.

—— (1937) *A Social Problem Group?*, London: Oxford University Press.

—— (1946) 'Social Problem Families in the Limelight', *The Eugenics Review*, 38(3): pp. 117–27.

—— (1952a) *Problem Families: Five Inquiries*, London: Eugenics Society.

—— (1952b) *Eugenics: Galton and After*, London: Duckworth.

—— (1956) 'The Medical Officer on Problem Families', in 'Notes of the Quarter', *The Eugenics Review*, 48(2): pp. 68–9.

Bland, Lucy and Doan, Laura (1998) *Sexology in Culture: Labelling Bodies and Desires*, Cambridge: Polity Press.

Blom-Cooper, Louis and Drew, Gavin (eds) (1976) *Law and Morality*, London: Duckworth.

Bohne, Luciana (1990) 'Leaning Toward the Past: Pressures of Vision and Narrative in *Lawrence of Arabia*', *Film Criticism*, 15(1): pp. 2–16.

Bourne-Taylor (1988) *In the Secret Theatre of Home: Wilkie Collins, Sensation Narrative and Nineteeth Century Psychology*, London and New York: Routledge.

Bristow, Joseph (1998) 'Symonds's History, Ellis's Heredity: Sexual Inversion', in Lucy Bland and Laura Doan (eds) *Sexology in Culture: Labelling Bodies and Desires*, Cambridge: Polity Press.

British Medical Association (1955) *Homosexuality and Prostitution: A Memorandum of Evidence prepared by a Special Committee of the Council of the British Medical Association for submission to the Departmental Committee on Homosexuality and Prostitution*, London: British Medical Association, December.

British Medical Journal (1950) 'Homosexuality in Society', 2: pp. 631–2.

Brown, Beverley (1980) 'Private Faces in Public Places', *Ideology and Consciousness*, 7.

Buci-Glucksmann, Christine (1994) *Baroque Reason: The Aesthetics of Modernity*, London: Sage.

Buck-Morss, Susan (1991) *The Dialectics of Seeing: Walter Benjamin and the Arcades Project*, Cambridge, Mass, and London: The MIT Press.

Burdett, Carolyn (1998) 'The Hidden Romance of Sexual Science: Eugenics, the Nation and the Making of Modern Feminism', in L. Bland and L. Doan (eds) *Sexology in Culture: Labelling Bodies and Desires*, Cambridge: Polity Press.

Burns, Karen (1991) 'Beating the System: Systems, Genres and the Topos of Place', in *Knowledge +/de Experience*, Brisbane: Queensland University Press.

Calder, Angus (1997) 'Introduction' to *Seven Pillars of Wisdom*, Hertfordshire: Wordsworth Editions.

Carpenter, Edward (1896) *Love's Coming of Age. A Series of Papers on the Relations of the Sexes*, Manchester: Labour Press.

Carstairs, G. M. (1962) *This Island Now: The BBC Reith Lectures 1962*, Harmondsworth: Penguin Books.

Carter, Paul (1987) *The Road to Botany Bay: An Essay in Spatial History*, London and Boston: Faber and Faber.

Cartwright, Lisa (1992) '"Experiments of Destruction": Cinematic Inscriptions of Physiology', *Representations*, 40(Fall): pp. 129–52.

Charlton, Warwick (1963) *Stephen Ward Speaks*, London: a 'Today' publication.

Charney, Leo (1998) *Empty Moments: Cinema, Modernity and Drift*, Durham and London: Duke University Press.

—— and Schwarz, Vanessa R. (eds) (1995) *Cinema and the Invention of Modern Life*, Berkeley, Los Angeles and London: University of California Press.

Chesser, Eustace (1949) *Grow Up – And Live*, Harmondsworth: Penguin Books.

—— (1958a) *Live and Let Live: The Moral of the Wolfenden Report*, London, Melbourne and Toronto: Heinemann.

—— (1958b) *Women: A Popular Edition of 'The Chesser Report'*, London: Jarrolds.

Ching-Liang Low, Gail (1989) 'White Skins/Black Masks: The Pleasures and Politics of Imperialism', *New Formations*, 9: pp. 83–104.

Cocks, H. G. (2003) *Nameless Offences: Homosexual Desire in the Nineteenth Century*, London and New York: I. B. Tauris.

Collier, Howard (1937) *Happy Marriage in Modern Life: A Challenge to Youth and Society*, London: British Social Biology Council.

Colomina, Beatriz (1994) *Privacy and Publicity: Modern Architecture as Mass Media*, Cambridge, Mass, and London: The MIT Press.

Conekin, Becky (2003) *'The Autobiography of a Nation': The 1951 Festival of Britain*, Manchester: Manchester University Press.

Conekin, Becky, Mort, Frank and Waters, Chris (eds) (1999) *Moments of Modernity: Reconstructing Britain 1945–1964*, London: Rivers Oram Press.

Cook, Matt (2003) *London and the Culture of Homosexuality, 1885–1914*, Cambridge: Cambridge University Press.

Cooke, Douglas (ed.) (1944) *Youth Organisations of Great Britain 1944–45*, London: Jordan & Sons.

Crary, Jonathan (1995) 'Unbinding Vision: Manet and the Attentive Observer in the Late Nineteenth Century', in Leo Charney and Vanessa R. Schwarz (eds) *Cinema and the Invention of Modern Life*, Berkeley, Los Angeles and London: University of California Press.

—— (1999) *Suspensions of Perception: Attention, Spectacle and Modern Culture*, Cambridge, Mass, and London: University of California Press.

Crisp, Jane, Ferres, Kay and Swanson, Gillian (2000) *Deciphering Culture: Ordinary Curiosities and Subjective Narratives*, London and New York: Routledge.

d'Emilio, John (1989) 'The Homosexual Menace: The Politics of Sexuality in Cold War America', in Kathy Peiss and Christina Simmons (eds) *Passion and Power: Sexuality in History*, Philadelphia: Temple University Press.

Daily Express, 22 March 1963.

Daily Express, 24 March 1963.

Daily Express, 24 June 1963.

Daily Express, 4 August 1963.

Danius, Sara (2002) *The Senses of Modernism: Technology, Perception and Aesthetics*, Ithaca and London: Cornell University Press.

Davidson, Arnold I. (2001) *The Emergence of Sexuality: Historical Epistemology and the Formation of Concepts*, Cambridge, Mass, and London: Harvard University Press.

Dawson, Graham (1991) 'The Blond Bedouin: Lawrence of Arabia, Imperial Adventure and the Imagining of English–British Masculinity', in Michael Roper and John Tosh (eds) *Manful Assertions: Masculinities in Britain since 1800*, London and New York: Routledge.

—— (1994) *Soldier Heroes: British Adventure, Empire and the Imagining of Masculinities*, London and New York: Routledge.

Deleuze, Gilles (1992) 'Postscript on the Societies of Control', *October*, 59(Winter): pp. 3–7.

—— (1998) 'The Shame and the Glory: T. E. Lawrence', in *Essays Critical and Clinical*, London and New York: Verso.

Dimendberg, Edward (2004) *Film Noir and the Spaces of Modernity*, Cambridge, Mass, and London: Harvard University Press.

Doane, Mary Ann (2002) *Modernity, Contingency, the Archive: The Emergence of Cinematic Time*, Cambridge, Mass, and London: Harvard University Press.

Dowling, Linda (1994) *Hellenism and Homosexuality in Victorian Oxford*, Ithaca and London: Cornell University Press.

Durham Peters, John (1999) *Speaking into the Air: A History of the Idea of Communication*, Chicago and London: University of Chicago Press.

Earle, Peter (1963) 'The Hidden World of Stephen Ward', *News of the World*, 4 August.

East, Norbert (1949) *Society and the Criminal*, London: HMSO.

Elliot, Katherine (1942) 'Foreword', in Pearl Jephcott, *Girls Growing Up*, London: Faber and Faber.

Flint, Kate (2000) *The Victorians and the Visual Imagination*, Cambridge: Cambridge University Press.

Frayn, Michael (1963) 'Festival', in Michael Sissons and Philip French, *Age of Austerity*, London: Hodder and Stoughton.

Fussell, Paul (1975) *The Great War and Modern Memory*, New York and London: Oxford University Press.

Garber, Marjorie (1992) 'The Chic of Araby: Transvestism and the Erotics of Cultural Appropriation', in *Vested Interests: Cross Dressing and Cultural Anxiety*, London and New York: Routledge.

Gates, Barbara (1988) *Victorian Suicide: Mad Crimes and Sad Histories*, Princeton, New Jersey: Princeton University Press.

Gatens, Moira (1991) *Feminism and Philosophy: Perspectives on Difference and Equality*, Cambridge: Polity Press.

Gillespie, R. D. (1942) *Psychological Effects of War on Citizen and Soldier*, New York: W. W. Norton and Company Inc.

Gledhill, Christine and Swanson, Gillian (eds) (1996) *Nationalising Femininity: Culture, Sexuality and British Cinema in the Second World War*, Manchester and New York: Manchester University Press.

Glover, Edward (1940a) 'Changes in Psychic Economy', *The Lancet*, March 23.

—— (1940b) *The Psychology of Fear and Courage*, Harmondsworth: Penguin.

—— (1943; 3rd edn 1969) *The Psychopathology of Prostitution*, London: Institute for the Study and Treatment of Delinquency.

—— (1944) *The Diagnosis and Treatment of Delinquency: being a Clinical Report on the work of the Institute during the Five Year 1937–1941*, London: Institute for the Scientific Treatment of Delinquency, reprinted in Craig, R. N. (1944) *Mental Abnormality and Crime*, London: Macmillan.

—— (1957) *The Psychopathology of Prostitution*, London: Institute for the Study and Treatment of Delinquency.

Gosling, Ex-Det. Supt. John and Warner, Douglas (1960) *The Shame of a City: An Inquiry into the Vice of London*, London: W. H. Allen.

Graves, Robert (1927) *Lawrence and the Arabs*, London: Jonathan Cape.

Greenblatt, Stephen (1991) *Marvelous Possessions: The Wonder of the New World*, Oxford: Oxford University Press.

Griffith, Edward F. (1948) *Morals in the Melting Pot*, London: Methuen.

Hacking, Ian (1995) *Rewriting the Soul: Multiple Personality and the Sciences of Memory*, Princeton, New Jersey: Princeton University Press.

Haire, Norman (1948) 'Prostitution: Abolition, Toleration or Regulation', *Marriage Hygiene*, 1(4): pp. 220–9.

Hall Williams, J. E. (1960) 'The Street Offences Act, 1959', *Modern Law Review*, 23(2): pp. 173–9.

Hall, Lesley A. (1992) 'Forbidden by God, Despised by Men: Masturbation, Medical Warnings, Moral Panic, and Manhood in Great Britain, 1850–1950', *Journal of the History of Sexuality*, 2(3): pp. 365–87.

Hall, Stuart (ed.) (1980) 'Reformism and the Legislation of Consent', in *Permissiveness and Control: The Fate of Sixties Legislation*, New York: Barnes & Noble.

Halperin, David M. (1990) 'Why is Diotima a Woman?', in *One Hundred Years of Homosexuality*, London: Routledge.

—— (2002) *How to Do the History of Homosexuality*, Chicago and London: University of Chicago Press.

Harper, Sue (1996) 'The Years of Total War: Propaganda and Entertainment', in Christine Gledhill and Gillian Swanson (eds) *Nationalising Femininity: Culture, Sexuality and British Cinema in the Second World War*, Manchester and New York: Manchester University Press.

Harrisson, Tom and Madge, Charles (1939; republished 1986) *Britain, by Mass Observation*, London: Century Hutchinson.

Harvey, David (1989) *The Condition of Postmodernity*, Oxford: Oxford University Press.

Hauser, Richard (1962) *The Homosexual Society*, London: The Bodley Head.

HMSO (1956a) *The Statement on the Findings of the Conference of Privy Councillors on Security*, Command Paper 9715, London: HMSO.

HMSO (1956b) *Report of the Morton Commission on Marriage and Divorce*, Command Paper 9678, London: HMSO.

HMSO (1957) *Report of the Departmental Committee on Homosexual Offences and Prostitution*, Command Paper 247, London: HMSO.

HMSO (1963a) *Lord Denning's Report*, Command Paper 2152, London: HMSO.

HMSO (1963b) *Report of the Tribunal Appointed to Inquire into the Vassall Case and Related Matters*, Command Paper 2009, London: HMSO.

Hocquenghem, Guy (1978) *Homosexual Desire*, London: Allison & Busby.

Hopkins, Harry (1964) *The New Look: A Social History of the Forties and Fifties in Britain*, London: Secker & Warburg.

Horne, Julia (1991) 'Travelling through the Romantic Landscapes of the Blue Mountains', *Australian Cultural History*, 10.

Hornsey, R. Q. D. (2003) *Homosexuality and Everyday Life in Post-war London*, University of Sussex: unpublished thesis.

—— (2009, forthcoming) *The Spiv and the Architect: Space, Time and Male Homosexuality in Post-War London*, Minneapolis: University of Minneapolis Press.

Houlbrook, Matt (2005) *Queer London: Perils and Pleasures in the Sexual Metropolis, 1918–1957*, Chicago and London: University of Chicago Press.

House of Commons (1958) *Hansard House of Commons Debates*, 596: 428.

House of Commons (1963) *Hansard House of Commons Debates*, 679: 54.

Hyde, H. Montgomery (1970) *The Love That Dared Not Speak Its Name*, Boston and Toronto: Little, Brown (published in the UK as *The Other Love*).

Igra, Samuel (1940) *Germany's National Vice*, London: Quality Press.

Irving, Clive, Hall, Ron and Wallington, Jeremy (1963) *Scandal '63*, London: William Heinemann.

James, Lawrence (2005) *The Golden Warrior: The Life and Legend of Lawrence of Arabia*, London: Abacus.

James, William (1890) *Principles of Psychology*, London: Macmillan.

Jay, Martin (2005) *Songs of Experience: Modern American and European Variations on a Universal Theme*, Berkeley, Los Angeles and London: University of California Press.

Jephcott, Pearl (1942) *Girls Growing Up*, London: Faber and Faber.

Joint Committee of the British Medical Association and the Magistrates' Association (1946) *'The Problem Girl': A Report on the Problem of the Unstable Adolescent Girl*, London: British Medical Association.

Kaplan, Caren (1996) *Questions of Travel: Postmodern Discourses of Displacement*, Durham and London: Duke University Press.

Kaplan, Cora (1986) 'Wild Nights: Pleasure/Sexuality/Feminism', in *Sea Changes*, London: Verso.

Keeler, Christine and Meadley, Robert (1985) *Sex Scandals*, London: Xanadu.

Keeler, Christine and Thompson, Douglas (2001) *The Truth at Last: My Story*, Basingstoke and Oxford: Pan Books.

Kennedy, Ludovic (1964) *The Trial of Stephen Ward*, London: Victor Gollancz.

Knightley, Philip and Kennedy, Caroline (1987) *An Affair of State: The Profumo Case and the Framing of Stephen Ward*, London: Jonathan Cape.

Kosofsky Sedgwick, Eve (1990) *Epistemology of the Closet*, Berkeley: University of California Press.

Kushner, H. I. (1993) 'Suicide, Gender and the Fear of Modernity in Nineteenth-Century Medical and Social Thought', *Journal of Social History*, 26(3): pp. 461–90.

Laird, Sydney M. (1943) *Venereal Disease in Britain*, Harmondsworth: Penguin.

Lawrence, T. E. (1927) *Revolt in the Desert*, London: Jonathan Cape.

—— (1935/26) *Seven Pillars of Wisdom: A Triumph*, London: Jonathan Cape. (Reprinted in 2000 at Harmondsworth by Penguin Classics, with the 'suppressed introductory chapter' restored.)

—— (1939) 'The Suppressed Introductory Chapter for *Seven Pillars of Wisdom*', in *Oriental Assembly*, London: Williams and Norgate.

—— (1955) *The Mint: A Day Book of the RAF Depot between August and December 1922 with Later Notes, by 352087 A/C Ross*, Harmondsworth: Penguin.

Leman, Joy (1996) 'Pulling our Weight in the Call-Up of Women: Class and Gender in British Radio in the Second World War', in Christine Gledhill and Gillian Swanson (eds) *Nationalising Femininity: Culture, Sexuality and British Cinema in the Second World War*, Manchester and New York: Manchester University Press.

Lewis, Hilda (1954) *Deprived Children: The Mersham Experiment, A Social and Clinical Study*, London, New York and Toronto: The Nuffield Foundation and Oxford University Press.

Liddell Hart, Basil (1934) *'T. E. Lawrence' in Arabia and Others*, London and Toronto: Jonathan Cape.

Luckhurst, Roger (2002) *The Invention of Telepathy, 1870–1901*, Oxford and New York: Oxford University Press.

MacAndrew, Rennie (1941; 19th edn 1952) *The Red Light: Intimate Hygiene for Men and Women*, London: The Wales Publishing Co.

Mack, John E. (1990/76) *A Prince of Our Disorder: The Life of T. E. Lawrence*, Oxford: Oxford University Press.

Mann, Jean (1958) debate on 'Homosexual Offences and Prostitution (Report)', *Hansard House of Commons Debates*, 596: 25.

Mass Observation (1948) 'A Report on Shopping', D87/5P, Report no. 3055, November.

Matless, David (1998) *Landscape and Englishness*, London: Reaktion Books.

McDougall, William (1908; 21st edn 1928) *An Introduction to Social Psychology*, London: Methuen, Enlarged.

—— (1923; 6th edn 1933) *An Outline of Psychology*, London: Methuen.

—— (1924) *Ethics and Some Modern World Problems*, New York and London: G. P. Putnam's Sons.

—— (1926; 4th edn 1944) *An Outline of Abnormal Psychology*, London: Methuen.

—— (1927) *Character and the Conduct of Life*, London: Methuen.

—— (1932/50) *The Energies of Men: A Study of the Fundamentals of Dynamic Psychology*, London: Methuen.

—— (1944) *An Outline of Abnormal Psychology*, London: Methuen.

McLaine, Ian (1979) *Ministry of Morale: Home Front Morale and the Ministry of Information in World War II*, London: Allen & Unwin.

Medhurst, Andy (1984) '*Victim*: Text as Context', *Screen*, 25(4–5): pp. 22–35.

Merriman, Peter (2004) 'Driving Places: Marc Auge, Non-Places, and the Geographies of England's M1 Motorway', *Theory, Culture and Society*, 21: pp. 145–67.

Meyers, Jeffrey (1989/73) *The Wounded Spirit: T. E. Lawrence's Seven Pillars of Wisdom*, London: Macmillan.

Miller, D. A. (1990) 'Anal Rope', *Representations*, 32: pp. 114–33.

Miller, Emanuel (ed.) (1940) *The Neuroses in War*, London: Macmillan.

Minns, Raynes (1980) *Bombers and Mash: The Domestic Front 1939–45*, London: Virago.

Moran, L. J. (1991) 'The Uses of Homosexuality: Homosexuality for National Security', *International Journal of the Sociology of Law*, 19: pp. 149–70.

Morgan, A. E. (1943) *Young Citizen*, Harmondsworth: Penguin.

Mort, Frank (1999) 'Mapping Sexual London: The Wolfenden Committee on Homosexual Offences and Prostitution 1954–57', *New Formations*, special issue: Sexual Geographies, 37(Spring): pp. 92–113.

Nava, Mica (1996) 'Modernity's Disavowal: Women, the City and the Department Store', in Mica Nava and Alan O'Shea (eds) *Modern Times: Reflections on a Century of English Modernity*, London and New York: Routledge.

—— (1999) 'Wider Horizons and Modern Desire: The Contradictions of American and Racial Difference in London 1935–45', *New Formations*, special issue: Sexual Geographies, 37(Spring): pp. 71–91.

Nead, Lynda (2000) *Victorian Babylon: People, Streets and Images in Nineteenth-Century London*, New Haven and London: Yale University Press.

News of the World, 5 May 1963.

News of the World, 9 June 1963.

News of the World, 16 June 1963.

Nutting, Anthony (1961) *Lawrence of Arabia: The Man and the Motive*, London: Hollis and Carter.

Pailthorpe, G. W. (1932a) *Studies in the Psychology of Delinquency*, London: HMSO.
—— (1932b) *What We Put in Prison and in Preventive and Rescue Homes*, London: Williams and Norgate.
Pateman, Carole (1989) *The Disorder of Women*, Cambridge: Polity Press and Basil Blackwell.
Pear, T. H. (1939) 'Some Problems and Topics of Contemporary Social Psychology', in F. C. Bartlett, M. Ginsberg, E. J. Lindgren and R. H. Thouless (eds) *The Study of Society: Methods and Problems*, London: Kegan Paul, Trench, Trubner.
Peiss, Kathy (1984) 'Charity Girls and City Pleasures', in A. Snitow, C. Stansell and S. Thompson (eds) *Desire: The Politics of Sexuality*, London: Virago.
Perrot, Michelle (ed.) (1990) *A History of Private Life: From the Fires of Revolution to the Great War*, Cambridge, Mass: Belknap/Harvard University Press.
Petro, Patrice (1987) 'Mass Culture in Weimar: Contours of a Discourse on Sexuality in Early Theories of Perception and Representation', *New German Critique*, 40.
Pines, Malcolm (1991) 'The Development of the Psychodynamic Movement', in German E. Berrios and Hugh Freeman, *150 Years of British Psychiatry, 1841–1991*, London: Gaskell.
Porter, Roy and Hall, Lesley (1995) *The Facts of Life: The Creation of Sexual Knowledge in Britain, 1650–1950*, New Haven and London: Yale University Press.
Pumphrey, Martin (1987) 'The Flapper, the Housewife and the Making of Modernity', *Cultural Studies*, 1(2): pp. 179–92.
Rappaport, Erika Diane (2000) *Shopping for Pleasure: Women in the Making of London's West End*, Princeton, New Jersey: Princeton University Press.
Rawlinson, Peter (1989) *A Price Too High: An Autobiography*, London: Wiedenfeld and Nicholson.
Rendell, Jane (2002) *The Pursuit of Pleasure: Gender, Space and Architecture in Regency London*, London: The Athlone Press.
Rice-Davies, Mandy (1964) *The Mandy Report*, London: Confidential Publications.
Riley, Denise (1983) *War in the Nursery: Theories of the Child and Mother*, London: Virago.
Roback, A. A. (1927) *The Psychology of Character, With a Survey of Temperament*, London: Kegan Paul, Trench, Trubner.
Rolph, C. H. (ed.) (1961/55) for and on behalf of the British Social Biology Council, *Women of the Streets: A Sociological Study of the Common Prostitute*, London: Ace Books.
Rose, Nikolas (1986) *The Psychological Complex: Psychology, Politics and Society in England, 1869–1939*, London: Routledge.
—— (1990) *Governing the Soul: The Shaping of the Private Self*, London and New York: Routledge.
Rowntree, B. Seebohm (1945) 'Foreword', in Tom Stephens (ed.) *Problem Families: An Experiment in Social Rehabilitation*, London: Pacifist Service Units.
Schivelbusch, Wolfgang (1979) *The Railway Journey: Trains and Travel in the Nineteenth Century*, New York: Urizen Books.
Schmideberg, Melitta (1942) 'Some Observations on Individual Reactions to Air Raids', *International Journal of Psychoanalysis*, 23: pp. 7–9.
Scott, George Ryley (1940) *Sex Problems and Dangers in War-Time: A Book of Practical Advice for Men and Women on the Fighting and Home Fronts*, London: T. Werner Laurie.

Scott, Peter (1954) 'A Clinical Contribution', in Norwood East (ed.) *The Roots of Crime*, London: Butterworth.

Scottish Youth Advisory Committee (1945) *The Needs of Youth in These Times*, Edinburgh: Scottish Education Dept.

Shepherd, Ben (2000) *A War of Nerves: Soldiers and Psychiatrists 1914–1994*, London: Jonathan Cape.

Sheridan, Mary D. (1956) 'The Intelligence of 100 Neglectful Mothers', *British Medical Journal*, 1: 91–3, January, cited in C. P. Blacker, 'The *Medical Officer* on Problem Families', in 'Notes of the Quarter', *The Eugenics Review*, 48(2): pp. 68–9.

Silverman, Kaja (1992) 'White Skins, Brown Masks: The Double Mimesis, or With Lawrence in Arabia', in *Male Subjectivity at the Margins*, New York and London: Routledge.

Singer, Ben (1995) 'Modernity, Hyperstimulus and the Rise of Popular Sensationalism', in Leo Charney and Vanessa R. Schwarz (eds) *Cinema and the Invention of Modern Life*, Berkeley, Los Angeles and London: University of California Press.

Slater, Don (1993) 'Going Shopping: Markets, Crowds and Consumption', in Chris Jenks (ed.) *Cultural Reproduction*, London and New York: Routledge.

Slater, Eliot and Woodside, Moya (1951) *Patterns of Marriage*, London: Cassell.

Smart, Carol (1981) 'Law and the Control of Women's Sexuality', in B. Hutter and G. Williams (eds) *Controlling Women*, London: Croom Helm.

—— (1996) 'Good Wives and Moral Wives: Marriage and Divorce 1937–1951', in Christine Gledhill and Gillian Swanson (eds) *Nationalising Femininity: Culture, Sexuality and British Cinema in the Second World War*, Manchester and New York: Manchester University Press.

Smithies, Edward (1982) *Crime in Wartime: A Social History of Crime in World War II*, London: Allen & Unwin.

Soddy, Kenneth (1960) 'Not Yet … ?', *Lancet*, 2: pp. 197–99.

Spensky, Martine (1992) 'Producers of Legitimacy: Homes for Unmarried Mothers in the 1950s', in Carol Smart (ed.) *Regulating Womanhood: Historical Essays on Marriage, Motherhood and Sexuality*, London and New York: Routledge.

Spurr, David (1993) *The Rhetoric of Empire: Colonial Discourse in Journalism, Travel Writing and Imperial Administration*, Durham and London: Duke University Press.

Starkey, Pat (2000a) *Families and Social Workers: The Work of Family Service Units 1940–1985*, Liverpool: Liverpool University Press.

—— (2000b) 'The Feckless Mother: Women, Poverty and Social Workers in Wartime and Post-War England', *Women's History Review*, 9(3): pp. 539–57.

Stephens, Tom (ed.) (1945) *Problem Families: An Experiment in Social Rehabilitation*, London: Pacifist Service Units.

Summers, A. and Dorril, S. (1987) Chapter 2, 'Pygmalion and the Popsies', in *Honeytrap the Scandal*, London: Coronet Books, pp. 38–58.

Sunday Pictorial, 25 May 1952.

Swanson, G. (1994a) 'Consuming Spaces: Redefining Sexual Geographies', in Kathie Gibson and Sophie Watson (eds) *Postmodern Spaces/Cities*, London: Basil Blackwell.

—— (1994b) 'Good Time Girls, Men of Truth and a Thoroughly Filthy Fellow: Sexual Pathology and National Character in the Profumo Affair', *New Formations*, 24(Winter): pp. 122–54.

—— (1995) *'Gone Shopping...': Women, Consumption and the Resourcing of Civic Cultures, Cultural Policy Paper No 2*, Brisbane: Australian Key Centre for Cultural and Media Policy.

—— (2000) 'Locomotive Stomachs and Downcast Looks: Urban Pathology and the Destabilised Body', in Jane Crisp, Kay Ferres and Gillian Swanson, *Deciphering Culture: Ordinary Curiosities and Subjective Narratives*, London and New York: Routledge.

—— (2007a) 'Serenity, Self-Regard and the Genetic Sequence: Social Psychiatry and Preventive Eugenics in Britain, 1930s–1950s', in *New Formations*, special issue: Eugenics, 60: pp. 50–65.

—— (2007b) '"Shattered into a Multiplicity of Warring Functions": Synthesis, Disintegration and "Distractibility"', *Intellectual History Review*, 17(3).

Thacker, Andrew (2003) *Moving Through Modernity: Space and Geography in Modernism*, Manchester and New York: Manchester University Press.

Thane, Pat (1999) 'Population Politics in Post-War British Culture', in Becky Conekin, Frank Mort and Chris Waters (eds) *Moments of Modernity: Reconstructing Britain 1945–1964*, London and New York: Rivers Oram Press.

The Times, 6 April 1951.

Thomson, Mathew (1998) *The Problem of Mental Deficiency: Eugenics, Democracy and Social Policy in Britain, c 1870–1959*, Oxford: Clarendon Press.

—— (2006) *Psychological Subjects: Identity, Culture, and Health in Twentieth-Century Britain*, Oxford and New York: Oxford University Press.

Thouless, R. H. (1925/44) *General and Social Psychology*, London: University Tutorial Press.

—— (1939) 'Problems of Terminology in the Social Sciences', in F. C. Bartlett, M. Ginsberg, E. J. Lindgren and R. H. Thouless (eds) *The Study of Society: Methods and Problems*, London: Kegan Paul, Trench, Trubner.

Thurlow, David (1992) *Profumo: The Hate Factor*, London: Robert Hale.

Titmuss, Richard M. (1950) *Problems of Social Policy*, London: His Majesty's Stationery Office and Longmans, Green.

Trist, G. and Murray, H. (eds) (1990) *The Social Engagement of Social Science: A Tavistock Anthology, Volume I: The Socio-Psychological Perspective*, Philadelphia: University of Pennsylvania Press.

Urry, John (2004) 'The "System" of Automobility', *Theory, Culture and Society*, special issue: Automobilities, 21(4–5): pp. 25–39.

Vidler, Anthony (2000) *Warped Space: Art, Architecture, and Anxiety in Modern Culture*, Cambridge, Mass, and London: The MIT Press.

Walkowitz, Judith R. (1980) *Prostitution and Victorian Society: Women, Class and the State*, Cambridge: Cambridge University Press.

—— (1982) 'Jack the Ripper and the Myth of Male Violence', *Feminist Studies*, 8(3): 566–9.

—— (1992) *City of Dreadful Delight: Narratives of Sexual Danger in Late-Victorian London*, London: Virago.

Wallace, V. H. (1951) 'Prostitution in London', *International Journal of Sexology*, 5(1): 48.

Waller, Jane and Vaughan-Rees, Michael (1987) *Women in Wartime: The Role of Women's Magazines 1939–1945*, London: Macdonald Optima.

War Office (1948) *Statistical Report on the Health of the Army 1943–45*, London: HMSO.

Waters, Chris (1999) 'Disorders of the Mind, Disorders of the Body Social: Peter Wildeblood and the Making of the Modern Homosexual' in Becky Conekin, Frank Mort and Chris Waters (eds) *Moments of Modernity: Reconstructing Britain 1945–1964*, London and New York: Rivers Oram Press.

Weeks, Jeffrey (1977) *Coming Out*, London: Quartet.

—— (1989) *Sex, Politics and Society: The Regulation of Sexuality since 1800*, Harlow: Longman.

West, Nigel (1983) *A Matter of Trust: MI5 1945–72*, Sevenoaks: Coronet.

West, Rebecca (1965) *The Meaning of Treason*, Harmondsworth: Penguin.

Wigley, Mark (1992) 'Untitled: The Housing of Gender', in Beatriz Colomina (ed.) *Sexuality and Space*, New York: Princeton Architectural Press.

—— (1995) *White Walls, Designer Dresses: The Fashioning of Modern Architecture*, Cambridge, Mass, and London: The MIT Press.

Wildeblood, Peter (1957) *Against the Law*, Harmondsworth, Middlesex: Penguin.

Wilson, Elizabeth (1980) *Only Halfway to Paradise – Women in Post-War Britain: 1945–1968*, London and New York: Tavistock Publications.

—— (1994) 'The Invisible *Flâneur*', in Sophie Watson and Katherine Gibson (eds) *Postmodern Cities and Spaces*, Oxford and Cambridge, Mass: Basil Blackwell.

Wilson, Jeremy (1989) *Lawrence of Arabia: The Authorised Biography of T E Lawrence*, London: Heinemann.

Winnicott, D. W. (1950) 'Thoughts on the Meaning of the Word Democracy', *Human Relations*, 4: pp. 171–85. Reproduced in Trist, Eric and Murray, Hugh (1990) *The Social Engagement of Social Science: A Tavistock Anthology, Volume 1: The Social-Psychological Perspective*, Philadelphia: University of Pennsylvania Press.

Winship, Janice (1996) 'Women's Magazines: Times of War and Management of the Self in Women's Own', in Christine Gledhill and Gillian Swanson (eds) *Nationalising Femininity: Culture, Sexuality and British Cinema in the Second World War*, Manchester and New York: Manchester University Press.

Wofinden, R. C. (1944) 'Problem Families', *Public Health*, September, pp. 136–9. Cited in Wofinden, R. C. (1946) 'Problem Families', *The Eugenics Review*, 38(3): pp. 127–32.

Wolfenden, John (1976) *Turning Points: The Memoirs of Lord Wolfenden*, London, Sydney and Toronto: The Bodley Head.

Women's Group on Public Welfare (in association with the National Council for Social Services) (1943) *Our Towns: A Close-Up*, London: Oxford University Press.

Wootton, Barbara (1956) 'Sickness or sin?', *Twentieth Century*: pp. 435–42.

Yellowlees, Henry (1943) *Out of Working Hours: Medical Psychology on Special Occasions*, London: J. A. Churchill.

Filmography

Lawrence of Arabia (1962) dir. David Lean, Horizon Pictures, UK.

Victim (1961) dir. Basil Dierden, Parkway Films, UK.

Index